771

KT-489-197

To P. Still the first for the first . . .

Basic Photography
Sixth Edition

Michael Langford FBIPP, HonFRPS
Royal College of Art, London

Focal Press
An imprint of Butterworth-Heinemann
Linacre House, Jordan Hill, Oxford OX2 8DP
A division of Reed Educational and Professional Publishing Ltd

℞ A member of the Reed Elsevier plc group

OXFORD BOSTON JOHANNESBURG
MELBOURNE NEW DELHI SINGAPORE

First published 1965
Second edition 1971
Third edition 1973
Fourth edition 1977
Fifth edition 1986
Sixth edition 1997

British Library Cataloguing in Publication Data
A CIP record for this book is available from the British Library

ISBN 0240 51485 8

Library of Congress Cataloguing in Publication Data
A catalogue record for this book is available on request

Composition by Genesis Typesetting, Rochester
Printed and bound in Great Britain

Contents

Introduction

'. . . Technique is basic to the art of photography'
Beaumont Newhall, Museum of Modern Art (*Essays*, 1980)

Basic Photography is an introductory textbook, covering the under-lying principles of photographic practice, for students of all ages. It explains equipment and techniques, provides background on how current 'silver halide' materials and processes work, and shows the relationship between visual and technical aspects of photography. Beginning at square one, it assumes that you have no theoretical knowledge of photography, nor any scientific background. In short, the book provides a groundwork for professional photographers which will interest and inform amateur photographers too.

'Photography', or 'light drawing', is essentially a combination of technique and visual observation. Developing your ability to make successful photographs must include some basic technical theory, otherwise you will not get the most out of your tools, fully explore materials, or turn out reliable results. This aspect of learning photography is like learning to write: first you have to shape the letters forming words, then spell, then string together sentences and para-graphs. But the individual who can do all this is no writer until he or she has ideas to express through words. In the same way technical theory to the photographer is a means to a visual end – valid in so far as it offers better control and self-confidence in achieving something to be said *through pictures*.

Basic Photography opens with a broad look at photography – putting it in context as a visual medium. Then it goes on to show how photography's components, procedures and chemical processes fit together. These chapters are laid out in the same order as image production, starting with chapters on light and lenses, and proceeding through cameras, subject lighting, and composition. (These 'front end' aspects remain valid whether you use traditional photographic materi-als, or newer electronic methods of image recording.) The book continues with films, exposure, processing, printing, and finishing.

Many photography courses start off with students using colour (slide) film, to build up confidence in camera handling and picture composition before progressing to more technical aspects of darkroom

work. Others begin with black and white photography, which, far from being eclipsed by colour, remains an important creative medium. Reflecting both approaches, *Basic Photography* covers camera aspects of colour and black and white photography, colour film processing, and black and white processing and printing. (Colour printing will be found in the companion volume, *Advanced Photography*; the sixth edition of *Advanced Photography* also covers digital imaging. The history of technical and stylistic movements in photography is described in *Story of Photography*, also published by Focal Press.) This is also logical from the point of view of the vast majority of photographers who begin by shooting colour film and using commercial colour printing services.

Revisions in this new edition take into account improvements in cameras – from compacts to new medium format professional equipment. The Advanced Photographic System is included and there are updates on films and developers. Health and safety aspects, too, are discussed in more detail. I have also had the opportunity to make improvements to several page layouts.

The text remains in a form that I hope is the most useful for students – either for 'dip-in' study, or sequential reading. You will find the summaries at the end of each chapter a good way of checking contents, and revising. Make use too of the Glossary and Appendices at the back of the book.

M.L.

1
What is photography?

Basically photography consists of a mixture of practical science, imagination and design, craft skills, and organising ability. Try not to become absorbed in the craft detail too soon, but put it into perspective by starting with a broad look at what making photographs is all about. On the one hand there is the machinery and the process itself. On the other you have the variety of visual approaches to picture making – from something objective, factual and precise, to work which is self-expressive and open to interpretation.

Why do you want to take photographs? What is actually involved? What roles do photographs play, relative to other ways of making pictures or expressing information and ideas? And what makes a result good or bad anyway?

Facets of photography

One of the first attractions of photography for many people is the lure of the equipment itself. All that ingenious modern technology designed to fit hand and eye – there is great appeal in pressing buttons, clicking precision components into place, and collecting and wearing cameras. Tools are vital, of course, and detailed knowledge about them absorbing and important, but don't end up shooting photographs just to test out the machinery.

Another attractive facet is the actual *process* of photography – the challenge of care and control, and the way this is rewarded by technical excellence and a final object you produced yourself. Results can be judged and enjoyed for their own intrinsic photographic 'qualities', such as superb detail, rich tones and colours. The process gives you the means of 'capturing your seeing', making pictures from things around you without having to laboriously draw. The camera is a kind of time machine, which freezes any person, place or situation you choose. It seems to give the user power and purpose.

Yet another facet is enjoyment of the visual structuring of photographs. There is real pleasure to be had from designing pictures as such – the 'geometry' of lines and shapes, balance of tone, the cropping

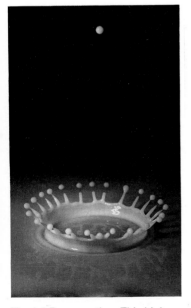

Fig. 1.1 Frozen action. This high-speed flash shot of a splash of milk is a factual record. But it can also be enjoyed for its natural design, normally too brief for the human eye alone to see

1

and framing of scenes – whatever the subject content actually happens to be. So much can be done by a quick change of viewpoint, or choice of a different moment in time.

Perhaps you are drawn into photography mainly because it is a quick, convenient and seemingly truthful way of *recording* something. All the importance lies in the subject itself, and you want to show objectively what it is, or what is going on. Photography is evidence, identification, a kind of diagram of a happening. The camera is your visual notebook.

The opposite facet of photography is where it is used to manipulate or interpret reality, so that pictures push some 'angle' or attitude of your own. You set up situations (as in advertising) or choose to photograph some aspect of an event but not others (as in politically biased news reporting). Photography is a powerful medium of persuasion and propaganda. It has that ring of truth when all the time, in artful hands, it can make any statement the manipulator chooses.

Another reason for taking up photography is that you want a means of personal self-expression. It seems odd that something so essentially objective as photography can be used to express, say, issues of identity, or metaphor and mysticism – describing daydreams that may not be immediately apparent from the subject matter in front of the camera. But we have probably all seen images 'in' other things, like reading meanings into flickering flames, shadows or peeling paint. A photograph can intrigue through its posing of questions, keeping the viewer returning to read new things from the image. The way it is presented too may be just as important as the subject matter. Other photographers simply seek out beauty, which they express in their own 'picturesque' style, as a conscious work of art.

These are only some of the diverse activities and interests covered by the umbrella term 'photography'. None are 'better' or more important than others. Several will be blended together in the work of a photographer, or any one market for professional photography. Your present enjoyment in producing pictures may be mainly based on technology, art or communication. And what begins as one area of interest can easily develop into another. As a beginner it is helpful to keep an open mind. Provide yourself with a well-rounded 'foundation course' by trying to learn something of *all* these facets, preferably through practice rather than theory alone.

How photography works

Fig. 1.2 The basic stages between subject and final photographic image

Whatever your eventual aims, you should be able to use the photographic process confidently. You don't need to understand

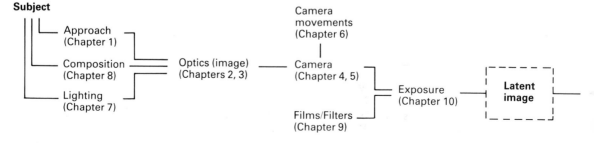

physics to take good photographs, of course, but at least have a sound technical knowledge of image forming, exposing, processing and printing. In outline the technical aspects of photography work as follows:

Exposing an image on film

Light from the subject of your picture passes through a glass lens, which bends it into a focused (normally miniaturised) image. The lens is at the front of a light-tight box or camera with film facing it at the other end. Light is prevented from reaching the film by a shutter until your chosen moment of exposure. The amount of exposure to light is most often controlled by a combination of the time the shutter is open and the diameter of the light beam passing through the lens. The latter is altered by an aperture, like the iris of the eye. Both these controls have a further influence on visual results. Shutter time alters the way movement records blurred or frozen; lens aperture alters the depth of subject that is shown in focus at one time (depth of field).

You need a viewfinder or focusing screen for aiming the camera and composing, and a light meter for measuring the brightness of each subject. Once you have programmed the meter with the light sensitivity of the film you are using it reads out, or automatically sets, an appropriate combination of aperture and shutter speed. With knowledge and skill you can override these settings to achieve chosen effects or compensate for conditions which will fool the meter.

Processing the film

A correctly exposed film differs from an unexposed film only at the atomic level – minute chemical changes forming an invisible or 'latent' image. Developing chemicals must then act on your film in darkness to amplify the latent image into something much more substantial and permanent in normal light. You apply these chemicals in the form of liquids; each solution has a particular function when used on the appropriate film. With most black and white films, for example, the first chemical solution develops light-struck areas into black silver grains. You follow it with a solution which dissolves ('fixes') away the unexposed parts, leaving clear film. So the result, after washing out by-products and drying, is a black and white negative.

A similar routine, but with chemically more complex solutions, is used to process colour film into colour negatives. In this instance a

developer forms dye in three layers – yellow, magenta and cyan – together with black silver. Then all silver is bleached and fixed, leaving a negative colour picture made up from the three dye layers alone. Colour slide film needs more processing stages. First a black and white negative developer is used, then the rest of the film (normally fixed) is colour developed to create a positive image in silver and dyes. When all the silver is bleached and fixed away, you are left with a positive dye-image colour slide.

Printing

The next stage of production is printing, or, more often, enlarging. Your picture on film is set up in a vertical projector called an *enlarger*. The enlarger lens forms an image, of almost any size you choose, on to light-sensitive photographic paper. During exposure the paper receives more light through clear areas of your film than through the denser parts. The latent image you have recorded on the paper is next processed in chemical solutions broadly similar to the stages needed for film. For example, black and white paper is exposed to the black and white film negative, then developed, fixed and washed so it shows a 'negative of the negative', which is a positive image – the familiar black and white print. Colour paper after exposure goes through a sequence of colour developing, bleaching and fixing to form a colour negative of a colour negative. Other materials and processes give colour prints from slides.

The important feature of printing (apart from allowing change of image size and running off many copies) is all the ways you can correct or manipulate your picture. Unwanted parts near the edges can be cropped off and chosen areas made lighter or darker. Working in colour you can use a wide range of enlarger colour filters to 'fine-tune' the colour balance of your print, or to create effects. With experience you can combine parts from several film images into one print, form pictures which are part-positive part-negative, and so on.

Routines and creative decisions

Photographic techniques fall into two categories.

● First, there are set routines where consistency is all important, e.g. film processing or paper processing, especially in colour. Professionally these tasks are now mostly done by machine.
● Second, there are those stages at which creative decisions must be made, and where a great deal of choice and variation is possible. These include organisation of the subject, lighting and camera handling, as well as printing. As a photographer you will need to handle and make these decisions yourself, or at least closely direct them.

With technical knowledge plus practical experience (which comes out of shooting lots of photographs under different conditions) you gradually build up skills that become second nature. It's like learning to drive. First you have to consciously learn the mechanical handling of a car. Then this side of things becomes so familiar you concentrate more and more on what you want to *achieve* with the machinery.

Eventually you can spend most time on picture-making problems such as composition, and capturing expressions and actions which differ with every shot and have no routine solutions. However, always keep yourself up-to-date on new processes and equipment as they come along. You need to discover what new visual opportunities they offer.

Colour and black and white

Most people take their first photographs in colour. Visually it is much easier to shoot colour than black and white, because the result more closely resembles the way the subject looked in the viewfinder. You must allow for differences between how something looks and how it comes out in a colour photograph, of course (see Chapter 6). But this is generally less difficult than forecasting how subject colours will translate into tones of monochrome. At its best, black and white photography is considered more interpretative and subtle, less crudely lifelike than colour. For this reason it has become a minority enthusiasts' medium, still important for 'fine prints' and gallery shows. Here it readily rubs shoulders with black and white photography of the past.

Colour materials and processes are much more complex than black and white. This is why it was almost a hundred years after the invention of photography before reliable colour print processes appeared. Even then they were expensive and laborious to use, so that until the 1970s photographers mostly learnt their craft in black and white and worked up to colour. Today much of the chemical complexity of colour photography is locked up in the manufacturers' films, papers, ready-mixed solutions and standardised processing routines. It is mainly in printing that colour remains more demanding than black and white, because of the extra requirements of judging and controlling colour balance (see *Advanced Photography*). So in the darkroom at least you will find that it is still best to begin with black and white.

Picture structuring

The way you visually compose your pictures is just as important as their technical quality. But this skill is acquired with experience as much as learnt. Composition is to do with showing things in the strongest, most effective way, whatever your subject. Often this means avoiding clutter and confusion between the various elements in the picture (unless this very confusion contributes to the mood you want to create). It involves you in the use of lines, shapes and areas of tone within your picture, irrespective of what the items actually *are*, so that they relate together effectively, like a kind of unselfconscious geometry. See Figure 1.3.

Composition is therefore something photography has in common with drawing, painting and the fine arts generally. The main difference is that you have to get most of it right while the subject is still in front of you. The camera works fast; it does not offer the same opportunity to build up your final image gradually afterwards, as does a pencil or brush.

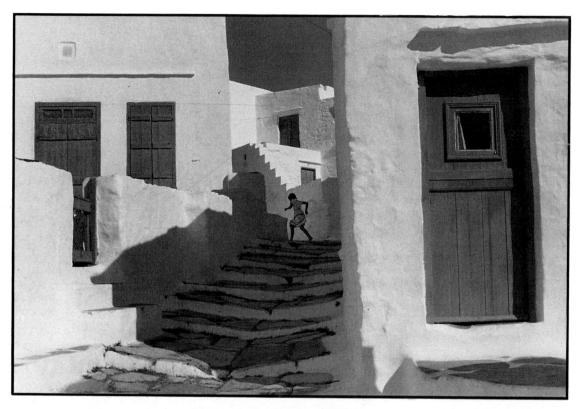

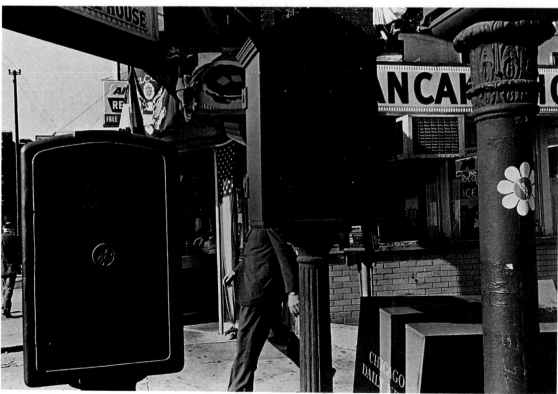

Fig. 1.3 Siphnos, Greece, 1961. A Henri Cartier-Bresson picture strongly designed through choice of viewpoint to use line and tone, together with moment in time

'Rules' of composition have gone out of fashion, with good reason. They encourage results which slavishly follow the rules but offer nothing else besides. As Edward Weston once wrote: 'Consulting rules of composition before shooting is like consulting laws of gravitation before going for a walk'. Of course it is easy to say this when you already have an experienced eye for picture making, but guides are helpful if you are just beginning (see Chapter 8). Practise making critical comparisons between pictures that structurally 'work' and those that do not. Discuss these aspects with other people, both photographers and non-photographers.

Where a subject permits, it is always good advice to shoot several photographs – perhaps the obvious versions first, then others with small changes in the way items are juxtapositioned, etc., increasingly simplifying and strengthening what your image expresses or shows. It's your eye that counts here more than the camera (although some cameras get far less in the way between you and the subject than others).

Composition can contribute greatly to the style and originality of your pictures. Some photographers (Lee Friedlander, for example: Figure 1.4) go for offbeat constructions which add to the weirdness of picture contents. Others, like Arnold Newman and Henri Cartier-Bresson, are known for their more formal approach to picture composition.

Composition in photography is almost as varied as composition in music or words – melodic or atonal, safe or daring – and can enhance subject, theme, and style. Every photograph you take involves you in some compositional decision, even if this is simply where to set up the camera or when to press the button.

Fig. 1.4 Lee Friedlander's Chicago street scene seems random in composition and timing – with every object cut into by something else. However, it purposely expresses an off-beat, depersonalised strangeness. The picture leaves the viewer asking questions

The roles photographs play

There is little point in being technically confident and having an eye for composition, if you do not also understand *why* you are taking the photograph. The purpose may be simple – a clear, objective record of something or somebody for identification. It may be more nebulous – a subjective picture with connotations of security, happiness or menace, for example. No writer would pick up a pen without knowing whether the task is to produce a data sheet or a poem. Yet there is a terrible danger with photography that you set up your equipment, busy yourself with focus, exposure and composition, but think hardly at all about the meaning of your picture and why you should show the subject in that particular way.

People take photographs for all sorts of reasons of course. Most are just records and reminders of vacations, or family and loved ones. These fulfil one of photography's most valuable social functions, freezing moments in our own history for recall in years to come.

Sometimes photographs are taken to show tough human conditions and so appeal to the consciences of others. Here you may have to investigate the subject in a way which in other circumstances would be called prying or voyeurism. This difficult relationship with the *subject* has to be overcome if your final picture is to win a positive response from the *viewer*.

Fig. 1.5 This documentary shot by Dorothea Lange was taken in San Francisco during the 1930s Depression. It relies greatly on human expressions to communicate an 'in America we trust' appeal

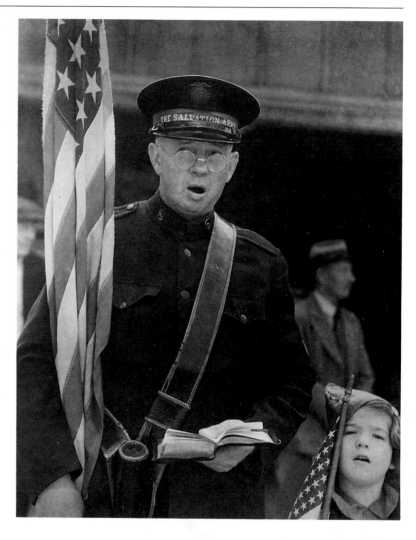

Understanding the best approach to the subject to create the right reaction from your target audience is vital too in photographs that advertise and sell. Every detail in a set-up situation must be considered with the message in mind. Is the location or background of a kind with which consumers positively identify? Are the models and the clothes they are wearing too up (or down) market? Props and accessories must suit the lifestyle and atmosphere you are trying to convey. Generally viewers must be offered an image of themselves made more attractive by the product or service you are trying to sell. In the middle of all this fantasy you must shoot a picture structured to attract attention; show the product; perhaps leave room for lettering; and suit the proportions of the showcard or magazine page on which it will finally be printed.

News pictures are different again. Here you must often encapsulate an event in what will be one final published shot. The moment of expression or action should sum up the situation, although you can colour your report by choosing when, and from where, you shoot. Photograph a demonstration from behind a police line and you may show menacing crowds; photograph from the front of the crowd and

you show suppressive authorities. You have a similar power when portraying the face of, say, a politician or a sportsperson. Someone's expression can change between sadness, joy, boredom, concern, arrogance, etc., all within the space of a few minutes. By photographing just one of those moments and labelling it with a caption reporting the event, it is not difficult to tinker with the truth.

At another level, decorative photographs for calendars or editorial illustration (pictures which accompany magazine articles) can communicate beauty for its own sake – beauty of landscape, human beauty, and natural form or beauty seen in ordinary everyday things (Figure 1.7). Beauty is a very subjective quality, influenced by attitudes and experience. But there is scope here for your own way of seeing and responding to be shown through a photograph which produces a similar response in others. Overdone, it easily becomes 'cute' and cloying, overmannered and self-conscious.

Photography can provide objectivity and information in the kind of record pictures used for education, medicine, and various kinds of scientific evidence. Here you can really make use of the medium's superb detail and clarity, and the way pictures communicate internationally, without the language barrier of the written word. Features of a camera-formed image are not unlike an eye-formed image (Chapter 3). This seems to make it easier to identify with and read information direct from a photograph than from a sketch.

Photographs are not always intended to communicate with other people, however. You might be looking for self-fulfilment and self-expression, and it may be a matter of indifference to you whether others read information or messages into your results – or indeed see them at all. Some of the most original images in photography have been produced in this way, totally free of commercial or artistic conventions, often the result of someone's private and personal obsession. You will

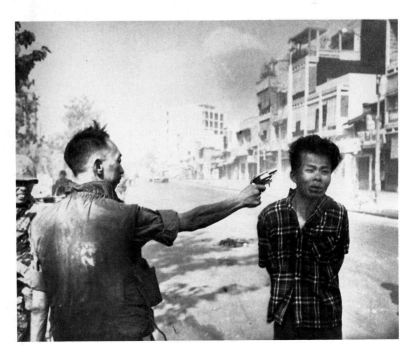

Fig. 1.6 Street execution of a Viet Cong suspect. Newspaper photographer Edward Adams' picture summed up the brutality of the Vietnam war. As a record of what was actually going on it shocked the world

find examples in the photography of Diane Arbus, Clarence Laughlin or Jerry Uelsmann (Figure 1.8), and photograms by Man Ray or Moholy Nagy.

There are many other roles photographs can play: mixtures of fact and fiction, art and science, communication and non-communication. Remember too that a photograph is not necessarily the last link in the chain between subject and viewer. Editors, art editors, and exhibition organisers all like to impose their own will on final presentation. Pictures are cropped, captions are written and added, layouts place one picture where it relates to others. Any of these acts can strengthen, weaken or distort what a photographer is trying to show. You are at the mercy of people 'farther down the line'. They can even sabotage you years later, by taking an old picture and making it do new tricks.

Attitudes towards photography

Today's awareness and acceptance of photography as a creative medium by other artists, by galleries, publishers, collectors and the

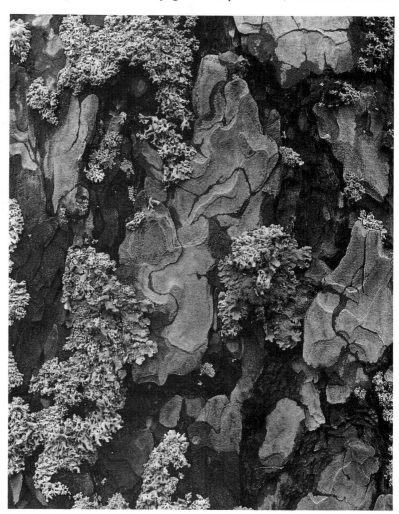

Fig. 1.7 Fungus and bark on a tree trunk The detail and tone range offered by 'straight' photography strengthen the subject's own natural qualities of pattern and form

Fig. 1.8 A dream-like image constructed by Jerry Uelsmann – printed from several negatives onto one piece of paper. The information content and apparent truthfulness of photography make it a convincing medium for surreal pictures

general public has not been won easily. People's views for and against photography have varied enormously in the past, according to the fashions and attitudes of the times. For a great deal of the 19th century (photography was invented in 1839) photographers were seen as a threat by painters who never failed to point out in public that these crass interlopers had no artistic ability or knowledge. To some extent this was true – you needed to be something of a chemist to get results at all.

Pictorialism and realism

By the turn of the century equipment and materials had become somewhat easier to handle. Snapshot cameras, and developing and printing services for amateurs, made black and white photography an amusement for the masses. In their need to distance themselves from all this and gain acceptance as artists, 'serious' photographers tried to force the medium closer to the appearance and functions of paintings of

Fig. 1.9 'La Lettre' by Robert Demachy, 1905. A pictorial (or 'picturesque') subject and style. Demachy made his prints by the gum bichromate process, which gives an appearance superficially more like an impressionist painting than a photograph

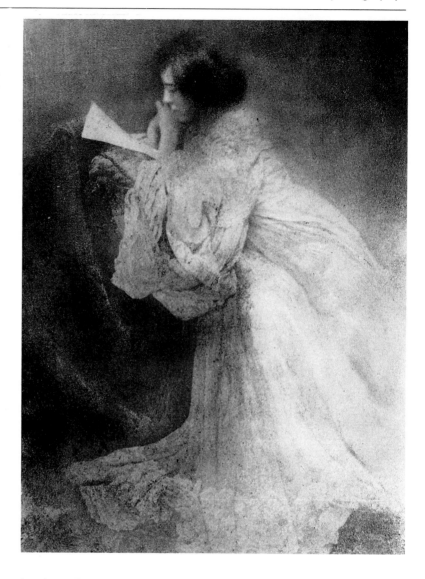

the day. They called themselves 'pictorial' photographers, shooting picturesque subjects, often through soft-focus camera attachments, and printing on textured paper by processes which eliminated most of photography's 'horrid detail'.

Fortunately the advent of cubism and other forms of abstraction in painting, at the same time as techniques for mechanically reproducing photographs on the printed page, expanded photographers' horizons. 'Straight' photography came into vogue early this century with the work of Edward Weston, Paul Strand and Albert Renger-Patzsch. They made maximum use of the qualities of black and white photography previously condemned: pin-sharp focus throughout, rich tonal scale and the ability to shoot simple every-day subjects using natural lighting. Technical excellence was all important and strictly applied. Photography had an aesthetic of its own, but something quite separate from painting and other forms of fine art.

The advent of mechanically printed photographs opened up the market for press and candid photography. Pictures were taken for their action and content rather than greatly considered treatment. This and the freedom given by precision hand cameras led to a break with age-old painterly rules of composition.

The 1930s and 40s were the great expansion period for picture magazines and photo-reporting, before the growth of television. They also saw a steady growth in professional aspects of photography: advertising; commercial and industrial; portraiture; medical; scientific and aerial applications. Most of this was still in black and white. Use of colour gradually grew during the 1950s but it was still difficult and expensive to reproduce well in publications.

Rapid, far-reaching changes took place during the 1960s. From something which a previous generation had regarded as an old-fashioned, fuddy-duddy trade and would-be artistic occupation, photography became very much part of the youth cult of the 'swinging sixties'. New small-format precision SLR cameras, electronic flash, machines and custom laboratories to hive off boring processing routines, and an explosion of fashion photography, all had their effect. Photography captured the public imagination.

Young people suddenly wanted to own a camera, and use it to express themselves about the world around them. The new photographers were interested in contemporary artists, but neither knew nor cared about the established photographic clubs and societies with their stultifying 'rules' and narrow outlook on the kind of pictures acceptable for awards.

The fresh air this swept into photography did immeasurable good. Photographers were no longer plagued with self-conscious doubts such as 'is photography Art?' It was accepted as a *medium* – already the dominant form of illustration everywhere and, in the hands of an artist, a growing art form. Since photographs have become so universal in recent years they have become integrated with modern painting, printmaking, even sculpture. Critical discussion of photographs (and the meaning behind them) has matured and widened out. This in turn attracts in talented people who have chosen to use photography as a fine art.

Colleges and galleries

Before the 1950s, photography was taught hardly anywhere in schools and colleges. Few one-person portfolios of photographs were published as books, and it was extremely rare for an established art gallery to hang prints, let alone public galleries to be devoted to photography. By the 1970s all this had changed. Photography as such was taught in technical colleges, then art colleges, high schools, and (in the US at least) universities. Educational bodies recognised the value of including photography in art and design, social studies and communications. There was demand for a wide range of publications reproducing the work of individual photographers, partly as a result of this study, partly popular interest.

Adventurous galleries put on photography shows – between 1950 and 1970 these increased ten-fold. Photography no longer

Fig. 1.10 Colour photography is often considered more objective and life-like than black and white. But a hand-coloured black and white print, like this portrait by Sue Wilks, allows you to emphasise chosen areas with total expressive freedom

meant professional applications, amateur snaps and pictorial camera-club prints. For the first time, photographers' names began to appear alongside their pictures in magazines, and creative work was sold as 'fine prints' in galleries to people who bought them as investments. Art curators rediscovered older photographers such as Bill Brandt and André Kertesz, brought them out of semi-obscurity, and exhibited their work in international art centres.

Today the availability of less daunting, user-friendly camera equipment combined with a much bigger public audience for photography (willing to receive original ideas) encourages a broad flow of pictures. For all its short history, photography is growing to become as varied and profound as literature or music.

Styles and approaches

The 'style' of your photography will develop out of your own interests and attitudes, and the opportunities that come your way. For example, are you mostly interested in people or in objects and things you can work on without concern for human relationships? Do you enjoy the split-second timing needed for action photography, or prefer the slower soul-searching approach possible with landscape or still-life subjects?

If you aim to be a professional photographer you may see yourself as a generalist, handling most photographic needs in your locality. Or you might work in some more specialised area, such as natural history, scientific research or medical photography, combining photography

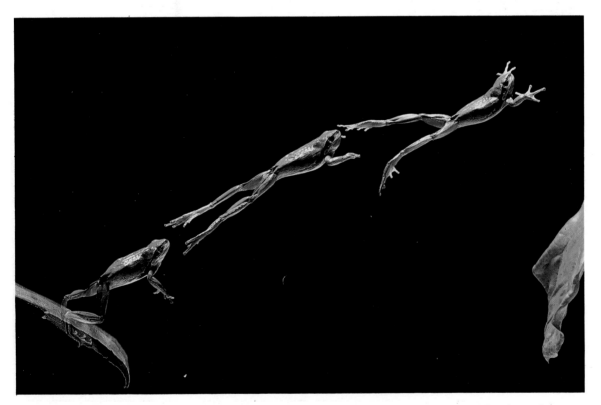

Fig. 1.11 Tree frog jumping. A rapid sequence of three ultra-fast flash exposures made on one frame of film and shot in a specially devised laboratory set-up, by Stephen Dalton. Time-and-action record photography provides unique subject information for natural history research and education

with other skills and knowledge. Some of these applications give very little scope for personal interpretation, especially when you must show facts clearly and accurately to fulfil certain needs. There is greatest freedom in pictures taken by and for yourself. Here you can develop your own visual style, provided you are able to motivate and drive yourself without the pressures and clear-cut aims present in most professional assignments.

Style is difficult to define, but recognisable when you see it. Pictures have some characteristic mix of subject matter, mood (humour, drama, romance, etc.), treatment (factual or abstract), use of composition, even the picture proportions. Technique is important too, from choice of lens to form of print presentation. But more than anything else style is to do with a particular way of *seeing*.

You can't force style. It comes out of doing, rather than of analysing too much, refined down over a long period to ways of working which best support the things *you* see as important and want to show others. It must not become a formula, a mould which makes everything you photograph turn out looking the same. The secret is to coax out the essence of each and every subject, without repeating yourself. People should be able to recognise your touch in a photograph but still discover things unique to each particular subject or situation by the way you show them.

Look at collections of work by acknowledged masters of photography (single pictures, shown in this book, cannot do them justice): Henri Cartier-Bresson's love of humanity, gentle humour and brilliant use of composition, Jerry Uelsmann's surreal, viewer-challenging presentation of landscape, or Robert Demachy's romantic pictorialism. In the fields of scientific and technical illustration the factual requirements of photography make it less simple to detect individuals' work. But even here high-speed photography by Dr Harold Edgerton and medical photography by Lennart Nilsson stand out, thanks to these experts' concern for basic visual qualities too.

Measuring success

There is no formula way to judge the success of a photograph. We are all in danger of 'wishful seeing' in our own work, reading into pictures the things we *want* to discover, and recalling the difficulties overcome when shooting rather than assessing the result as it stands. Perhaps the easiest thing to judge is technical quality, although even here 'good' or 'bad' may depend on what best serves the mood and atmosphere of your picture.

Most commercial photographs can be judged against how well they fulfil their purpose, since they are in the communications business. A poster or magazine cover image, for example, must be striking and give its message fast. But many such pictures, although clever, are shallow and soon forgotten. There is much to be said for other kinds of photography in which ambiguity and strangeness challenge you, allowing you to keep discovering something new. This does not mean you have to like everything which is offbeat and obscure; there are as many boring, pretentious and charlatan workers in photography as in any other medium.

Reactions to photographs change with time too. Live with your picture for a while (have a pinboard wall display at home) otherwise you will keep thinking your latest work is always the best. Similarly it is a mistake to surrender to today's popular trend; it is better to develop the strength of your *own* outlook and skills until they gain attention for what they are. Just remember that although people say they want to see new ideas and approaches, they still tend to judge them in terms of yesterday's accepted standards.

A great deal of professional photography is sponsored, commercialised art in which success can be measured financially. But most adventurous, avant-garde picture making is done as some kind of personal project – perhaps to express preoccupations and concerns. Artistic success is often measured in terms of the enjoyment and stimulus of making the picture, and satisfaction with the result.

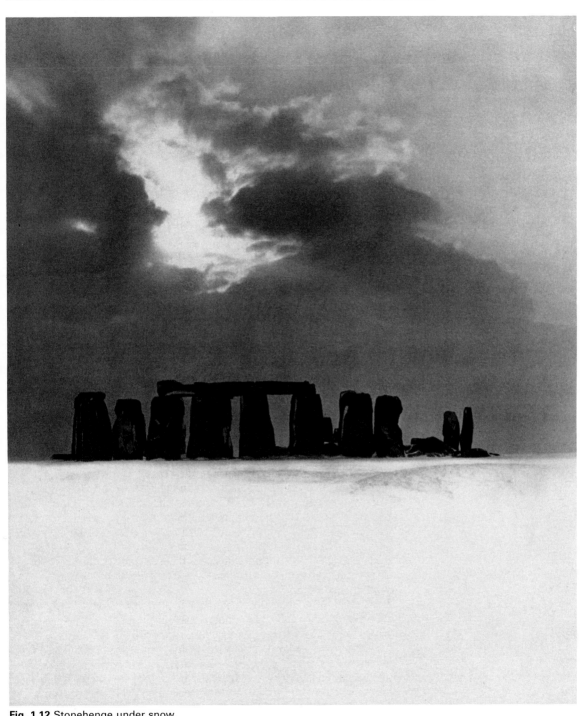

Fig. 1.12 Stonehenge under snow, by Bill Brandt. A strong interpretative black and white landscape image of great simplicity. It was seen and photographed straight but printed with careful control of tonal values

Fig. 1.13 The subject here is the inside of a circus tent – but content is mostly irrelevant in John Batho's creative composition concerned with colour and line. You might read it as landscape, or as flat, two-dimensional abstract design – a piece of artwork complete in itself

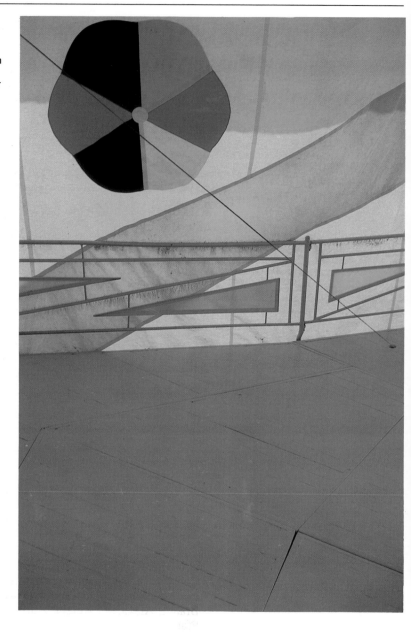

Rewards come as work published in its own right or exhibited on a gallery wall. Perhaps the measure of true success is when you do your own self-expressive thing, but also find that people flock to your door to commission and buy this very photography.

Summary: What is photography?

● Photography is a *medium* – a vehicle for communicating facts or fictions, and for expressing ideas. It requires craftsmanship and artistic ability in varying proportions.

● Technical knowledge is essential if you want to make full use of your tools and gain confidence. Knowing 'how' frees you to concentrate on 'what' and 'why' (subject and meaning).

● Always explore new processes and equipment as they come along. Discover what kind of images they allow you to make.

● Visually, camera work in colour is easier than black and white. Colour is more complex in the darkroom.

● Photography records with immense detail, seems essentially objective and truthful. But you can use it in all sorts of other ways, from propaganda to 'fine print' self-expression.

● Developing an eye for composition helps to simplify and strengthen the point of your picture. There are helpful beginners' guides to composition, but avoid slavishly following 'rules'.

● Photographs can be enjoyed/criticised for their *subject content*, or their *structure*, or their *technical qualities*, or their *meaning*, individually or together.

● The public once viewed photography as a stuffy, narrow pseudo-art, but it has since broadened into both a lively occupation and a creative medium, exhibited everywhere.

● Learn from other photographers' pictures but don't let their ways of seeing get in the way of your own response to subjects. Avoid copying their style.

● Success might be gauged from how well your picture fulfils its purpose. It might be measured in technical, financial or artistic terms (your own or other people's opinions). In an ideal world all these aspects come together.

Projects

These projects can be completed in either written or verbal (discussive) form, but must contain visual material such as prints, photocopies or slides.

1. Find and compare examples of *people photographs* which differ greatly in their function and approach. Some suggested photographers: Cecil Beaton, Diane Arbus, Yousuf Karsh, Dorothea Lange, Elliott Erwitt, Julia Margaret Cameron, August Sander, Barbara Kruger, Martin Parr, Cindy Sharman.
2. Compare the landscape work of three of the following photographers, in terms of their content and style: Ansel Adams, Franco Fontana, Bill Brandt, Alexander Keighley, Joel Meyerowitz, Fay Godwin, John Pfahl.
3. Looking through newspapers, magazines, books, etc., find examples of photographs (a) which provide objective, strictly factual information; and (b) others which strongly express a particular point of view, either for sales promotion or social or political purposes. Comment on their effectiveness.
4. Produce examples of photographs in which *structure* is more important than actual *content*. Possible photographers include Ralph Gibson, André Kertesz, Lee Friedlander, Paul Strand, Moholy Nagy, Barbara Kasten.
5. Find photographs which are *either* (a) changed in meaning because of adjacent text or caption, or by juxtaposition with other illustrations; *or* (b) changed in significance by the passing of time.

2
Light and image forming

It was said earlier that you don't have to understand physics to take good photographs. But understanding the practical principles behind photography and photographic equipment gives you a broader, more flexible approach to problem solving. It is also interesting. For example, the way light can be manipulated to form images is not really very complicated – did you know it can be done with a hole in a card?

We start with the very foundation stone of photography, which is light. What precisely is *light*, and which of its basic features do you need to know when you are illuminating a subject, using filters and lenses, learning about colour and how colour films work? From light and colour we go on to discuss how surfaces and subjects look the way they do, and why light has to be bent with glass to create a usable image.

The lens is without doubt the most important part of any camera or enlarger. Starting with a simple magnifying-glass lens you can begin to see how photographic lenses form images. Later this will lead on to camera equipment itself.

Light itself

Light is fundamental to photography; it is even in the very name ('photo'). And yet you are so familiar with light you almost take it for granted. Light is something your eyes are sensitive to, just as your ears relate to sound and your tongue to taste. It is the raw material of sight, communicating information about objects which are out of range of other senses. Using light you can show up some chosen aspects of a subject in front of the camera and suppress others. Light channels visual information via the camera lens onto photographic material, and enables you to enjoy the final result. At this very moment light reflected off this page carries the shape of words to your eyes, just as sound would form the link if we were talking. But what exactly *is* light?

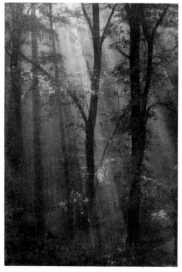

Fig. 2.1 Light travels in straight lines, shown clearly in this wooded landscape by pictorialist Alexander Keighley (1917)

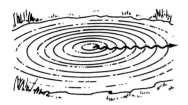

Fig. 2.2 Light travels as if in waves, like the outward movement of ripples when a smooth water surface is disturbed. (Light also vibrates in planes other than the vertical; see Figure 9.36)

Visible light is a stream of energy radiating away from the sun, or some other radiant source. It has four important features, which all occur at the same time:

1. Light behaves as if it moves in waves, like ripples crossing the surface of water. Different wavelengths give our eyes the sensation of different colours.
2. Light travels in a straight line (within a common substance of uniform composition). You can see this in light 'beams' and 'shafts' of sunlight.
3. Light moves at great speed (300,000 kilometres or 186,000 miles per second through the vacuum of space). It moves marginally slower in air, and slightly slower still in denser substances such as water or glass.
4. Light also behaves as if it consists of energy particles or 'photons'. These cause chemical changes in films, bleach dyes, etc. The more intense the light, the more photons it contains.

Wavelengths and colours

What you recognise as light is just part of an enormous range of 'electromagnetic radiations'. As shown overleaf, this includes radio waves having wavelengths of hundreds of metres through to gamma and cosmic rays with wavelengths less than ten thousand-millionths of a millimetre. Each band of electromagnetic radiation merges into the next, but has its own special characteristics. Some, such as radio, can be transmitted over vast distances. Others, such as X-rays, will penetrate thick steel, or destroy human tissue. Most of this radiation cannot be 'seen' directly by the human eye, however. Your eyes are only sensitive to a narrow band between wavelengths 400 nm and 700 nm approximately. (A nanometre or nm is one millionth of a millimetre.) This limited span of wavelengths is therefore known as the *visible spectrum*.

When a relatively even mixture of all the visible wavelengths is produced by a light source the illumination looks 'white' and colourless. But if only some wavelengths are present the light appears coloured. For example, wavelengths between about 400 nm and 450 nm are seen as dark purpley violet. This alters to blue if wavelengths are changed to 450–500 nm. Between 500 nm and 580 nm the light looks

Fig. 2.3 A simple concept of electro-magnetic energy. Most light sources (e.g. the sun, incandescent lamps) emit a mixture of wavelengths

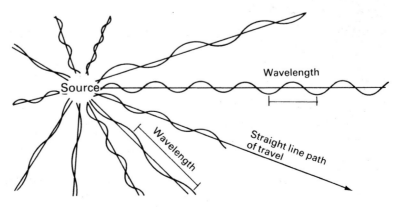

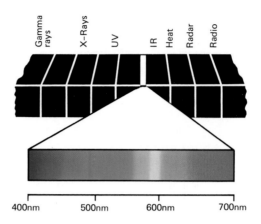

Fig. 2.4 Part of the electromagnetic spectrum (above), and the visible spectrum of light (below). Mixed in roughly the proportions shown here, the light appears 'white'

more blue-green, and from about 580 nm to 600 nm you see yellow. The yellow grows more orange if the light wavelengths become longer; at 650 nm it looks red, becoming darker as the limit of response is reached at 700 nm. So the colours of the spectrum – violet, blue, green, yellow and red – are really all present in different kinds of white light such as sunlight, flash or studio lamps.

The human eye seems to contain three kinds of light receptors, responding to broad overlapping bands of blue, green and red wavelengths. When all three receptors are stimulated equally by something you see, you tend to experience it as white, or neutral grey. If there is a great imbalance of wavelengths – perhaps the light contains far more red (long) waves than blue (short) waves – stimulus is uneven. Light in this case may look orange tinted, just as happens every day around sunrise or sunset.

Try to remember the sequence of colours of the visible spectrum. It's useful when you need to understand the response to colours of black and white films, or choose colour filters and darkroom safelights (see Chapter 12). Later you will see how the concept of three human visual receptors together responding to the full colour spectrum is adapted to make photographic colour films work too.

The bands of wavelengths just outside the limits of the visual spectrum are known as ultra-violet (shorter wavelength than violet), and infra-red (longer wavelength than red). Although you cannot consciously 'see' ultra-violet (UV), all films are sensitive to wavelengths down to about 250 nm. This often causes problems with shots of distant landscapes (see page 178). UV also tans skin and causes some substances to fluoresce and 'glow' with visible light, much used in discos.

You can sense long-wave infra-red (IR) by its warmth. When you switch on an electric fire your hand will feel the warm infra-red before the bars become hot enough to glow with visible light. A few special photographic films are made with near-IR sensitivity (up to about 900 nm). They are mostly used for aerial and scientific purposes, but will also give strange unearthly pictorial effects.

It seems odd that humans can biologically sense only such a tiny part of the vast electromagnetic spectrum. However, with most naturally occurring infra-red, ultra-violet, X-ray and gamma-ray wavelengths from space shielded from us by the Earth's atmosphere, we have evolved

Fig. 2.5 A compact, distant light source casts sharp, harsh shadows. A larger source – formed with tracing paper or by bouncing off a diffusing surface – gives soft, graduated shadows. See also Figure 7.1

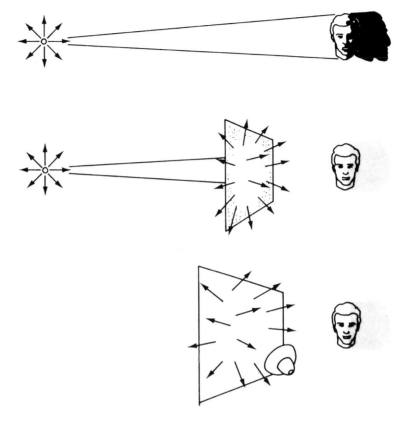

without need of detection devices (or defences) for these kinds of radiation. Beings on another planet, with a totally different environment, might well have evolved with organs capable of sensing, say, radio waves but completely 'blind' to visible light as we know it.

Shadows

Light travels in straight lines and in all directions from a light source. This means that if you have direct light from a comparatively 'compact' source such as the sun in a clear sky, a candle, or a bare light bulb, this light is harsh and objects throw sharp-edged shadows. Figure 2.5 shows how having all the light issuing from one spot must give a sudden and complete shut-off of illumination at the shadow edge. But look what happens when you place tracing paper in the light beam (or block the direct light and reflect the remainder off a matt white wall). Tracing paper passes light but also *diffuses* it. Emerging light is scattered by the etched paper into new straight lines proceeding in all directions from every part of its large area surface. The object you were illuminating now casts a softer-edged, graduated shadow, and the larger and closer your diffusing material is the less harsh the shadow becomes. This is because light from a large area cannot be completely blocked out by the subject; most of the parts previously in shadow now receive at least some illumination. The same would happen with sunlight on an overcast day.

Noticing the difference between harsh and soft lighting and how you can control it is the first step in understanding lighting for photography (see Chapter 7). Shadow qualities greatly influence the way scenes look. Remember this is not something you can alter in a photograph by some change of camera setting or by a subsequent darkroom process.

When light reaches a surface

When light strikes the surface of another substance, what happens next depends upon the type of material, its texture and colour, and the angle and colour content of the light itself.

Light-stopping objects

If the material is completely opaque to light, such as metal or brick, some light is reflected and some absorbed (turned into weak heat energy). The darker the material the smaller the proportion of light reflected. This is why a dark camera case left out in the sun gets warmer than a shiny metal one. If the material is also coloured it reflects wavelengths of this colour and absorbs most of the other wavelengths present in the light. For example blue paint reflects blue, and absorbs red and green from white light. But if your light is already lacking some wavelengths this will alter subject appearance. Lit by deep red illumination, a rich blue will look and photograph black. You need to know about such effects in order to use colour filters (Chapter 9).

Surface finish also greatly affects the way light is reflected. A matt surface such as an eggshell, drawing paper or dry skin scatters the light evenly. The angle from which light strikes it makes very little difference. However, if the surface is smooth and reflective it acts more like a mirror, and reflects almost all the light back in one direction. This is called *specular reflection*.

If your light strikes the shiny surface at right angles it is reflected backward along its original path. You get a patch of glare, for example, when flash-on-camera shots are taken flat on towards a polished glass window or gloss-painted wall. But if the light is angled it reflects off such surfaces at an angle. As shown in Figure 2.6, the angles made by

Fig. 2.6 Reflection. With specular reflection, as from polished metal, the angle of reflection matches the angle of incidence. Diffuse reflection, as from the matt surface of this paper, scatters light more evenly

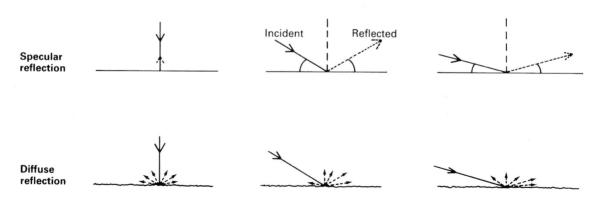

Specular reflection

Incident Reflected

Diffuse reflection

the received ('incident') and the reflected light at the surface are equal. So use oblique light to bounce glare light away when photographing a glossy reflective surface. (If your light source is flash built into the camera you may have to angle your camera viewpoint.)

Surfaces make a big difference to the way things look. Black gloss paint, for example, can look white if it is reflecting direct sunlight back towards the camera. But seen or lit from a different angle it will look a rich black, deeper than any matt-surfaced black can give. These are factors you must also consider when choosing which printing paper surface will best suit a particular picture (Chapter 12).

Light-transmitting objects

Not every material is opaque to light, of course. Clear glass, plastic and water, for example, are *transparent* and transmit light directly, while

Fig. 2.7 Transmission. Diffuse materials, such as milky plastic, scatter light more or less evenly. Clear material passes most light directly. Angled light is part refracted, part reflected, until at low surface angles it becomes almost wholly reflected

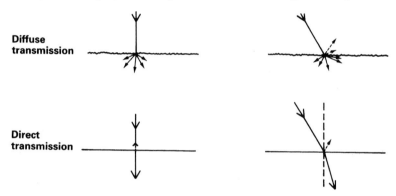

tracing paper, cloud and textured glass diffuse the light they transmit and are called *translucent*. In both cases if the material is coloured it will pass more light of these wavelengths than other kinds. Deep red stained glass transmits red wavelengths but may be almost opaque to blue light. See Figure 2.9.

Since translucent materials scatter illumination they seem milky when held up to the light and look much more evenly illuminated than clearer materials, even when the light source is not lined up directly

Fig. 2.8 Refraction. Light slows when passing from air into glass. Wavefronts slow unevenly if light reaches the denser medium obliquely (left). The effect is like driving at an angle from the highway onto sand (right). Uneven drag causes change of direction. Perpendicular light (centre) slows without altering direction

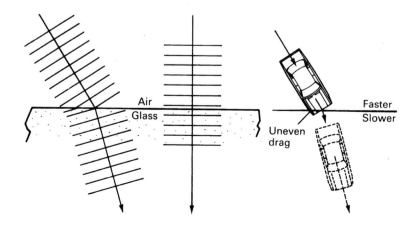

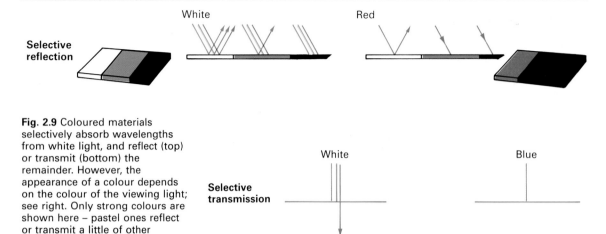

Fig. 2.9 Coloured materials selectively absorb wavelengths from white light, and reflect (top) or transmit (bottom) the remainder. However, the appearance of a colour depends on the colour of the viewing light; see right. Only strong colours are shown here – pastel ones reflect or transmit a little of other wavelengths too

behind. Slide viewers work on this principle. The quality of the light is similar to that reflected from a white diffused surface.

Interesting things happen when direct light passes obliquely from air into some other transparent material. As was said earlier, light travels slightly slower when passing through a denser medium. When light passes at an angle into glass, for example, its wavefront becomes slowed unevenly because one part reaches the denser material first (think of the light waves like ripples on water, Figure 2.1). As a result the direction of the light skews, and bends into a new straight-line path slightly steeper into the glass (more perpendicular to its surface). This bending of light path when travelling from one transparent medium into another is known as *refraction*.

You can see refraction at work when you poke a straight stick into water; it looks bent at the water surface. Again, looking obliquely through a thick, half-closed window, parts of the view through the glass look offset relative to what can be seen direct. It is because of refraction that lenses bend light and so form images, as we will come to shortly.

Remember that refraction only bends *oblique* light. Light which strikes the boundary of two transparent materials at right angles slows minutely but does not change direction. And most light reaching the boundary at a very low angle (very oblique) is reflected off the surface.

In practice then the range of objects around you appear the way they do because of the mixture of effects they have on light – diffuse and specular reflection, some absorption, often transmission and refraction too. For example, an apple side-lit by direct sunlight reflects coloured wavelengths strongly from its illuminated half. Most of this is diffusely reflected, but part of its smooth skin reflects a bright specular highlight, just where the angle of the sun to the surface matches the angle from this point to your eye. The shape and relative darkness of the shadow to one side of the apple gives you further clues to its form. From experience your eyes and brain recognise all these subtle light 'signals' to signify solidity and roundness, without your actually having to touch the apple to find out. This is essentially what optical aspects of seeing and photographing objects are all about.

Fig. 2.10 Inverse square law:
'When a surface is illuminated by
a point source of light the
intensity of light at the surface is
inversely proportional to the
square of its distance from the
light source'. Twice the distance
gives one-quarter the illumination
because the light is spread over
four times the area

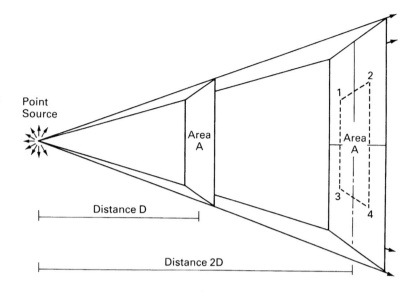

Light intensity and distance

The actual brightness of an object will depend on how much light it
reflects (or if rear-lit how much it *transmits*), and the intensity and
distance of the illuminating light source. Figure 2.10 shows that
because light travels in straight lines a surface receives four times as
much illumination (four times as many photons) from a compact light
source as it would if the same-size surface were twice as far away. For
example, if you are using a flashgun or small studio lamp to light a
portrait, halving its distance from the subject gives you four times the
light, so exposure can be quartered. The same applies to printing
exposures when you alter enlarger height (Chapter 12).

In practice this 'inverse square law' means that you must be
especially careful when illuminating a number of items at different
distances in a shot, using one harsh compact light source. It may then

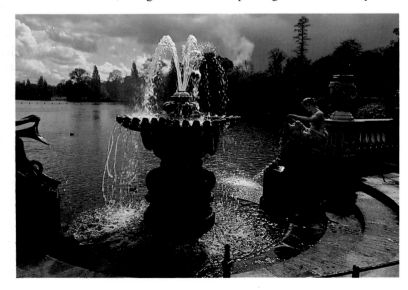

Fig. 2.11 Light communicates
information about this scene to
you in a mixture of ways. The
water jets *transmit* and *refract* light,
glittering parts of the lake surface
specularly reflect, while the grey
stone *diffusely reflects* light. The
distant lake and dark cloud
selectively reflect blue sky. Black
areas beneath the fountain *absorb*
most of the incident light

be impossible to correctly expose items nearest and farthest from the light at any one exposure setting. A solution is to move the light source much further away, so the ratio of nearest to farthest distance becomes less (page 117), or change to a larger, diffused light source which will give you much less 'fall-off' effect.

The same problem does not arise with direct sunlight outdoors. The sun is so vastly far away that any two places on earth – be they seashore or mountain peak – are almost equal in distance from the sun. Brightness variations in landscape photography may be created by local atmospheric conditions but not by the sun's distance. If you are photographing indoors, however, using the sun's light entering through a small window, the window itself acts like a light source. Intensity will then alter with distance in the same way as if you had a lamp this size in the same position.

How light forms images

Suppose you set up and illuminate a subject, and just face a piece of tracing paper (or film) towards it. You will not of course see any image on the sheet. The trouble is that every part of your subject is reflecting some light towards every part of the paper surface. This jumble of light simply illuminates it generally.

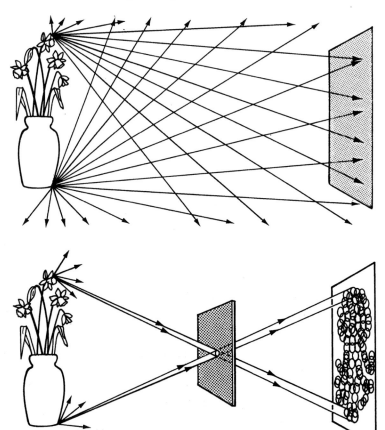

Fig. 2.12 A screen held towards an illuminated subject receives a jumble of uncontrolled light rays, reflected from all its parts. A pinhole restricts rays from each part of the subject to a different area of the screen; a crude upside-down image is formed

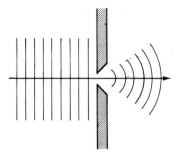

Fig. 2.13 Diffraction. Light waves passing the very edge of an aperture are bent slightly outwards. Hold up your hand against the light, fingers pressed lightly together; the slit of illumination between any two fingers, viewed from about 15 cm (6 in), appears with a multi-line edge due to diffraction effects. This is why camera lenses do not close down to pinhole size

One way to create order out of chaos is to restrict the light, by adding between subject and paper a sheet of opaque material containing a pinhole. Since light travels in straight lines, those light rays from the top of the subject able to pass through the hole can only reach the *bottom* part of the paper. And light from lower parts of the subject only reaches the *top* of the paper (Figure 2.12). As a result your paper sheet shows a dim, rather fuzzy *upside-down* representation of the subject on the other side of the pinhole.

The best way to see a pinhole image is to be in a totally darkened room, with black paper over the window facing a sunlit scene outside. Make a drawing-pin size hole in the paper and hold up tracing paper about 30 cm (12 in) in front of it to receive the image.

You can easily take colour photographs using a pinhole if your camera has a removable lens. See Project 2 at the end of the chapter. The business of actually forming an image is not therefore particularly complicated or technical.

Limitations to pinhole images

When you check a pinhole-formed image closely, however, results leave a lot to be desired (see Figure 2.15). For one thing, none of the image detail is ever quite sharp and clear, no matter where you position the tracing paper. This is because the narrow 'bundle' of light rays reflected from any one part of the subject through the pinhole forms a beam that is *diverging* (gradually getting wider). As Figure 2.12 shows, the best representation you can get of any one highlight or point of detail in the subject is a *disc* of light. What should be details become many overlapping discs of light which give the image its fuzzy appearance.

The second poor feature of a pinhole image is that the picture is so *dim*. You can brighten it by enlarging the hole, but this makes image detail even less sharp and clear. (If you make *two* holes you get two overlapping images, because light from any one part of the subject can then reach the paper in two places.)

Even if you accept a dimmer image and try to improve detail by using a still smaller hole, those discs of light can obviously never be smaller than the hole itself. In any case, you quickly get to a point where further reduction actually makes results worse. This is because of an optical effect known as *diffraction*. Light waves passing close to an opaque edge slightly change direction, like water waves spreading where they enter a harbour (Figure 2.13). The smaller and rougher the hole the greater the percentage of light rays displaced by this edge effect, relative to others passing cleanly through the centre.

Using a lens instead

The best way to form a better image is to make the hole bigger rather than smaller. Then *bend* the broad beam of light you produce so that it narrows (*converges*) instead of continuing to expand (*diverge*). This is done by using refraction through a piece of clear glass. Figure 2.8 showed how light passing obliquely from air into glass bends at the point of entry to become slightly more perpendicular to the surface. The opposite happens when light travels from glass into air, as air is less dense. So if you use a block of glass with sides which are non-parallel (Figure 2.14) the total effect of passing light through it is an overall change in direction.

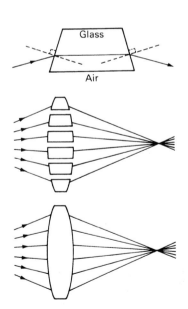

Fig. 2.14 Lens evolution. Using a non-parallel sided glass block, refraction at each air/glass surface causes an overall change of direction. Think of a lens shape as a series of blocks which bend many light rays to a common point of focus

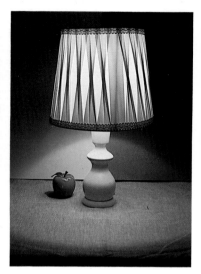

Fig. 2.15 Pictures taken using a 35 mm SLR camera body fitted with (left) kitchen foil having a 0.25 mm diameter pinhole; (centre) a plastic magnifying glass 'stopped down' to f/8 with a hole in black paper; and (right) the camera's standard 50 mm lens at f/11. Based on TTL light readings, the pinhole needed 20 seconds, the magnifier 1/60 and the lens 1/30 exposure. The cheap magnifier, when focused for the centre, gives poorest definition of all near picture edges. The pinhole gives slightly unsharp detail everywhere (image colour change and the extra exposure needed are due to reciprocity failure; see page 161)

Fig. 2.16 A converging lens bends diverging beams of light to a point of focus. However, if the lens–screen distance is incorrect, either too near or too far as shown right, images again consist of fuzzy 'circles of confusion.' (This is why out-of-focus highlights become discs – Figure 2.20)

In practice, a shaped piece of glass that is thicker in the centre than at its edges will accept quite a wide beam of diverging light and convert it into a converging beam. Mechanically it is easiest to create this required shape by grinding a circular disc of glass. So you have a circular glass *converging* lens.

Immediately you make images using a lens instead of just a hole, some interesting changes take place. For example, the upside-down picture on your tracing-paper screen is now much brighter, but details are only sharply resolved when the paper is at one 'best' distance from the lens. When it is positioned too close or too far away, the light rapidly broadens out (Figure 2.16) and points of detail turn into discs even larger than given by a pinhole. The result is a very unclear 'out-of-focus' effect. So a lens has to be focused precisely; the correct position will depend on the light-bending power of the lens, and the distance between lens and subject.

Greatest bending power is given by a lens made from glass with a high *refractive index* and/or formed into a steeply curved, thick shape. This is taken into account in the term *focal length*. As shown in Figure 2.17, the focal length of a simple lens is the distance between the lens and a sharply focused image of an object at infinity. (In practice this can be something on the horizon, or the sun when the lens is used as a burning glass.)

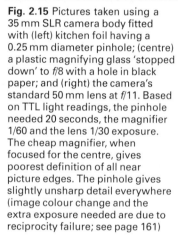
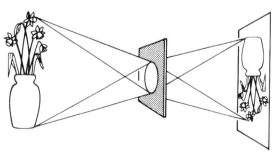
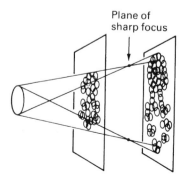

Plane of sharp focus

Fig. 2.17 Measuring the focal length of a simple, symmetrical, converging lens

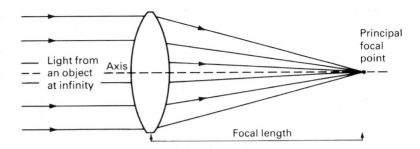

Principal focal point

—— Light from an object ——— at infinity

Axis

Focal length

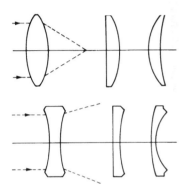

Fig. 2.18 Converging lens shapes (top, left to right): double convex, plano-convex, converging meniscus. Diverging lens shapes (bottom, left to right): double concave, plano-concave, diverging meniscus. Diverging lens elements are used in direct viewfinders, and combined with (stronger) converging elements in camera lenses

A lens with a long focal length has weak bending power – it needs a long distance to bend light rays to a point of focus. The *stronger* the power of the lens, the *shorter* its focal length. The picture detail is also smaller in size than the same subject imaged by a longer focal length lens.

The lens-to-image distance you need for sharp focus changes when your subject is nearer than infinity. The rule is: the closer your subject, the greater distance required between lens and image. Figure 2.21 shows that this is because light from a point relatively close to the lens reaches the glass as a more diverging beam than light from something farther away. You often see camera lenses move *forwards* when set for close distances, and for really close work you may have to fit an extension tube between body and lens (see page 88). Clearly there are problems when the scene you are photographing has a mixture of both distant and close detail, all of which you want in focus.

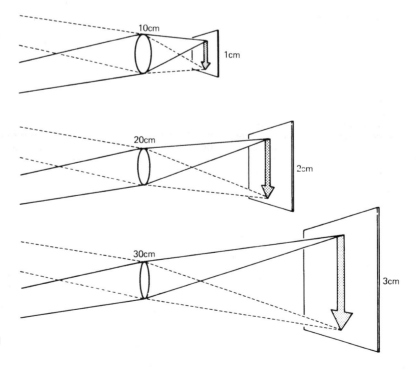

Fig. 2.19 For a distant subject, image size is proportional to focal length

Fig. 2.20 This image was made
with a wide-diameter lens focused
for one droplet on the barbed
wire. Droplets closer (left) and
further away (right) become
unsharp patches of light at this
focus setting. Each patch takes on
the shape of the lens diaphragm

Conjugate distances

The distances between your subject and lens, and between lens and
image (known as 'conjugate distances') follow a basic pattern, shown
in Figure 2.22. For example, light from a subject located somewhere
between infinity and two focal lengths from your converging lens will
come into focus somewhere in a zone between one and two focal
lengths on the imaging side of the lens. It's the kind of situation you
meet in most general photography. When the lens-to-image distance is
one focal length, as you already know, subjects at infinity are in focus.
And where the subject is precisely two focal lengths distant the sharp
image is formed two focal lengths behind the lens, as well as being
exactly the *same size* as the subject. Magnification (height of subject
divided into the height of its image) is then said to be 1. This is a typical
situation for close-up and 'actual size' photography.

When your subject is closer than two focal lengths, the image is
formed beyond two focal lengths behind the lens, and magnification is
more than 1. In other words, the image shows the subject enlarged. This
is the situation when a lens is used for projecting slides or making
enlargements. (Notice too why slides must be upside-down to project as
a right-way-up picture.)

The nearer your subject comes to being one focal length from the
lens, the bigger and further away its sharp image becomes. When it is
exactly one focal length away no image forms at all; light passes out of
the lens as parallel rays. (This is the reverse of imaging a subject
located at infinity.) When the subject comes closer still, your lens will

Fig. 2.21 Light from a point on a
close subject arrives at the lens as
a more diverging beam than light
from a distant subject. Given the
same refraction it then needs a
greater distance to come to focus

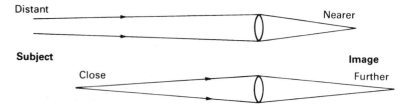

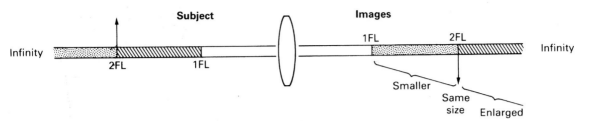

Fig. 2.22 Conjugate distances (common shading shows subject zones and their related image zones)

not give any image that you can focus onto a surface. But if you now *look* through the glass your eye will see an enlarged *upright* image of the subject. The lens is now acting as a magnifying glass.

Check out all these imaging zones for yourself, using a converging-lens reading glass. It is always helpful to know (at least roughly) where and what size to expect a sharp image, especially when you are shooting close-ups, or printing unusual size enlargements. Ways of calculating detailed sizes and distances are shown on page 289.

Summary: Light and image forming

● Light travels in straight lines, as if in wave motion. Wavelengths are measured in nanometers. Light forms a tiny part of a much wider range of electromagnetic radiation. It transmits energy in the form of 'photons'.

● Your eyes recognise wavelengths between 400 nm and 700 nm as progressively violet, blue, green, yellow, red – the visible spectrum. All colours if present together are seen as 'white' light.

● Outside the visible spectrum, radiation still relevant to general photography includes ultra-violet and (near) infra-red.

● Subjects illuminated by a relatively compact direct light source cast harsh, hard-edged shadows. Light from a large-area source (including hard light *diffused*) gives softer, graduated shadows.

● Light striking an opaque material is absorbed and/or reflected.

● Smooth, shiny surfaces give you specular reflection – direct light is mostly reflected all one way. Oblique illumination bounces off such a surface at an angle matching the light received. Matt surfaces scatter reflected light, are much less directional.

● Non-opaque materials which are transparent directly transmit light; translucent materials diffuse light. Light passing obliquely from one transparent material to another of different density is refracted (bent) more perpendicular to the surface in the denser medium.

● Coloured materials absorb and reflect or transmit light *selectively* according to wavelength. Appearance varies with the colour of the light source illuminating them.

● The amount of illumination (photons) received by a surface area from a direct, compact light source is quartered each time its distance from the light source is doubled.

● Because light travels in straight lines a pinhole in an opaque material forms a crude upside-down image of an illuminated subject.

● One of the limiting factors when passing light through a small hole is displacement due to diffraction.

- A converging lens gives you a brighter, sharper image than a pinhole, by bending diverging light from your subject so that it converges to a point of focus. The position of sharp focus depends on the refracting power of the lens, and subject distance.
- Lens power is shown by focal length, in simple optics the distance between the lens and a sharp image of an object at infinity. The longer the focal length the larger the image.
- Close subjects come to focus farther from the lens than distant subjects. A subject two focal lengths in front of the lens is imaged same-size two focal lengths behind the lens. Magnification is image height divided by subject height.

Projects

1. Make a simple pinhole camera using a tube of opaque card with kitchen foil stretched flat across one end. Fit a disc of tracing paper halfway down the tube. Pierce the foil cleanly with a thick darning needle. Examine the image of a window or brightly lit outdoor scene from a position in shade. Vary the size of hole and distance of tracing paper. What image changes do these produce?
2. Take pinhole colour slides. Remove the lens from a single-lens-reflex 35 mm camera and tape kitchen foil in its place (it is easiest to tape it across an extension ring which you then simply attach or detach from the body). Pierce the foil with a needle to give a hole about 0.3 mm diameter, free of bent or ragged edges. You should just be able to make out the image through your camera viewfinder. Set your internal exposure meter to manual mode. If the image is too dim to get readings, set the camera's ISO scale to its highest rating or the exposure-compensation dial to the most extreme minus setting. Then multiply the exposure time shown either by the set ISO divided by the actual ISO, or the equivalent effect of the compensation setting.
3. Take pictures using a magnifying (reading) glass in place of your regular SLR camera lens. Fit a collar of black paper around the rim of the glass to prevent direct light entering the camera. Try some shots adding black paper with a hole in it over the lens to reduce its diameter by half. Compare the results, and also against results of Project 2.
4. Using a hand torch as subject, try forming images on tracing paper with a magnifying glass, or the lens detached from your camera. Work in a darkened room. Check out image size and position when the subject is in the various distance zones shown in Figure 2.22.

3
Lenses and their controls

The next step in understanding lenses is to see how the controls on your camera's normal lens allow you to alter the image. This introduces focusing scales and lens aperture (including *f*-numbers). The aperture adjusts image brightness and the range of subject distances you can focus sharply at one setting. It is vital in photography to know when and how to create total sharpness, or to localise image detail. Some differences between small-format and large-format cameras begin to appear here too.

Photographic lenses

A simple glass lens gives you a much better image than a pinhole. However, its quality is still a long way short of the standard needed for photography. When you look closely, image sharpness is not maintained equally over the whole picture, even when the subject is all at one distance. Some shapes are distorted and there are odd colour fringes plus a general 'misty' appearance. Occasionally such results work well as interpretative romantic images, but it is better to have a lens capable of producing utmost image clarity and detail and then add a diffuser or other attachment when you want pictures of the other kind.

Any single-element lens used alone gives an image with a mixture of optical defects, known as *aberrations*. Figure 3.1 shows how one such aberration occurs, based on the fact that refraction actually bends shorter wavelengths slightly more than longer wavelengths. The result is 'dispersion' of white light into a spread of colours, giving a minute colour fringe. Among other aberrations, straight lines near the edges of images are caused to bow outwards or inwards, termed *curvilinear distortion*; see *Advanced Photography*.

The main object of *photographic* lens design and manufacture is to produce lenses which minimise aberrations, while increasing performance. A range of special optical glasses is used, each type having different refraction and dispersion properties. A photographic lens has a 'compound' construction, designed with a series of elements of

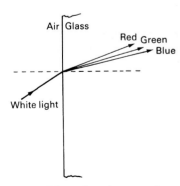

Fig. 3.1 Dispersion. Amount of dispersion is based on the difference between refraction of blue and red wavelengths (exaggerated here)

Fig. 3.2 One type of normal 50 mm lens made for a 35 mm camera. This has seven lens elements, five converging and two diverging light

different shapes and made from different glass types to help neutralise aberrations. (For example, a converging shape made from a glass with high refractive index and medium dispersion can be combined with a diverging shape in glass of weaker refractive index but equal dispersion. The two together cancel out the effects of colour dispersion but still converge light.)

Further lens elements give further aberration corrections. In fact, a camera lens of normal focal length typically has 5–8 elements (Figure 3.2). Their centring and spacing within the metal lens barrel is critical, and can be upset if the lens is dropped or roughly knocked. But even the number of elements causes problems, as the tiny percentage of light reflected off every glass surface at the point of refraction (Figure 2.7) multiplies as scattered light. If uncorrected, the result would be images that lack contrast and sparkle – like looking through a window with multiple double-glazing. Fortunately, modern lenses have elements surface-coated with one or more extremely thin layers of a transparent material, its refractive property critically related to that of the glass. Lens coating practically eliminates internal reflections under most conditions. However, light may still flare if you shoot towards a bright light source just outside the picture area so use a lenshood, see page 92. Flare and poorer image contrast are noticeable with lenses made before coating was introduced in the 1950s.

Your camera or enlarging lens is therefore a relatively thick barrel of lens elements, all of them refracting light but giving an overall *converging* effect. This makes it physically less easy to find the point from which to measure focal length (Figure 3.3). Fortunately you are unlikely to need to do this as every photographic lens has its focal length (usually in millimetres) clearly engraved around the lens barrel or front-element retaining ring. (A few older lenses, for large-format cameras, show two focal lengths. This is because they are 'convertible' types you can choose to use complete or with one group of the lens elements removed.)

Normal angle of view

The focal length regarded as 'normal', and therefore most often chosen for the standard lens on a camera, is approximately equal to the diagonal of the camera's picture format. This is typically:

Fig. 3.3 Refraction occurs at many surfaces within a camera lens. But if parallel light is tracked into the front and the cone of refracted light traced back from the rear, lines meet at an imaginary 'image principal plane' of refraction. Focal length is measured from where this line crosses the axis (the rear nodal point). It is equivalent to where the centre of a single element lens of this focal length would be located

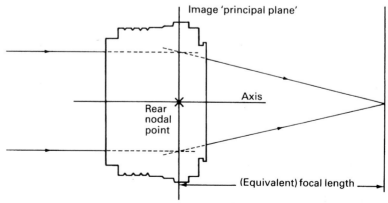

38–50 mm for a (24 × 36 mm format) 35 mm film camera
80–105 mm for a 6 × 7 cm roll film camera
150–180 mm for a 4 × 5 in sheet film camera

As shown in Figure 2.20 and Figure 3.5, the shorter the focal length the smaller the *image* the lens produces. But a lens of short focal length used with a small-format camera gives the same *angle of view* as a lens of longer focal length used in a bigger camera. You are just scaling everything up or down. All three combinations therefore give an angle of view of about 45°, and each camera set up to photograph the same (distant) subject will include about the same amount of the scene. The use of lenses giving a wider or narrower angle of view is discussed in Chapter 5.

Covering power

If you take any lens and check the image it forms on a large piece of paper you will see that the picture is formed within a circular patch. Towards the edge of this patch detail becomes poorer and illumination quickly tapers off into darkness. Even a good-quality photographic lens has limited 'covering power'. This is because (a) the oblique light reaching the edges of the image patch is increasingly blocked off ('vignetted') by the depth of the lens barrel, (b) relative to the central

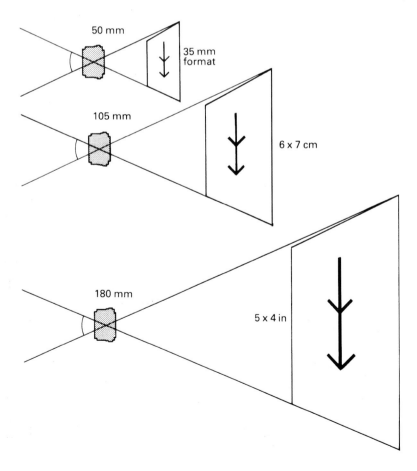

Fig. 3.5 Angle of view. The three lenses here differ in focal length but are used on different format cameras Ratio of focal length to format diagonal remains similar; each gives approximately the same angle of view

area this angled light is spread over a larger surface, making the image dimmer, and (c) the light rays focused well off-axis are more difficult to correct for aberrations than in the centre of the image field (see photograph on page 99).

It is vital that the lens you use has covering power which exceeds the picture format dimensions of your camera (or film carrier if it is an enlarger lens). Otherwise the corners of pictures will 'fade off'. Irrespective of focal length, then, a lens is designed to 'cover' adequately a particular picture size. You could use it in a *smaller*-format camera or enlarger, but not a larger one. For example, a lens designed to cover a 6 × 6 cm negative might be used on a 35 mm camera but not the reverse.

In practice you cannot make mistakes with small interchangeable-lens cameras, because their lens mounts prevent you fitting unsuitable optics. However, it can happen with view cameras (Chapter 4) and occasions when you try combining or adapting lenses. It is vital that any lens designed for tilting movements, or to be used off-centre on the camera, has exceptionally good covering power. See camera movements (Chapter 6).

Focusing

Your lens unit will probably include some means of adjusting its position backwards and forwards, for focusing. Most small-format camera lenses have a focusing mount; the whole lens shifts smoothly by about a centimetre or so within a sleeve, or internal elements shift position, when the lens barrel is rotated. At the same time a scale of subject distances passes a setting mark for use if you focus the lens by estimate or measurement alone. (Very simple cameras show symbols instead.) Sometimes your lens is *autofocusing* – coupled to a motor which drives it backwards and forwards under the control of a sensor which detects when the image is sharp; see page 72.

Fig. 3.6 Covering power. The patch of image light here is insufficient to cover film format A. Format B is sufficiently covered provided it remains centrally aligned with the lens. Only film format C is suitable if you intended to use this lens off-centre (essential for most camera movements). See also Figure 6.2

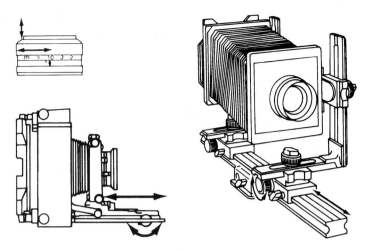

Fig. 3.7 Focusing. Typical 35 mm camera lens carries focusing ring, making lens shift forwards or backwards within barrel (note that the distance setting mark has a separate, short line for use when shooting infra-red). Normal lenses for larger-format cameras need greater focusing movement – the whole camera front slides along a rail

Normal lenses for large-format sheet film cameras need more focusing movement to cover a similar range of subject distances, owing to their longer focal length. The whole front unit of the camera moves independently of the back, the two being joined together by bellows. There is seldom any scale of distances on lens or camera; you focus by checking the image itself. See page 63.

Aperture and *f*-numbers

Inside most photographic lenses you will see a circular hole or aperture located about midway between front and back elements. Usually a series of overlapping black metal blades called an iris diaphragm allows the size of this aperture to be narrowed continuously from full lens diameter to just the centre part of the lens. It is adjusted with a setting ring or lever outside the lens barrel. Most smaller-format cameras control the aperture size automatically, at the moment of exposure. (On single-lens reflex cameras you may not see the aperture actually alter when you turn the ring, unless you first detach the lens from the camera. See page 7.)

A series of relative aperture settings can be felt by 'click' and are shown on a scale of figures known as *f-numbers*. Notice that the *smaller* the relative aperture the *higher* the *f*-number. They typically run:

f/2; 2.8; 4; 5.6; 8; 11; 16; etc.

The *f*-numbers follow what is an internationally agreed sequence relating to the brightness of the image. It is like operating a 'light tap'; each change to the next highest number halves the amount of light passing through your lens. And because the aperture is positioned in the lens centre it dims or brightens the entire image evenly.

The *f*-number system means that every lens set to the same number and focused on the same (distant) subject gives matching image brightness, irrespective of its focal length or the camera size. You can change lenses, but as long as you set the same *f*-number the image brightness remains constant.

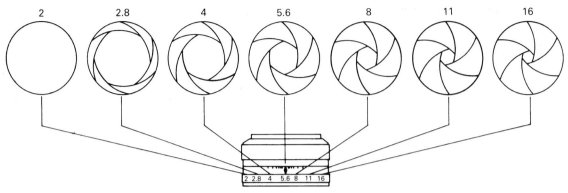

Fig. 3.8 Typical *f*-number sequence (lenses may open up beyond *f*/2, and stop down beyond *f*/16)

How f-numbers work

The *f*-numbers themselves denote the number of times the effective diameter of the aperture divides into the lens focal length. So *f*/2 means setting an aperture diameter one-half the focal length; *f*/4 is one-quarter, and so on. The system works because each *f*-number takes into account two main factors which control how bright an image is formed:

1. *Distance between lens and image.* As you saw in Figure 2.10, doubling the distance of a surface from a light-source quarters the light it receives. And since distant subjects are focused one focal length from the lens, a lens of (say) 160 mm focal length basically forms an image only one-quarter as bright as a lens of 80 mm.
2. *Diameter of the light beam.* Doubling the diameter of a circle increases its area four times. So if the diaphragm of the first lens passes a beam of light 20 mm wide and the second only 10 mm wide, the first image is four times as bright as the second.

Now if you express (2) as a fraction of (1), you find that both lenses are working at relative apertures of *f*/8 (160 ÷ 20, and 80 ÷ 10), which is correct since their images match in brightness. So:

$$f\text{-number} = \frac{\text{lens focal length}}{\text{effective aperture diameter}}$$

In practice the *f*-number relationship to brightness breaks down when working very close up, because the lens-to-image distance will then differ greatly from one focal length. See page 195.

As for the sequence of figures, notice how *alternate f*-numbers double: 2, 4, 8 etc. (Some numbers are incongruous because they are rounded up or down; for example 2.8 × 4 = 11.2.) This reflects the fact that doubling the diameter of a circle quadruples its area, so opening the aperture to twice its previous width makes a difference of two, not just one, *f*-number settings.

The *f*-number settings are also referred to as 'stops'. In early photography, long before iris diaphragms, each stop was a thin piece of metal punched with a hole the required size which you slipped into a slot in the lens barrel. Hence photographers speak of 'stopping down' (changing to a smaller opening, higher *f*-number). The opposite term is 'opening up'.

You will find in practice that upper and lower limits of the *f*-number scale vary with different lenses. Most small-format camera lenses stop

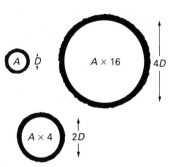

Fig. 3.9 Each time the diameter (*D*) of a circle is doubled its area (*A*) increases four times

Fig. 3.10 Image brightness. These lenses differ in focal length and therefore give different-size images of a distant subject But by having diaphragm diameter one-eighth of focal length in each case, the images match in brightness. Both are working at *f*/8

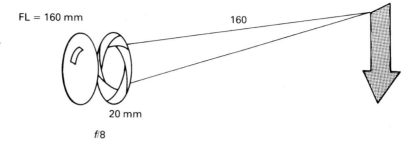

FL = 160 mm

20 mm

f/8

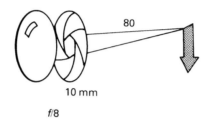

FL = 80 mm

10 mm

f/8

down to *f*/16 or *f*/22. Larger, sheet-film camera lenses are designed to continue down to *f*/32 or *f*/45. Smaller apertures are useful for extra depth of field (see below) but if taken to extremes, diffraction starts to destroy image detail. This is why no lens will stop down literally to pinhole size.

At the other end of the *f*-number scale, limits are set by price and the current state of technology. The wider the maximum relative aperture setting the more difficult it is for the manufacturer to suppress aberrations. The lens must also be bigger, and costs more. But then a wide-aperture lens passes more light (it is 'fast') and this is handy in dim conditions – for photo-journalism for example. Lenses of *f*/1.4 are quite common for small-format cameras. Often a lens design may produce acceptable image quality up to a relative aperture wider than, say, *f*/2 but not as wide as the next *f*-number, *f*/1.4. A maximum setting of *f*/1.8 or some other 'non-standard' *f*-number will then appear on its scale. Most large-format camera lenses only open to about *f*/4 at the most. In fact, the 'best' aperture with most lenses is around *f*/8, being a compromise between the opposite influences of lens aberrations and diffraction.

The *f*-number of your lens's maximum aperture, together with its focal length, name and individual reference number, are engraved on the lens rim. You will often find that, of two lenses identical in make and focal length, one is almost twice the cost of the other because it has a maximum aperture one stop wider. This may be a high price to pay for the ability to shoot in poorer light or use faster shutter speeds.

Depth of field

Your lens aperture is an important control for dimming or brightening images – helping to compensate for bright or dim subject

Fig. 3.11 This collection of lenses – for large, medium and small format cameras – shows the variety of ways in which information on aperture, focal length, maker, and reference number appear

conditions (see Chapter 10). But it has an even more important effect on visual results whenever you photograph scenes containing a number of items at various distances from the lens. Imagine for example that the shot consists of a head-and-shoulders portrait with a street background behind and some railings in front. If you focus the lens to give a sharp image of the face and take a photograph at widest aperture, both the street and railings will appear unsharp. But if you stop down to, say, $f/16$ (giving more exposure time to compensate for the dimmer image) you will probably find that everything appears in focus from foreground through to background. This changing 'zone' of sharp focus, either side of the object distance on which you actually focused, is known as *depth of field*.

Depth of field is the distance between the nearest and furthest parts of a subject that can be imaged with acceptably sharp detail at one focus setting of the lens.

Widest aperture (smallest *f*-number) gives least depth of field, while smallest aperture (highest *f*-number) gives most. There are two other significant effects: (1) depth of field becomes less when you are shooting close-ups than when all your subject matter is further away; (2) the longer the focal length of your lens the less depth of field it gives, even with the same aperture and subject distance (Figures 3.16 and 5.2).

Fig. 3.12 Shallow depth of field. Using a wide aperture (*f*/2) limits detail, concentrates interest on one chosen element – the pollen-covered flower tip

Fig. 3.13 Maximum depth of field. This scene has important elements at several different distances and was shot at *f*/16 to produce sharp detail throughout

Practical significance

It is very important to be able to control depth of field and make it work *for* your pictures, not *against* them. By choosing shallow depth of field you can isolate one item from others at different distances. You can create emphasis, and 'suggest' surroundings without also showing them in such detail that they clutter and confuse. Such pictures are said to be 'differentially focused'; see Figure 3.12. But remember that minimising depth of field with a wide aperture also means you must be really accurate with your focusing – there is much less latitude for error. You may also have exposure problems if you choose to shoot at wide aperture in bright lighting, or with fast film, or want to create blur effects using a slow shutter speed.

On the other hand, by choosing greatest possible depth of field your picture will contain maximum information. It can be argued that this is

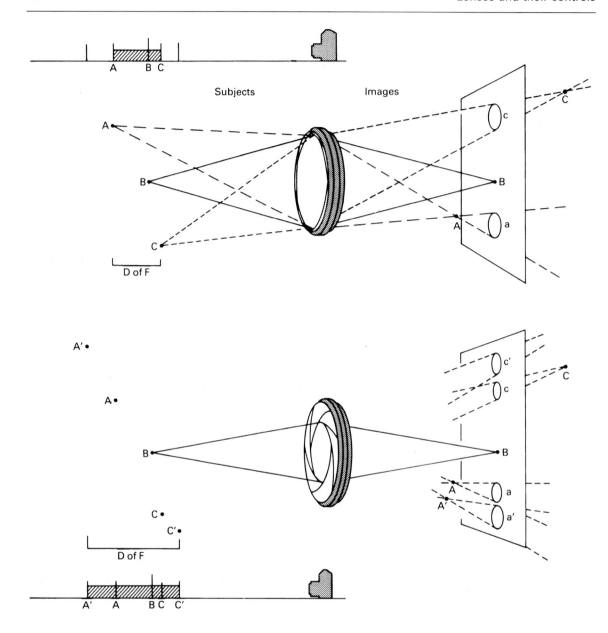

Subjects Images

Fig. 3.14 Why depth of field increases. Top: if image discs a and c, representing points A and C, equal the largest acceptable circles of confusion, then depth of field (when the lens is focused for B) just extends to subjects A and C. Bottom: stopping down the lens makes all light cones narrower, brings discs representing A' and C' also within acceptable circle of confusion size. Depth of field now extends from A' to C'

more like seeing the actual subject, because the *viewer* can decide what to concentrate on, rather than being dictated to by you. For most commercial and record photography, people expect photographs to show detail throughout. Just be careful that you notice (and avoid) any unwanted clutter in the foreground or background. Where possible, check the actual focused picture with the diaphragm aperture at the same diameter to be used for photography.

Sometimes you cannot produce sufficient depth of field by stopping down (perhaps lighting conditions are so dim or film so slow that an unacceptably long exposure is needed). In such cases take any step which makes the image *smaller*. Either move back, or use a shorter focal length lens or smaller-format camera. Later you will have to

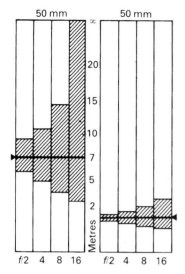

Fig. 3.15 Depth of field at different apertures when a 50 mm lens is focused for 7 metres (left) and 1.5 metres (right)

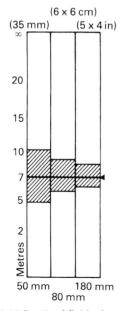

Fig. 3.16 Depth of field when standard focal length lenses for different formats are used at identical aperture (f/4) All were focused at 7 metres

enlarge the image in printing, but you still gain on depth of field. See also camera movements, page 109.

How depth of field works

To understand why depth of field changes you need to remember how a lens critically focuses an image point at one distance only, depending on how far the lens is from the subject. See Figure 3.14. In this position light from other parts of the subject nearer or farther from the lens comes to focus farther away or nearer, forming discs instead of points of light. They are known as *circles of confusion*. Large circles of confusion, overlapping, give the image an extremely unsharp appearance.

Since your eyes have limited resolving power, when viewing a final print or slide you rate an image acceptably sharp even when tiny discs are present instead of dots. The upper limit to what is seen as acceptably sharp is taken to be 0.25 mm diameter on the final print. (Viewed from about 25 cm this is indistinguishable from a dot for most people.) Lens manufacturers for 35 mm format cameras assume that if 25×20 cm (10×8 in) enlargements are made (film image magnified $\times 8$) to this standard then the largest acceptable circle of confusion *on film* is 0.25 $\div 8 = 0.03$ mm.

By accepting discs up to this size as sharp, subjects slightly nearer and farther away than the subject actually in focus start to look in focus too. And if the lens aperture is made smaller all the cones of light become narrower, so that images of subjects even nearer and farther are brought into the zone of acceptable sharp focus. Depth of field has increased.

Again if you move farther back from the subject or change to a shorter focal length lens, the positions of sharp focus for images of nearest and farthest subject parts bunch closer together. Their circles of confusion become smaller, again improving depth of field.

So you produce greatest depth of field when:

- *f*-number is high (the lens is stopped down);
- subject is distant;
- focal length is short;
- permissible circle of confusion is large.

You will find that, with subjects beyond about ten focal lengths from the lens, depth of field extends farther behind the subject than towards the lens. There is a photographer's maxim 'focus one-third in', meaning focus on part of the scene one-third inside the depth of field required. With close-up work, however, depth of field extends more equally before and behind the focused subject distance.

Using scales and tables

You often find that camera lenses carry a depth of field scale, next to a scale of subject distances (Figure 3.17). The scale gives you a rough guide to the limits of depth of field and is useful if you are 'zone focusing' – presetting distance when there is no time to judge focus and depth of field visually. Scales also show how you can gain bonus depth of field in shooting distant scenes. When focused on infinity (losing half your depth of field 'over the horizon'), read off the nearest subject distance sharp. This is called the 'hyperfocal distance' for the *f*-number you are using. Change your focus to this setting and depth of field will extend from half the distance through to the horizon. See Figure 3.18.

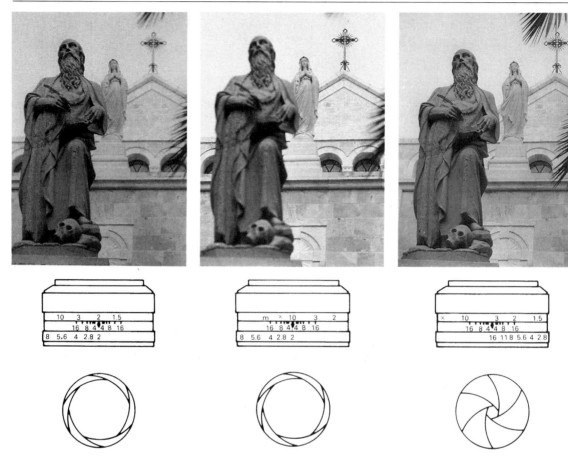

Fig. 3.17 Zone focusing. The lens above has a depth of field scale located between focusing and f-number scales. When zone focusing, first visually focus the nearest object you want sharp (left) and note the marked distance. Then do the same for the most distant part (centre). Using the depth of field scale, set the lens for a distance which places both near and far parts within the zone of sharp focus at a small aperture here f/16 is needed (right). You must also set a slower shutter speed to maintain the same exposure

Depth of field is also exploited in cheap cameras with simple symbols for setting lens focus. Typically a silhouette of mountains sets the lens to its hyperfocal distance; a 'group of people' symbol means 3.5 metres; while a 'single head' is 2 metres. Provided the lens has a small working aperture, these zones overlap in depth of field. So users stand a good chance of getting in-focus pictures as long as they make the correct choice of symbol.

Published depth of field tables, like scales, are only a guide. They are of greatest use for showing you the *relative* effects of distance, focal length, etc. Remember that depth of field limits don't occur as abruptly as the figures suggest – sharpness deteriorates gradually. Much depends too on what *you* regard as a permissible 'circle of confusion'. If you

Fig. 3.18 Hyperfocal distance. For extra depth of field with distant scenes, first set the lens to infinity, and note the nearest distance still within depth of field for the f-number you are using, in this instance f/8 (left). Then refocus the lens for this 'hyperfocal' distance (right). Depth of field will extend from half this distance to infinity

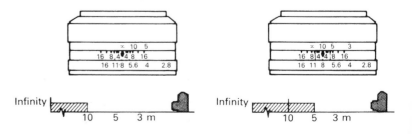

1	2 Maximum c. of c. to give acceptable 10 × 8 in print	3 Focal length	4 Subject distance	5 Relative aperature	6 Distance to nearest sharp point	7 Distance to farthest sharp point	8 Depth of field (approximate)	Notes
Format								
4 × 5 in	0.125 mm	150 mm	4 m	f/8	3.55 m	5.19 m	1.64 m	'Standard' image (for comparative purposes)
4 × 5 in	0.125 mm	150 mm	4 m	f/22	2.72 m	8.12 m	5.4 m	Longer exposure required
4 × 5 in	0.125 mm	150 mm	8 m	f/8	5.93 m	13.24 m	8.31 m	Flatter perspective. Smaller image* (more subject included)
4 × 5 in	0.125 mm	75 mm	4 m	f/8	2.9 m	7.07 m	4.17 m	Small image* (more subject included)
4 × 5 in	0.125 mm	300 mm	4 m	f/8	3.7 m	4.42 m	0.72 m	Large image* (less subject included)
4 × 5 in	0.125 mm	75 mm	2 m	f/8	1.66 m	2.56 m	0.9 m	Steeper perspective
24 × 36 in	0.031 mm	50 mm	4 m	f/8	2.9 m	7.07 m	4.17 m	Similar subject inclusion and perspective to standard image
24 × 36 in	0.031 mm	150 mm	4 m	f/8	3.83 m	4.19 m	0.36 m	Less subject included
24 × 36 in	0.031 mm	28 mm	2 m	f/8	1.23 m	5.59 m	4.36 m	Steeper perspective

*If negative is enlarged to match 'Standard', c. of c. should be 0.06 mm and depth of field is halved.

By comparing columns 6 and 7 with column 4, note that it is good practice with most subjects to focus 'one-third in'. Thus, if the subject extends from 3.5 m to 5 m from the camera, focus the lens for 4 m.

Fig. 3.19 Comparative effects of f-number, circle of confusion. focal length and subject distance on depth of field

intend to make big enlargements, your standard of sharpness on film must be higher, and this automatically means less depth of field. Even if your camera allows you to observe depth of field effects on a focusing screen (page 57) you should work well within the limits of what *looks* sharp, or you may be disappointed with the final print.

When using a camera giving a large-format image you can anticipate less enlargement than, say, with a 35 mm camera. But although this makes a larger circle of confusion permissible, the long focal length lens needed by the large camera to include the same angle of view has a much stronger and opposite influence. In practice the larger your camera the less your depth of field (Figure 3.19). What the table does not show, however, is the effect of the grain pattern of the chemically recorded image when the smaller film is enlarged. Since final sharpness in your photograph is influenced by graininess as well as factors like depth of field, this deprives the small camera of some of its advantages. You will find more on camera comparisons in the next chapter.

Depth of focus

Depth of field is concerned with making light from different subject distances all come to focus at one lens setting. But *depth of focus* refers to how much you can change the lens-to-image distance without the focused image of any one subject growing noticeably unsharp. It is therefore more concerned with tolerance and accuracy in focusing.

As Figure 3.20 shows, depth of focus increases with small aperture and large permissible circle of confusion. Unlike depth of field,

Fig. 3.20 Depth of focus, assuming that diameter *C* is the maximum permissible circle of confusion. Think of this focusing latitude as the distance you could freely move a ring along two cones positioned apex to apex

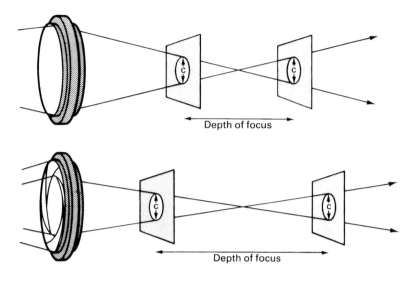

however, depth of focus becomes greater the *closer* your subject and the *longer* the focal length of the lens. Both changes cause light to come to focus farther from the lens, making the cones of light narrow.

Practical significance

A small-format camera needs its lens more precisely positioned relative to the film than a large camera. This is because of its shorter focal length normal lens, and smaller acceptable maximum circle of confusion. A large-format camera does not therefore need engineering with quite the same precision as a 35 mm camera, and its greater depth of focus also allows more use of 'camera movements'. See Chapter 6.

When you visually focus the image given by a camera or enlarging lens, always have the lens at widest aperture. This minimises depth of focus, making it easier to see the true position of accurate focus. The picture is brighter too. Again, when you use the camera to focus very close subjects (photomacrography) it is easiest to alter lens focus to get the image roughly correct size – then *move the whole camera* backwards or forwards to get the picture pin-sharp. You will be focusing by exploiting the shallow depth of field under these conditions, avoiding the deep depth of focus which could keep you adjusting lens focusing for a long time.

Lens care

Your lens is the most important part of the camera or enlarger. It is important to protect its glass surfaces. On a camera you can do this with some form of lens cap, or a clear glass UV filter (page 178). Avoid carrying a camera over your shoulder or in a bag containing other loose items without some lens protection. A small speck on the glass is relatively unimportant – it just minutely reduces illumination, but a greasy finger mark, scratches, or a layer of dust will scatter and diffuse light, so your images have less contrast and detail.

Loose dust and debris is best puffed away with a blower brush or gently guided to the rim of the lens. Grease or marks left by spots of rain may have to be removed with a soft tissue moistened in lens cleaning fluid. A scratched lens will probably have to be sent for repolishing.

Don't become too obsessive about polishing lenses. You will do far more harm than good if you start to mark permanently the surface of the glass or top coating. Prevention is much better than cure.

Summary: Lenses and their controls

● Photographic lenses are assembled from multi-elements to correct aberrations caused by dispersion, distortion, etc. in single-element lenses. Glass surfaces are coated throughout to minimise reflections. Smallest and largest aperture settings are also limited to help reduce aberration effects.

● The focal length for a 'normal' lens is approximately the diagonal of its camera picture format. But it must be designed with sufficient covering power to give a quality image over the whole area.

● The longer the focal length of a lens the greater the physical focusing movement it must make to cover a range of subject distances.

● An out-of-focus image of a point on the subject broadens into a 'circle of confusion'. Provided this is relatively small (typically 0.25 mm or smaller on the final result) it will still look acceptably sharp.

● Relative apertures are calibrated in *f*-numbers. Each number is focal length divided by diameter of effective aperture, so the *lowest f*-number denotes *widest* aperture setting. Each *f*-number change either doubles or halves image brightness. Typically the scale runs *f*/2, 2.8, 4, 5, 6, 8, 11, 16.

● Depth of field is the zone between nearest and furthest subjects which are all acceptably in focus at one distance setting.

● Depth of field is increased by 'stopping down'. It is also greater when you focus distance subjects, use a lens of shorter focal length, or accept lower standards of sharpness.

● When shooting three-dimensional scenes, control over depth of field allows you to isolate and emphasise, or give maximum information by resolving detail throughout. Preview the effect visually by checking the image itself, or use a depth of field scale if you are zone focusing.

● As a guide, focus on an item one-third inside the total depth of field you need. For distant shots, focusing for the hyperfocal distance will give you depth of field from half this distance to infinity.

● Small-format cameras give greater depth of field than large-format cameras, assuming normal lenses used under the same conditions of distance and *f*-number.

● Depth of focus is the amount that lens-image distance can vary before a sharply imaged part of the subject appears unsharp. Unlike depth of field it is greatest with close subjects and long focal length lenses.

● Take care of your lenses by protecting them from scratches, finger marks and dust. Clean only when necessary. Learn to remove dust and slight marks safely, and leave the rest to experts.

Projects

1. Visually check depth of field. Use a single-lens reflex camera fitted with a preview button (or work with a large format camera). Arrange a scene containing well-lit objects at, say, 1 m, 2 m and beyond 3 m. Focus for 2 m and view the result at widest aperture. Next set the lens to *f*/8, press the preview button if using an SLR, and *ignoring the dimmer image* see how nearest and farthest objects have improved in sharpness. Test again at *f*/16. Also compare the effects of focusing on closer or more distant groups of objects.

2. Bright out-of-focus highlights spread into approximately *circular* discs of light because lens and diaphragm are nearly circular. Cut out a star or cross shape from black paper and hold it against the front of your SLR camera lens, set to widest aperture. View a subject full of sparkling highlights (such as crumpled foil) rendered out of focus, and see the change of appearance your shape gives.

3. You can improve sharpness by 'stopping down' your eye, just like a camera. Make a 1–2 mm diameter hole in black paper and hold this close in front of one eye in bright light conditions. You should now be able to see objects as close as 5 cm quite sharply, or if you normally wear reading glasses, you can read this page without them.

4. If your lens has a depth of field scale, compile a simple table of the nearest and farthest objects sharp at different combinations of *f*-number and focusing distance. Note how depth of field differs between close subject focusing distances and settings near to infinity (∞).

5. Using your camera on a tripod, compose a picture containing detailed objects over a wide range of distances, from about 0.5 m to the far horizon. Take a series of shots at (1) widest aperture and (2) smallest aperture, with the lens set for (a) infinity, (b) the hyperfocal distance for your aperture (read this off the depth of field scale), (c) a foreground object, (d) the same object as (c) but with the camera twice as far away and refocused. Compare results for depth of field changes. Remember to adjust exposure time for each change of aperture.

4
Cameras

This chapter takes you from the lens alone to the camera as a whole. It explains the principal camera components, and shows how – put together in different combinations – they make up today's mainstream camera designs. It also compares the advantages and disadvantages of various camera types.

When looking at modern sophisticated equipment it's hard to believe that a camera is basically a box with a lens at the front and film at the

Fig. 4.1 Main camera types and formats. A: 35 mm compact. B: 35 mm single-lens reflex. C: 6 × 6 cm single-lens reflex. D: 6 × 6 direct viewfinder rollfilm camera. E: 5 × 4 in monorail view camera. F: baseboard view camera

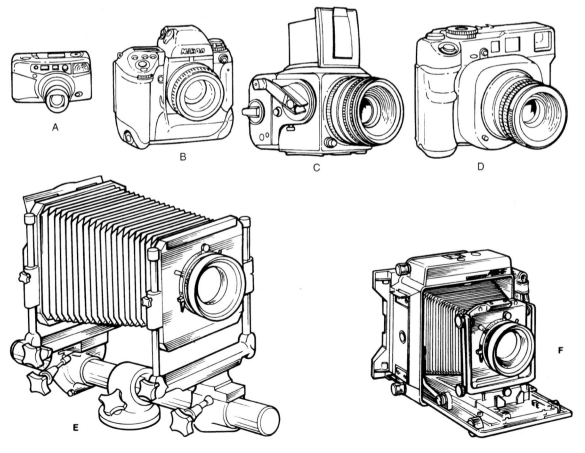

back. Yet the first cameras were just that – wooden boxes put together by the local carpenter. A telescope objective was mounted over a hole at the front, and a holder for light-sensitive material arranged to fit into the other end.

During 160 years' evolution many different camera designs have been invented, improved or discarded. The relatively recent introduction of microelectronics has greatly increased performance, particularly in 35 mm film size cameras. And yet the whole range of contemporary cameras can be divided into just four main types: view cameras, compacts, twin-lens reflexes and single-lens reflexes. At the same time, camera picture sizes fall into three different groups: *large format* (sheet film, typically 5 × 4 in), *medium format* (rollfilm sizes giving 6 × 6 cm etc.) and *small format* (principally 35 mm film).

The essential components

Whatever its picture size or type of design, a camera should offer the following controls and adjustments, either manual or automated:

1. Some means of accurately aiming the camera and composing the picture.
2. Ability to focus precisely.
3. A shutter to control the moment of exposure and the time that light acts on the film.
4. An aperture to control depth of field and image light intensity.
5. A method of loading and removing film, without allowing unwanted light to affect it.

And preferably:

6. A light meter to read the exposure needed for each scene.

Aiming and composing

The simplest arrangement is to have a line-of-sight viewfinder mounted on top of your camera giving a direct view of the subject. This is

Fig. 4.2 Left: main components necessary in a photographic camera, whatever its actual design or size. Right: components with similar functions in our human camera, the eye. L: lens. M: muscles which alter lens shape to focus. I: iris (diaphragm). R: retina, light-sensitive surface. 0: optic nerve communicating image information to brain. F: clear fluid filling eyeball

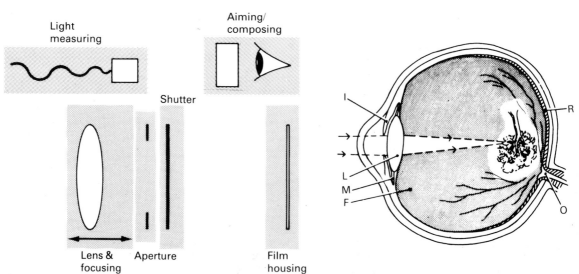

Light measuring

Aiming/ composing

Shutter

Lens & focusing

Aperture

Film housing

Fig. 4.3 Parallax separation between viewfinding (V) and taking lens (T) causes framing variations between what is seen and what is photographed. Parallax error increases greatly at close subject distances (exaggerated here). Lower left: on some twin-lens reflex cameras a bar moves into view as you focus close-ups – this indicates the top of the frame as photographed

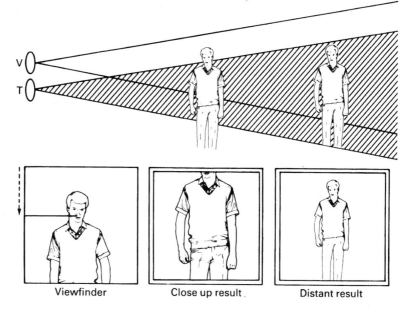

Viewfinder Close up result Distant result

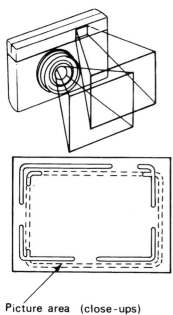

Picture area (close-ups)

Fig. 4.4 On compact cameras the viewfinder may suffer both horizontal and vertical parallax error. Extra lines in the viewfinder display show this displacement at closest focusing distance

Fig. 4.5 With static subjects you can correct both framing and viewpoint differences by raising the camera

masked to have the same angle of view and height-to-width proportions as the picture given by the camera lens. Unfortunately if you have viewfinder and camera exactly coinciding in what they show of distant subjects, the same fixed viewfinder shows a slightly displaced framing-up of close subjects (Figure 4.3). This is because of their separate, parallel viewpoints – a fault known as *parallax error.*

A better way to aim and compose accurately for all subject distances is by some arrangement that allows you to view the actual image formed by the camera lens. This is physically more difficult to achieve. You can use a translucent glass screen in place of the film (view cameras, page 61), then exchange this for film before shooting. Or you can have a mirror system behind the lens which reflects the image to a screen at the top of the camera, but moves out of the way of the film just before exposure (reflex cameras, page 67).

Focusing

The crudest system is to adjust the lens-film distance by turning the lens focusing control to the estimated setting on a scale of subject distances. Some cameras with direct viewfinders have a rangefinder focusing device. You see the subject twice: once straight through the viewfinder, the other ducted (via a mirror and window) from a viewpoint further along the camera body. This second view is superimposed over the centre part of the first (Figure 4.7). Turning the lens focusing control also alters an optical mechanism causing the second view to shift sideways relative to the first. When both versions of the subject appear as one your lens is also properly focused for this subject distance.

A rangefinder gives you a clear, positive method of focusing even under dim lighting. The longer the distance between the two viewpoints (viewfinder and rangefinder windows) the greater their parallax difference and so the more accurate your rangefinder will be. Most

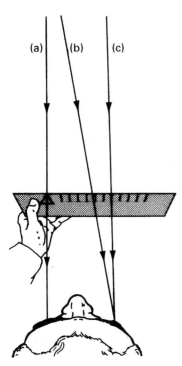

Fig. 4.6 Rangefinder principle.
With your *left* eye, line up near
and distant objects (a) with datum
mark on ruler. *Right* eye will see
the near object (b) and the distant
object (c) behind two different
marks on the ruler

Figure 4.7 An optical rangefinder
using glass (S) with semi-silvered
spot, and a pivoting mirror (M)
controlled by the camera lens
focusing mechanism. In the
viewfinder you see a second
image centre-frame. The two
coincide and merge when
rangefinder (and lens) are set for
the distance of this subject; see
broken line at M

rangefinder cameras go further and automate the system to provide full
autofocus (AF). Here your subject distance is sensed by methods such
as infra-red scanning and the lens automatically adjusted by motor
drive; see page 66.

Another way of focusing is to check the actual image formed by the
camera lens. Once again a straight or reflex focusing screen
arrangement is needed, so focusing is combined with viewfinding. On
small-format reflex cameras the screen may incorporate a crossed prism
device as a further focusing aid. This splits and offsets the image in the
centre of the screen when not in focus; see Figure 4.34. Focusing in a
reflex camera can also be automated.

A focusing screen is the only system which can also *show* you the
effects of depth of field on your picture at different aperture settings.

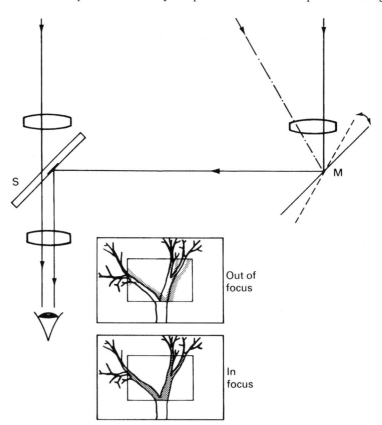

But since you will initially want to compose and focus with the lens at
widest aperture (brightest image, least depth of field) there must be
some way of quickly snapping the aperture down to the correct
exposure setting after focusing but before shooting.

Shutter

The camera shutter is a mechanical unit set in one of two positions,
either (a) in the middle of the lens, next to the aperture, or (b) at the
back of the camera just in front of the film surface.

The front or 'between-lens' shutter has several thin opaque blades
which rapidly swing out of, and back into, the light beam to make the

Fig. 4.8 Bladed, between-lens shutter. Lower mechanism shows how blades (simplified here to three) rapidly open or close with part-rotation of ring

exposure when the release is pressed. In this central position the shutter has an even effect on the whole image, and only a small movement is needed to open and close the light path. It is also easy to synchronise this action with flash: contact is made to the (electronic) firing circuit the instant the blades are fully open.

The rear or 'focal-plane' (FP) shutter has to be larger, in order to fill the rectangular or square picture area itself. Usually it consists of two opaque roll-up blinds. One opens to start the exposure, the other follows to block out the light again. (For short exposures the two blinds follow each other across the film so closely they form a slit which actually exposes the picture.) After each shot the blinds are wound back, this time overlapped to avoid further exposure, ready for the next picture. Some small-format cameras use two or three sliding metal blades to open and close the focal plane.

The main reason for having a focal-plane shutter is to allow light to pass through the lens and provide an image for viewfinding and focusing via a reflex system (Figure 4.32). It also means that one shutter will serve a range of lenses of different focal length, lenses which can be interchanged at any time without allowing the light in to fog your film.

Synchronising FP shutters with flash is more difficult, unless you have a 'long-peaking' electronic flash unit. The flash must go off when the entire frame is uncovered; you cannot use fast speeds (in some instances 1/125 second or less) because then a slit is actually exposing the film, and only part of the picture area records (Figure 4.9). Electronic flash contact is made when the edge of the opening blind gets to the far end of the frame. Provided you use the speed marked on the camera for flash, *or any speed slower*, the second blind will not yet have started to travel and the full frame is uncovered for exposure.

$\frac{1}{250}$ sec

(Resetting)

$\frac{1}{60}$ sec

(Resetting)

Fig. 4.9 Focal-plane blind shutter. At fast speeds (top sequence) film frame is never fully uncovered at any one time. For flash, change to slower speed (bottom sequence); flash circuit fires when first blind has fully opened. Blinds are reset overlapped (far right) by camera's film wind-on mechanism

(Avoid 1/250 or less with most 35 mm metal blade FP shutters; 1/60 or less with large 6 × 7 cm blind FP shutters.)

The usual range of shutter speeds, on both types of shutter, is:

1, 1/2, 1/4, 1/8, 1/15, 1/30, 1/60, 1/125, 1/250, 1/500 second

This doubling/halving progression (figures rounded up or down in some instances) complements the aperture *f*-number scale in terms of exposure given to the film. In other words, 1/30 at *f*/8 is the same exposure as 1/60 at *f*/5.6 or 1/15 at *f*/11. Actual choice depends on the depth of field you want and whether movement should record frozen or

blurred (see pages 141 and 282). By combining fastest shutter speed with smallest aperture – or slowest speed with widest aperture – you can give correct exposure over a very wide range of subject brightness conditions.

On slow shutter speed, such as 1/30 second or longer, a device comes into operation to delay your shutter closing again after fully opening. The system can be mechanical or electronic. A wholly mechanical between-lens or focal-plane shutter uses a train of gears (you can hear them buzzing at 1/4 second or longer) as a delay. The longest shutter setting that mechanical gearing systems normally offer is 1 second. You can give longer periods by setting the letter 'B' on the scale of speeds (B stands for 'Brief', or 'Bulb' after early photographers' use of an air bulb and tube system to hold the shutter open). On B setting the shutter opens when you press the release button and remains open as long as you keep it pressed down, normally using a cable release. Some view-camera shutters have a further 'T' setting, useful when focusing. On T ('Time') one press of the release opens and holds the shutter open; you must press the release again to close it.

Electronically timed shutters hold open silently while a tiny capacitor is charged with electricity, or a computer-type quartz timer creates a delay. Times up to 8 seconds or so can be set. (In fact exposures of several minutes are possible with some internal meter cameras operating in aperture-priority mode, explained on page 200.) Practically all modern SLR cameras now have electronic shutters; some show you a numerical count-down during long exposures, on a display panel.

Between-lens and FP shutters that are electronically timed integrate easily with the metering, autofocus and film wind-on circuits of small-format cameras. They give 'stepless' settings – speeds between the marked times – when exposure is under the automatic control of the meter. Operating power is drawn from the camera's main battery supply. (An electronic between-lens shutter for view-camera use has a battery compartment attached.) However, if the battery fails or your camera meter circuit is not switched on, many electronic shutters can only give you 1/60 second; sometimes faster speeds too, if none of these settings need a delay circuit. Some shutters cease functioning altogether.

The fastest shutter speeds are possible with FP shutters, because they can simply be set to run with a very narrow slit width, not needing particularly rapid blind speeds. (Speeds up to 1/12000 second are possible on some small-format cameras with fast-acting metal blade FP shutters.) Large diameter between-lens shutters for view cameras on the other hand have big cumbersome blades to move, and so may not operate faster than 1/250 second.

All focal-plane and most between-lens shutters, mechanical or electronic, have to be tensioned before they can be fired to take the picture. Often the cocking mechanism is set by winding on the film and so is hardly noticed. View cameras usually have a tensioning lever beside the shutter, and this must be activated before you fire the shutter with another lever or a cable release. See Figure 4.15.

Fig. 4.10 Metal focal-plane shutter, seen from film side. Thin sliding blades open vertically

Aperture

Physically, the diaphragm system used for lens aperture control differs little from camera to camera. As shown in Chapter 3, a series of

Fig. 4.11 Depth of field preview. Preset-aperture lenses remain fully open for viewing and composing (left). Pressing the preview control stops down the lens to the taking aperture (right). The focusing screen becomes darker but now shows depth of field as it will appear on film

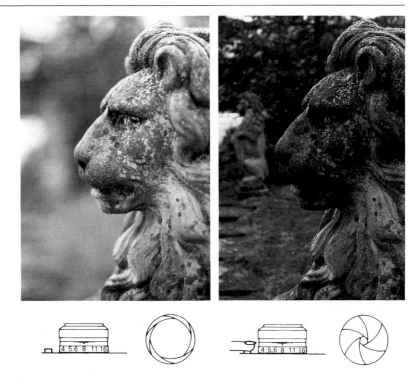

overlapping sliding blades forms a hole of continuously variable diameter. Sometimes, however, when the camera has a between-lens shutter, shutter and diaphragm are combined. The shutter then has five or six suitably shaped blades designed to open only part-way, temporarily forming a hexagonal aperture of the correct size according to the *f*-number preset. This reduces the mechanism needed and is very suitable for fully automated compact cameras.

In cameras that allow you to compose and focus the actual lens image, the aperture can be preset. This means that you (or the camera's auto-exposure system) set the required *f*-number but the lens still stays fully open for brightest image viewing until just before the shutter is fired. On single-lens reflex cameras this last-minute stopping down is triggered automatically from the shutter release mechanism. On most view cameras you can stop down directly to a preset aperture by manually releasing a 'press focus' lever.

In all cases you will probably want to check depth of field effects at different shooting apertures. On some 35 mm and most rollfilm SLR cameras there is a special aperture-preview button on the camera body or lens; so long as you keep this pressed the diaphragm responds to any setting made on the *f*-number scale. Regard an aperture-preview button as a desirable feature in any SLR camera intended for serious photography.

Film housing

The oldest way to load and remove light-sensitive film from the camera is to have separate sheets in a light-tight holder. This system is still used for view cameras. The double-sided holder slips into the back of the

Fig. 4.12a 35 mm cassette film,
120 rollfilm, and 5 × 4 in sheet
film (part-inserted in film holder)

Fig. 4.12a 35 mm cassette film,
120 rollfilm, and 5 × 4 in sheet
film (part-inserted in film holder)

Camera
auto-sensing
code

Film notch
code

Fig. 4.12b APS cartridges are
smaller than 35 mm cassettes.
Light-proof apertures in the base
signal (1) contains unexposed
film; (2) is partly exposed; (3)
exposed but unprocessed, or (4)
contains processed film (see page
160)

camera, displacing a focusing screen, and one side is then opened to face the (shuttered) lens. Most cameras, however, use film in lengths (35 mm wide, or 6.2 cm wide rollfilm) to allow many exposures at one loading. The film passes from feed to take-up compartments behind a picture-size aperture, flattened against it by a spring-loaded pressure plate. It is protected from light during loading and unloading because the film is contained in a cassette having a velvet 'light-trapped' feed slot, or rolled up on a spool together with opaque backing paper. See Figure 4.12.

Between exposures regular 35 mm cassette film is wound through the camera onto a permanently fitted open take-up spool. It must be rewound into its light-proof cassette before you open the camera to remove the film for processing. Rollfilm does not need rewinding; it winds completely on to an identical, removable, take-up spool protected by the last few inches of backing paper. (You can also buy 35 mm bulk film for 250- or 500-exposure accessory backs, page 92.) Disc and cartridge film units are designed for easy loading of simple amateur cameras.

An advantage of sheet film holders is that they allow you to change what is in your camera from one film type to another at any time. To do the same with a 35 mm or rollfilm camera without wasting frames you must either have two or more bodies, changing the lens from one to the other, or use a camera designed with interchangeable film magazines. Most cameras with magazine backs also accept pack holders for instant picture film.

Lengths of film are shifted through the camera either by an electric motor triggered immediately the shutter closes after each exposure, or by hand using a wind-on lever. The wind-on, shutter cocking and exposure release are normally interlocked, so that you cannot take another picture before you have wound on the previous shot, and vice versa. The system may be overridden for special superimposition effects. Most 35 mm cameras with built-in motor drive power-rewind the film back into its cassette after the last picture has been taken.

Light measurement

Practically all modern small- and medium-format cameras have some form of built-in circuit to measure the brightness of light from the subject and so assess correct exposure. This signals when you have

manually set a suitable combination of *f*-number and shutter speed, or else it automatically sets (a) the correct shutter speed for an aperture you have set (aperture priority or Av mode), (b) the correct aperture for a shutter speed you have set (shutter priority or Tv mode), or (c) a suitable combination of shutter and aperture settings chosen by the system from a built-in programme. These are discussed in detail in Chapter 10.

The tiny light-sensitive measuring cell may be located on the front of the camera body pointing direct at the subject from close to the lens, or cells can be suitably positioned inside the camera, sampling light which has come through the camera lens itself; see Figure 10.17. In both positions the cell should measure through any filter you may use over the lens. An internal cell system works equally well with any change of lens.

All modern exposure-measuring systems need to be powered by a battery. This can be tapped off the same power circuit for autofocus, shutter timing and film drive. You must also set the sensitivity of the film you are using (its ISO speed). Many 35 mm cameras do this automatically, sensing a bar code on the cassette via electrical contacts in the film feed compartment. Large-format cameras seldom have light-measuring arrangements built in, and you have to add a metering attachment or use a hand meter instead (Chapter 10). Alternatively take readings with a small-format internal-meter camera and then transfer the settings it shows.

Different combinations of these component systems – for aiming, focusing, control of exposure and depth of field, and measuring light – go to make up various commercial camera designs. Each advance in technology that brings improvements in one component therefore makes changes in several camera types. Developments in miniature photocells allowed internal metering; improvements in electronics made exposure-programming and autofocus possible. The trend is towards greater user-convenience, and more versatile and reliable equipment.

Camera types

No one camera is *ideal*. Some are specialised tools which enable you to tackle a narrow range of tasks in ways impossible with any other gear. Some are extremely versatile but something of a compromise, without ideal features for any one kind of photography. Weigh up the advantages and disadvantages of the four main camera types, and be prepared to use several cameras complementing each other in features and subject range. Try to get 'hands on' experience so that you can compare convenience, toughness and reliability. Decide what sort of camera controls feel right for you, and consider whether the size and proportions of the picture a particular camera gives are best suited to your work.

Choice of format

Figure 4.13 shows, actual size, the most common picture formats given by today's cameras. At first you might imagine that using an enlarger

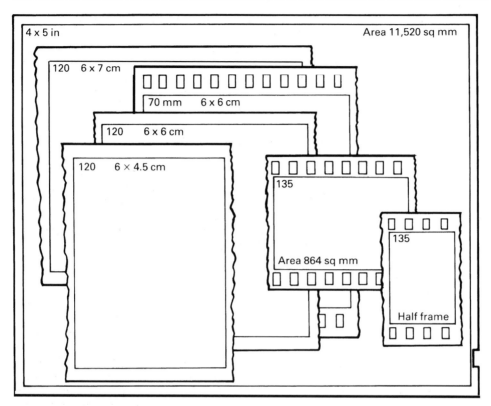

Fig. **4.13a** Commonly used picture formats on various size films, drawn here full scale; 120 rollfilm gives different formats according to camera design

Fig. **4.13b** APS film, actual size. The whole picture area is exposed in the camera, but can be cropped in enlarging to give three alternative ratios. C ('classic') dimensions give a 2:3 ratio. H (HDTV) dimensions give 9:16, and P ('panorama') give 1:3. Your choice when shooting is signalled magnetically on the film edge and programmes the mini-lab enlarger.

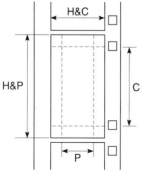

makes film size rather irrelevant, because all results can be blown up to a given size. However, other things being equal:

1. The larger the format the finer the quality your final image is likely to have – better definition, less grainy pattern, subtler tone and colour gradation. The 4×5 in format, for example, has 13 times the area of the regular 35 mm format; you can make enlargements to 16×20 in before image quality becomes worse than an enlargement to only 4×6 in from 35 mm. Format difference becomes increasingly apparent in prints over about 10×12 in.

2. Large-format cameras offer you the widest range of camera movements for image control (Chapter 6).

3. The smaller the camera the less it intrudes between you and your subject. A small camera gives you greater freedom of viewpoint, is much faster to set up and use, and allows you to shoot frames in quicker succession.

4. Pictures shot on small-format cameras have greater depth of field than pictures on large-format cameras (standard lenses, and same f-number) even when enlarged to the same size. See page 47. Put another way, you can shoot at a much wider aperture and still get the same depth of field.

5. Small format cameras are often fitted with lenses that are 'faster', i.e. have larger maximum apertures. Among other advantages, the brighter image makes it possible to shoot at hand-held shutter speeds under dim lighting. 35 mm camera systems have a vastly greater range of lenses and accessories available too; see Chapter 5. Where

equivalent items exist at all for medium or large-format kits they are much more costly.

6. Several specialised light-sensitive materials are made only for large-format (sheet film) cameras. Having sheet film holders allows you to change from one film to another with ease, and you can process pictures individually. However, a small-format camera kit is easier to carry, and makes it easier to shoot and process a large *quantity* of pictures. Also 35 mm is ideal for slides.

The other important consideration is format *shape*. Height-to-width proportions have a strong influence on picture composition. Most formats are rectangular, 35 mm regular frame having a ratio of 2:3. At first sight a square format would seem the easiest to work with. You don't have to choose between vertical and horizontal shapes when framing up a shot. But then you don't have the up/down or sideways thrust they can add to your picture either. Most pictures finally seem to be used in some rectangular format anyway.

Of course, during enlarging you can crop off unwanted image parts, but you will find that the original camera format still influences your picture making. Similarly some shapes are definitely more 'comfortable' to compose subjects within than others. A few panorama wide-angle rollfilm cameras (Figure 4.25) offer ratios of 1:2 or even 1:3. These long thin negatives, up to 6 × 17 cm, must be enlarged using a large format enlarger.

One final point concerns professional photography and client relations. Small-format cameras are still seen as *amateur* cameras, however excellent their performance. When you are being paid a large sum for a commercial shot and turn up with a 35 mm outfit not dissimilar to the client's own, the effect is less impressive than large, more specialist-looking equipment. This is a valid aspect of business psychology.

Fig. 4.14 View cameras. Both monorail (centre), and baseboard (right) designs are derived from wooden sliding-box plate cameras (left) used by pioneer photographers in the 1840s

View cameras

This type of camera design relates back directly to the earliest form of photographic plate camera, as used by pioneers such as Louis Daguerre.

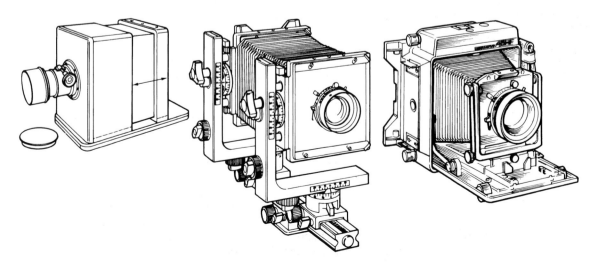

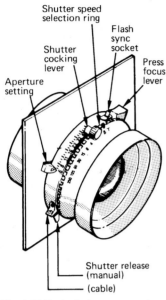

Shutter speed
selection ring

Flash
sync
socket

Shutter
cocking
lever

Press
focus
lever

Aperture
setting

Shutter release
(manual)

(cable)

Fig. 4.15 Typical view camera lens with (non-electric) shutter, mounted on interchangeable lens panel

Fig. 4.16 Monorail camera showing (left) the basic principle of unit construction. Design allows utmost independent movements of lens and film (A–D). By fitting larger back, conical bellows and extension rail, 5 × 4 converts to 10 × 8 in (E). Some cameras have U-shaped standards, others L-shaped (Figure 4.14); the latter have more precisely coinciding vertical and horizontal pivots but are more complex to engineer

Equipment then consisted of two boxes, one sliding inside the other for focusing, and having a lens at the front and a ground glass screen at the back. Today's view cameras are still large format, but designed for sheet film. The most popular size is 4 × 5 in; others include 10 × 8 in, 7 × 5 in and 9 × 6.5 cm. Often you can adapt *down* from any of these sizes by fitting an appropriate back or adaptor for smaller sheet film, or rollfilm, or instant-picture material.

The camera lens (with between-lens shutter) is mounted on a clip-on panel which fits over the camera front. You can quickly change to lenses of different focal lengths, also ready-mounted on panels. The front of the camera is connected to the back by opaque concertina bellows to keep out non-image-forming light, yet allow a wide range of lens-to-film focusing distances. A finely etched glass screen at the back shows you the (upside-down) image for focusing and composition. This back can be rotated from horizontal to vertical format. As the screen is spring-loaded, when you push in a film-holder between glass and bellows your film surface becomes located in exactly the position previously occupied by the etched surface of the glass.

The lens-carrying front of the camera can be tilted, or offset sideways up or down independently from the back. These 'camera movements' are especially important for architectural and still-life photography. They allow you extra control over depth of field and shape distortion, explained in detail in Chapter 6.

There are two main types of view-camera design, monorail and baseboard. Monorail types are unit-constructed on a rail, like an optical bench, and are always used on a stand. You dismantle the camera for transportation, and as Figure 4.16 shows you can put together different units to 'build' the required camera for each job. To focus you move either the front (lens) standard or rear (focusing screen) standard along the rail. Having such an open unit structure, a monorail offers the same camera movements front and back, allowing an enormous amount of offsetting. It is also possible to fit a *larger*-format back – say 10 × 8 instead of 5 × 4 – connected to the front by tapering bellows. (You must of course change to a lens able to cover 10 × 8.)

The baseboard type of view camera, also called a 'technical camera', is a box-like unit with a hinged front. Opening this flap you find you

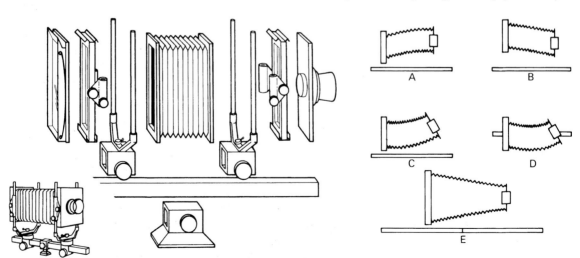

Fig. 4.17 Baseboard camera folded, and open for use on a tripod. The lens pulls forward on to focusing track; metal flaps fold out from back to shade focusing screen

can pull the lens standard out onto it, on runners. Then by turning a milled knob at the edge of the board you move the runners, focusing the lens backwards or forwards while you check the image on the focusing screen. Baseboard construction means that the camera is quicker to set up on its stand and use than a monorail type. However, it offers less comprehensive movements, especially back movements.

With all view cameras you need a fold-out hood or an old-fashioned focusing cloth over your head and camera back to block out ambient light, so you can clearly see the image. Figure 4.18 shows the typical sequence needed to take a picture. Exposure is most often measured with a separate hand meter (Chapter 10).

One or two extra camera features help to speed up this lengthy routine. For example, a large sliding lever attached to aperture and shutter controls allows settings to be read and changed easily from behind the camera. A hood containing a mirror turns the image right way up for viewing (Figure 4.19), although it is reversed left to right and appears somewhat dimmer. You can also use a system linking the lens panel and camera back by cable. Then as you insert the film holder it automatically closes and tensions the lens shutter; withdrawing it

A B C D E

Fig. 4.18 Operating a view camera. A: Composing and focusing. B: stopping down and checking depth of field. C: closing and setting the shutter. D: inserting film holder (and withdrawing darkslide covering film). E: firing the shutter

after exposure re-opens the shutter to let you see the image on the screen again.

View camera advantages

1. Cameras offer an unrivalled range of camera movements, especially monorail designs.
2. You can take and process single exposures. When working in the studio this allows a check on each result as you go along.
3. Relatively simple construction. There's little to go wrong.
4. The large format and static nature of the camera encourage you to build up carefully considered compositions, almost like drawing or painting.
5. Excellent for architectural, landscape and still-life photography, for close-ups and copying because even the normal-length bellows allows considerable lens–film extension.
6. Large-format image quality; choice of special film types.

Eyepiece

Mirror

Fig. 4.19 Image-inverting hood for view cameras. By attaching this over the focusing screen you see the image right way up. The hood also substitutes for a focusing cloth

View camera disadvantages

1. The camera kit, film holders and tripod are bulky to carry and slow to set up and use.
2. The dim, upside-down image is awkward to view.

Fig. 4.20 A camera offering rising front movement is ideal for this kind of architectural subject, where most elements are well above the lens centre. Tilting the camera upwards would have made vertical lines converge. See Figure 6.4

3. It takes time to measure exposure, and with a hand meter there are exposure calculations needed when working close; see page 195. (Some cameras have an internal meter accessory, Figure 10.24.)
4. To exploit most camera movements you must have lenses with exceptionally good covering power (page 37).
5. Impractical camera for most fast-moving situations: sports, candids, etc.

Direct viewfinder cameras

This term covers cameras using direct-vision (also known as real image) viewfinders, including small-format 'compacts'. They are sophisticated descendants of snapshot cameras which were once the main rivals to large-format cameras. Most direct viewfinder cameras are designed as self-contained units with everything including flash built in, instead of being part of an extensive 'system' like monorail view cameras or single-lens reflexes. They are often completely automated, not showing you what settings are being made but containing advanced technology to ensure a low failure rate over a wide range of subject conditions.

A typical high-quality compact uses 35 mm film and gives full-frame format pictures. It has motor drive and a non-interchangeable zoom

Fig. 4.21 35 mm medium-cost compact camera. A: shutter release/motor wind-on button. B: frame counter. C: switch for power rewinder. D: direct viewfinder. E: built-in flash. F: rangefinder windows for IR autofocus system. G: switch for slide-away lens cover and power circuit. H: light sensor for auto-exposure program. J: self-timer, also controls focus-hold

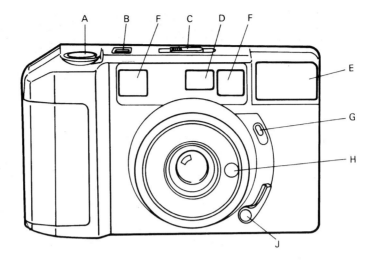

lens, see page 86. Simpler compacts have a lens of fixed focal length between 35 mm and 40 mm. This relatively short focal length gives greater depth of field and a wider angle of view (see page 82) than a 50 mm lens, standard for most 35 mm format cameras. You compose and aim looking through the separate optical viewfinder unit set into the top of the camera – your picture area appears as a white outline 'suspended' on a slightly larger viewing area (Figure 4.22). A short extra line shows you the true upper limit of the frame when shooting close-ups (parallax correction), and there is also a central zone showing where focusing takes place. Information appears alongside the frame line, such as the distance focused on, and warning signals for 'beyond exposure range', 'use flash', etc.

Most compacts are autofocusing, but a few use a visual rangefinding system (page 54). The latter usually includes parallax correction using optics which slightly shift the suspended frame position in the viewfinder according to the subject focusing distance you set.

Autofocusing (AF) compacts work by means of an active infra-red (IR) focusing system, containing transmitting and receiving diodes similar to those used for remote control of a TV set. The system works on the rangefinder principle of triangulation (Figure 4.7) but sends out a beam of invisible IR light from one window at the top of the camera and has a narrow-angle detector cell behind the other (Figure 4.23). A motor focuses the camera lens and scans an IR beam across the subject. Both stop when a strong return signal is detected.

Alternatively a 'passive' system is used whereby two rangefinder images are compared by an array of CCD elements which detect when they match in pattern and contrast. Both systems work fairly fast and accurately for any subject occupying the small mid-frame target area. An IR system will even focus in the dark, but can be fooled sometimes if you are photographing through glass windows at 90°. A passive system is sometimes defeated in dim ambient light or when your subject noticeably lacks contrast or pattern.

In both instances take care when shooting two people not to permit the sensor to measure off the background between the pair. There is usually a control which allows you to focus for a subject centre-frame,

Fig. 4.22 Typical compact direct vision finder. F: frame line. A: autofocus area. D: distance zone auto-selected. S: shake warning light (slow speed in use). R: 'flash ready' sign

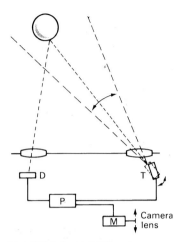

Fig. 4.23 Infra-red AF system. Transmitter (T) scans centre of subject area. Detector (D) senses when reflected signal is strongest. Processing circuit (P) relates this to the position of (T) and halts camera lens focusing motor at correct distance setting

then lock the lens and alter composition to have your main subject off-centre. However, this takes time.

Having a between-lens shutter makes compact cameras very quiet, but this advantage is sometimes destroyed by motor noise when focusing and winding on film. Shutter speeds and apertures are set internally by a fully automatic programme, typically over a range 1/8 second at f/2.8 to 1/500 at f/16, according to the subject brightness reading; see page 200. If conditions demand speeds of 1/30 second or slower, a signal warns you to use flash instead. Semi-automated compacts have setting scales for shutter and aperture. You set aperture and the camera meter sets shutter speed; or you can set both manually and the meter confirms when a combination will give correct exposure.

Variations and specials

There are many variations of direct viewfinder cameras, including amateur types using APS cartridge films. At the simplest level you can buy 'single use' small format cameras ready loaded with film. The lens has a fixed focus setting, usually for hyperfocal distance, see page 45. After exposing the last frame the camera body is broken open at the lab to remove the film for processing. The lens/shutter/flash assembly goes for factory recycling.

Amongst advanced 35 mm formats the Leica is an unusual form of direct viewfinder camera, still used by some professional photo-journalists because of its rugged precision and quietness. This costly camera has a focal-plane shutter, and a modest range of interchangeable lenses. The viewfinder frame line automatically changes to suit the lens you fit. Exposure reading is through the taking lens, another unusual feature in a direct viewfinder design. A hinged light sensor just in front of the shutter blind moves out of the way immediately before you shoot. The Leica gives you a range of manual or semi-automatic exposure modes similar to those described for single-lens reflexes.

A few viewfinder cameras are made for rollfilm formats too. Such cameras have between-lens shutters, and are focused by simple distance scale setting, optical rangefinder, ground glass screen or some form of autofocusing system. A few specialist types such as architectural 'shift' cameras offer camera movements which are coupled to the viewfinder. See Figures 4.25 and 6.1b.

Direct viewfinder camera advantages

1. An all-in-one unit, mostly quick to bring into use and record things as they happen – getting a picture you would otherwise miss. For candid photography it is possible to hold up an AF compact and shoot 'blind' over the heads in a crowd. Press photographers often carry an automatic compact as a back-up camera.
2. The viewfinder gives a sharp, bright image. You also see part of your subject in the viewfinder before it enters the marked frame, good for sport and action.
3. Most viewfinder cameras are very compact and lightweight for their format size, relative to an SLR.
4. Compacts with active (IR) autofocus systems will focus even in darkness.

Lock ⟶

Fig. 4.24 AF lock. When the main subject will not be in the centre of the frame, briefly re-compose the picture (left), lock the autofocus, then return to the picture composition you have chosen (right)

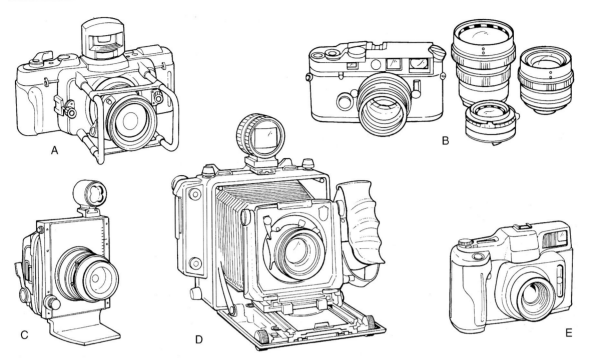

Fig. 4.25 Professional type cameras using direct viewfinders. A: wide-angle 6 × 17 cm rollfilm type. B: Leica 35 mm. C: architectural 'shift' camera using rollfilm or sheet film back. D: baseboard 4 × 5 camera with coupled rangefinder. E: Autofocusing 6 × 4.5 cm rollfilm type. (These cameras are all much more expensive than 35 mm compacts)

5. Motor-driven compacts allow you to shoot sequences or panoramas in a quick series of exposures, without lowering the camera from your eye.

Direct viewfinder camera disadvantages

1. Parallax error between viewfinder and lens is a real problem when working close. Even if *framing* is corrected, *viewpoint* difference still gives you a slightly different alignment of elements one behind another – sufficient to spoil critical compositions.
2. There is no convenient way of visually checking depth of field.
3. It is easy to have a finger, or strap, accidentally blocking the lens, exposure sensor, or autofocus rangefinding window. You will not see this looking through the separate viewfinder.
4. Inexpensive autofocus compacts take a perceptible time to focus (typically 1/10 second). Delay between pressing and firing can mean you lose the key instant of a fast action shot. Avoid AF-only models of this kind for sports photography, etc.
5. Some cameras have only one integral lens. Where this is a zoom type it has only a modest focal length range and maximum aperture.
6. The small flash built into compact cameras is not very powerful and gives only 'flat on' light. It cannot be bounced, see page 121.
7. Some compacts are totally reliant on battery power to work at all.

Twin-lens reflexes

Reflex cameras as such relate back to one of the earliest forms of camera obscura used for sketching views. With a mirror fixed at 45°

behind the lens the image is reflected up to a horizontal surface and becomes *right way up*. Soon after the invention of photography this reflex arrangement was mounted on top of a basic plate camera to act as a full-size focusing viewfinder (Figure 4.26).

The few twin-lens reflexes (TLRs) still in use today have two lenses of identical focal length mounted one above the other on a common panel. The distance from the top lens (via the mirror) to the focusing screen must be the same as the distance between the bottom lens and the film. The focusing screen is also the same size as the picture format. You can therefore focus and compose the image on the top screen, where it is shaded from light by a hood, then fire the between-lens shutter in the lower lens knowing that the picture will be correctly focused on film. Differences in viewpoint between the two lenses give parallax error, especially with close subjects.

The top lens has a fixed aperture, often one stop wider than the maximum given by the diaphragm of the lower lens. This produces a bright image and minimal depth of field for easier visual focusing. A Fresnel screen, Figure 4.28, helps to ensure you see an evenly illuminated picture. The image on the screen is right way up, but *reversed left to right*, a feature which makes it almost impossible to follow moving subject matter. Most models therefore have a simple fold-in direct viewfinder in the metal hood (V in Figure 4.27). However, since this viewpoint is 75 mm (3 in) or more from the taking lens, parallax error is even more extreme.

Most TLR designs use rollfilm, and produce square pictures. This choice of format shape is because the camera is awkward to use on its

Fig. 4.26 For centuries artists used the reflex 'camera obscura' (top) to form a right-way-up image on glass, convenient for tracing. When mounted on a plate camera, with lenses linked, it allowed full-size composing and focusing (bottom)

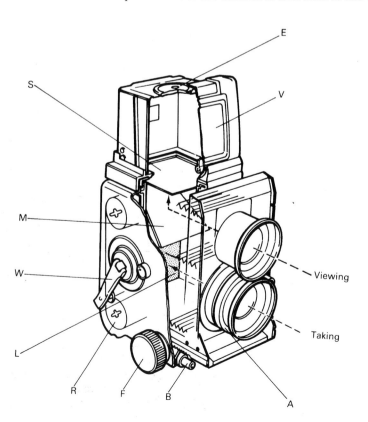

Fig. 4.27 Twin-lens reflex. A: aperture and shutter setting controls. B: shutter release. F: focusing knob, shifts entire twin-lens panel. R: rollfilm spool. L: light-sensitive emulsion. W: film wind-on handle (folds out). M: fixed mirror. S: focusing screen. E: focusing magnifier. V: push-in hood section, forms direct viewfinder with rear eyepiece

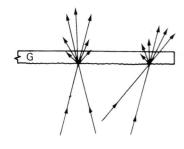

To viewer

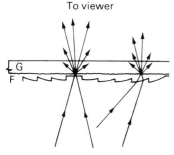

Fig. 4.28 Fresnel screen. Top: the finely grained focusing screen (G) for medium- and small-format cameras tends to give uneven illumination. Bottom: backed by a thin Fresnel lens (F), light reaching the screen edges is directed inwards, towards your eye

side – the image on screen goes upside-down. Some models have built-in exposure meters, usually located behind a semi-silvered area of the mirror. The design of TLR cameras has developed very little since the 1950s.

TLR advantages

1. A mechanically simple and therefore reliable design. The shutter is very quiet.
2. You can see the visual effect of focusing, on the full-size screen, even during the exposure itself.
3. The camera is easy to use over a wide range of viewpoints from floor level to high above your head (holding the camera upside-down).
4. Within its limitations it is a hardy, 'workhorse' camera still used by some professionals for weddings and portraiture.
5. A TLR camera costs less than a medium-format SLR with similar quality lens.

TLR disadvantages

1. Parallax error creates difficulties with close-up work.
2. The image on the screen is reversed left-to-right.
3. Although there is a depth of field scale you cannot check its *visual* appearance.
4. The camera is relatively bulky for its format.
5. Additional lenses are rare, and have to be bought in pairs.

Single-lens reflexes

The single-lens reflex (SLR) was developed to overcome most of the disadvantages of the twin-lens reflex camera. The design avoids parallax error completely, by using the same lens for both viewfinding and photography. A hinged 45° mirror reflects the image up to a horizontal focusing screen, but flips out of the way just before the (focal-plane) shutter fires. The distance between lens and focusing screen, via the mirror, equals the lens-to-film distance. So what is sharp on the screen will be sharp on the film.

On most SLRs a pentaprism above the screen corrects the image left-to-right and reflects it out through an eyepiece at the back of the camera, so you see the subject as it might be seen direct. Typically the screen shows 95–98 per cent of what will record on film – you get in minutely more than you expect. If you normally wear glasses for distant sight, or use reading glasses, buy an accessory dioptric corrector lens which fits over the camera eyepiece. This allows you to remove your glasses and bring your eye close enough to view the entire screen, yet see the image clearly.

The focusing screen itself is interchangeable. The most popular type for non-autofocus cameras has central 'crossed wedges' moulded into its surface, which shows a rangefinder-type double image of subjects not properly in focus; see Figure 4.33. A surrounding ring of microprisms breaks up an unsharp image into a shimmering dot pattern. Both focusing aids are designed to work with the lens at wide aperture; stopping down partly blacks out these areas.

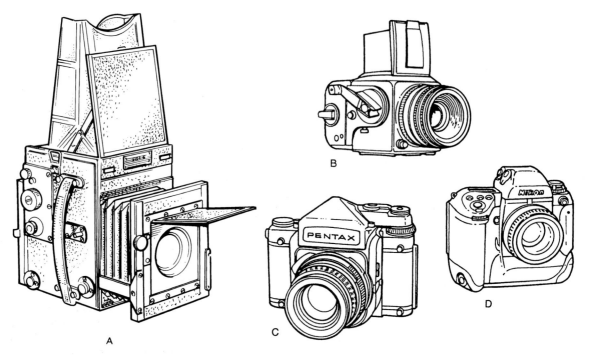

Fig. 4.29 Single-lens reflexes, all based on plate camera design (A). Modern versions use formats 6 × 6 cm (B), 6 × 7 cm (C). 35 mm SLR cameras (D) are similarly related

Fig. 4.30 Basic internal structure of a manual 35 mm SLR. E: eyepiece at rear of camera. P: pentaprism. F: focusing screen. M: hinged mirror. S: shutter (film behind). W: film wind-on mechanism. D: tensioning drum for shutter blinds. C: typical cell position behind the lens for exposure measuring

A B C D

Fig. 4.31 Main actions of SLR. A: composing and focusing. B: when release is pressed, aperture closes to pre-setting and mirror rises. C: shutter in front of film fires. D: mirror returns, aperture reopens, film winds on

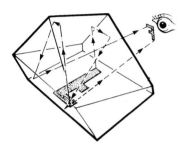

Fig. 4.32 Pentaprism. Shaped block of glass reflects light across its 'roof' so that the (laterally reversed) image on the camera's reflex focusing screen is presented to the eye as right-reading

Unsharp Focused

Fig. 4.33 Focusing aids, and camera setting LCD readout, as they are presented in the viewfinder of a manual-focus SLR. Bottom: when the image is unsharp, prisms moulded into the focusing screen (right) give subject a split and offset appearance, while a surrounding ring of microprisms forms a shimmering grid pattern

Most autofocus SLRs use a passive electronic system to detect when the image is sharp. Some of the centre part of the picture is directed down on to a charge-coupled device (CCD) sensor (Figure 4.35). With unsharp images the system also detects whether the lens should be focused towards or away from the camera body. It may respond by signalling which way you must turn the lens, alongside the focusing screen ('focus confirmation'), or more often it controls a motor within the camera body or lens which fast-shifts your focus setting by the required amount (full AF). Focus detection can be coupled to exposure release, so that you cannot shoot until the image has come into focus – useful in action photography (but sometimes a handicap too).

Exposure is read through-the-lens (TTL). The camera body contains suitably positioned light sensors which view subject brightness on the focusing screen, or else read it via light reflected off the shutter blind and film at the moment of exposure (Figure 10.17). The readings made are translated by the camera's circuitry to give semi-automatic, fully automatic, or manual exposure settings; see pages 199–201. Where light is measured off the film surface the system can control the duration of a flash unit. The flash may be built-in or an add-on 'dedicated' unit which links into the camera circuitry as described on page 207.

The focal-plane shutter, and reflex design, make this an ideal camera to use with a range of lenses of different focal length, described in Chapter 5. You can change lenses quickly; they attach with a positive bayonet-fitting twist action, and the mount also makes electrical or mechanical connections to the camera body. The focusing screen shows you every alteration given to the image by zooming or changing lenses, the use of close-up extension tubes, adjustment of special effects attachments, etc. Almost all lenses have 'preset' apertures, meaning that the lens remains wide open until just before shooting, for clarity of viewfinding and focusing. (If you need to see the appearance of depth of field you can press an aperture preview button, Figure 4.11, provided the camera offers one.) The meter reads the image at open aperture but is programmed by the *f*-number you have set on the scale.

When you press the exposure release on an SLR camera a lot of mechanical things have to happen fast. Typically the mirror rises, the lens stops down, the focal plane shutter fires, the mirror returns, the lens opens fully, and the film is transported by motor or hand wind-on.

Variations and specials

There are dozens of variations of the SLR. They range in format from APS to rollfilm (6 × 6, 6 × 4.5, 6 × 7 and 6 × 8 cm). Rollfilm types such as Hasselblad or Mamiya mostly have magazine backs and are

Fig. 4.34 Typical 35 mm SLR body-top controls. Top: basic manual focus and wind type. Bottom: autofocus and motor-wind model. R: release for shutter. S: shutter speed control. P: preview button. A: aperture setting. X: ISO setting. RW: rewind crank. C: exposure compensation dial. H: hot shoe for flash. E: eyepiece. L: wind-on lever. F: frame counter Z: power film rewind. With the automatic model, changes are made by selecting the mode or programme you need on command dial CD, and then operating electronic input dial ES. Settings produced appear on body-top display panel (D), and are also presented to your eye alongside the focusing screen

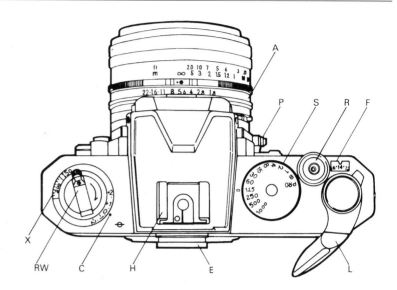

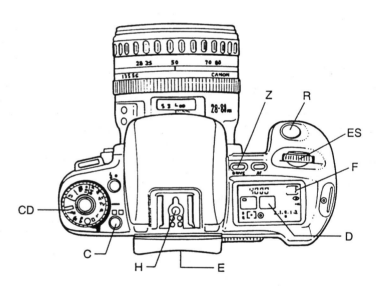

used extensively for professional photography. However, none of these cameras is as sophisticated as the latest 35 mm SLRs.

Variations and special forms of 35 mm and rollfilm SLRs come about by adding or changing units – backs, focusing screens, bodies, etc. Most systems offer a range of bodies with different degrees of automation and programming – some hidden, others with a comprehensive range of selectable modes. Frequently one model is a manual type, see above, and this is probably your best choice when first learning photography. There is also a wide range of accessories for each make of camera, thanks to the huge market for SLR designs. They allow you to tackle virtually every form of small- and medium-format photography. See Chapter 5.

SLR advantages

1. The camera gives you the ability to precisely frame up the picture, focus, and (models with preview) observe depth of field, without the slowness of a view camera.
2. 35 mm types offer you a choice of fast, accurate modes for setting correct exposure by using through-the-lens measurement of subject lighting (including flash).
3. Key information such as correct exposure and focus, shutter speed and *f*-number, are signalled direct to your eye from alongside the focusing screen.
4. There is a vast back-up range of lenses and accessories. This makes SLR outfits versatile 'unit systems' – able to tackle most photography well.
5. Magazine loading on some models speeds up film changing.
6. Fully AF models adjust the lens faster than you can focus it by hand. And they work with a range of lenses.

SLR disadvantages

1. You cannot see through the viewfinder whilst exposure is taking place. This can be a nuisance during long exposures or when panning at slow shutter speeds; see page 150.
2. When you are viewing at open aperture (having set a small aperture) it is easy to forget the changes that increased depth of field will give to your picture.
3. The camera is electronically and mechanically more complex (and noisy) than other designs. Relative to a compact it is heavier and tends to be more complicated to use. Most SLRs also rely on battery power to function.
4. Few camera movements are possible. (But see shift lenses, page 98, and bellows accessories, page 89.)
5. The range of speed settings available for use with flash is limited (unless your flash gun provides a long peak).
6. Use of passive autofocus sharpness detection relies on sufficient ambient light and subject contrast. And some systems fail to work when a linear polarising filter is over the lens (see page 180).

Fig. 4.35 SLR autofocus. The system below samples some of the lens-focused light passed through a hole in the mirror. Below aperture F (the same distance from the lens as the film) a pair of separator lenses bring the beam to two points of focus on a CCD sensor (S). See right. The sensor's 128 segments detect the relative spacing of the two points of light, and control motor (M) to adjust camera lens position. System works with a range of interchangeable lenses

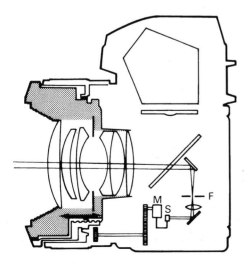

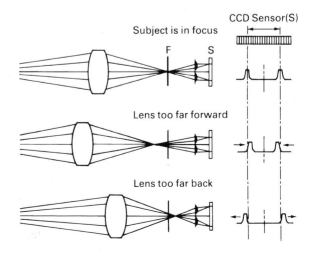

Summary: Cameras

● No one camera is the perfect tool for every job. You will probably need at least two cameras, complementing each other in format or design features.

● All cameras using a separate lens for viewfinding suffer from parallax error. Even if there is parallax correction of framing, viewpoint difference upsets critical subject alignments.

● A coupled rangefinder allows accurate auto or manual focusing of subjects down to about one metre. But where you have access to the camera lens image – on SLR and view cameras – you combine focus, framing, and visual check of depth of field, whatever lens is fitted.

● A focal-plane shutter works with all lenses, permits lens change in mid-film, and allows reflex image viewing. But it may not suit flash used at its fastest speeds. The larger the camera the more these FP flash limits apply (and the noisier the shutter sounds).

● Electronically timed shutters give greatest setting range, and link in with other electronics. But without battery power they are severely restricted or fail.

● Magazine backs (35 mm or rollfilm), an additional 35 mm body, or separate filmholders (sheet film cameras) all enable you to shoot a subject on more than one type of film.

● TTL metering systems read light from inside the camera, and work with all lenses and attachments. Some cameras have a simple measuring cell facing the subject direct. You need a hand meter for cameras without built-in exposure reading.

● The larger your camera format, the better the final image detail and gradation, the less the depth of field, and the more movements that may be available. Smaller-format cameras are less obtrusive, more flexible, have 'faster' lenses and allow rapid sequences to be shot.

● Format proportions – rectangular or square – affect the way you compose pictures.

● View cameras, basically simple, offer camera movements and large-format composition, focusing, and depth of field check. But cameras are bulky and slow to use, need a stand, and give a dim, upside-down image. They are a good choice for architecture and still life because of movements and have features that encourage very considered compositions.

● Compacts, all-in-one cameras, offer complete exposure and focus (AE and AF) automation and can be brought into use quickly. Their direct viewfinding system is bright, but has parallax inaccuracies and cannot show depth of field. The built-in lens and on-camera flash tend to give fixed results. A few models offer interchangeable lenses, or larger formats. Good for candids because of speed and quietness.

● Twin-lens reflexes allow full-format image focusing and composition, up to and during exposure. Mechanically simple and quiet, most give square pictures. But the finder shows images reversed left-to-right, suffers parallax error and normally cannot show depth of field. They are also bulky relative to their format.

● Single-lens reflexes provide critical focusing, framing and (if pentaprism) correct-way-round composition. Most 35 mm types offer multi-option TTL exposure automation, plus autofocus and autowind. Cameras are backed up by an extensive range of lenses and accessories.

● SLR cameras lose the viewfinder picture during exposure, and there are restrictions on flash shutter speeds and camera movements. But they tackle most subjects well, within limits of format size.

● Remember, a camera is only a means to an end. Don't become so absorbed in the various models that photography becomes camera collecting. They are only tools to make photographs – learn to use them thoroughly, then concentrate on the photography.

Projects

1. Organise for yourself 'hands on' experience of each of the four camera types described. Try to handle both monorail and baseboard view cameras, and the Leica direct viewfinder camera. Compare practical features such as weight and balance (hand-held cameras) and the ease of working fingertip controls. Do you feel at home with their format proportions, the clarity of focusing and ability to frame-up shots? Check prices, not only of the camera itself but of the extra lenses and accessories you will eventually need, and the film processing and enlarger equipment necessary for this format in the darkroom. (Read Chapter 6 when evaluating view cameras. Similarly Chapters 5 and 10 relate directly to SLR systems.)

2. Decide the best *pair* of cameras together able to cover the widest range of work you expect to do. They are likely to complement rather than repeat each other's features, but don't leave gaps – tasks that neither camera can really tackle.

3. For ultimate difference in camera handling try landscape photography using (a) a 4 × 5 in view camera and (b) a 35 mm compact. Compare a contact print from (a) with an equal-size enlargement from (b), then enlarge each to 16 × 20 in.

4. Make a comprehensive list of the technical features you consider (1) essential, (2) useful but additional, and (3) unnecessary, in a 35 mm SLR camera. Obtain brochures on two or three competing models (similar price range) and compare them for each item on your list.

5. Check your ability to guess distances visually, so you can pre-focus your (non-AF) hand camera and so avoid wasting time when shooting candids. Estimate your distance from a subject, then check by physical measurement or by focusing a (reflex) camera and checking off the distance scale. Memorise the amount of an average figure – head, head and shoulders, or half-length – your lens causes to just fill the frame at particular distances.

6. Rate the four main types of camera described in this chapter in terms of their suitability and convenience for: sport and action, studio portraiture, architecture, general 'snapshots' (in inexperienced hands), candids, close-ups, landscapes, night shots, studio still-life.

5
Extra lenses, camera kits

The camera itself is only part of the 'tool box' you need for taking photographs. If your camera allows you to interchange lenses you will want extra lenses with different focal lengths. This means thoroughly understanding what wide-angle, telephoto, and zoom types offer for practical picture making. Each of these lenses has its own character- istics, special advantages, and limitations. You should also pick from the hundreds of accessories – stands, close-up gear, motor drives, meters, flash units, bags, etc. – to build up a sensible working outfit for your kind of photography.

Why change lenses?

Cameras so far discussed have all had standard focal length lenses – typically 50 mm, 105 mm and 180 mm, for 24 × 36 mm (35 mm), 6 × 7 cm and 4 × 5 in formats respectively. As Figure 3.5 showed, each of these combinations gives an angle of view (or 'field of view') of about 45°.

To understand why 45° is considered normal, try looking through a 35 mm SLR fitted with a standard lens, holding the camera in upright format and *keeping both eyes open*. Compare picture detail on the focusing screen with the subject seen direct. Your naked eye sees a great deal more of your surroundings, of course. But within the area imaged by the standard lens and isolated by the picture format the relative sizes of things at different distances match normal eyesight.

If you keep to the same format camera but change to a lens of longer or shorter focal length you can:

1. Alter angle of view (enlarge or reduce image detail and so get less or more subject in).
2. Disguise how far or how close you are from the subject and so suppress or exaggerate perspective in your picture.

Each of these changes needs looking at in more detail.

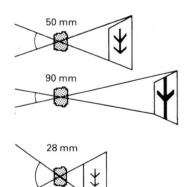

Fig. 5.1 Changing focal length while keeping the same picture format alters the combination's angle of view. Compare this with Figure 3.5

Enlargement of centre of 28 mm shot

135 mm

50 mm

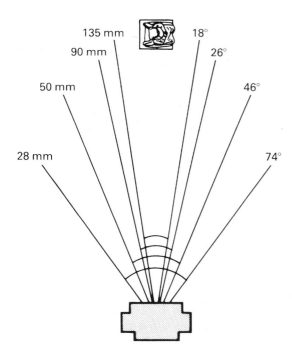

135 mm 18°
90 mm 26°
50 mm 46°
28 mm 74°

28 mm

Fig. 5.2 Above: angles of view given by some lenses of different focal lengths (35 mm format). Right: differences in the amount included by three such lenses at identical subject distance. Top left: enlarging part of the 28 mm lens image proves that lens change alters magnification, but not perspective. All shots were taken at the same aperture. Note the 28 mm blow-up has greater depth of field, but enlarged grain gives poorer detail than sharply imaged parts of the 135 mm lens version

Including less, or more, subject

Changing the lens in your camera to one with a longer focal length makes the image detail bigger – you no longer include as much of the scene and the angle of view becomes narrower (Figure 5.1). At first sight you seem closer to your subject but this is only an illusion due to magnification; see Figure 5.2. Creating larger detail is helpful if you cannot get close enough to your subject – for example in sports and natural-history work, candids and architectural detail.

Any slight camera movement is also magnified, so if you are using the camera hand-held, change to a faster shutter speed to avoid blur.

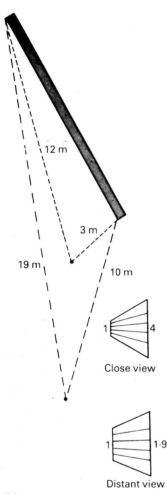

Fig. 5.3 Viewpoint and perspective relationship. Apparent convergence of horizontal lines in this oblique wall grows less steep as the viewer's distance increases. See text

Other changes include less depth of field for the same *f*-number, and greater physical lens movement needed for focusing. The angle of view is inversely proportional to the focal length. For example, a 100 mm lens gives half the angle and twice the image magnification of a 50 mm lens, assuming distant subjects.

Changing to a 'wide-angle' lens (shorter focal length) gives all the opposite effects. You include more scene, especially foreground and surroundings, everything is imaged smaller, there is greater depth of field, and less physical focus movement is required. A wide-angle lens is an important aid for cramped locations, especially building interiors where a standard lens never seems to show enough. Similarly, you can shoot views, groups, or any large subject where it is impossible to get back far enough to include everything.

Remember that the lens must be *designed* as a wide-angle. It is no good taking a standard 50 mm lens from a 35 mm format camera and trying to use it as a wide-angle in a 6 × 7 cm camera, because it will not cover this larger format – the picture will probably darken at the corners (Figure 3.6).

Altering perspective

By changing focal length together with your *distance from the subject* you exert a powerful influence on the perspective of your pictures. Perspective itself is concerned with the way objects at different distances appear to relate in size, and how parallel lines on oblique surfaces apparently converge towards some far-off point – all of which gives a strong sense of depth and distance in two-dimensional pictures of three-dimensional scenes.

As Figure 5.3 shows, if you look obliquely at a garden wall of uniform height you see the nearest end much taller than the far end. The difference between these two 'heights' is in direct ratio to their distances from you, so if the near end is 3 metres away and the far end 12 metres, ratio in height is 4:1. But move back until you are 10 metres from the near end and the far end will be 19 metres (10 m + 9 m) away. The ratio becomes only 1.9:1, and the wall's visual perspective is less steep.

Perspective therefore changes according to the distance of your viewpoint from the subject. But if you have lenses of different focal lengths you can vary your distance and then disguise this viewpoint change by using another lens to include the same amount of subject. Imagine taking one photograph of the oblique wall using a 50 mm lens, 3 metres from its near end. If you then stepped back to 6 metres and took another shot using a 100 mm lens instead, the wall's near end would record the same size but have a less diminished far end, giving flatter perspective and therefore less apparent depth.

You can use *steep perspective* (close viewpoint, wide-angle lens) whenever you want to exaggerate distance, caricature a face into a big nose and tiny ears, or dramatically emphasise some foreground item such as an aggressive fist by exaggerating its relative size. Similarly use it to create a dynamic angle shot looking up at a building and exaggerating its height.

Use *flattened perspective* (distant viewpoint, long focal length lens) to compress space, to make a series of items one behind the other appear 'stacked up', adding a claustrophobic effect to a traffic jam or a

Fig. 5.4 Altering distance and focal length. Each picture was taken with a lens of different focal length (35 mm format), but the camera distance was altered each time so that the near end of the monument remained about the same height

28 mm

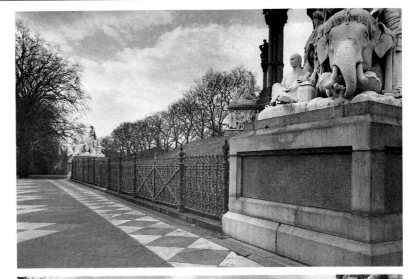

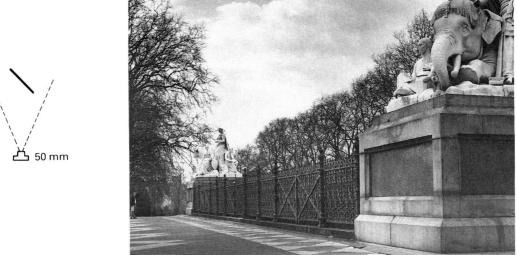

50 mm

135 mm

crowd. In landscapes it helps to make background features dominate over the middle distance, or merges both into flat pattern. Portraits tend to be more flattering, with nose and ears shown in proportions closer to true size.

These controls over perspective are very valuable to you as an image maker – as important as depth of field. Use them to help make the point of your picture. But if overdone (the two extremes of focal length giving either telescope or fishbowl effects) they easily become gimmicks which overwhelm your subject matter.

The final appearance of perspective also depends on the finished picture size and the distance from which you view it. Strictly speaking, the image appears natural in scale and perspective if your ratio of *picture width to spectator viewing distance* matches the ratio of *subject width to camera distance* when the shot was taken. For example, if something 4 metres wide is photographed from 8 metres (ratio 1:2) the print or projected slide will look normal seen from a distance twice its width. This might be a 12.5 cm wide print viewed from 25 cm, or a 50 cm print viewed from 100 cm. In practice you tend to look at all hand-size prints from a 'comfortable' reading distance of about

Fig. 5.5 Walker Evans' choice of a long focal length lens and distant viewpoint made these industrial chimneys of Bethlehem, Pennsylvania, dominate over workers' graveyard. Technique strengthens a powerful human statement

Fig. 5.6 A claustrophobic view of New York from the top of the Empire State Building using a 35 mm camera with 150 mm lens. The flattened perspective gives a stacked-up, pattern effect

Fig. 5.7 Using a wide-angle (24 mm) lens here allowed all six benches to be included and exaggerated the shadowy foreground. The resulting picture relies on pattern

Fig. 5.8 Exaggerated scale gives dramatic emphasis. Shot from a viewpoint close to the fist, using a 35 mm camera with 28 mm wide-angle lens, at wide aperture

25–30 cm, which usually works out right for a natural perspective effect from normal-angle lens photography. But reading wide-angle close shots and long-focal-length distant shots from the same viewing position gives an impression of steepened or flattened perspective.

Artists traditionally draw or paint portraits with flattened perspective for naturalistic results when they know the work will be viewed from a distance, for example high up in a gallery or church. Bear this in mind when planning an exhibition. If you want to exaggerate the illusion of compressed space and flattened perspective, print long-focal-length (narrow-angle) shots big, and hang them in enclosed areas where the viewer has to stand close. See Chapter 14.

Lens changing in practice

On view cameras the lenses are changed complete with panels. When you fit a wide-angle, the lens has to be quite close to the focusing screen to give a sharp image. This may mean changing to a recessed

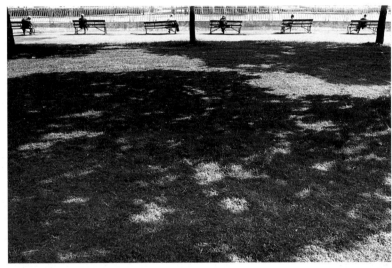

lens panel, or removing the regular bellows from a monorail and using shorter 'bag bellows' instead (Figure 5.9). You must be careful not to let the front of the rail (or the front track on a baseboard camera) be included in the lens's wide angle of view.

The greatest variety of interchangeable lenses today are made for single-lens reflexes, especially 35 mm format; see Figure 5.10. Originally their range was very restricted by the need for wide-angles to be placed close to the film (where they fouled mirror movement), and the awkward physical length of long focal length lenses. This is now solved by making long-focus lenses of *telephoto* construction and wide-angles of *inverted telephoto* construction. As Figure 5.11 shows schematically, a telephoto has weak diverging elements at the back which give it a longer effective focal length (and corresponding image size) than the physical distance from the back lens surface to the film would suggest. In fact this distance is often less than half the focal length. An inverted-telephoto wide-angle, on the other hand, has weak

Fig. 5.9 Near right: using a wide-angle lens with a view camera, you may include the front part of the rail or baseboard in your picture (only apparent when stopped down). Far right: arrange that the monorail projects behind rather than in front, or use a drop baseboard. To focus the lens close enough to the film, change the monorail to compact bag bellows, or fit a recessed lens panel

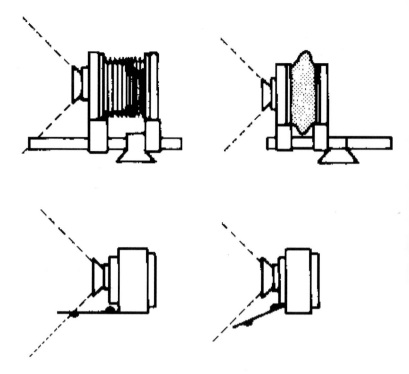

negative elements at the front, still giving a short effective focal length but allowing more than this distance between lens and film.

Most small- and medium-format wide-angle optics today are of inverted-telephoto design, and virtually all long focal lengths intended as narrow-angle lenses are telephotos. This is why we tend to use the word 'telephoto' to mean the same as long focus. But don't confuse the two – they may differ greatly in coverage. A 210 mm telephoto for 35 mm would not cover 4 × 5 in fully, whereas a 210 mm designed for the large format would be fine.

Fig. 5.10 Angle of view (nominal) given by different combinations of focal length and format diagonal. Lenses must also fully cover the picture format – you may be able to use a lens on a camera that is smaller, Figure 5.16, but not larger in size

When you change focal lengths on an SLR, then, the distance between the back of the lens and the film may be remarkably little different from your standard lens – at least with lenses with focal lengths between about 28 mm and 100 mm. Each SLR lens has a bayonet mount suiting a particular brand of body. So you cannot fit lenses from a Nikon to an Olympus body, and so on. Each maker also has different (patented) mechanical and electrical couplings between

	Wide-angle							'Normal'		Long focal length								
	100°	94°	90°	80°	74°	62°	56°	**50°**	**46°**	28°	24°	21°	18°	14°	12°	8.5°	6°	2.5°
35 mm ▶	18	20	21	25	28	35	40	**45**	**50**	85	100	120	135	180	210	300	400	1000 mm
6 × 6 cm ▶			38	45	54	65	70	**80**	**93**	150	185	220	240 mm					
6 × 7 cm ▶			45	50	60	70	80	**90**	**105**	165	210	240	270 mm					
5 × 4 in ▶			75	90	105	130	140	**165**	**180**	300	370 mm							
10 × 8 in ▶					210	265	285	**330**	**360**	600	740 mm							

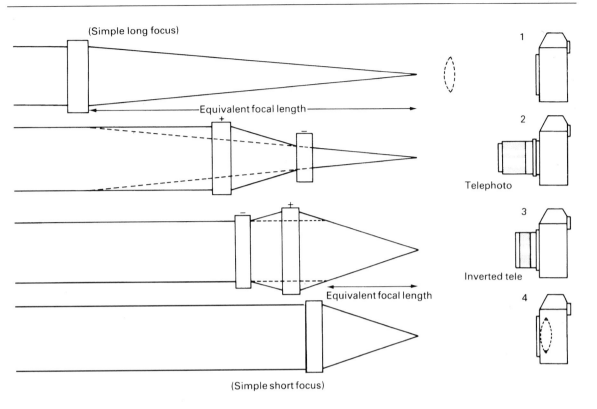

(Simple long focus)

Equivalent focal length

1

Telephoto 2

Inverted tele 3

4

(Simple short focus)

Fig. 5.11 Telephoto and inverted telephoto designs solve camera design space problems. Telephoto construction allows the rear glass of the lens to be relatively close to the film (2). The resulting, less protruding, lens gives images identical to a long focal length lens (1) positioned normally much further forward. Inverted telephoto design (3) allows more space between a wide-angle lens and the film than its short focal length would otherwise permit (4)

body and lens to convey information about the aperture set, to control autofocus, etc. Occasionally, when a maker develops a new body, lens mounts are changed – but this is done as rarely as possible to keep faith with previous purchasers of their lenses.

Independent lens makers produce optics to fit a range of cameras; you specify the type of body and the lens comes fitted with the appropriate coupling. The quality of the independent lenses varies more than lenses supplied by the camera manufacturer. The latter have to reach a minimum optical standard common to an entire range. The best independent brands are consistently good too, but the cheapest undergo less rigid quality control and may be anything from quite good to poor.

Lens kits

There is no doubt that standard lenses (normal focal length) represent best value for money. Made in large quantities, they tend to be cheaper and have wider maximum apertures than wide-angles and longer focal length lenses. If you often photograph architectural interiors and exteriors or need to use dramatic angles and steep perspective, the next lens to buy after a standard is a wide-angle. As Figure 5.13 shows, the most popular wide-angle, giving about 70–80°, is 28 mm for 35 mm format (40 mm for 6 × 6 cm, or 90 mm for 4 × 5 in). Using lenses wider than 80° (24 mm focal length on a 35 mm camera) begins to introduce 'wide-angle distortion', making objects near corners and furthest edges of your picture appear noticeably elongated and stretched. It is like having additionally steep perspective in these zones,

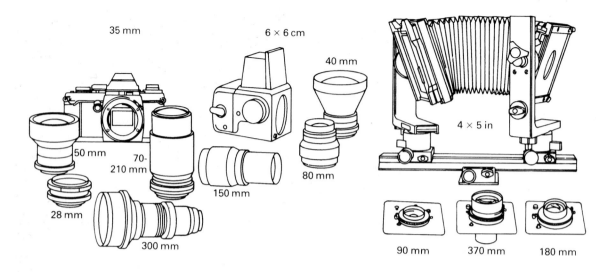

35 mm 6 × 6 cm 40 mm 4 × 5 in

50 mm 70-210 mm 80 mm 150 mm

28 mm 300 mm 90 mm 370 mm 180 mm

Fig. 5.12 Some camera-body/lens kits. Each include normal, wide-angle and long focal length types designed for the format

Fig. 5.13 Extreme wide angle (16 mm on 35 mm camera) gives unacceptable distortion with a subject of known shape, unless you want a special effect. However, viewing this page from 3.3 cm would make picture perspective appear normal

although you can help to disguise the effect by composing plain areas of sky, ground or shadow here. Geometric shape distortion and uneven illumination tend to be most noticeable with wide-angle lenses for large formats; not being of inverted telephoto design they are positioned close to the film centre and so project a very oblique image into the corners.

Another feature of a wide-angle lens is that it gives greater depth of field than a standard lens at the same aperture. This can be an advantage, but also makes it more difficult to pick out items by differential focus. Extreme wide-angles virtually need no focus adjustment and record everything in focus – from a few inches to infinity. Also they may no longer accurately image vertical and horizontal lines near picture edges as straight, becoming 'fisheye' lenses.

Perhaps you will choose a telephoto instead of, or as well as, a wide-angle. A moderately long focal length, such as 100 mm on 35 mm format (24°) makes a good portrait lens. It will allow you to fill the frame with a face from a distance of about 1.5 metres, which avoids steep perspective and a dominating camera presence. Longer lenses will be needed for natural history subjects, sports activities, etc., which you cannot approach closely, or any scene you want to shoot from a distance in order to appear intentionally with bunched-up, depth-flattened form.

Working in the studio on still lifes, most users of 4 × 5 in cameras prefer lenses between 180 mm and 370 mm which, for this format, are again moderately long focal length. With food shots, for example, such a lens allows the camera to be kept back from the subject, avoiding any suggestion of elliptical distortion of plates, tops of wine glasses, etc.

In general, lenses with angles of view of less than 180° begin to make you conscious of 'unnatural' scale relationships between nearest and farthest picture contents. This is more like looking through a telescope than seeing the scene direct. The longer the focal length, too, the more difficult it is to get sufficient depth of field and avoid camera shake when using the lens hand-held. Focusing is also very critical. Your image contrast is frequently lower than with a standard lens,

Fig. 5.14 Inside a British telephone box, taken with an 8 mm fisheye. Lens gives a circular picture with vertical and horizontal lines increasingly bowed according to their distance from the centre

Fig. 5.15 Extreme long focal length lens (800 mm on 35 mm camera) picks out distant bus as a strangely flattened shape. The furthest end of the vehicle appears taller than its nearest part – an optical illusion due to minimal perspective

Fig. 5.16 A 'step-down' system. This 6 × 6 cm body (only) is mounted on an adaptor plate in place of the focusing screen of a 5 × 4 in monorail. Although restricted to lenses of relatively long focal lengths, camera movements are made possible

especially in landscape work where atmospheric conditions over great distances also take their toll. Image definition is easily upset in pictures taken through window glass or scratched filters, or when there are any marks on the lens surfaces.

Extreme telephotos (beyond 500 mm) may be so long physically that you mount *the lens* on a tripod, with the camera attached. One way to reduce length and weight with such lenses is to design them with mirrors, so that the light path is 'folded up' (see *Advanced Photography*).

Wide-angle and telephoto *convertor* attachments are available for some SLR lenses. A wide-angle device fits over the front of the prime lens and typically reduces focal length by 40 per cent. A tele attachment fits between lens and body and typically doubles the focal length. Provided the tele attachment is a multi-element unit designed for your particular lens, image quality will be maintained. The combination has its aperture reduced by two *f*-number settings if focal length is doubled. Wide-angle attachments are more prone to upset your image definition near picture edges – you should always use them well stopped down.

Remember too that you can sometimes fit a 'step-down' adaptor to make use of a large-format lens as a medium- or small-format long-focus lens. For example, a 180 mm standard lens from a 4 × 5 in camera can become a portrait lens on a 6 × 6 cm body.

Zooms or sets?

A zoom is a lens of *variable* focal length – altered by shifting internal glass elements. It is built into many modern compact cameras, but for 35 mm SLR cameras especially you can decide between a chosen set of lenses of fixed focal length, or have one (or perhaps more) zoom lenses. The control for changing focal length is usually a sleeve on the lens

Fig. 5.17 A 'one-touch' 70–210 mm zoom lens. The increase in depth of field as focal length is shortened is shown by lines on the lens barrel (below)

Focus

Zoom

barrel that you slide forwards and backwards. Turning the same sleeve focuses the lens ('one-touch' zooms). A zoom lens fitted to a compact camera is altered by a control on the body. This also adjusts optics within the viewfinder to match the changing angle of view.

Good quality zooms are optically complex – the focused subject distance must not change when you alter focal length, and the diaphragm must widen or narrow to keep the *f*-number constant. Also aberration corrections must adjust to maintain acceptable image quality throughout the entire range of subject distances and focal lengths. The best-quality zooms give image quality as good as fixed-focal-length lenses. Limits to their aberration correction at the extremes of zoom range typically appear when straight lines near frame edges begin to bow inwards or outwards. As Figure 5.19 shows, lenses with greatest zooming range occur in the standard-to-telephoto (50–300 mm) category. But you can also buy wide-angle zooms such as 24–50 mm, or tele-zooms 200–600 mm. Perhaps most useful of all are zooms which extend from moderate wide-angle to medium telephoto such as 28–135 mm.

The practical *advantages* of a zoom are:

1. Continuous change of image size possible within the limits of its zoom range – equivalent to far more than just two or three fixed-focal-length lenses.

70 mm

210 mm

70–210 mm

Fig. 5.18 (Top) the results at extremes of focal-length change, and (bottom) when zooming the lens throughout a $\frac{1}{2}$ second exposure

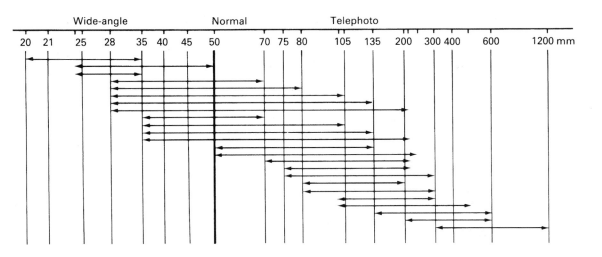

Fig. 5.19 The focal-length range of some zoom lenses designed for 35 mm format

2. Ability to frame up action shots, candids, and sports pictures where things can happen unexpectedly and you may be too far away or too close with any regular lens.
3. No risk of losing a picture because you were changing lenses at the decisive moment.
4. Fewer items to carry.
5. Ability to zoom (or change image size in steps) during actual exposure, for special effects.
6. On most zooms, the 'macro mode' facility for ultra-close work, see page 91.

A zoom's *disadvantages* are:

1. Widest aperture is about $1-1\frac{1}{2}$ stops smaller than a typical fixed focal length lens.
2. It is bigger and more expensive than any one fixed lens within its range.
3. The continuous focusing scale does not usually go down to close subject distances.
4. Some cheaper types give poorer image contrast and definition, and distort shapes when used at the maximum limits of their range.
5. Zooms can make you lazy about using perspective well. It is tempting to just fill up the frame from wherever you happen to be. Instead, consciously try to choose a viewpoint distance to make use of juxtapositions and steep or flattened perspective, *then* adjust focal length to include just the area you want.

Even high quality zooms may change their *maximum* aperture between the extremes of zoom range, for example giving half or one stop less light at the longest focal length setting (maximum aperture is then engraved *f*/3.5/4.5, or similar). This is unimportant provided you are using a through-the-lens meter, but remember to allow for it if you are shooting at the lens's widest settable aperture and working with a separate meter, or a non-dedicated flashgun (page 206).

Depth of field always changes throughout the range, unless you compensate by altering *f*-number. It is greatest at shortest focal length,

so whenever possible focus your zoom at the longest focal length
setting, making critical sharpness easy to see – then change to whatever
focal length you need.

Everyone's lens requirements vary. Often the most versatile focal
lengths, shown in Figure 5.11, are between about 24 mm and 250 mm
for 35 mm format; between 45 mm and 270 mm for 6 × 7 cm; between
90 mm and 370 mm for 4 × 5 in cameras. You may cover this ground
with a kit of three or four fixed focal lengths, or (for a 35 mm SLR)
either two zooms, or two zooms plus a standard lens. These could, for
example, be 24–50 mm and 50–250 mm; or more compact 24–35 mm
and 70–210 mm zooms, plus a 50 mm with its bonus of a maximum
aperture two or three stops wider. Alternatively just keep a 35–70 mm
lens on the camera, or a 28–210 mm provided you accept its extra bulk
and weight. Other lenses worth considering for a small- or medium-
format camera kit are a shift lens (page 98) and a macro lens (see
below).

It is seldom economic buying lenses of extreme focal length; for
example an *f*/4 600 mm lens costs over thirty times the same maker's
50 mm standard lens! Instead it is possible to hire them for unusual
jobs. Sometimes you may choose optical distortion and unnatural
perspective as an essential element in a picture, but for most work such
devices are a distraction, and become monotonous with overuse. You
will often do better by moving either closer or farther back, and using
more normal optics.

Close-up equipment

Fig. 5.20 Bellows extension for
close-ups. A: view camera and
distant subject. B: imaging the
subject life-size requires bellows
twice the lens focal length. C: the
same lens needs two sets of these
bellows and extension rail, to
image the subject × 3

The closest you can approach a subject and still focus a sharp image
depends on how far the lens can be spaced from the film *relative to its
focal length*. Typically a 35 mm camera with standard 50 mm lens
focused out to its closest subject distance gives an image about one-
tenth life size. This can also be written as a ratio of 1:10, or
magnification of × 0.1, and means that a subject 10 cm high is imaged
1 cm high on film.

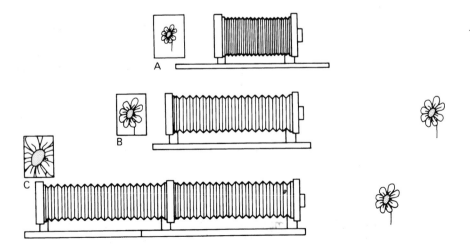

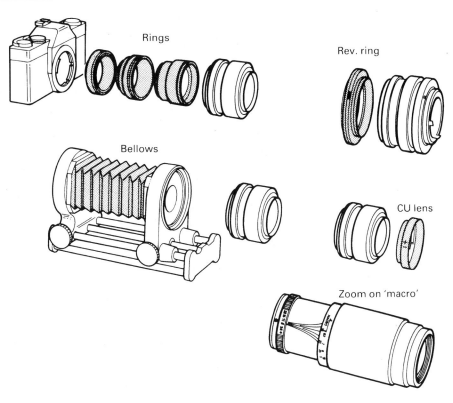

Rings

Rev. ring

Bellows

CU lens

Zoom on 'macro'

Fig. 5.21 35 mm close-up
equipment

Most 5 × 4 in monorail view cameras have bellows which will
stretch to at least 36 cm. Used with its standard (180 mm) lens, this
allows you to approach still closer, giving an image up to life-size – a
ratio of 1:1 or magnification of × 1. If you use a shorter-focal-length
lens this same bellows extension will allow you to work even closer and
image at still greater magnification. See formulae on page 289. You can
take this further by changing to extra-long bellows, or adding two sets
of regular bellows together (Figure 5.20).

To shoot close-ups using a small- or medium-format camera you can
expect to need some extra equipment (Figure 5.21). There are various
options:

1. Adding bellows, or extension rings, between camera body and
 lens.
2. Using a reversing ring to remount your regular lens back-to-front.
3. Changing to a 'macro' lens with its own built-in, extra-long focusing
 movement.
4. Using a zoom lens set to 'macro'.
5. Fitting an accessory close-up lens or adaptor over the front of your
 standard lens.

Of these only option 5 is practical on TLR cameras or any camera
without interchangeable lenses.

Bellows or rings

Bellows allow you maximum flexibility in focusing close subjects,
although at *minimum* extension their bulk often prevents you getting a

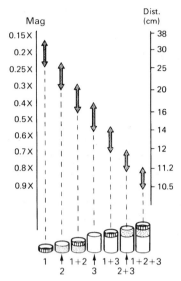

Fig. 5.22 A set of three extension rings can be used in seven different combinations. Added to the normal focusing adjustment of the 50 mm camera lens, these give an overlapping sequence of sharply focused subject distances, from 38 cm (nearest focusing for the lens used alone) down to 10.5 cm

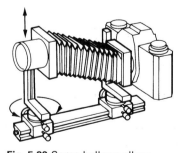

Fig. 5.23 Some bellows allow camera movements, too. But this off-centre use of the lens is often only possible when racked out to focus close objects, otherwise most lenses produce cut-off

sharp image of anything beyond about 30 cm. Rings or tubes are cheaper than bellows, and come in sets of three (typically 7, 14 and 25 mm for small-format cameras). These can make up seven alternative lengths, used singly or in combinations. Together with your lens's own focusing adjustment, each gives you an overlapping range of distances so you can achieve some continuity of focusing; see Figure 5.22.

Simplest bellows and tubes are 'non-automatic', meaning that the preset aperture of the camera lens no longer remains wide open until the moment of shooting. So you must be prepared to compose a dim image every time a small aperture is set. 'Automatic' extension units maintain a mechanical link between lens and body, so that the SLR aperture system still functions normally.

In all instances, your camera's through-the-lens meter still gives an accurate exposure reading. However, with options 1–4 above, if you are using any *other* form of metering (such as a hand meter) the exposure shown must be increased to compensate for the effect of the unusual lens-film distance; see page 195.

Some 35 mm format bellows units are built like miniature monorail units, see Figure 5.23. These allow a wide range of camera movements (Chapter 6) to manipulate depth of field and image shape, but only when working close up. For most movements you must use a lens with generous covering power.

Reversing ring

A reversing ring simply allows you to mount your camera lens back-to-front. This gives you three advantages at minimal cost:

1. The lens becomes spaced farther forward from the film.
2. Since most SLR normal and wide-angle lenses are inverted telephotos the effective focal length is shorter when reversed, giving greater magnification at the same extension.
3. It gives better definition, since the subject-to-lens distance (normally long) and lens-to-film distance (normally short) are largely exchanged when you work very close up.

Against this:

1. Your aperture presetting no longer functions.
2. With most lenses the focusing ring will not work, so you can focus only by shifting the whole camera backwards or forwards.
3. Aperture scales, etc., read upside-down. And the back (now front) end of the lens really needs a hood to give it physical protection.

Macro lens

Macro lenses are designed for close-up purposes, with maximum correction of optical aberrations when subject and image distances are similar. (The word 'photomacrography' refers to imaging at about 1:1 scale.) They cost more than regular lenses, have a smaller aperture, and also stop down further. Typical focal length, for 35 mm format, is either 50 mm or 100 mm, with an *f* range 4–32.

The focusing movement on a general macro lens takes it continuously from infinity setting to 1:1 ratio or beyond. This range, plus its aperture preset facility, makes it very convenient to use. Such macro

lenses give acceptable results with distant subjects, but for close-ups offer better definition than when a normal lens is used in conjunction with bellows or rings. For critical scientific work some manufacturers offer 'true' macro lenses, designed and corrected for specific magnifications, and intended for use only under a narrow range of conditions.

Macro zooms

Most zoom lenses, when set to shortest focal length, allow you to select a 'macro' setting. This repositions internal elements with optical results similar to reversing the lens. Your zoom control then becomes the focusing control, and you can sharply image subjects within a narrow range of close distances. Typical magnification ratios are around 1:4. Some cheap zooms give quite poor quality close-ups, with image softening towards corners of the frame.

Close-up lens

If you attach a converging 'close-up lens' over the front of your standard lens its focal length is changed. Or, to put it another way, the combination allows you to focus on a subject at a distance equal to the attachment's focal length, when the prime camera lens is set for infinity. Attachments are usually calibrated in dioptres such as + 1, + 2, etc. The higher the dioptre the greater the magnification, and the shorter its focal length.

Adding a close-up lens means you can work *without* having to extend the normal lens-film distance, or alter exposure. They therefore suit fixed-lens compacts and TLR cameras, as well as SLRs. Separate viewfinder cameras of course suffer extreme parallax problems working so close in. You can buy attachments for some compacts which combine the close-up lens with prismatic windows to adjust your viewfinder angle, and also make the autofocus system set the prime camera lens for infinity. With a TLR you can focus and compose with a close-up lens over the upper lens, then change it to the taking lens, and raise the camera by an amount equivalent to the distance between viewing and taking lens.

Essentials, and extras

Choosing other accessories for your camera kit is mostly a matter of personal selection. Build them up from essentials – for example, a cable release and a tripod (with a pan and tilt top) are vital for a view camera, and needed sooner or later for every other camera type. Match the tripod to the camera's size and weight, and don't overlook the value of a small table tripod or clamp fitted with a ball and socket head. One of these will pack easily into a shoulder bag. For support in action photography – especially when you use a telephoto lens – try out a monopod, or a pistol grip or rifle-butt camera support. These are all more portable and less obtrusive than a tripod.

If your camera has no built-in exposure meter you must have a hand meter, or an add-on unit (such as a probe system for a view camera); see page 201. You will also need filters for black and white and colour

Fig. 5.24 A selection of accessories. 1 and 2: rifle stock and pistol grip hand-held camera supports. 3: pocket tripod. 4: focusing screen viewing hood, replaces pentaprism on some models, for waist-level shooting. 5: eyepiece cup. 6: right-angle eyepiece. 7: cable release. 8: tripod carrying pan/tilt head, and monopod. 9: bulk 35 mm film back. 10: Polaroid back for 6 × 6 cm. 11: changing bag. 12: flashgun. 13: travelling case for view camera kit. 14: aluminium, foam-filled, general camera case. 15: compartmented shoulder bag

photography (Chapter 9), plus some form of filter holder to suit the front diameter of your set of camera lenses. The holder can form part of a lens hood (Figure 5.25), an accessory always worth fitting to reduce flare when your subject is lit from the side or rear. It can also protect your lens. However, be sure that the hood is not so deep that it protrudes into the field of view. Check that corners of the frame do not darken when the lens is focused for infinity, fully stopped down and (if it is a zoom) set to shortest focal length. Most telephotos have built-in 'slide out' hoods, and extreme wide-angles incorporate shading flanges at top, bottom and sides. You cannot safely add to these devices unless you are shooting close-up (the extreme extension then narrows the field of view).

You will probably need a portable flashgun for use on location. This might be a powerful 'hammer-head' type sufficient to light fairly large industrial and architectural subjects, or a smaller dedicated gun which mounts on the camera for 'fill-in' and general flash work. Both should be capable of swivelling, and bouncing light, and allow the 'adding on' of additional heads. It is important to check out the flashgun's guide number and recycling time (page 205). See also studio flash, Chapter 7.

There are several worthwhile accessories for viewfinding and focusing. An SLR viewfinder eyecup helps to prevent reflections and

Fig. 5.25 Lens hoods. A: push-on hood in rubber. B: bellows unit-length can be adjusted to remain just outside the field of view of the lens in use. C: narrow-angle lenses often have their own pull-out hoods. D: extreme wide-angle with fixed, built-in hood. An overlong lens hood will give a vignetting effect at picture corners

stop sidelight entering the eyepiece, which confuses the meter system on some models. A right-angle unit is helpful for low viewpoints and when the camera is rigged vertically for copying. A few 35 mm and most rollfilm SLR cameras allow the pentaprism to be interchanged. You can then fit a waist-level finder, a high-magnification finder, or an action finder which allows you to see the image from a range of distances and angles. You can also change focusing screens to suit the work you are doing – perhaps fit a cross-line grid screen for alignment of double exposures, copying, or critical architectural subjects; or more transparent screen for brighter images in close-up photography. Changing to a screen without a split-image focusing aid is also helpful if you frequently use lens-extension devices, or long-focus or small-aperture lenses, all of which tend to 'black out' half the split area.

Provide yourself with ample film holders for a view camera, or film magazines for cameras (i.e. rollfilms) which accept interchangeable backs. Instant-picture film backs are a good investment for large- and medium-format professional work. They allow a final visual check on lighting, critical layout and exposure, and confirm the correct functioning of your flash and shutter equipment. An add-on motor drive (or the smaller but less wide-ranging film winder) will be helpful if your rollfilm or 35 mm camera does not already have motor-driven film. It is also possible to combine this with an extra-capacity film back, such as a 100-exposure 6 × 6 cm magazine for 70 mm perforated film or 250-exposure back for most 35 mm SLR cameras.

All the leading camera brands offer dozens of other accessories, ranging from backs which light-print words and numbers on every frame, to underwater camera housings, and radio or IR remote shutter releases. A changing bag is a useful standby if film jams inside any camera or magazine, or you must reload sheet film holders on location. Other 'back-up' includes a lens-cleaning blower brush, lens tissue, and spare batteries.

Finally you need one or more cases for your camera equipment. There are three main kinds. Large metal cases with plastic foam lining have compartments for the various components of a view camera outfit plus accessories. This kind of case has the advantage that you can stand on it – when, for example, you are focusing the camera at maximum tripod height. A smaller, foam-filled metal attaché case suits a medium- or small-format kit and is designed for you to cut away lumps of foam to fit your own choice of components. (Avoid cases which make it obvious they contain photographic equipment, and so encourage theft.) A tough waterproof canvas shoulder bag with pouches and adjustable compartments is one of the most convenient ways of carrying a comprehensive 35 mm outfit.

5 × 4 in kit
Camera with standard and wide-
 angle bellows
90, 180, 240 mm lenses
Six double sheet film holders
Instant-picture back
Focusing hood or cloth
Hand meter

Fig. 5.26 Examples of camera kits.
In addition each kit needs an
appropriate tripod, lens hood,
filters and cable release

6 × 6 cm kit
Body
Two magazines
Instant-picture back
50, 80, 200 mm lenses
Magnifying hood
Pentaprism finder
Extension tubes
Hand meter
Flashgun

35mm kit
Two bodies
28, 50, 105 mm lenses or zoom
 equivalents
Tele-converter
Extension tubes
Flashgun

Horses for courses

No two photographers will agree on the contents of an 'ideal' camera
kit. The three outfits listed in Figure 5.26 are each reasonably versatile
within the limits of a 4 × 5 in view camera, 6 × 6 cm SLR, and 35 mm
SLR respectively. For more narrowly specialised subjects you could
simplify each of these kits, discarding some accessories and perhaps
adding others. For example, for portraiture work using a medium-
format SLR, have wide-aperture normal and medium long focal length
lenses (or zoom equivalent) plus tripod. Include flash, a folding
reflector board (Figure 7.11), some effects filters, and several film
magazines.

For *architectural* interiors and exteriors you might use a monorail
view camera outfit with normal and wide-angle lens, normal and bag
bellows, tripod, high-sensitivity hand meter, film holders and instant-
picture back, a powerful flashgun, and colour filters.

For *sport and action* you need a 35 mm SLR with 35–200 mm zoom,
ultra-wide-aperture normal lens (for indoor activities), 250 mm mirror
lens plus × 2 adaptor, 21 mm wide-angle lens, tripod, rifle grip, film
winder, and an extra body with bulk-film back and motor drive. For
shallow *underwater* photography pack a 35 mm motor-drive under-
water body and 50 mm underwater lens (changes from 45° to 34° in
water); underwater macro lens, separate flash unit on a long lead, and
warm-tinted filters.

Summary: Extra lenses, camera kits

● Changing the focal length of your camera lens alters image size and
(provided it still covers the picture format adequately) angle of view.
● A longer focal length enlarges detail, gives narrower angle of view,
less depth of field, and exaggerates blur from camera shake.

● A shorter focal length (wide-angle lens) makes image detail smaller, increases depth of field, diminishes camera shake blur. Extreme wide-angles begin to distort the apparent shapes of objects farthest from the picture centre.

● Perspective in pictures depends on your camera's viewpoint and distance relative to different elements in a scene. Results are also influenced by final print size and viewing distance.

● To steepen perspective, move closer and change to a wide-angle lens. To flatten perspective, move farther back and change to a longer focal length.

● Most wide-angle and narrow-angle long focal length lenses for small-format cameras (especially SLRs) are designed with inverted-telephoto and telephoto construction respectively. This way the lens-film distance varies less than differences in focal length would suggest.

● You can alter focal length by changing complete lenses, by adding an optical attachment to the front or rear, or by using a zoom lens.

● Extreme focal lengths give such unnatural images they must be used with restraint. The most versatile kits contain moderately wide and telephoto lenses plus a normal lens, or (small-format cameras) one or two zooms covering all these focal lengths.

● Zooms have a continuous range, are excellent for action photography by avoiding wasted moments when lens changing, and offer zoom effects and macro focusing. But they have a smaller maximum aperture and tend to be larger than fixed focal length lenses.

● You can focus very close subjects by increasing lens-film distance using rings, bellows, or a macro focusing lens. Recalculate exposure if you are not using TTL metering. Alternatively add converging elements to an existing lens.

● The most useful other camera accessories are likely to be tripod, cable release, filters, hood, flash and separate meter, according to your outfit. Also extra film holders, magazines and spare bodies, motor drive, viewfinder aids and carrying case.

● Don't be bemused by novelty. Adding and interchanging accessories to adapt your camera can be slower, more expensive and less satisfactory than changing to a different camera system – such as a larger or smaller format.

Projects

1. Get some practical experience of a range of lens types for your camera. Compare the size of image detail, the depth of field (at same *f*-number), the effect of camera shake, amount of focus adjustment necessary, and any edge-of-frame distortions. Assess the closest subject distance you can focus, and the lens's size, weight and price.

2. Check which of your lenses are of telephoto, inverted telephoto, and symmetrical construction. Compare the distance from nearest lens surface to sharp image (a) when the front of the lens faces the subject, and (b) when it is reversed.

3. Take a full-face head shot of someone you know, using each of a range of lenses from wide-angle to telephoto or an equivalent zoom. For each focal length change your distance to maintain the same

distance between the eyes in each image. Compare the perspective of your results.

4. Test a zoom lens by imaging a squared-up modern building or grid-type subject. Arrange horizontal and vertical lines to run parallel and close to all four picture edges. Check that these lines remain straight and in focus at longest and shortest focal length settings.

5. Try zooming during exposure. Use shutter speeds around $\frac{1}{4}$ second. Have the camera on a tripod and either zoom smoothly throughout exposure or add a brief static movement at the start or finish. Make your centre of interest dead centre in the frame, and include patterned surroundings.

6. Check out the maximum magnification you can obtain with your equipment. Image a ruler and count how many millimetres fills the width of your frame. (With rings or bellows it is easiest to set the lens as far as possible from the film, then focus by moving the whole camera forwards and backwards.)

6

Camera movements

'Camera movements' is the general name given to all the shift or pivoting movements of the lens, or the film plane, *independently of the rest of the camera*. They include shifting the lens off-centre of the film and tilting it up or down, and also pivoting the camera back, to form a more useful image under particular sets of conditions. The advantage of a camera with movements is that it can get you out of all kinds of difficulties. Movements can provide additional depth of field, adjust the apparent shape of subjects, even allow you to photograph square-on views of reflective surfaces without your reflection showing.

The mechanics of movements

Movements are traditionally provided on large-format cameras, but are gradually spreading to the more professional types of medium- and small-format camera too. To understand them, regard movements as being *neutral* when the surface of the lens is parallel to the film, the lens centre is aligned with the centre of the picture format, and a line between the two (the lens axis) is parallel to the camera base. This is of course exactly their layout in a regular camera. From here you need to discover how each movement is physically achieved and what it is called.

There are shift movements (rising, drop and cross front or back) and pivoting movements (swing front or back), see Figure 6.1.

● *Rising front* means upward shift of the lens, remaining parallel to the film surface.
● *Drop front* means shifting the lens downwards, again parallel to the film, placing the lens axis below the centre of the picture format.
● *Cross front* involves shifting left or right, parallel to the film, placing the lens axis to one side of the picture centre.

These three shift movements are achieved on a monorail view camera by undoing locks on the front (lens) standard and sliding it a few centimetres up, down or sideways. In fact, since front and back standards are identically engineered, you can double the effect by

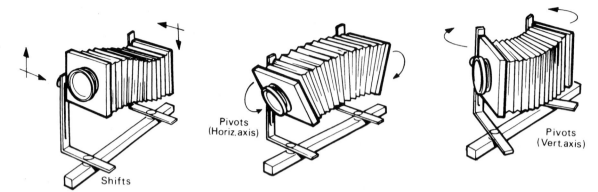

Shifts

Pivots
(Horiz. axis)

Pivots
(Vert. axis)

Fig. 6.1a A monorail camera offers greatest variety and range of shift and pivot movements, which can be used simultaneously. See also Figure 6.13

moving them in opposite directions – for example shifting the back of the camera downwards when you use rising front. Standard-length bellows may not be flexible enough to allow much shift movement. You can work more easily by changing to bag bellows instead (Figure 5.9). Sometimes, for instance in architectural photography, shift movements alone may be sufficient, in which case you can use a bellowless (or 'solid') wide-angle shift camera, shown below.

Rising and cross front are more restricted on a baseboard view camera, especially when you are using a wide-angle lens and need to have it close to the focusing screen. Also it may be difficult to achieve much drop front except by tilting the baseboard, as Figure 6.1 shows. On small- or medium-format cameras the body as such may not offer movements. Instead you fit a 'shift' or 'perspective control' (PC) lens. This has a special mount allowing the whole lens to slide a centimetre or so off-centre in one direction. The mount itself rotates, to allow you to make this off-setting give either upward, downward or sideways shifts.

Fig 6.1b Other cameras offering movements. Below: A: baseboard cameras have a restricted range. B: 35 mm shift lens, racked upwards to give rising front. C: bellows unit replacing Hasselblad body. Accepts regular lens and film magazine but uses direct focusing screen. D: shift camera set to give rising front. Viewfinder is linked and pivots to adjust framing

● *Swing front* means pivoting the lens so that it tilts upwards or downwards about a horizontal axis, or sideways about a vertical axis,

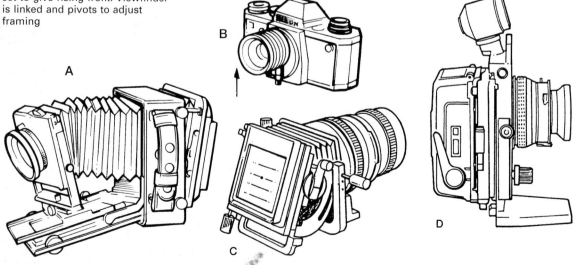

A

B

C

D

both at right-angles to the lens axis itself (Figure 6.1a). Front swings on view cameras are achieved by releasing a lock on the side of, or below, the lens standard, pivoting it several degrees and then re-locking. Some medium-format SLR cameras allow you to replace the reflex body with a very flexible bellows system. This provides a full range of swings, but you must then compose and focus on a rear screen, like a view camera. One or two shift lenses for 35 mm SLRs also contain a pivoting mechanism. Using this in conjunction with its rotating mount, you can make the lens swing about a vertical or horizontal axis, or anywhere in between.

● *Swing back* means pivoting the back of the camera about a horizontal or vertical axis across the film surface, usually at right-angles to the lens axis (Figure 6.1). On a monorail view camera you achieve this movement by mechanically adjusting the back standard in the same way as you would alter the front standard for swing front. Baseboard view cameras offer much less swing back because of their box-like structure. This movement is not offered by small-format cameras, although you can produce something similar by working close-up with a suitable macro bellows attachment. Notice how swing back does not itself move the lens axis off the centre of the picture format (Figure 6.9). Therefore the lens you use need not have exceptional covering power, unlike lenses used with shift or swing front movements.

Fig. 6.2 Lens coverage. Below, right: the total image patch given by a lens. This may be sufficient when the lens is always centre format (solid outline, below), but when using R (rising front) or C (cross front) lack of coverage darkens corners at top or side. 'Cut-off' may become more obvious when the lens is stopped down

Lens coverage

It is important to notice how shift movements or lens pivoting tend to move the lens axis *away from the centre of the picture format*. You should only do this if your lens has sufficient covering power (Figure 3.6) to continue to illuminate the entire picture area. Otherwise the corners and edges of the format farthest from the lens axis will show blur and darkening. Most good lenses for view cameras are designed with these movements in mind and have generous covering power

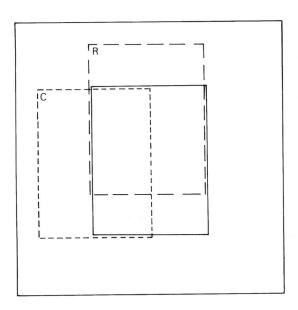

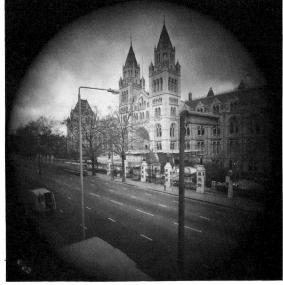

Fig. 6.3 A lens which only just covers a format when focused for infinity (A) darkens bottom corners of the frame when swing front (C) or rising front (D) is used. But focused for close subjects (B), the same lens gives a larger image patch and allows use of these de-centring camera movements

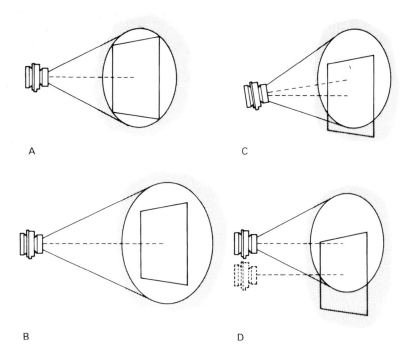

(although rarely enough to allow the *maximum* movement offered by a monorail, especially when shooting distant subjects).

The usual range of lenses for medium- and small-format cameras cover little more than the picture area for which they are designed. Shift lenses are exceptional. Optically they must cover a much larger image patch. Mechanically the back of the lens must be far enough forward to allow off-setting and pivoting without fouling the sides of the mount. Freedom of movement also means that any mechanical links to body-driven autofocus or preset stopping down must be omitted – you view the image at your actual shooting aperture. Most shift lenses are wide-angle, typically 75 mm for 6 × 7 cm, or 35 mm or 28 mm for 35 mm format, and so must be extremely inverted telephoto to fulfil the necessary mechanical requirements. This difficult specification and the relatively small market for these lenses makes them much more expensive than conventional types.

Covering power is much less of a restriction if you only use movements when shooting close-ups. As Figure 6.3 shows, any lens focused well forward of the film for very close subjects uses much less of its normal covering power. Under these conditions you can safely use conventional lenses (including macros) for shifts and for swing front movements – a small-format SLR with close-up bellows unit, for example (Figure 5.23).

Using movements to control the image

When you are experienced you will often use several camera movements together. But to start with it is best to see the effect (and the limitations) of each movement separately. Try to have a camera with a

good range of movements by you as you read, and check out the image changes on its focusing screen.

Rising front

Effect. As you raise the lens the image shifts vertically too. The lowest parts of the subject no longer appear but you gain an equivalent extra strip at the top of the picture. Raising the lens, say, 1 cm raises the image 1 cm. But in most situations the image is smaller than the subject, so this small shift alters subject inclusion by several metres – far more than if you raised the *whole camera* by 1 cm. The ratio between the strip of subject gained or lost and the amount of rising front is the same as

subject-to-lens-distance : lens-to-image distance

Typically this is about 100:1 using a 90 mm lens (5 × 4 in camera), or 300:1 with a 28 mm shift lens (35 mm camera) for the same distance subject. You can see from this too that, when working close up, more lens movement is needed for a quite modest shift of subject inclusion. (The ratio becomes 1:1 when image and subject sizes are equal.)

Use. Rising front allows you to include more of the tops of subjects (losing an equivalent strip at the bottom) *without tilting the camera upwards*. The objection to tilting the whole camera is that vertical lines seem to converge. Tall buildings shot from street level or cylindrical containers photographed from low level in the studio begin to look triangular. You can argue that this is exactly how they appear when you look up at a subject. However, the stereoscopic effect of seeing with two eyes plus the physical act of looking up helps you to accept converging uprights as a perspective effect – the top of the subject is experienced as more distant than the base. On a two-dimensional photograph results can be interpreted as something with non-parallel sides, particularly when they are just slightly out of true. (The same problem occurs when you must record a painting fixed too high to allow a centred camera viewpoint, or have to shoot an interior showing more ceiling detail than floor, without walls appearing to converge.)

To use rising front for, say, the tall building assignment, choose the best viewpoint for perspective and subject inclusion, and position the camera *with its back absolutely vertical*. This is vital if vertical lines in the structure are to reproduce parallel. The top of the building will now be out of the picture and too much is included at the bottom. Focus the

Fig. 6.4 Shooting a subject well above camera height, you can either (left) leave out its top detail or (centre) tilt the camera, giving converging vertical lines. But camera movements allow you to keep the camera back vertical and raise the front (right) to include subject top without convergence. Inset: equivalent movements on a 35 mm camera

Fig. 6.5 Extreme rising front used with a wide-angle lens may not give 'cut-off', but stretches recognisable shapes and details near the top part of the picture (furthest from the lens centre). Results in this area are like an extreme wide-angle; see Figure 5.14. However, in cramped locations this may be unavoidable

image, then raise the shift lens or camera front until the image of the top of the building moves on to the focusing screen. If in doing this you lose too much at the bottom of the scene, either move back (and accept slightly flatter perspective) or change to a wider-angle lens.

Drawbacks. Every camera movement has potential ill effects. The two drawbacks to shift movements are 'cut-off' (image darkening) and shape elongation. Both are likely to show in that part of the picture you have just moved onto the screen. Watch out for darkening towards the two corners here, and remember that cut-off has a much more obvious edge when the lens is stopped down. This kind of trouble occurs most often with a view camera movement. Using a shift lens the special mount is an integral part of the lens design; it should not permit so much off-setting that the lens no longer covers the intended format.

Subject shapes within the area shifted into your picture may look stretched and elongated. This is because they are well off the lens axis, so that light strikes the film more obliquely here. Disguise distortion by keeping such areas plain or free of recognisable elements, especially in the corners.

Drop front

Effect. Shifting the lens downwards, making the lens axis lower than the centre of your picture, includes more at the bottom of your subject and less at the top.

Use. You can use a camera viewpoint looking slightly down, yet avoid vertical parallel lines in the subject appearing to converge downwards. In architectural photography, for example, your only camera position may be high up, perhaps to avoid traffic obstructions. In the studio you may want to show something of the top surfaces of upright objects such as boxes and packs. In all cases keep your camera back parallel to the vertical surface you do not want to taper, then shift the lens downwards to get the lower subject parts into your picture.

Drawbacks. There are the same risks of cut-off and image elongation as described with rising front, but this time they will appear in the *lowest* parts of the scene.

Fig. 6.6 Left: used from the high viewpoint needed to show mug tops, a camera without movements has to tilt downwards, making vertical sides converge. Right: by keeping the camera back vertical and using drop front, the mug sides remain parallel. Overdone, shapes look elongated. To avoid this, move the camera further away, reduce front movement, and enlarge up

Cross front

Effect. Shifting the lens left or right of centre means that more is included on one side of the picture, and less on the other.

Use. Cross front allows you to shoot an apparently 'square on' image of a subject from a slightly oblique viewpoint. For example, you may need a flat-on record photograph of a shop window, or an interior shot directly facing a mirror. Instead of setting up the camera opposite the centre of the glass where its reflection will be seen, you can position it farther to the left, keeping its back parallel to the subject. Then you cross the front to your right so that the whole image of the window or mirror shifts sideways until it is centre frame.

Similarly, when a pillar or other obstruction prevents a square-on view of some wall feature you can set up the camera right next to the obstruction, Figure 6.7, its back parallel to the subject. Then cross the front to move the feature into frame. (This often gives less distortion than the alternative – fitting the camera in between obstruction and subject and changing to a wider-angle lens.) Rather more subtly, cross

Fig. 6.7 Using cross front for a square-on image, despite obstruction. Without movements viewpoint A gives convergence, B is blocked and C, using extreme wide-angle lens, gives distortion. In D the camera is next to the obstruction, back parallel to poster and movements neutral. E is the same camera position as D but with the cross front shifted to the right. (For easier comparison all lens images are shown right way up.)

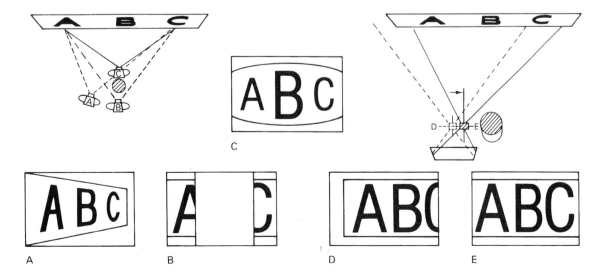

front allows you to manipulate one aspect of perspective. Instead of inward-facing oblique surfaces converging to a central 'vanishing point' as normal, you can offset this point of convergence to the left or right to give a less symmetrical picture structure.

Drawback. If overdone, your image may show signs of cut-off and elongation along the side and corners of the frame farthest from the shifted lens axis.

Front swing

Effect. Pivoting the lens (a) alters effective coverage because it moves the point where the lens axis meets the film format, and (b) tilts the plane over which the subject is sharply imaged. The latter effect is explained as follows. A subject at right-angles to the lens axis is normally sharply focused as an image on film also at right-angles to the axis. This is typical, say, of copying a flat surface – subject plane, lens surfaces and film are all parallel. But when you swing the lens it views the subject obliquely (Figure 6.8). One part of the subject, now effectively closer, is brought to focus slightly farther from the lens. In fact the whole plane on which the subject is sharply focused is pivoted to become much *less parallel* to the subject.

Uses. You can swing front to achieve effect (a) above, in which case (b) usually forms the drawback. Or you can use it for (b) but find yourself limited by (a). Here are examples of each kind of situation.

Photographing a tall structure, you use rising front to avoid tilting the camera and making vertical lines appear to converge. However, there is darkening and other tell-tale signs of image 'cut-off' in corners around the top of the subject. By unlocking the horizontal axis swing movement, you can pivot the lens to point upwards very slightly. This makes the lens axis less off-centre on the film; effective coverage is improved and cut-off miraculously disappears.

However, your lens, in viewing the subject obliquely, sharply images it on a plane at an angle to the back of the camera. It is probably

Fig. 6.8 Using swing front to improve coverage. A: using rising front alone. B: result of using swing front too. C: after fully stopping down. S: plane of sharp focus for subject. Compare with Figure 6.3

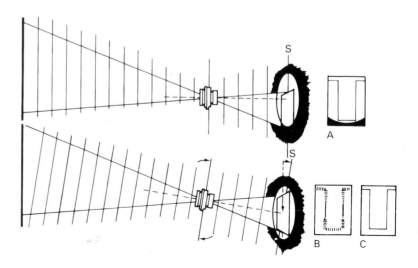

impossible now to render the top and bottom of your subject sharp at the same time, so focus for the centre and stop down.

As another example, you have to photograph an expanse of mosaic floor extending into the distance. The camera views the floor obliquely, and even at smallest aperture there is insufficient depth of field. By pivoting the lens slightly downwards about a horizontal axis it views the floor less obliquely, giving a better compromise between planes of floor and film. This adjustment of swing front is critical, but you will find depth of field greatly improves across the floor surface.

The drawback this time is that your lens axis is now much higher than the centre of the film. A lens with only adequate covering power may produce signs of cut-off around corners of the picture where the farthest parts of the floor are imaged. See Figure 6.10 (centre and bottom).

Although examples given above feature swings about a horizontal axis, the same principles apply to vertical-axis swings. Their use in equivalent circumstances would be to improve coverage with extreme *cross* front, or increase depth of field over an obliquely photographed *vertical* surface, such as a long wall.

Swing back

Effect. Pivoting the camera back (a) swings the film into (or out of) the plane of sharp focus for a subject, and (b) alters image shape.

Uses. Once again you can use this movement primarily for (a) and suffer (b), or the reverse.

For example, you have to photograph, from one end, a long table laid out with cutlery and mats. The table must taper away into the distance, its oblique top surface sharp from front to back. Unfortunately there is insufficient depth of field for you to do this, even at smallest aperture. When you think about the problem (see Figure 6.10), light from the closest part of the table actually comes to focus some way behind the lens, while the farthest part comes to focus nearer the lens. So by swinging the back of the camera until that part of the film recording near subjects becomes farther from the lens and the part recording far subjects becomes closer, you have angled the film into the plane of sharp focus. Depth of field is greatly extended – and may even be sufficient to shoot at a wider aperture.

The drawback is that the part of your image now recorded farther back from the lens is considerably larger than the image recorded near the lens. Front parts of the table will reproduce larger than they appear to the eye, and distant parts appear narrower. Perspective appears steeper, although *only along the plane of the table*, which may give it a noticeably elongated shape. (Sometimes of course you can choose just this kind of distortion for dynamic effect.)

As another example, the new wing of a building must be shown obliquely, to taper away at one side to a feature at the far end. But it is surrounded by other buildings, and the only available viewpoint is opposite the centre of the wing. From this square-on position it appears rectangular. However, you can set up the camera to include the whole wing, then swing the back about a vertical axis to bring the right-hand side of the film closer to the lens, and the left-hand side farther away. In this way, the image at the left end is made bigger and at the right end becomes smaller – the building appears tapered (Figure 6.11).

Fig. 6.9 Swing back movements do not require exceptional covering power – lens axis remains centred on picture format

Fig. 6.10 Top: using swing back alone. Near parts of an oblique subject come to focus farther from the lens. So pivoting the film into the (more upright) plane of sharp focus increases depth of field across subject, but exaggerates shape (A). Centre and bottom: using swing front alone. Slight horizontal pivoting of lens gives a better compromise between subject and film planes. Depth of field improves without shape distortion (B) but a lens with poor covering power will give 'cut-off' (C)

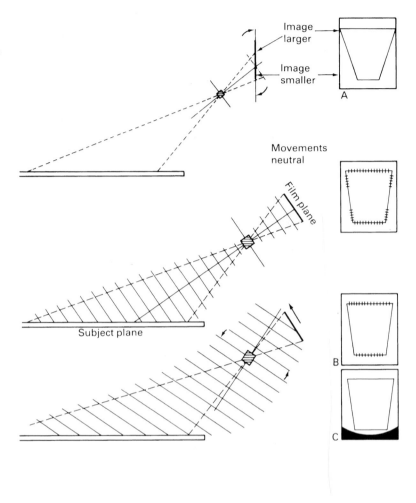

Fig. 6.11 Swinging the camera back non-parallel with a 'square-on' subject, to create false perspective. (Unlike a true oblique viewpoint you do not see the subject's side too.) As the film is now oblique to the plane of sharp focus, the depth of field will be insufficient unless you fully stop down

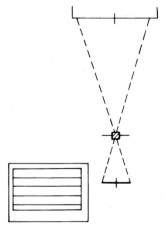

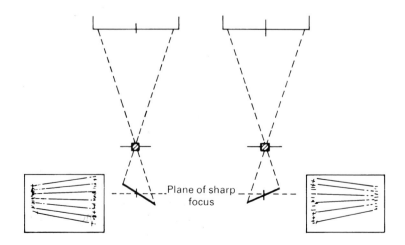

Fig. 6.12 U-shape monorail designs do not pivot horizontally on the film plane (F) because film holders could not then be inserted from the side. Therefore (top right) swing back moves the film in radius M, shifting the image down screen and possibly vignetting at the top. The L-shape design avoids this problem and allows a true film-plane pivot

The drawback is that the camera back no longer corresponds with the plane of sharp focus for the building (which, because it is square on, is at right-angles to the lens axis). Both ends will look unsharp; you must stop down fully and if necessary reduce the amount of swing to get the whole image in focus. This technique also gives a slight but tell-tale distortion. In a truly oblique view of a rectangular building you would also show something of the nearest *end wall*, but in your picture the end is cut off straight. It may need disguising with foreground elevation, etc.

Combined use of movements

Combinations of movements are useful either to gain extra collective effect or to create a movement the camera itself does not directly offer. Most importantly, you can often produce the result you want and

 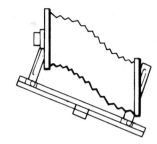

Fig. 6.13 Combining two movements to produce a third. Swinging front and back of view camera gives additional drop front (left) or rising front (centre). A 35 mm PC lens which allows pivoting and shift at right-angles to each other will give swing back (right)

minimise problems by combining a *little* of each of two movements which have a common effect but different drawbacks.

For instance, in tackling the mosaic floor you could create your extra depth of field by using a little of each of front *and* back swings. The back is swung (horizontal axis) just enough to start to improve depth of field, without noticeable shape distortion. Then the front is swung (horizontal axis) just enough to extend depth of field to the whole floor at your chosen aperture, without noticeable cut-off due to poor coverage. You will notice that in doing this the subject plane (the floor), the film plane (camera back) and the lens plane (glass surfaces) all point towards one imaginary position below the camera. The less front swing you set the more back swing is needed, and vice versa. This meeting of planes, giving best compromise position of front and back to maximise depth of field over an oblique subject plane, is known as the Scheimpflug principle, as shown in Figure 6.14 below. Remember it as a guide. Of course, it applies equally to a *vertical* subject plane – imagine Figure 6.10 as a plan instead of a side view, with the swings about vertical axes instead.

The great thing about camera movements is to understand and control them, but use them with restraint. Decide whether it is necessary to show the verticals in a building or studio still-life as truly vertical, or whether tapering will give a stronger impression of height, more striking composition, etc. There are clear optical limitations to camera movements, too. Your lens may not cover sufficiently; the camera may not allow enough shift or tilt; bellows or lens hood may obstruct the picture with some movements; and when scenes contain equally important horizontal *and* vertical oblique planes, any movements to help one will usually worsen the other.

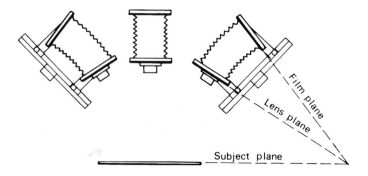

Fig. 6.14 The Scheimpflug correction, to maximise depth of field. This uses some swing of both front and back, minimising the side effects of each movement. See Figure 6.15

Fig. 6.15 Camera movements used to improve depth of field. A: no movements, fully stopped-down lens. B: swinging lens more parallel to keyboard improves sharpness, but signs of cut-off (darkening) appear at picture top. C: instead, swinging the back more vertical gives depth of field needed but distorts shape unacceptably. D: combined use of some front and back swings (Scheimpflug) achieves results with minimum side-effects

Summary: Camera movements

● The main camera movements are *shifts* (rising, drop, cross) and *swings* (back or front, vertical or horizontal axis).

● Monorail cameras offer greatest range of movements, often exceeding the covering power of your lens. Medium- or small-format SLRs provide movements via a shift or PC lens, a bellows body replacement, or a suitable macro bellows unit for close-ups only.

● Shifts and front swings impose greatest strain on lens coverage. Watch out for signs of 'cut-off', especially when focused for distant subjects.

● Rising, drop and cross front allow you to shift the image (like 'scrolling' on a computer) to include parts of a scene above, below, or to one side which would otherwise need oblique angling of the camera.

● Front swings help improve depth of field over one oblique subject plane, or they can reduce 'cut-off' when using a shift movement. When front swings are used to gain depth of field, the lens may no longer cover; when they are used to improve coverage, you lose depth of field.

● Back swings also help improve depth of field over an oblique subject plane, or you may choose them to alter the shape of your image of a subject viewed flat on. When used for depth of field, the perspective will be distorted; used for shape change, you lose depth of field.

● The Scheimpflug correction, combining front *and* back swings, gives maximum depth of field with minimum loss of coverage and shape distortion.

● Understand what movements do and how they work on your camera. Use them intelligently and with restraint, having weighed up gains and losses.

Projects

1. If you have a sheet film camera with movements, check out how far you can use shifts and front swings before your lens gives cut-off. For your subject use something large and distant, and include some even tone, such as a plain sky. As you use each movement, watch the appropriate corners of the focusing screen for any darkening. Take comparative photographs with and without the lens stopped down.
2. Test your use of movements by imaging an oblique surface, such as a patterned table-top seen from an angle. Using front and/or back swings, try to focus the whole surface sharply, without stopping down.
3. Using a 35 mm camera with shift lens, take an (apparently) 'square on' picture of a wall mirror, without showing the camera.
4. Take pictures of a tall building showing two sides from ground level, preserving parallel vertical lines in each result. For the first shot include the top of the building by means of rising front (or shift lens). In the second avoid movements – just include the top by using a wider-angle lens. For the third use the original lens, without movements, having moved back until the whole building is included. Compare results for distortion of building shape: which version is the most acceptable?

7
Subject lighting

In the early days of photography the main function of subject lighting was to give enough illumination to get a reasonably short exposure. Today, faster lenses and films allow you far more *options*, so that lighting can be used to express (or repress) chosen aspects such as texture, form, depth, detail and mood. The way you select and organise your lighting is highly creative and individualistic – in fact you will find lighting one of the most stimulating, exciting aspects of picture making. A photographer's work can frequently be identified through use of lighting and you have probably noticed how often a studio portrait or a movie can be 'dated' by the way it was lit.

The illumination of your subject relies on the same characteristics of light – its straight-line travel, effect of size of source, diffusion, reflection, colour content, etc. – that were discussed in Chapter 2. You can use each of them in various practical ways to alter the appearance of a subject, and they apply to any source, whether the sun, a flashgun, a studio lamp or even a candle. Of course there are 'tricks of the trade' too, some of which are dealt with towards the end of this chapter, but even these are just short-cuts based on the same logic of how light behaves.

By far the best place to learn lighting is in the studio. Work with a still-life subject on a table in a large, blacked-out room, and have your camera fixed on a tripod. Make sure there is ample room to position lights or reflectors anywhere around all four sides of the table. Once you have experienced how lighting works with everything under your control, it is far easier to understand the cause and effect of the many 'existing' situations you will meet.

Characteristics of lighting

There are six features of lighting to bear in mind. These are its quality, direction, contrast, evenness, colour and intensity. Start by looking at these one at a time, then see how they are combined in different kinds of equipment and techniques.

Quality

This is mostly concerned with the type of shadow the light source causes objects to cast – hard and clear-cut, or soft and graduated. As shown in Figure 2.5, lighting quality depends on the *size* of the source relative to its distance from your subject. Hardest light comes from the most compact, point-like source, such as a spotlight or projector bulb, a small flashgun, a clear glass domestic lamp, a lighted match or direct light from the sun or moon. (The sun and moon are vast in size, but because of their immense distances they form relatively small, compact sources in our sky.) All these light sources are very different in other respects, such as intensity and colour, but you will find they all give sharp-edged shadows.

Softest light comes from a large, enveloping source. This might be totally overcast sky or light from a blue sky excluding the sun, a lamp

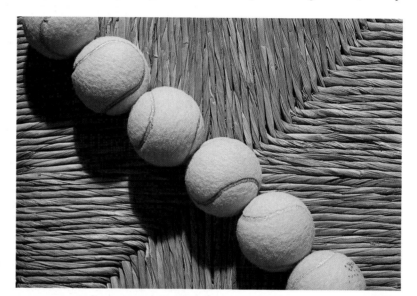

Fig. 7.1 Lighting quality. Top: illuminated by a distant, compact light source, these tennis balls cast hard-edged shadows. Bottom: enlarging the light source using tracing paper close to the subject makes softer-edged shadows and more subtle modelling appear. The 'soft, directional' lighting looks less dramatic in the studio, but often gives best results when photographed

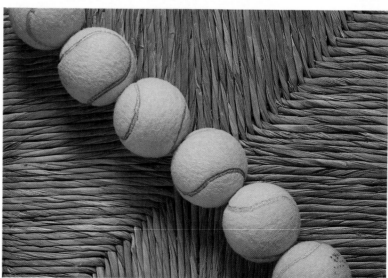

or flashgun with a large-diameter matt reflector, or a cluster of fluorescent tubes. You can make any hard light source give soft lighting by placing a large sheet of diffusing material, such as tracing paper, between it and the subject. The larger and closer your diffuser is to the *subject* the softer the lighting. Similarly you can direct a hard source on to a large matt reflector such as a white-lined umbrella, card, the ceiling or a nearby wall, and use only the light bounced from this for subject illumination.

The opposite conversion is also possible. You can make a large soft light source give hard illumination by blocking it off with black card leaving only a small hole. Indoors, if you almost close opaque window blinds you can produce fairly hard light even when the sky outside is overcast.

The size and closeness of your light source also change the character of *reflections* from gloss-surfaced subjects. A hard light source gives a small, brilliant highlight. Typical of this is the catchlight in the eyes of a portrait. Soft light gives a paler, spread highlight, which may sometimes dilute the underlying colour of an entire glossy surface, making it look less rich.

Direction

The direction of your light source determines where your subject's light and shade will fall. This in turn affects the appearance of texture and volume (form). As Figure 7.2 shows, there are infinite variations in height and position around your subject, particularly when you have free movement of the light. If you must use fixed, existing light you may be able to move or rotate your subject instead, or perhaps plan out the right time of day to catch the direction of sunlight you need.

We tend to accept lighting as most natural when directed from *above*; after all, this is usually the situation in daylight. Lighting a subject from *below* tends to give a macabre, dramatic, even menacing effect. Frontal light from next to the camera illuminates detail, gives small shadows, minimises texture and flattens form. Reflective surfaces seen flat-on flare light straight back towards the lens. This is typical of direct flash from the camera.

Side lighting or top lighting helps to emphasise texture in surfaces facing the camera, and shows the form of three-dimensional subjects. Back lighting can create a bold edge line and give you a strong shape, but most of the subject detail is lost in shadow which also flattens form. All these changes of direction work with both hard and soft light sources, but they are more marked with hard light because of its sharp-edged shadows.

Contrast

Lighting contrast is the ratio between light reaching the lit parts and light reaching the shadowed parts of your subject. Photographic film cannot accommodate as wide a range of brightness in the same scene as can the eye. Often this means that when you expose to get detail in the lightest areas (Chapter 10) the shadows reproduce black and featureless, even though you could see details there at the time. Alternatively, exposing to suit shadows 'burns out' details in lighter areas.

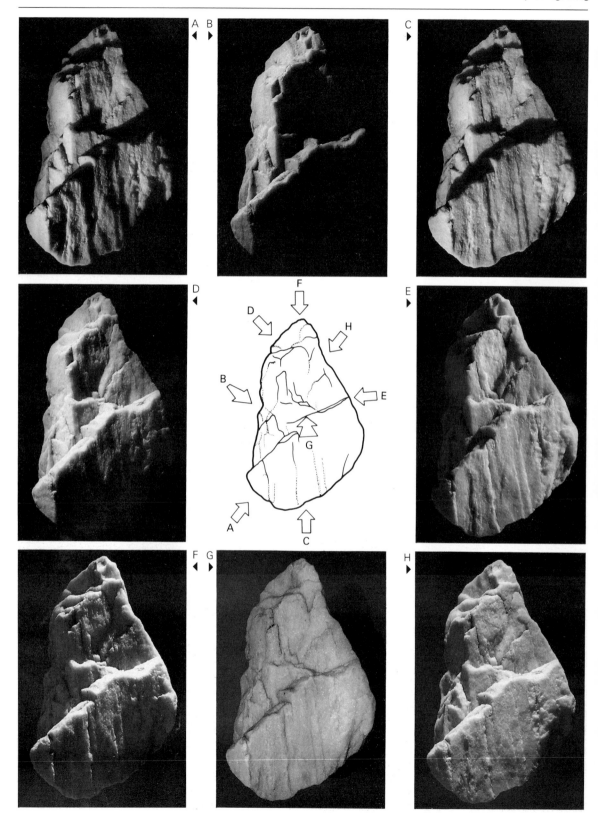

Fig. 7.2 Lighting direction. The same piece of stone changes greatly in apparent shape and form according to the relative position of the light source. See central key

The problem is greatest with hard side or top lighting: although the lit surfaces then show excellent form and texture there are often large shadow areas. If you want to improve shadow detail you could add an extra direct light from the opposite direction, bur this often forms an extra set of cross-shadows which can be confusing, 'stagey' and unnatural. A much better solution is to have some kind of matt reflector board near the subject's shadow side to bounce back spilt main light in a soft, diffused form. For relatively small subjects, portraits, etc. you can use white card, cloth, newspaper or a nearby pale-surfaced wall. With large subjects in direct sunlight you may have to wait until there is cloud elsewhere in the sky to reflect back some light, or until the sun is diffused. With fairly close subjects you can use flash on the camera (preferably diffused with care to add a little soft frontal light, without overwhelming the main light; see page 210).

As a guide, an average subject lit with lighting contrast of 10:1 will just about record with detail throughout, in a black and white photograph. That represents $3\frac{1}{2}$ stops difference between exposure readings for the most illuminated and most shaded subject areas of inherently equal tone. The equivalent for a colour print is about 3:1. See also page 194. With experience you can judge how contrast will translate onto film, but as a beginner always remember to use lower lighting contrast than might seem best at the time of shooting.

Fig. 7.3 Flat-on frontal lighting given by flash from the camera illuminates all the subject detail, suppressing form and texture. Here its stark effect seems to suit the theme of this documentary picture of the Depression: 'nobody had a dime, but they had each other'

Fig. 7.4 Lighting contrast control. All three pictures are lit by one diffused floodlight about 90 degrees from the right; see diagram. A: no fill-in, producing maximum lighting contrast. B: large matt white reflector is added left, directly facing the light, to reduce contrast. C: as B, but using red instead of white reflector board

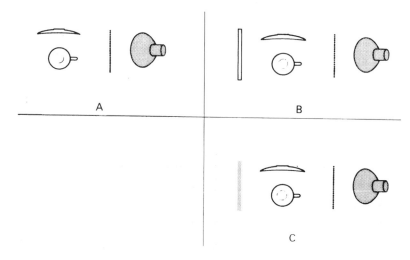

A

B

C

Fig. 7.5 Distance and evenness. To improve evenness with an oblique (point) light source pull it back farther from the subject. Provided the shift is in a direct line, direction and quality of the lighting remains unchanged

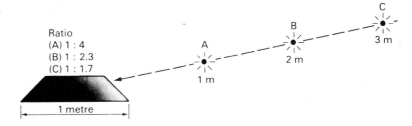

Ratio
(A) 1 : 4
(B) 1 : 2.3
(C) 1 : 1.7

1 metre

Unevenness

Lighting unevenness is met most frequently when using a hard light source, such as a spotlight or flashgun, too close to the subject. When you double the distance of a point source (Figure 2.10) light intensity at the subject drops to one-quarter. So if you light a pair of people or a still-life set occupying space, say, one metre wide from a position one metre to one side, the illumination will fall-off from this side of the set to the other by 2 stops.

If you want to avoid such unevenness (without also affecting lighting quality or direction) just pull the light source back farther, in a direct line from the set (Figure 7.5). At 2 metres the variation becomes $1\frac{1}{4}$ stops, and at 3 metres only $\frac{2}{3}$ stop. Alternatively diffuse the light, narrow the set, or position the darkest, least reflective objects nearest the light source.

Colour

Most light sources used for photography emit 'white' light, a mixture of all colours. They are said to have a continuous spectrum, although its precise mixture may vary considerably from an ordinary domestic light bulb, rich in red and yellow but weak in blue, to electronic flash which has relatively more energy in blue wavelengths than red. As Figure 7.6 shows, most sources can be given a 'colour temperature'; the higher the kelvin figure the bluer the light.

Fig. 7.6 The colour temperature of some white light sources. Numbers are the temperatures (measured in kelvins, K, on the Absolute scale) to which a specified metal body must be heated to colour-match the light. CT differences near the top of the scale create less colour change than at the low end. Daylight (D) film also suits flash, but 'tungsten' (T) film shows a bluish cast with 3400 K over-run lamps

When shooting colour, especially colour slides, you must be careful to use lighting of the correct colour temperature to suit your film. Normally this is 3200 K ('tungsten light' film) or 5500 K ('daylight' film). Alternatively you can use a tinted correction filter to bring light source and film into alignment, such as an 85B or 80A (Figure 9.31). If all your subject lighting is the same colour temperature, the adjusting filter can be used over your camera lens. If it is mixed – daylight and

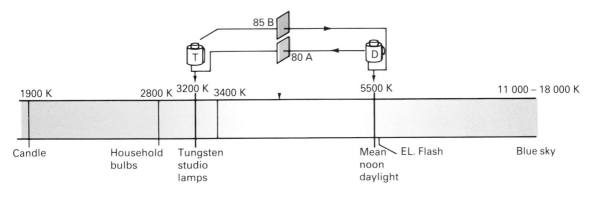

85 B

80 A

| 1900 K | 2800 K | 3200 K | 3400 K | 5500 K | 11 000 – 18 000 K |

Candle | Household bulbs | Tungsten studio lamps | Mean noon daylight | EL. Flash | Blue sky

studio lamps, for example – you must place a filter over one of these sources to make it match the other, as well as the film. Some light sources, such as sodium street lights and lasers, do not produce a full range of wavelengths and so cannot be filtered to give a white-light result.

This colour content of your light source is much less important in black and white photography, but strongly coloured light will make the colours of your subject record with distorted tone values. (In red light, for example, blues look and record black, reds very light.) See Chapter 9.

Intensity

Most of the effects of the intensity of your lighting can be controlled by choice of exposure settings, together with speed of film; see Chapter 10. Indirectly this means that lighting level can affect depth of field and movement blur – bright illumination and fast film leading to small aperture and fast shutter speed, for example. With very dim light and long exposure times colour film often gives distorted colours, too (page 161).

The light output of tungsten (incandescent) studio lamps can be quoted in watts, and electronic flash in watt-seconds. (See also 'guide numbers', page 205.) High-wattage lamps – say 1 kilowatt and above – produce a lot of heat and glare, and are generally uncomfortable to use in the studio. Sometimes, however, high-intensity lighting is necessary. Perhaps you are using a large-format camera with slow film and must shoot at very small aperture for depth of field. This is where powerful studio flash heads, each equipped with a tungsten modelling lamp, are so valuable. Provided that the modelling lamp is positioned close against the flash tube it allows you to preview the quality and direction of your lighting, but of course when the flash fires its intensity is vastly greater for a brief instant. Flash intensity can be reduced by selecting full, half, or quarter power settings. Most hand flashguns measure light reflected off the subject and control their own light duration; you can also effectively *increase* the output of a flashgun by firing it several times during a time exposure. See Chapter 10.

Tungsten lighting can be made dimmer by fitting a wire gauze 'scrim', or moving lamps farther away. It is possible to dim lamps too by reducing the voltage of the supply with a variable resistor, but this is not suitable for colour photography. Dimmed lamps (unlike reduced power flash) have a lower colour temperature and give results with a red cast.

Sources of lighting

The range of photographic lighting equipment seems complicated at first sight, but each unit is designed to make use of the various basic principles already discussed.

Tungsten lighting units

Tungsten lighting is so called because the lamps contain a fine filament of tungsten metal which heats up, becomes incandescent and radiates light when electric current passes through it. Units for hard lighting

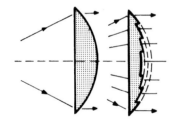

Fig. 7.7 Tungsten lamp units for hard lighting. Compact coiled-filament lamps (A) in clear quartz or glass, used in focusing spotlight (B) or open-fronted reflector (C). Accessories: barndoors (D), wire gauze 'scrim' (E), acetate filter holder (F), and snoot (G)

Fig. 7.8 Top: shaped 'Fresnel lens' bends spotlight illumination like fatter lens (left) but is less bulky, with larger cooling surface. Bottom: shifting lamp in focusing spotlight adjusts beam width. Broadest beam gives hardest, most point-like lighting; see Figure 2.5

(Figure 7.7) use bunched 'coiled coil' filaments to produce an effect as close as possible to a point of light. The filament is sealed into a sleeve of clear quartz filled with a halogen (often iodine) vapour to minimise filament vaporisation. This kind of tungsten lamp is therefore known as a tungsten-halogen or quartz-iodine type. Do not finger the quartz when fitting or replacing such lamps – natural grease left on its surface becomes burnt in and can cause it to crack. Handle them in the small plastic sleeve provided, which slides off once the lamp is mounted in its lighting unit.

A tungsten lighting unit can simply be a polished concave reflector, open at the front. The lamp holder often shifts backwards or forwards slightly within the reflector to give a narrower or broader beam. Alternatively the lamp can fit within an optical spotlight. This is an enclosed lamphouse with a curved reflector at the back and a large simple lens at the front to focus the light in a controllable beam. You shift the lamp using an external control to form either a wide beam or a concentrated pool of light.

Both these hard lighting units accept fit-on accessories. For example, hinged 'barndoors' on a rotary fitting allow you to shade off any part of the light beam. A conical 'snoot' narrows the whole beam, limiting it to some local part of your subject. A 'scrim' reduces light intensity, usually by one stop, without altering its colour or quality, and a filter holder (spaced away from the unit to reduce heat) accepts sheets of tough, theatre-type dyed acetate, also known as 'gels'.

You will find that with each type of unit you get hardest quality light when the beam is at broadest setting. Only focus a narrow beam when you want a *graduated* patch of illumination, say on a background behind a portrait. This will also give softer edges to the shadows. To light a small area evenly and with sharp-edged shadows, first focus a broad beam then restrict this with barndoors or a snoot.

Units for soft lighting (Figure 7.9) use a large translucent glass lamp, usually with a 500 W or 1000 W tungsten filament. This is housed in a wide, often matt white, dish reflector to form a floodlight. The lamp sometimes faces inwards, to turn the whole dish into a more even large-area light source. You can also buy, or make up, large 'window lights' consisting of a grid of floodlight bulbs behind a diffusing sheet of opal plastic. For black and white work this unit could instead contain fluorescent tubes, which give out far less heat. Always the aim is to form a lighting unit as large and as even as possible.

Your lighting units should have stands which allow the head to be set at any angle or position, from floor level to above head height. For location work, lightweight heads such as QI lamps can have clamps with ball and socket heads, so they will attach to doors, backs of chairs, etc. Consider too the use of a 'sun gun' – a totally mobile small, hard QI unit hand-held by an assistant and powered from a belt of

Fig. 7.9 Studio lighting units, giving increasingly soft illumination (left to right). They use 3200 K diffuse-glass floodlamps in (A) matt white open-fronted reflector, (B) wider dish flood with direct light shield and (C) large opal plastic-fronted box which simulates overcast light from a window

Fig. 7.10 Producing soft illumination from a relatively hard source. Left: 'bouncing' spotlight from a large area of matt white wall or directing it through tracing paper. Right: spreading light from a small flood by reflection from a white overhead canopy, or (lower) by moving it in a wide arc over subject during a time exposure

Fig. 7.11 Tungsten location-lighting equipment. A: battery-belt powered sun gun. B: suitcase lighting kit containing three TH lamps and stands. C: clamp for lightweight lamphead. D: dyed acetates E: cable and multi-sockets. F: folding lightweight reflector surfaces

rechargeable batteries. Typically this gives up to 20 minutes of 300 W lighting.

When you use tungsten lighting for colour photography, make sure you have lamps that all give the same colour temperature, preferably matching your film, and run them at their specified voltage. Over- or under-running by as little as 10 per cent will give a noticeable blue or orange tint to results.

Flash units

One advantage of flash as a light source is its favourable intensity/heat ratio. Another is its brief duration which allows you to work with the camera hand-held, and gives blur-free images of moving subjects.

Fig. 7.12 Electronic flash sources, from tiny built-in unit (A), to powerful hammerhead gun attachment with separate power pack (F). Units give hard light unless bounced or diffused and are self-contained, battery powered. Studio/location unit (G) operates from the regular electricity supply, contains a modelling lamp, and although it has a compact coiled tube it produces soft light when reflected off a white-lined umbrella. (See also Figure 10.31)

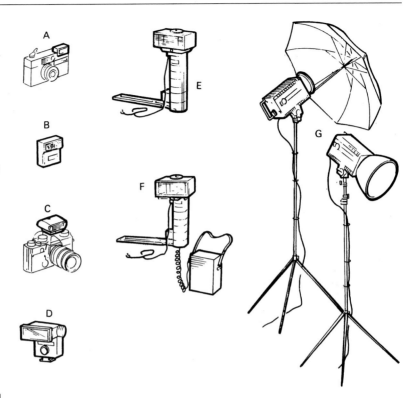

Fig. 7.13 Studio flash head detail, showing spiral flash tube surrounding a tungsten modelling lamp of similar diameter

Fig. 7.14 Most add-on flashguns allow the flash tube and reflector to tilt upwards, for bouncing off a ceiling, etc.

Electronic flash produces its light when a relatively high-voltage pulse is discharged through a gas-filled tube. The flash is typically $\frac{1}{1000}$ second or less, and matches daylight in colour; otherwise it complies with all the same optical principles as tungsten lighting.

Hard light is produced from a unit with a short or tightly coiled tube in a small, highly polished reflector. This is typical of flash built into the camera and powered by battery. Separate clip-on flashguns, including powerful 'hammerhead' types (Figure 7.12), also give hard light and some can be crudely focused to match the angle of view of tele or wide-angle lenses when directed from the camera. Used off-camera this feature is of limited value, as short of shooting an instant picture you cannot preview where your light is falling.

Most studio flash is powered from the regular electricity supply (or a mobile generator), and this makes it practical to include a small tungsten modelling lamp in the flash head. To do its job properly the modelling lamp must match the size and position of the flash tube as closely as possible. For example, a tungsten lamp is often housed within a coiled flash tube and backed by a polished reflector in an open-fronted unit. The combination gives you previewable hard light. For tighter lighting control – matching that of a tungsten focusing spotlight – the flash head can be housed behind a Fresnel lens optical system. In all instances you can leave the modelling light on while firing the flash.

Flash equipment for soft lighting most often consists of the standard (hand-flash or studio) unit directed backwards on to a white reflector board or the white lining of an umbrella (Figure 7.12). The resulting light matches the quality of a tungsten flood of this diameter. A large,

Fig. 7.15 Top: ring flash unit and its power-pack. Above: the soft-edged rim shadow here is typical when using ring flash with the subject close to the background

fabric 'soft box' fitted over a studio flash head gives similar quality lighting, or you can build a 'window light' housing several flash heads in a white-lined box behind diffusing plastic.

Flash tubes can be formed into almost any shape. This makes possible 'ring flash' – a circular light source which encircles the lens, giving a unique 100 per cent frontal light (Figure 7.15). The camera sees shadows mostly hidden behind the objects casting them, resulting in flattened form and an unusual dark rim to outlines. See Chapter 10 for further flash information.

Daylight

Daylight is more variable than man-made light sources. Its quality ranges from intensely hard (direct sun in clear atmosphere conditions) to extremely soft (totally clouded sky in an open environment). Colour varies from about 18 000 K when your subject is in shadow and only lit from blue sky, to an orangey 3000 K around dawn or dusk. (Strictly 'daylight' colour film is balanced for 5500 K, this being a mixture of direct noon sun plus some skylight.)

The sun's direction varies not only from east to west throughout the day but also, unless you are on the equator, throughout the year – the sun tracking most directly overhead on the longest summer day. Considered use of daylight may therefore call for planning, patience and the good fortune of getting all the aspects you need together at one time. Fortunately, outdoors, the very character of natural daylight is often an important feature in pictures. It would be foolish, for instance, to try and 'correct' the orange tint of a setting sun when an evening atmosphere is vital to the realism of your result.

Other sources

Other photographic lighting you will meet includes over-run 'photo lamps' or 'photofloods', and QI movie lamps – often used for their high intensity and efficiency. However, all these may operate at 3400 K, designed for black and white and colour negative *movie* stock. They are unsuitable for 3200 K tungsten-light colour film unless filtered (pages 173 and 177).

It is still possible to use flashbulbs – once-only sources which are fired from a simple battery circuit and therefore need minimal equipment. Clusters of large flashbulbs are still sometimes used by industrial photographers because they provide great intensity and easier handling than electronic flash in tough locations. Bulbs are normally dyed blue to give light matching daylight in colour.

Fluorescent tubes can form useful studio light sources for black and white photography. You can group them vertically, in clusters, to softly light standing figures, still-lifes, etc. Although filters are available for shooting in colour with tubes (page 176), they are not recommended for accurate results. But often you are forced to work with them – when they form the existing light in shops, for example.

Back-up equipment

Your equipment for lighting should also include diffusers, reflectors (folding ones are particularly handy, Figure 7.11), supports for paper

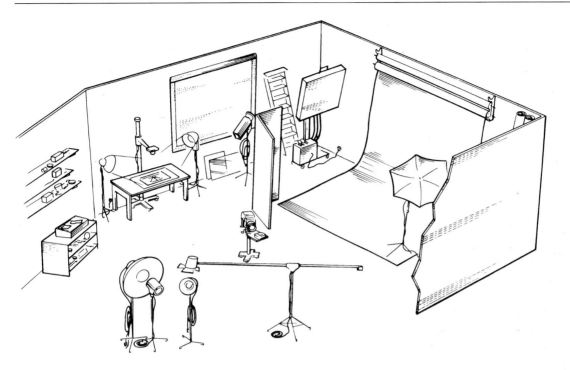

Fig. 7.16 Layout of general studio.
Main set, using 3 m wide
background paper, is equipped
with flash window light and
umbrella unit (note flash spot
stored near blacked-out window).
Tungsten lamps are in use for
copying with 35 mm camera on
pillar stand, others are stored
foreground. Card, glass, blocks
and clamps for supporting
objects, tape and tools are all vital
elements

backdrops, stands, clamps, sticky tape and black card. Blue acetate to
make tungsten lamps match the colour of daylight when combining two
kinds of light is often useful. Similarly orange acetate, fitted over flash,
can match it into a tungsten-lit location.

Have sufficient cable to link your units to the nearest supply, and
don't exceed its fuse rating. Remember:

$$\text{Total amps drawn by lamps} = \frac{\text{total number of watts}}{\text{voltage of the supply}}$$

This means that one 250 V socket fused at 13 A will only power 3250
W of lighting. When servicing the equipment check that your lighting
units and plugs are all properly grounded (earthed). If you are using a
drum of cable always *unwind this fully* before passing current through
it, or the coils will over-heat. Finally, don't jolt lamps while they are hot
– especially tungsten-halogen types which easily short out their closely
coiled filaments, and are expensive to replace.

Practical lighting problems

Think carefully what your lighting should actually *do* for your subject,
other than allow convenient exposure settings. Perhaps it must
emphasise the form and surface textures of a new building, or a small
product in the studio. It might heighten features in a dramatic male
character portrait, or be kind to an ageing woman's wrinkles. Your
lighting will often be the best way to emphasise one element and
suppress others, or reveal extreme detail throughout. It can 'set the
scene' in terms of mood and atmosphere, or simply solve a technical
problem such as excessive contrast in an existing light situation.

Building up your lighting

Working in the studio, or some other area where you have complete control, you can build up your subject lighting one source at a time. Don't just switch on lights indiscriminately – each unit should have a role to play. Have the camera on a tripod and keep returning to it to check results from this viewpoint every time you alter the light.

Starting from darkness, switch on your main light (soft or hard) and seek out its best position. If you are just showing a single textured surface – such as a fabric sample, or weathered boarding – try a hard light source from an oblique direction. By 'skimming' the surface it will emphasise all the texture and undulations. If this means that one end receives much more light than the other, move your light source farther away.

One hard light will probably exaggerate dips in the surface into featureless cavities. Also, if the picture includes other surface planes at different angles, some of these may be totally lost or confused in shadows.

A solution is to introduce a second or 'fill' light, but without adding a second set of hard shadows. (We are rather conditioned by seeing the world lit by one sun, not two.) Try adding very diffused light – perhaps just 'spill light' from the first source bounced off a white card reflector – sufficient to reveal detail in what still remain shadows. The reflector will have to be quite large, and probably set up near the camera so that it redirects light into all shadows seen by the lens. If you cannot

Fig. 7.17 Direct evening sunlight skim-lights a Cotswold cottage wall. This light dramatically enhances texture, provided that the subject is all on one plane

Fig. 7.18 The same principle of single-source skim light as Figure 7.17, but using an overhead desk lamp in a darkened studio. Once again, only one plane of the subject is being shown

Fig. 7.19 Complex still-life groups can be illuminated to reveal forms without confusing shadows by using a large diffused light source across the top and side of the set. Here a window light from top right is augmented by a second diffused source from the far left

produce enough fill-in in this way, try illuminating your reflector card with a separate lighting unit. Another approach is to change your harsh main light to something of softer quality, perhaps by diffusing it.

If your picture contains a more distant background, you can light this independently with a *third* source (maybe limited by barndoors) so that the surface separates out from the main subject in front. Again be careful not to spread direct light into other areas, if this creates confusing criss-cross shadows. In fact, when you have a great mixture of objects and separate planes to deal with in the same picture, there is a lot to be said for using one large, soft, directional light source (i.e. from one side and/or above). This can produce modelling without excessive contrast or complicated cast shadow lines, giving a natural effect like overcast daylight from a large window or doorway, see Figure 7.19.

Much the same kind of build-up can be applied to formal portraiture. Decide viewpoint and pose, then pick the direction of your main light, watching particularly for its effect on nose shadow and eyes. With a 'three-quarter' head shot (Figure 7.21) think carefully whether the larger or the smaller area of face should be the lighter part. Consider how much, if any, detail needs restoring in shadows by means of a reflector. If you want to stress an interesting outline you could light the background unevenly, so that darker parts of the sitter appear against the lightest area of background, and vice versa – a device called 'tonal interchange'.

Fig. 7.20 Typical cast created when subject shadows only receive light from a clear blue sky. To show this silvery Chrysler Building the correct hue, shoot when there is sufficient cloud around to reflect back 'white' light, or pick a time of day when it is less backlit

You could even add a low-powered or distant spot to rim-light hair, shoulders or hands from high at the rear. However, there is a danger of so-called 'overlighting' which puts your sitter in a straitjacket. He or she cannot be allowed to move more than a few inches for fear of destroying your over-organised set-up, and this can result in wooden, self-conscious portraits. The more generalised and simple your lighting,

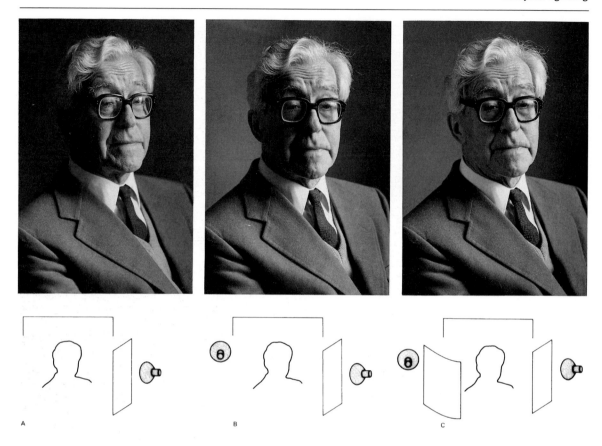

Fig. 7.21 Building up a lighting arrangement for formal portraiture. A: diffused flood main light from the side the sitter is facing. B: second flood added to lighten one side of background and pick out head outline by 'tonal interchange'. C: further addition of matt white reflector board, frontal left, softly fills in some shadow detail

too, the more freely you can concentrate on expression and people relationships.

The build-up approach to lighting applies equally to tungsten units and flash sources. Studio-flash modelling lamps will show you exactly what is happening at a comfortable illumination level, changing only in intensity when the flash is fired. See flash exposure technique, page 203.

Existing light

Learn to observe 'existing light', noticing what is causing the lighting effect you see, and how this will reproduce in a photograph. For example, look up from this book for a moment and observe how your own surroundings are lit. Hard illumination or soft, even or uneven? Which areas are picked out by lighting direction and which suppressed? Are any textures or forms emphasised? Try slitting your eyes and looking through your eyelashes – this makes shadows seem darker and contrast greater, a good guide to their appearance on a final print.

Often when you are working with existing light you will need to modify it in some way. When shooting a black and white portrait outdoors, you may find direct sunlight too harsh and contrasty, but the light changes completely if you move your subject into the shadow of a building. However, this gives a blue cast from the clear sky unacceptable for colour photography, so it may be better to remain in

Fig. 7.22 Supplementing uneven existing light with flash. A: correctly exposed for daylight-lit parts of room 1/60 at *f*/8. B: flash bounced off ceiling above camera (see diagram) set to autoflash exposure. Result has overlit foreground. C: flash positioned as B but set on manual mode and reduced to one-quarter the correct power. Exposure settings as A. Result shows realistic balance of 4.1 daylight/flash

sunlight but work near a light-toned wall to soften shadows, or use a diffused flashgun on the camera to help to fill them in. Since the latter is likely to be a battery-operated flash unit you cannot *see* the effect created, and results have to be worked out by careful calculation of exposure (page 210) or instant-picture test shots.

Supplementary artificial light is often needed when you shoot an architectural interior using existing daylight. There may be excessive contrast between views through and areas near windows, and the other parts of a room. You can solve this by bouncing a powerful light source off a ceiling or wall not actually included in the picture, to raise shadow-area illumination to a level where detail just records at the exposure given for brighter parts.

This artificial light source might be portable QI lamps or a flash unit. If you are shooting in colour, have any tungsten supplementary lighting filtered to match the daylight, and be careful not to bounce off tinted surfaces. Sometimes a dimly lit interior can be 'painted with light' to reduce contrast, by moving a lamp in a wide arc over the camera during a time exposure.

Mixtures of existing light sources which have different colour temperatures are always a problem when shooting in colour. You may be able to switch off, or screen off, most of one type of illumination and use the correct film or filter for the other. Otherwise decide which of the two kinds of lighting will look least unpleasant if uncorrected. A scene lit partly by daylight and partly by existing tungsten lighting often looks best shot on daylight-balanced film. The warm cast this gives to

Fig. 7.23 Mixed lighting. Mass in St Peter's, Rome, celebrated at a tungsten-lit altar, with daylight illuminating the surrounding interior. In this instance the best compromise was to shoot on tungsten-balanced film, making the key area the correct colour, but giving an exaggerated blue cast elsewhere. On daylight film, the central area would reproduce orange, surroundings the correct colour. Lighting related to film colour balance is shown further on page 173

tungsten-lit areas is more acceptable than the deep blue that daylight-lit parts will show on tungsten-balanced film. However, much depends on what you consider the key part of your picture; see Figure 7.23.

Special subjects

Copying

The main aim when copying photographs, drawings, etc. is to create totally even lighting free from reflections off the surface of the original. Figure 7.24 shows the best way to approach this, using two floods at about 30° each directed towards the far edge of the subject. Black card around the camera will prevent shiny parts reflecting and showing up in your picture. See also polarising filters, page 179.

Fig. 7.24 Set-up for copying artwork, etc. Lamps are at 30° to surface, distanced at least twice the width of the artwork and directed towards opposite edge. Black card near camera blocks reflections. Below: an upright pencil placed centrally on the subject will cast shadows of equal intensity and length if lighting is even

Macro work

Sometimes in extreme close-up photography you want flat-on frontal illumination to light every tiny detail of a coin, etc., or some recessed item such as a watch mechanism or electronic layout. A ring flash is sometimes the answer, but you can also work with a piece of clean, thin, clear glass set at 45° between lens and subject (as shown in Figure 7.25). A snooted spotlight or similar hard light source is directed at 90° from one side so that it reflects off the glass and is directed down on to your subject, sharing the same axis as the lens.

Transparent/translucent subjects

Glassware etc. is often best lit from the rear. Either use a large white background spaced behind the objects and direct all your lighting evenly onto this, or direct lights on to the glass from the sides or rear so that the background remains dark. The former gives a dark outline to the glass against a predominantly light ground. The latter produces a

Fig. 7.25 Coins photographed through glass at 45 degrees (see diagram). To produce flat-on frontal illumination, the camera lens looks down the same path as the incident light

Fig. 7.26 Silhouette lighting of glassware, against a separately lit white surface some distance behind. A spotlight, shielded from the glasses direct, illuminates white card which reflects soft highlights into the glasses to suggest their roundness and sheen

Fig. 7.27 The same set as Figure 7.26, re-lit to give a more delicate, luminous look to the glasses. Grey card covers the background seen by the camera, and soft lighting is directed through the glass from side and rear. A frontal reflector board returns some light to help reveal form and surface

Fig. 7.28 'Tent' lighting for reflective subjects. For this shot of silver tableware a large sheet of tracing paper formed a canopy over the set, and was evenly rear-illuminated by floods. To prevent dark reflections the camera was shielded behind white card, leaving a hole for the lens

white outline against dark. If the glass has a glossy surface you can suggest this quality by adding a rectangular-shaped light source from near the front, simply to appear as a window-like reflection.

Highly reflective surfaces

Subjects with mirror-like surfaces such as polished silver or chrome bowls, spoons or trays impose special problems. They tend to reflect the entire studio in great detail, confusing their own form. You can treat them with a dulling spray but this may suggest a matt rather than a polished finish. Often the best approach is to enclose the subject in a large, preferably seamless, translucent 'tent' such as a white plastic garbage bag or sphere, or improvised from muslin or tracing paper. Cut a hole just wide enough for the camera lens to peer in, remembering that the longer its focal length the farther back it can be, giving a smaller and more easily hidden reflection. Illuminate the outside skin of the tent using several floods, or move a single flood over this surface, painting it with light during a time exposure.

Summary: Subject lighting

● The six main facets of subject lighting are its quality, direction, contrast, evenness, colour and intensity. They are all inter-related, but the most universally important are quality and direction – because neither can be adjusted later by some camera setting or printing technique.
● Contrast or lighting-ratio needs to be kept within bounds if you want detail from highlights through to shadows. It is often best controlled by using a reflector placed near the subject's shadow side, or the use of additional light sources.
● To improve evenness, increase the distance from light source to subject, or diffuse or bounce the light so that it becomes enlarged and less 'point source' in character.

● Lighting colour, often quoted as a colour temperature (kelvins), should suit the balance of your colour film, or be brought into line by using a colour filter over the light or lens.

● Tungsten lighting units – QI lamps, focusing spotlamps, individual floods or larger window-light units – mostly operate at 3200 or 3400 K. Only the former suits tungsten-light film without filtration.

● Electronic flash is equally versatile with hard direct light, soft bounce light, window light, focusing spotlight and ring-light units. The colour of regular daylight and most flash suits 'daylight' colour film balanced for 5500 K. Try to avoid mixed colour-temperature lighting conditions, except for effect.

● A good lighting kit should include blue and orange correction acetates, reflectors, diffusers, stands, clamps and cables.

● When lighting a subject, try to introduce one source at a time, and consider what each must do. It is good advice to keep things simple, aiming mostly for a natural daylight effect.

● Learn to recognise the technical pitfalls of existing light – contrast, unevenness, mixed colour. Be prepared to improvise to control contrast and colour, or to return at another time for the lighting quality and direction you need.

● Certain lighting 'formulae' are helpful for special subjects: for example, 30° lighting for copying, ring-flash or 45° glass for maximum detail macrowork, backlighting for transparent subjects, and a light-diffusing tent for polished objects.

Projects

1. Experiment, using an ordinary desk lamp and a simple opaque object, tracing paper and card. Observe how you can vary the illumination *quality*, from hard to very soft. Shoot a series of black and white comparative pictures.

2. Photograph a white box in the studio on a white background, to show its top and two sides. Choose and arrange your lighting so that *each* of the three box surfaces photographs with a different tone.

3. Take two photographs of either tennis balls or eggs. In one they should strongly reveal their rounded three-dimensional form. In the other make them look like flat two-dimensional discs or ovals. The only change between each version should be in the lighting.

4. Check out the appearance of subjects when lit by direct or bounced flash, directed from various positions. If you have only a battery flashgun, tape a hand torch to it and work in a darkened room to preview results. Take pictures of the most interesting variations. See exposure, page 203.

5. Set up a still-life group consisting of two or three neutral or pale-coloured, matt-surfaced items, lit either by daylight or by tungsten lamps. Have the camera on a tripod. Take three colour slides demonstrating radical differences due to *each* of the following changes in subject lighting: (a) quality, (b) direction, (c) contrast and (d) colour. Measure and set correct exposure for each picture, but make no other alteration. Compare results.

8

Organising the picture

This chapter is concerned with how you compose the image of your subject as a picture. It deals more with recognising and exploiting visual features of scenes and framing them up in the strongest possible way, rather than with technological knowledge.

Sometimes a photograph has to be composed in an instant, as some fast-changing action is taking place, so that exactly what you include and how it looks is changing every fraction of a second. Or your picture may be constructed quite slowly, as with a still-life shot painstakingly built up item by item. Most photography lies somewhere between these two extremes, but whatever the conditions there is always the need to make decisions on picture structuring. Basically you have to pick out from a mixture of three-dimensional elements, an image that works in two dimensions (perhaps translated into black and white too) and enclosed by corners and edges.

A successful photograph can be much more than a record. It should be able to tell you more, express or interpret more, than if you were actually there at the time viewing the subject itself. To achieve this you need to be a good organiser – being in the right place at the right time with suitable equipment, and perhaps any necessary props, models, lights, etc. You should also understand your technique – best use of perspective, lighting control, depth of field, exposure, etc. But perhaps above all you need the ability to know when all the visual elements look right and 'hold together' in a way that gives an outstanding visual result.

Often composition means simplifying from chaos, having a picture structure which is balanced and harmonious. Sometimes you may want the opposite, choosing imbalance and awkwardness, a kind of off-beat confusion which is the point of the picture or the way you decide to interpret the subject. Today, picture structuring is so subjective – open to individual style and original interpretation – that there are strong arguments for *not* having rules of composition. However, when you compare pictures that 'work' and are successfully structured for their content and purpose against others which are not, most of the long-established guidelines still apply. (In any case it is difficult to be a revolutionary until you know what you are revolting against.)

Good picture-making demands that you really notice subject features, and then structure this subject matter effectively within the frame.

Noticing subject features

We tend to take the things around us for granted. There is too little time to spare. It is easy to get into a state where we no longer really *look* at objects, but just accept them for what they are or do. Have you really examined that table, the apple in that nearby bowl, a stone brought in from the garden? Imagine that you have just arrived from another planet and, having never experienced these items before, set out to evaluate them. Try jotting down the list of *basic visual qualities* you notice about the table, for example. It has its own particular shape; it may have texture, pattern, form, colour and tone values.

Fig. 8.1 Grouping still-life objects together in the studio is often a problem of forming a satisfactory overall shape. Close viewpoint and camera movements (swing back here) help give dramatic perspective but mean you must finalise the position of everything meticulously, checking out the image on the focusing screen

Every object has individuality in this way and everybody can form their own analysis, deciding which are for them the strongest visual features. There are no academic 'rights' and 'wrongs' about such an assessment. It is personal to *you* – an opening to express feeling as a photographer and not just blandly record everything in front of the camera.

Like most people you are probably stimulated by a change of environment – a trip abroad, or just a visit to an unfamiliar building. Here you are seeing new things, therefore making new evaluations. After a while the environment becomes commonplace, objects are accepted and grow less interesting. A young child examines (looks, bites and presses) each new material it meets, naively making an analysis – hard or soft, rough or smooth. A good photographer retains this ability always to look freshly at the visual content of subjects and situations. It provides the starting point from which to decide what features to make prominent.

Shape

A bold shape or outline is one of the strongest ways to identify an object or person, dramatically so in the case of a silhouette or shadow. A shape can be formed collectively by a mixed group of objects or be

Fig. 8.2 'An Eastern Texan', Russell Lee's documentary portrait, works strongly through its use of a bold, simple shape, and the subject's direct relationship to the camera

just a single item. In Figure 8.2 it is the shape of the hat and wearer's face that gives this portrait its stark framework. When you are putting together a number of items – grouping a collection of still-life objects in the studio perhaps, or deciding whether to include various elements present in a landscape – you can often help to tie the picture together through some overall shape; see Figure 8.1.

Having several strong shapes invites comparison, and may relate otherwise quite dissimilar objects. One way of repeating shape is by hard, cast shadow. This can produce interesting variations, as when shadow falls on oblique or undulating surfaces. Hard sidelight may cast the shadow of one elevation of something alongside another (for example a face-on portrait with a profile shadow cast on a nearby wall). Shadow shapes also tell you about things outside your picture area.

The best way to stress shape is through your viewpoint and lighting. Use both to simplify and isolate subject outline against a contrasting, preferably plain, tone. Shallow depth of field will help you disentangle shape from background details.

To achieve the opposite and suppress a characteristic shape, cast a complicated shadow across it, or show it mixed in with foreground and background elements which have confusing patterns or textures.

Texture

Texture is concerned with surface – for example, the tight smooth skin of an apple, or the pitted surface of corroded metal. It can vary in scale from the rugged contours of a distant mountain range to a brick in close-up. The visual appearance of texture suggests the character of particular materials, and reminds you how they would feel to your touch. Texture can also be a symbol for the passage of time, from the bloom of youth to wrinkled old age. In fact subjects containing a rich

Fig. 8.3 Pattern is often created by a mixture of actual forms and cast shadows, like these plants in Morocco rear-lit by sunlight. Try to use variations within a pattern, and include some core or 'break'. Notice here how many lines are prevented from running directly out of the frame

mixture of textures are especially rewarding because of the ability to contrast or 'play off' one against another.

As Figure 8.12 shows, textures are best revealed by oblique lighting from the side or rear. Unless you are dealing with a single flat surface, try to work with light that is soft in quality, to avoid empty distracting shadows. To suppress texture use either predominantly frontal lighting, or backlight which throws the subject into total silhouette.

Pattern

The human eye seems to enjoy pattern, whether repetitive and formal, or irregular and off-beat. So by finding and exploiting a visual pattern in a scene you can create harmony, even transform something consisting of many disparate parts into a satisfying whole.

Pattern may be formed from a number of elements identical in size, shape and colour but irregular in distribution, like fallen leaves. Texture often creates pattern (although you can also find pattern on virtually textureless surfaces). Similarly multiples of *shapes* give pattern, perhaps varied by the effects of perspective, or contrasting colour or tone.

Look for strong, interesting patterns within the structure of a plant, or in a row of houses, a display of goods, or a group of people; see

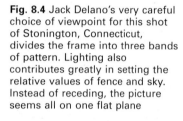

Fig. 8.4 Jack Delano's very careful choice of viewpoint for this shot of Stonington, Connecticut, divides the frame into three bands of pattern. Lighting also contributes greatly in setting the relative values of fence and sky. Instead of receding, the picture seems all on one flat plane

Fig. 8.5 Form revealed by sympathetic lighting and richness of tone preserved in exposure, development and printing. Edward Weston took this famous photograph of a pepper softly lit by daylight

Figure 8.4. Experiment with the effect of viewpoint, focal length, lighting, and the use of filters with black and white materials (page 167). There are no ground rules for lighting. Sometimes three-dimensional subjects, harshly side-lit, create a bold pattern of shadowed and lit areas. Sometimes soft, frontal illumination is best to show detail and suppress confusing texture in a mainly two-dimensional pattern.

Patterns are like musical rhythms which you can sometimes make dominate, or more often use as supportive 'backing', echoing or contrasting your main theme. In fact it is often the *breaking* of a pattern that gives emphasis to your chosen main subject.

Form

Form is to do with an object's volume and solidity. It is best shown in two-dimensional photography through tone graduation (shading), although shape contributes greatly too. Forms range from the natural flowing curves of a simple vegetable like Figure 8.5 to the geometric

Fig. 8.6 Dark, sombre, black and
white tones set the low key mood
of Bill Brandt's 1930s view of
Halifax. (This documentary shot is
often printed as a fine-art image
with the top half much darker,
and road and railway highlights
picked out with ferricyanide
reducer)

man-made structure of a building. They include things as diverse as the human figure, the monumental form of a giant rock, or a delicate flower. Some dramatic-looking forms are transient and not really solid or physically 'feelable' at all. Cloud formations, waves, the briefly held form of a wind-blown flag are all of this kind.

Learn to recognise form in objects irrespective of their actual function. A pile of old oil drums or a simple crumpled ball of paper can become as stimulating to photograph as a superbly designed car. Often this is the challenge – to make something that seems ordinary and familiar to others take on a new intensity of appearance. It is handled through your use of camera angle, perspective, lighting and the qualities of your final print.

Colour and tone

The colours and tone values in a scene contribute greatly to emphasis and to mood. The relationship of object colours themselves, plus any predominant colour in the lighting (due to surroundings or the light source itself) can have a harmonious or discordant effect. Colours close to each other in the spectrum tend to blend, while widely separated colours contrast (Figure 9.25).

Colour scheme is important too. A scene dominated by greens and blues suggests coldness and shade. Reds and yellows have the opposite association of warmth and sunlight. Notice how any element with a contrasting colour, or forming a small area of intense colour among muted hues, will appear with great prominence. Make sure that it really is intended to be important when shooting in colour, and remember it may lose this emphasis in black and white. Unwanted areas of colour can be subdued by cast shadow or shot against the light, or simply obscured by some close foreground object.

Often a scene with quite subtle colour values makes a more satisfying colour photograph than a gaudy mix of strong colours, although of course this will depend on the mood you want to create. A crowded fairground or street will look busier packed out with many contrasting colours, while a romantic landscape is more likely to be given strength and unity through limited, perhaps sombre, colouring.

The range and distribution of tone values (scale of greys) contained in a scene has its own effect on mood. Large areas of dark are easily associated with strength, drama, mystery and even menace. Scenes that are predominantly light in tone suggest delicacy, space and softness. You can exaggerate tonal values in a picture, especially in black and white photography (because colours are not then distorted too). Use their influences to help set the scene constructively.

If the lighting is contrasty you have the option of showing your main subject in a small lighted area and setting exposure only for this (page 202) to give the rest of the scene a 'low key' effect. Or, if the subject can be in a small area of shadow and you expose solely for this instead, lit parts become bleached out, helping to give 'high key'. Remember to choose a viewpoint or arrange the subject so that the main tone of background and foreground help along the scheme of your shot. Colour filters on black and white film can help too (Figure 9.28), by darkening chosen coloured areas, such as blue sky.

Notice how the distribution of tone values adds to your impression of depth and distance too, especially with landscape. Atmospheric

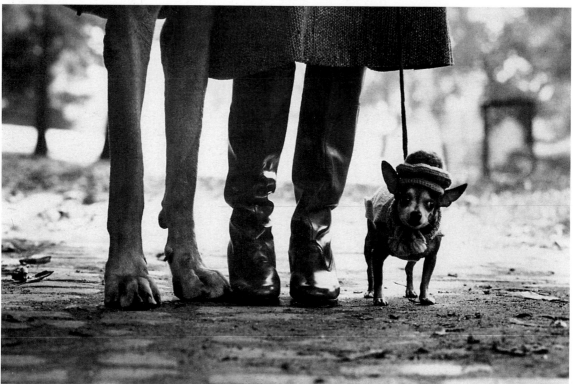

Fig. 8.7 Aerial perspective – the visual impression of distance through changing tone values – is a strong feature of Nick Rogers' misty landscape. The relatively close microlite aircraft is emphasised through being the only fully black element present

Fig. 8.8 A warm colour scheme strengthens the atmosphere of a summer storm in this shot taken of London's Hyde Park by Pradeep Luther. The muted landscape and dark cloud give the distant colourful rainbow and sunlit building great prominence

conditions often make objects look paler in both tone and colour with distance. Overlapping hill folds, trees, buildings, etc., at different distances appear like a series of cut-out shapes in different tones – an effect known as aerial perspective.

Movement

Movement is very apparent to the eye (even at the extremes of our field of vision we are highly sensitive to movements, probably for self-preservation). Fast movement makes subjects appear like streaky shapes, especially if they are close. Looking from the side of a moving vehicle, for example, close parts of the landscape whizz past while the horizon moves hardly at all. Movement seen against other movements in differing directions gives a sense of dynamic action, excitement or confusion.

Fig. 8.9 The humour in Elliott Erwitt's visual pun is partly the subject itself, but comes mostly from his masterly use of viewpoint, which exploits shape, scale and cropping

Fig. 8.10 This spinning fairground rise takes on a totally new dynamic form when spread and blurred by a one-second exposure. Having the camera firmly supported records stationary objects sharp, which helps 'play off' the movement and give a spectator's eye view. Compare with Figure 8.27

In still photography, moving images often record as unfamiliar forms and shapes *not* seen when you were watching the subject at the time, because the exposure onto film was much longer or shorter than the eye's own perception. This timing translation has to be anticipated, chosen, and as far as possible controlled.

Content and meaning

Most of the subject's features discussed so far have been concerned with narrow physical detail. Shape, texture, colour, etc., all have a combined effect on the appearance of things, to be stressed or suppressed according to their interest and importance. But these are also components in your subject's much wider content and meaning.

Perhaps significance hinges on juxtaposition of something expensive and luxurious against something cheap and tacky. It could be a particular action when someone is doing a job, or using equipment. Or it might be a facial expression that reveals some relationship – say between people and notices, or animals and children. They are all ways in which you can express *concepts and emotions* like craftsmanship, concern, bewilderment, aggression or joy.

Often meaning can be communicated by straight recording – the subject 'speaks for itself'. Sometimes (and this is usually more challenging for the photographer, and interesting for the final viewer) it operates through subtle use of symbols. For example, the cast shadow of a row of railings or a pile of timber can be made to look menacing, like some advancing horde. Use of 'old against new' can say something about ageing, irrespective of your actual subject. It is in this communication of symbol, metaphor and feeling that your ability to see and use basic subject qualities becomes especially important.

Structuring the picture

You can only go so far in looking at the subject direct. Picture composition must be done looking through the camera, because this brings in all kinds of other influences. Some are helpful, others less so.

The most obvious change is that you now have to work within a frame having distinct edges, corners and width-to-height ratio. The viewfinder or focusing screen is like a sheet of paper – you don't have to be able to draw on to it, but you must be able to see and structure pictures within its frame and give due thought to balance and proportions of tone or colour, the use of lines, best placing of your main feature, and so on. Some viewfinder systems make composition much easier than others. A small direct-vision finder, or the upside-down picture on a view camera screen, takes more time and practice to 'compose through' than the viewfinding optics of a modern SLR.

Using your camera as well as your eye means too that you add in all the techniques of photography, such as shallow or deep depth of field, blur, choice of focal length, etc. – hopefully to strengthen rather than detract from the points you want to make.

Fig. 8.11 Hands, or a colour slide mount, can quickly forecast how a scene will look – isolated and composed within a picture format. Position your eye the same distance from the slide mount as your camera lens's focal length to see how much is included. Alter this distance to preview other focal lengths

Fig. 8.12 Bruton Dovecot, Somerset. A picture by Fay Godwin structured through its viewpoint and lighting to give a strong horizontal flow

Fig. 8.13 Composition giving a dramatic vertical swing up to the figure shapes, by exploiting subject lines and using tall picture proportions

Proportions

Most cameras take rectangular pictures, so your first decision must be whether to shoot a vertical or a horizontal composition. Sometimes this choice is dictated by the proportions of the subject itself, or by how the result will be used (horizontal format for TV, vertical to suit a show-card layout or magazine cover). Often, however, you have a choice.

Of the two formats, horizontal pictures tend to be easier to scan, possibly because of the relationship of our two eyes, or the familiarity of movie and TV screen shapes. Horizontal framing seems to intensify horizontal movements and structural lines, especially when the format is long and narrow. In landscapes it helps increase the importance of skyline, and in general gives a sense of panorama, and of stability.

Vertical pictures give more vertical 'pull' to their contents. There is less ground-hugging stability, and this can give a main subject a more imposing, dominant effect. Vertical lines are emphasised, probably because you tend to make comparisons between elements in the top and bottom of the frame rather than left and right, and so scan the picture vertically.

Square pictures exert least influence. Each corner tends to pull away from the centre equally, giving a balanced, symmetrical effect. In fact this shape works well with formally structured symmetrical compositions such as Figure 8.14. However, many photographers find this 'least committed' of the three options the most difficult to work with.

Fig. 8.14 Standing stone, East Neuk. An unusual, near-symmetrical square format composition with the main subject blatantly dead centre, and the horizon splitting the frame. By Fay Godwin

You are not always restricted to a particular picture shape by subject proportions. A predominantly vertical subject can be composed within a horizontal format, sometimes by means of a 'frame within the frame' – showing it within a vertical area naturally formed by space between trees or buildings, or through a vertical doorway, window or mirror. It is also possible to crop any picture to different proportions during enlarging, producing either a slimmer or a squarer shape.

Some leading photographers feel strongly against any such 'manipulation', even to the extent of printing a thin strip of the film rebate all round the frame to prove it remains exactly as composed in the camera. Others argue that keeping every picture to camera format proportions is monotonous and unnecessary, and that cropping during printing is no

different from excluding parts of the subject from the viewfinder when shooting. Professionally, too, you may often have to produce results to proportions strictly imposed by a layout (pages 150–151).

Balance

Your combination of subject and the camera's viewpoint and framing often divide up the picture area into distinctly different areas of tone, colour and detail. Frequently these are the shapes and proportions of objects themselves, but sometimes they are formed by the way edges of the frame 'cut into' things: a cropped building or person, for example, is reduced to just a part. Think of these 'parts' as areas or bands of tone, pattern, colour, etc., which to some extent you can alter to different proportions, move around, and make to fill large or small portions of your picture, all by change of viewpoint or angle.

The main division in a scene might be the horizon line, or some foreground vertical wall or post which crosses the picture, or even the junction of wall and floor in an interior. With a distant landscape, for example, tilting the camera will shift the horizon, and might alter your picture content from the ratio one part sky:three parts land, to the reverse. When most of your picture is filled with dark land detail there is an enclosed feeling, and the added foreground makes scale differences and therefore depth more apparent. With most of the picture area devoted to sky the impression is more open and detached.

Fig. 8.15 Franco Fontana's 'Presence-absence' cleverly divides up the frame into strips and squares, putting some interesting shape into each. The final puzzle is to discover which are human and which are stone

Fig. 8.16 Frames within frames. Reflected in this mirror the family is grouped within one shape, placed beside the food on the sideboard like a picture in a frame. Mirrors, windows and doorways are all useful devices to relate one element to another

Fig. 8.17 Balance. Like weights at the end of scales, the shapes and tonal values here pivot about the old car. There is a kind of equilibrium about the bleak farmstead, but also a sense of deadness. Arthur Rothstein, FSA

A central horizon, dividing the picture into two halves, runs the danger of splitting it into areas of equal weight with neither predominating. Much depends on the range of shapes, colours and tones in each half. Occasionally, complete symmetry is useful as overall pattern surrounding and leading to a main subject.

The best placing of divisions depends on the weight of tone, strength of colour, and pattern of detail they produce in different parts of the picture. One approach is to go for a *balanced* effect (Figure 8.17) where weight of tone allows the picture to 'pivot' in the centre, but without being monotonous and over-symmetrical. On the other hand, a picture intentionally structured to appear imbalanced can add tension and will stand out amongst others. See Figure 8.22.

Line

You will improve the composition of pictures if you can use lines within your subject matter to give an appropriate structure or shape. They also help the mood you want to create.

Fig. 8.18 Thanks to the camera's single eye, lines can be built up within a composition from a chain of different objects at various distances. Fay Godwin shows this marker stone on the old Harlech road from a viewpoint which links it into criss-cross stone walling spanning the Welsh hills

Lines need not be complete outlines but a whole chain of spaced or overlapping shapes – clouds, hedges, a blurred movement, a background shadow – which your camera's single viewpoint sees as attached or linked together. In fact lines occur wherever a clear boundary occurs between tones or colours, with strongest lines where contrast is greatest. Subject lighting is therefore influential. Lines help to hold things together, give a flowing feeling to a landscape, 'round off' a group of still-life objects, or relate things in different parts of the frame; see Figure 8.18.

The general pattern of lines in a picture has an interesting influence. Well-spaced parallel lines and L shapes have the most tranquil, stable effect. Triangles, broad ovals or S shapes seem to offer more 'flow', encouraging you to view the picture more actively. Pictures with long, angled converging lines (formed by steep perspectives, for example) rapidly attract your eye to their point of convergence. A mass of short lines angled in all directions helps to suggest excitement, confusion and even chaos. Compare Figure 8.26 with Figure 8.3, for example.

All these reactions are probably linked to our visual experiences of life. Use them constructively. If you want a dramatic, dynamic image of a fast car, shoot it from a high or low angle, with steep perspective and bold contrasts. The same approach would be destructive for a gentle, romantic portrait, where a flowing open shape and graduated tones are much more helpful.

Emphasis

Try to ensure that everything included in the frame in some way supplements and supports (rather than dilutes or confuses) your main theme. The trouble is that photography tends to record too much, so you must be able to stress your chosen main element (or elements) relative to the rest of the picture. There are several well-proven ways of doing this. One is to choose a viewpoint which makes lines within the picture 'lead in' to the main subject; see Figure 8.21. You can also make your centre of interest prominent by showing it breaking the horizon or some other strong linear pattern.

Fig. 8.19 Emphasis by colour, contrasting with surrounding tones. Newspaper seller in Rome. Even the 0 and 8 formed by bits of string seem to possess surreal significance here

Fig. 8.20 Top: the so-called 'rule' of thirds. Dividing each side of the frame by three and drawing intersecting lines forms four alternative locations for strongly placing the main subject. Bottom: the Golden Mean of ideal proportioning (for the format itself or composition of subject areas within). Starting with a square, a line drawn from the centre of one side to an opposite corner becomes the radius of an arc. This defines the base line of the final 5:8 rectangle

Fig. 8.21 Scott memorial, Edinburgh. An example of composition making use of the rule of thirds

Fig. 8.22 No composition has to comply with rules. John Batho's 'Couple and Blue Sky' has a bold, lively effect because of its off-balance framing and restricted use of strong colours

Another method of emphasis is to show your main element against a background, or framed by foreground, which strongly contrasts in tone or colour. Choice of lighting is again important, see Figure 8.21. Camera techniques help to untangle subjects from surroundings too. Use shallow depth of field if things are at different distances; if one is moving relative to the other try panning (page 152).

There is a guide to the strongest positioning of your main subject within the frame, known as the *rule of thirds* (see Figure 8.20). This places an imaginary grid over the picture area, creating four off-centre intersections which tend to be strong locations. (A similar guide, much used in classical architecture and painting and called the *Golden Mean*, uses ratios of 5:8 instead of 1:2.)

Always remember such a guide but, like working only with a normal-angle lens, don't let it restrict and cramp your style. Sometimes the formality, or the tension, of your image will be better served if the main element is placed centrally, or against one edge. A shot can also be given *two* points of emphasis, and you can attract attention by placing them at opposite extremes of the frame so that the viewer scans from one to the other, making comparisons, conscious of distance and space.

Framing movement

You can alter your impression of active subjects by picture composition and choice of moment. Think of the frame as a stage. If the action is across the frame and you show the main subject at one side facing

Fig. 8.23 Framing action. Both these prints are from the same negative. By including most space in front of the boat (near right) the action seems to be just beginning. By reframing (far right) to crop the front and including more wake it seems that events are nearly over

inwards the activity seems just to have started. But if it faces outwards with all the space behind, the same subject seems to have travelled the distance, done the action.

You can make movement appear more dynamic and aggressive by composing it diagonally across the frame, angling vertical and horizontal subject lines, and if possible converging them too. Remember that even when no strong lines are present, a slow exposure (page 86), plus zooming and panning if necessary, will draw out highlights into powerful blur lines.

The timing of moving objects and rapid-changing situations can make or break a picture. Fast reaction may allow you to select and capture one brief decisive moment, summing up a whole event or situation. This could be a momentary expression, a key action (like breaking the winning tape in a race) or just two elements briefly included in the same frame and signifying something by their juxtaposition.

Commercial requirements

If you are producing pictures purely for yourself, or for a portfolio or exhibition with a completely open brief, there may be no-one else's requirements to take into consideration. But if you are a professional photographer given a commercial assignment, it is vital to adapt your freedom of approach to the needs of the job.

Commercial photography in its broadest sense (advertising, industrial, photojournalistic and even medical) is problem-solving. The problem may be mostly technical – how to get a detailed informative picture under difficult conditions. Or it might be much more subjective, perhaps concerned with creating atmosphere and mood.

Start off with a clear, accurate idea of all aspects of the problem via a briefing with the client, designer or editor. What is the subject, the purpose of the picture and its intended audience? You also need to know practical details such as final proportion and size, how it will be physically shown or reproduced, and what will appear around it.

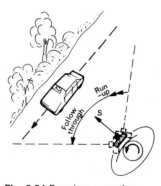

Fig. 8.24 Panning a moving subject. Shooting at about 1/15 second while panning the camera sideways can give a relatively stationary image of this moving subject. Background (and local parts of the subject not moving in quite the same direction) photograph blurred. Start to pan early to achieve smooth movement at the right speed when the shutter is fired (S), and follow through

Proportions

If your picture is to fill a space with fixed height-to-width proportions it will be a great help to mark up the camera focusing screen accordingly, and compose within this shape. As Figure 8.25 shows, by drawing a frame with the necessary proportions on paper and adding a diagonal you can scale it down to fit within any camera format. This is where it helps to have a camera allowing easy access to the focusing screen (including 35 mm SLR models with removable pentaprism).

Fig. 8.25 Transferring layout picture proportions to your camera focusing screen. Specified picture shape (A) is traced (B) and diagonal added. Aligning tracing with bottom left corner of focusing screen (C), the diagonal shows position for top of format. Wax pencil line drawn at this point gives you format (D), in same proportions as (A)

Use a black grease pencil to trace the new outline accurately on to the viewing side of your screen. In the same way you can mark out the precise areas where type matter or other images must finally appear within the completed illustration.

Preplanned proportions are not very practical with candid or press photography. Here they tend to follow on from picture contents rather than lead them. However, the art editor will thank you if you can cover the same subject in both vertical *and* horizontal formats. Ideally too, avoid tight framing, and leave sufficient content around the edges to allow cropping to slightly different proportions according to layout. (Of course you are then in the hands of the editor, who can destroy your composition – some photographers purposely make uncroppable pictures to avoid this situation.)

Size

The smaller your final picture the simpler its structure should be. If it is to be reproduced little larger than a postage stamp (or on coarse paper) aim for a bold, uncluttered image, perhaps with a plain and contrasting background. The larger the reproduction and the better the paper, the more detail and tone graduation will be preserved. If you know that your result will be displayed as a big photo-enlargement, for example, it is probably worth changing to a larger-format camera, or at least finer-grain film (page 162).

Managing the job

Having established the needs of the job – its 'open' aspects as well as its layout, content and approach – you can get down to planning. If you are working in the studio, what are the most appropriate accessories to include? Will some form of set need building or hiring? If it will be a location job the right place has to be found, and hired if necessary. Models must be short-listed through an agency, interviewed and chosen.

Lighting has to be thought out too. If you have to rely on natural light, consult weather forecasts for your location. Existing artificial light needs checking for its technical suitability. Tungsten or flash lighting units, and special equipment such as a wind machine, smoke machine or portable generator, may have to be hired. You must choose the most appropriate film stock – colour or black and white, negative or slide, plus instant picture material; see Chapter 9.

On the day, and with all necessary items brought together, you can put flesh on what has until now been the bare bones of a picture. Which are the subject's best features to exploit? What is distracting or irrelevant, and needs playing down or eliminating? Working through the camera, frame up the shot, checking proportions and balance. Is picture structure overpowering content? The main subject may require greater emphasis, through lighting, framing, relationship to other elements. Perhaps a different lens or change of viewpoint is the answer.

As shooting proceeds, instant pictures are taken to check that equipment is working properly, and to provide a quick print-out to compare against sketched layout. Later one roll or sheet of film typical of the shot will be test processed, then the remainder put through giving any modifications suggested by those first results.

Fig. 8.26 The eye seems to enjoy the sensuous pleasure of curved lines in pictures. The pattern in this weeping willow root seems to flow around smoothly, bringing you back to where you began

Fig. 8.27 The result of panning the camera at 1/15 second shutter speed. Notice how in the foreground and background vertical details disappear and horizontal highlights spread into lines. The picture gives an impression of moving with the cyclist. In bright light, shoot with slow film and a neutral density filter

Summary: Organising the picture

● Picture-building starts with recognising the basic visual qualities of your subject and needs of your picture, then emphasising or suppressing, and composing the resulting image in the strongest possible way.
● Look out for subject qualities such as *shape* (identification, framework), texture (feel and character of surface), *pattern* (harmony, rhythm), *form* (volume and solidity), *colour* and *tone* (mood, emphasis), and *movement* (action).
● Subject appearance must also relate to your picture's meaning and purpose. This brings in factors such as expressions and relationships, and the way we *read things into* objects and situations.
● Using a camera means working within a frame. Consider picture shape and proportions, balance of tone and colour, the use of lines to give structure and emphasis, and the positioning of your main subject.
● Seize every opportunity for a strong, structural composition even though you have to think and shoot fast. After a while composition becomes almost a reflex – but don't lapse into stereotyped pictures.
● Most professional photography is visual problem-solving. You need to (1) understand the purpose of the picture, (2) evaluate subject qualities in the light of this purpose, (3) compose the subject into an effective, satisfying image within the frame, (4) choose the right technical controls to carry through the idea, and (5) organise all aspects of the shooting session in a professional manner.

Projects

1. Choosing an appropriate subject in each case, produce four photographs. One must communicate texture, one shape, one form and one colour – excluding the other visual qualities as far as possible.
2. Photograph a mousetrap twice, each picture meeting one of the following briefings:
 (a) An objective illustration in a catalogue distributed to hardware shops. Final size reproduction 36 × 54 mm, horizontal format.
 (b) A poster advertising the play *The Mousetrap* (the picture should simply and dramatically draw attention to the title, and that the play is a thriller). Final poster A2 size, vertical format.
3. Produce four pictures which portray *one* of the following concepts: power, space, growth, action.
4. Take several pictures in which the main element (or elements) is composed close to the *sides or corners* of the frame. Make this unusual positioning contribute positively to your results.
5. Looking through books of photographs, find examples of pictures structured mostly through the considered use of (1) lead-in lines, (2) divisions or compartments within the frame, (3) patterns or textures, (4) high key, (5) low key, and (6) shape.

9
Camera films and filters

Having composed and formed the image at the back of the camera, the next stage is to record it permanently by 'getting it on to film'. One day capturing the image will be done purely electronically, using a light-sensitive chip and digital recording, in a manner similar to video. However, there are still technical problems to overcome in terms of satisfactory image quality at an acceptable capital cost, and for some time yet we shall still be shooting on *chemical* recording materials. They use light-sensitive compounds of silver, a system dating back some 150 years to earliest photography, although enormously improved in sophistication and performance.

This chapter discusses the various kinds of films, outlines how they work, their practical performance and their suitability for various types of work. The biggest distinction occurs between colour and black and white materials. *Colour* records more information, allows you to use extra variables in composition, often gives greater viewer-impact, and the results relate more closely to what you saw through the camera. *Black and white* is more restrained, more of an interpretation of reality; it allows very strong use of shapes and tonal range to show form, is cheaper to reproduce, avoids technical problems of wrong-colour lighting, and has more tolerance in exposure and processing.

Nevertheless, colour and black and white films share plenty of common ground. Speed rating, the relationship of graininess and sharpness, response to colour values, contrast, and the different physical forms camera materials take, are all important features. It is also relevant to look at filters here, because their use links up closely with the colour response of films.

Silver halide emulsions

Chemical change by light

Photographic materials are coated with crystals of silver halide, usually silver bromide. Within each minute crystal the atoms are electrically charged (in which state they are called ions) and spaced out evenly as a cubic 'grid' by electrical attraction (Figure 9.1). There are also a

Fig. 9.1 Action of light on a minute part of silver halide crystal. Left: unexposed atomic structure contains positively charged silver and negatively charged bromine ions (maintained by their electrical attraction) plus some unattached silver ions and sensitivity specks or crystal defects. Right: light donates photons, which release electrons from bromine ions. Electrons collect at the sensitivity specks, attract an equal number of the free silver ions, and combine with them as silver atoms. The tiny silver deposit triggers development during later processing

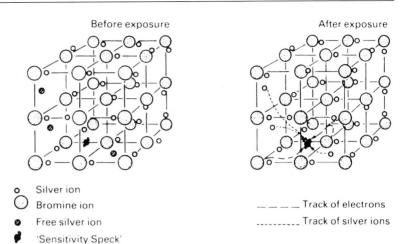

Before exposure After exposure

o Silver ion
◯ Bromine ion
◉ Free silver ion
♠ 'Sensitivity Speck'

_ _ _ _ Track of electrons
.......... Track of silver ions

number of free-to-move silver ions, and some crystal imperfections (called sensitivity specks), which have a vital role.

Things begin to happen when crystals are struck by light-energy particles ('photons', see page 21). The result is a small build-up of uncharged silver atoms, converted from the free silver ions, which accumulate at the sensitivity specks. Tiny deposits of dark silver form here, but they are far too small to see as any visible change, even through a microscope. If you give vastly more light, such as leaving the material in sunlight for several minutes, crystals do begin to darken slightly. In the camera, however, you need only give brief exposure to the relatively dim image – accumulating just sufficient photons to give tiny build-ups of silver atoms.

Most photons are received from bright parts of the scene, and least from where it is darkest, so you have all the components of a photographic image but in an invisible or 'latent' form. Later, at the processing stage, chemicals go to work on the tiny silver deposits forming the latent image. They will be grown and amplified enormously to give a visible, black chemical image; see Chapter 11.

How film is made

Approximately half the world's production of silver is used by the photographic industry. Bars of the metal are dissolved in nitric acid to form silver nitrate, and this is combined with a *halogen* element (typically iodine, bromine or chlorine in the form of alkali salts or *halides*, potassium iodide, potassium bromide or potassium chloride). After by-products have been removed the resulting compound consists of *silver halide* crystals, which are light-sensitive. So that these finely divided silver halides can be coated evenly on to film base, they are mixed with gelatin to form a creamy mixture known as a *silver halide emulsion*.

Gelatin is used because it is highly transparent and grainless. It becomes a liquid when heated – ideal for coating – but also sets ('gels') when chilled or dried. It holds the silver halides in a firm, even coating across the film surface, yet it will swell sufficiently in processing solutions to allow chemicals to enter and affect halide crystals.

Fig. 9.2 Electron photomicrograph of silver halide crystals, shown here approx × 3000

Fig. 9.3 Grain size and contrast. Emulsion with slow. equal-size grains tend to be slow and contrasty. All grains become developable (far right) at one triggering light level. Mixed large and small grains (near right) can yield a range of tones related to light received. They are also faster

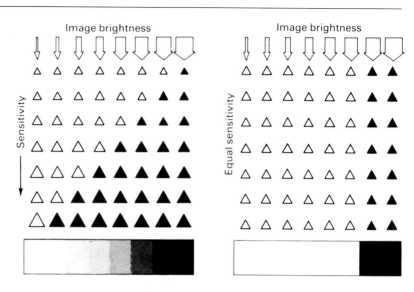

In detail, modern film manufacture is very complex and demanding. Mixed emulsions are given additives and held for fixed periods at controlled temperature to 'ripen'. This makes some crystals ('grains') grow larger, giving increased light sensitivity (greater 'speed') and producing less extreme contrast. Film contrast changes because, when

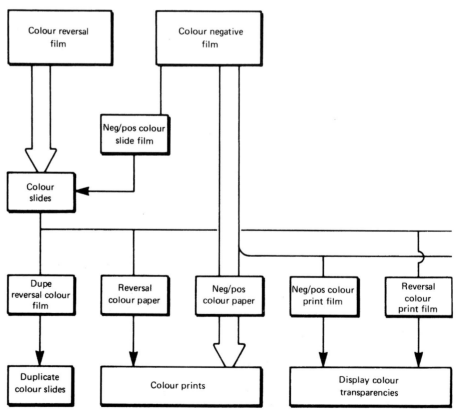

Fig. 9.5 The main types of camera film, and the routes, including crossovers, to different forms of final result

Fig. 9.4 Cross-section of black and white film. A: scratch-resistant gelatin top coat. B: one or more emulsion layers. C: foundation which improves adhesion to film base. D: gelatin anti-curl backing (may also contain anti-halation dye)

first formed, crystals are all very small and not particularly sensitive. They are affected by light equally; see Figure 9.3. When an emulsion has mixed sizes (mixed sensitivity), however, low-intensity light affects large crystals only, more light affects large and medium sizes, and brightest light affects all crystals, even the smallest. When the film is developed, these variations in light intensity therefore record as various grey *tones* rather than simply extremes of black or white.

Further traces of dyes are added to alter the emulsion's sensitivity to coloured light. In its raw state emulsion responds to blue and UV only,

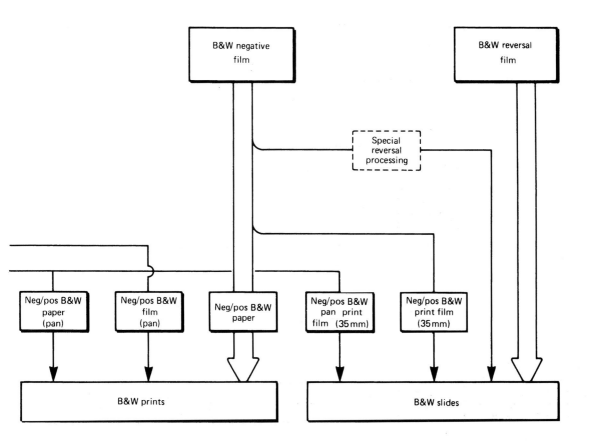

like (graded) black and white printing paper, but this can be extended to further bands or the whole visible spectrum. Meanwhile the film's base (most often polyester or tri-acetate) must receive several preparatory coatings:

1. Anti-curl gelatin layer is applied to the back to prevent the film shrinking or curling when the emulsion is coated on the front.
2. Anti-static treatment prevents a build-up of static electricity under very dry conditions, which can cause a spark when film unrolls.
3. A dark 'anti-halation' layer prevents light reflecting back from the base and forming 'halos' around the images of bright highlights. This dark layer may be between emulsion and base, or coated on the back of the film.

In addition, 35 mm film has grey dye in the base to prevent light passing into the cassette, piped along the thickness of the film. Anti-halation material disappears during processing.

Emulsion coating itself is extremely critical, and carried out in ultra-clean conditions. Black and white films may need three or four layers, while most colour films have more than ten layers of several different colour sensitivities. The final layer is clear protective gelatin. (For details of the structure of instant-picture materials, see *Advanced Photography*.) Film is coated in large rolls, typically 1.5 m wide by 900 m long. After drying, this is cut down to the various standard film sizes, either perforated (double for 35 mm, single for APS) or notched (sheet film), and edge printed.

Figure 9.5 shows the main forms of colour and black and white camera material for general photography. Many types are also made for X-ray, infra-red, lithographic and other special purposes. You can often shoot on one film and end up with a form of result normally produced from another – black and white prints from colour negatives, for example, or black and white slides from black and white negatives. But the most regular route, with fewest stages, always gives best quality. This is why it is important to know in advance what is finally needed from a job, in order to shoot on the right materials in the first place.

Features common to all films

Sizes and packings

Figures 9.7 and 9.8 show the main types and sizes of film. Disc and 110 cartridge film is designed for minute-format simple cameras. The range of emulsions here is very limited, usually colour only. APS films are 24 mm wide and come in cartridges which open and self-load inside the camera. The picture format is 17×30 mm, with 15, 25 or 40 exposures per film.

35 mm film is marketed in cassettes giving 12, 24 or 36 exposures of standard 24×36 mm format. The widest range of colour and black and white emulsions is made in this size. Some popular 35 mm emulsions are available as 50 ft and 100 ft (or 15 m and 30 m) lengths in tins. This bulk film is for cameras with special film backs (page 92), or it may be cut into short lengths to refill regular-size reloadable cassettes. Doing your own reloads reduces film costs but risks scratches and dust, even though you may use a bulk-film loader (Figure 9.6). It is false economy for professional work.

Fig. 9.6 35 mm bulk-film loader. Once it has been loaded with up to 30 m of film in the dark, you can insert and fill 36-exposure reusable cassettes in normal room light

Fig. 9.7 A range of packaged film materials, including (S) sheet film, (C) APS cartridge, (D) disc, (P) peel-apart instant-picture pack and an enveloped sheet, (B) bulk 35 mm. See also Figure 4.12

Rollfilm, rolled in backing paper on a spool, and coded 120, is 6.2 cm wide. The number of pictures per film depends on your camera's picture format; see Figures 4.13 and 9.8. 220 film is on thinner base, allowing twice the length and number of pictures on the same spool size as 120. Some double-perforated 70 mm films are available in 100 ft cans for bulk rollfilm-back cameras.

Sheet films packed 10, 25 or 50 per box come in several standard sizes. The edge-notching (Figure 9.9) helps you locate the emulsion surface when loading film holders in the dark, and has a shape code by which you can 'feel' film type, as well as identify it after processing. All films except bulk lengths have further type and batch identification data printed along their edges, but as this is printed by light it shows up only after processing. Check the manufacturer's information sheet to decode information.

Fig. 9.8 Film sizes – main camera materials

Film width	Maximum picture width (nominal)	Size coding	Notes
	10.6 mm	Disc	15 exposures per disc (largely discontinued)
16 mm	13 mm	110	Single-perforation; cartridge
24 mm	17 mm	APS	Perforations one edge; cartridge
35 mm	24 mm	135	Double-perforation; cassette
35 mm	28 mm	126	Single-perforation; cartridge
6.2 cm	6 or 4.5 cm	120	Unperforated, rolled in backing paper; gives 12 frames 6 × 6 cm, 10 frames 6 × 7 cm or 15 frames 6 × 4.5 cm
		220	As 120 but double length
7 cm	6 cm	70 mm	Double perforation; bulk film for cassette loading

*Camera sheet material sizes**

4 × 5 in	Also instant-picture single peel-apart units
9 × 12 cm	
5 × 7 in	
10 × 8 in	Also instant-picture single peel-apart units
3.25 × 4.25 in	Instant picture packs (fit special backs for rollfilm, e.g. 6 × 6 cm cameras)

*The actual cut size of sheet film is minutely smaller, to slip into holders.

Fig. 9.9 Typical sheet film notch codes. A: A typical transparency film (daylight). B: A transparency film (tungsten). C: A black and white film. D: most graphic-arts specialist films

Fig. 9.10 Instant-picture materials: (top) integral and (bottom) peel-apart types

Fig. 9.11 Film speed ratings. The ASA scale is linear – if the rating is doubled the film sensitivity is doubled. DIN ratings follow a logarithmic progression because they are related to film density (page 294). ISO combines both

Instant-print sheet materials are mostly used in ten-exposure packs $3\frac{1}{4}$ × $4\frac{1}{4}$ in or $3\frac{1}{4}$ × $3\frac{1}{4}$ in, or individual sheets 5 × 4 in or 10 × 8 in in special envelopes. They are of two main types (Figure 9.10). 'Integral' material ejects from the pack holder after exposure as a plain card, which forms a picture as you watch. 'Peel-apart' material is removed as a sandwich of two sheets that you leave together for a timed period, then peel to reveal a print on one sheet. Most packs are intended to fit amateur-type cameras designed exclusively for instant pictures, but there are pack holders to attach to the back of a view camera or a rollfilm reflex with magazine back. They allow you to produce a quick print using all or part of the instant-picture sheet. Most holders are designed for peel-apart material – the final image from a regular camera would otherwise be reversed left-to-right. Where a holder is designed for integral material it incorporates a mirror to overcome this problem.

APS films form part of a simplified handling system designed principally for amateurs, and closely linked to automatic photo-finishing machinery in commercial laboratories. Unlike the slightly larger 35 mm cassettes, APS cartridges have an external visual display showing whether their contents are exposed, unexposed etc. (see Figure 4.12b). The silver halide film itself carries an additional magnetic edge stripe able to record data – for example information from the camera on whether flash or ambient light was used. This also logs the user's choice of three viewfinder settings for different picture format ratios, and so programmes an automatic printer at the lab to enlarge the appropriate area of the negative (see page 232). (For 'panoramic' prints strips top and bottom of the picture are masked off Figure 4.13b.) Negatives are returned uncut in the original closed cartridge, which can also be inserted in any APS compatible film scanner forming part of a home computer system.

Speed rating

Film sensitivity to light is denoted by an emulsion speed figure, following strict test procedure laid down by standardising authorities. Systems change from time to time. At present most manufacturers quote an ISO (International Standards Organisation) figure; see Figure 9.11. This combines previous American-based ASA ratings and European DIN ratings. The *first* ISO figure doubles with each doubling of light sensitivity; the *second* number (marked with a degree sign) increases only by 3 with each doubling of sensitivity. Often the first ISO figure forms part of the film's brand name.

Your film's speed rating figure is based on standard conditions of lighting, typical exposure times and processing. If you intend to increase or decrease development from normal you can 'uprate' or 'downrate' film speed when exposing; this may be helpful when you

ISO	25/15°	50/18°	64/19°	100/21°	125/22°	200/24°	400/27°	640/29°	800/30°	1000/31°	1600/33°	3200/36°
Speed		*Slow*			*Medium*		*Fast*				*Ultra-fast*	
Grain			*Fine*				*Medium*			*Coarse*		
ASA	25	50	64	100	125	200	400	640	800	1000	1600	3200
DIN	15°	18°	19°	21°	22°	24°	27°	29°	30°	31°	33°	36°

Indicated exposure time (s) ▶	$\frac{1}{10,000}$	$\frac{1}{1,000}$	$\frac{1}{100}$	$\frac{1}{10}$	1	10	100
B & W negative	+ $\frac{1}{2}$ stop	none	none	none	+ 1 stop	+ 2 stops[†]	+ 3$\frac{1}{2}$ stops[†]
Colour negative	none	none	none	none	+ $\frac{1}{2}$ stop	+ 1 stop	+ 2 stops
Colour slide* (daylight)	+ $\frac{1}{2}$ stop	none	none	none	+ 1 stop 15B	+ 1$\frac{1}{2}$ stop 20B	Not fully correctable
Colour slide* (tungsten)	none	none	none	none	+ 1$\frac{1}{2}$ stop 10R	+ 1 stop 15R	Not fully correctable

*Colour correction filters vary with brand.
†Reduce development time by 20–30 per cent.

Fig. 9.12 Reciprocity failure: typical exposure/filter compensation required

Fig. 9.13 Reciprocity failure colour distortion. Exposure needed for this late dusk shot of Athens was 20 seconds. To compensate for RF effect on speed, lens was opened two stops (Figure 9.12). The pink/magenta cast is acceptable as suggesting evening light – in fact it was so dark that only lighted windows could be manually focused

want to alter contrast (page 226), or simply get maximum possible speed out of a film in dim conditions.

Exceptionally long or short exposures also influence film speed. Normally

Exposure = intensity × time

meaning that longer exposure to a dim image has the same cumulative effect in forming the latent image as shorter exposure to a brighter image. (This 'reciprocal' relationship is the whole basis of controlling exposure using aperture and shutter settings.) In practice, however, films behave as if they have less light sensitivity when exposures 1 second or longer, or 1/10000 second or shorter, are given. See Figure 9.12. This is called *reciprocity failure*, and also affects the various

Fig. 9.14 Relationship between film speed, sharpness and graininess. The faster the speed (emulsion C) the lower the resolution and the coarser the grain tends to be, relative to slower emulsions A or B. It is comparatively easy for manufacturers to make trade-offs between the three factors but difficult to increase the triangle area

Fig. 9.15 Typical examples of the image grain given by (left) ISO 32/16° (centre) ISO 125/22°, and (right) ISO 1000/31° films. Each film was processed normally in its recommended developer and is reproduced here enlarged approx × 32, equivalent to a print 45 inches high from the whole of a 35 mm format image

layers in colour films by different amounts, resulting in a colour cast. For critical work on slide films you often need a correcting filter.

Short-duration reciprocity failure is seldom met in practice except when using high-speed flash, but long-duration failure quite often occurs in dim image situations – night shots, etc. As the table shows, it is best to allow for this by widening the aperture (intensity) rather than further extending time. If you are exposing in highly coloured light or using film which has passed the expiry date stamped on its box, these factors too may give you a slower effective speed rating (plus lowering of contrast).

35 mm films have checkerboard codes printed on their cassettes. These allow contacts in the camera's cassette compartment to sense film speed electronically and so set the internal exposure meter automatically. If you want to uprate or downrate the film's normal speed, you must do this with the camera's exposure compensation dial (page 72). (The checkerboard code also communicates film length to the camera's exposure-counter mechanism.)

Grain and sharpness

Graininess refers to the pattern of grain clumps in the processed image. If this is coarse it will show up as a mealy pattern and break up delicate tone values when enlarged. Emulsion sharpness or 'acutance' is concerned with the degree of fine image detail the film can record. This brings in local contrast or edge sharpness, as well as grain, for an image can be fine-grained yet lack 'bite' because detail is flat and grey.

Film speed, graininess and sharpness are traditionally linked. As Figure 9.14 shows, it is hard for a manufacturer to improve speed without increasing the size of silver halides and so also coarsen grain. And if the emulsion is made thicker to obtain speed by containing more halides there may be minute scatter of light ('irradiation') within this sensitive layer which worsens sharpness. Modern flat-shaped 'tabular' grains offer more speed with less sharpness loss, but your choice of film is still a trade-off between speed and image quality. Fast films are inherently grainier than slow films, and the more enlargement your film is to receive later the more important this fact becomes.

Sometimes you may choose fast film intentionally to get a granular effect, Figure 9.16 for example. More often this choice is made because

Fig. 9.16 A moody, low-key shot taken on ISO 1000/31° film, then given extended processing and enlarged onto contrasty paper to maximise grain

the subject is dimly lit, and perhaps you need to stop down for depth of field *and* freeze movement with a short exposure. One way to reduce your grain problem and improve sharpness is by changing to a larger-format camera, because the film image will need less enlargement, but you will then have to stop down farther for the same depth of field.

Graininess is increased and sharpness reduced by overdevelopment and overexposure. In black and white photography there are numerous fine-grain and high-resolution developers to choose from, but they may reduce film speed too; see Chapter 11.

Response to colours

Film emulsions are sensitised during manufacture to some or all the colours of the spectrum. The vast majority of black and white films are given 'panchromatic' colour sensitivity, meaning that they respond – in monochrome – to virtually the whole of the visual spectrum as well as to shorter UV wavelengths (Figure 9.18). Notice that this response does not quite match the human eye's concept of light and dark colours. Pan film 'sees' (reproduces on the print) violet, blue and orange-red as somewhat *lighter* in tone and greens *darker* in tone than we would judge them to be. This difference is generally accepted, and is of some value in allowing slow pan materials to be handled under very deep green darkroom safelighting. For an exact match you can shoot using a yellow camera filter (page 169).

A few black and white films are made insensitive to the red end of the spectrum beyond about 590 nm, and are known as 'orthochromatic'. Ortho materials – mostly sheet film – are useful for photographing black and white photographs or drawings not involving colours. You can handle them in the darkroom safely under red illumination. Ortho films reproduce red as black on the final print, and orange as very dark. This can be of value in some forms of medical, forensic and scientific photography. Ortho film speed rating is lower when the subject is lit by tungsten light rather than daylight, because the former contains a higher proportion of red wavelengths.

Fig. 9.17 The reproduction of coloured pencils (see Figure 9.30 for actual hues) when photographed on (left) blue-sensitive, (centre) ortho, and (right) panchromatic films

One or two films, very slow and intended for darkroom rather than camera purposes, are made with blue (and UV) sensitivity only. You can also buy special films for camera use that are insensitive to almost the whole visual spectrum but respond to infra-red and UV; see *Advanced Photography*.

Fig. 9.18 Tonal reproduction of colours (final print) by panchromatic, ortho, and blue-sensitive black and white materials, relative to eye response. Remember these 'cut-off' wavelengths and colours for each type. All emulsions respond to ultraviolet down to about 250 nm – still shorter wavelengths are absorbed by gelatin

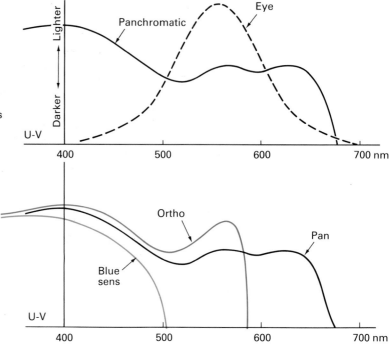

Fig. 9.19 Relative response curves for the three blue, green and red colour-sensitive emulsions used in a typical daylight-balanced slide film. Only response *above* the broken line is significant. Y, M and C stand for yellow, magenta or cyan dye finally formed in each emulsion to give a full coloured image; see Figure 9.30

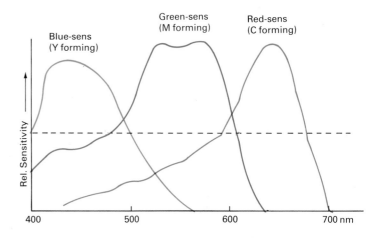

Fig. 9.20 One example of the complex multilayer structure of a modern colour slide film (relative thickness of layers only approximated)

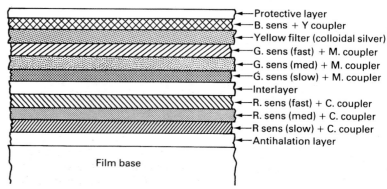

Colour films each have a stack of emulsion layers and use three different kinds of colour sensitisation (Figures 9.19 and 9.20). The top emulsion is sensitive to blue only; others respond to blue and green; and the remainder primarily to red. A yellow filter is incorporated below the blue-sensitive layer so that blue light cannot proceed farther into the film. Therefore you effectively have emulsions responding to blue only, green only, and red only – the three thirds of the spectrum. (Later each of these three emulsion types will form its image in a different *coloured dye*, to reproduce the image in full colour; see page 172.)

The precise balance or relative sensitivity of the three types of layer is carefully controlled during manufacture. Most colour films are balanced to give accurate colour reproduction when the subject is illuminated by daylight or flash (5000–6000 K). You can also buy a more limited range of tungsten-balanced films (once known as Type B films) which have slightly slower red-sensitive layers to give correct reproduction of subjects lit by red-rich 3200 K tungsten lamps. Apart from 'daylight' and 'tungsten' colour balance films, one or two exceptional materials are sensitised to infra-red or laboratory light sources.

Black and white films

Negative types

The majority of black and white films are designed to give you a negative image in black silver. In other words, the latent image recorded in the camera is strengthened into visible black silver during development, then the remaining creamy halides are removed leaving the film with a negative image (subject highlights darkest, shadows lightest) in clear gelatin.

General-purpose films range from about ISO 25/15° to ISO 1000/31°. The slower the film the finer the grain and the better its ability to resolve detail really sharply. Contrast – the range of grey tones formed between darkest black and complete transparency – is *slightly* harsher with slow films than fast films. This tendency is taken into account in the recommended development times, which tend to be shorter for slow films.

Films between ISO 125/22° and ISO 400/27° offer a good compromise between speed and graininess. However, ISO 400/27° film gives prints with a just visible grain pattern (noticeable in areas of even grey tone, such as sky) when 35 mm is enlarged to 10 × 8 in or beyond.

In general it is best to use the slowest film that subject conditions sensibly allow, especially when working on 35 mm. For occasions when you want to give long exposures to create blur in moving objects, this too will be easier on slow film (see also ND filters, page 179). However, slow film may prevent you from stopping down enough for depth of field, or necessitate a tripod in situations where it is impractical. Fastest film is necessary for reportage photography under really dim conditions, and action subjects or hand-held telephoto lens shots which demand exceptionally short shutter speeds.

A few black and white films give their final image in a brownish dye instead of silver. Extra components in the emulsion layers form tiny globules of dye wherever silver is developed. The processing you must

Fig. 9.21 A negative on black and white chromogenic dye-image film. Compare with subject in Figure 9.30

give these films is known as 'chromogenic' and finally bleaches away all silver, leaving your image in dye molecules alone. (The chemicals and processing stages needed are the same as for colour negative films; see page 225.)

The advantages of dye-image chromogenic films are (1) they are more able to tolerate inaccurate exposure – especially overexposure – than silver-image types, (2) you can choose to rate your film anywhere between ISO 125/22° and 1600/33°, provided you develop accordingly, and (3) grain pattern is smaller, softer-edged and more 'woolly' than silver. However, if used for its visual effect, this grain is less crisp and less attractive than silver; dye films also cost more, and you have much less choice of developers than with regular films (see page 223). Dye-image films are most popular for news and documentary photography because they suit a wide range of shooting conditions. They can also be processed in the automatic machines used in laboratories everywhere for colour negatives.

Line film

Some materials – mostly sheet film, but also 35 mm – are made with high-contrast emulsions. They give negatives with few or no greys at all between dense black and clear white, when processed in the appropriate contrasty developer. Line films and the more extreme lith films are intended for photographing printed texts, plans, pen-and-ink drawings, etc., which contain only pure black and pure white and need to reproduce in this form. Emulsions are very slow and fine-grain, and most often they are ortho or blue-sensitive for easy darkroom handling.

You can use line film to change images of full-tone-range scenes into stark black and white only (Figure 9.23). But because they are so slow and their high contrast demands absolute exposure accuracy, it is easiest to shoot the picture first on regular film, then reproduce this onto line

Fig. 9.22 High-contrast line films reproduce ink drawings (as here), diagrams, lettering, etc. in pure black and clean white only

Fig. 9.23 Line films can also be used to copy and convert a normal contrast print into a stark graphic image. Original shown in Figure 10.25

film by copying, or through printing in the darkroom. Line negative film is also excellent for making slides of black-line diagrams, which can then be projected as bold white-on-black images.

Slide films

There are three film types that allow you to make black and white slides direct with a 35 mm camera. These are:

1. Special slow, fine-grain 35 mm films (e.g. Agfa 'Scala') which must be sent to a nominated laboratory for black and white 'reversal' processing. The film is returned containing positive, full-tone-range pictures ready for projection.
2. Instant-picture film you process yourself in a simple unit (Figure 9.24) requiring no darkroom or washing facilities.
3. Suitable regular negative-type films which you then give special reversal processing (page 230).

All these materials can give excellent lecture slides, with rich tone-range, fine grain and extreme sharpness. But, as with all reversal-processed materials such as colour slides, you must get composition and exposure correct at the time of shooting because little adjustment is possible later.

Instant prints

There is a limited range of black and white instant-print materials, in either pack form or individual 4 × 5 in or 10 × 8 in sheets in special envelopes. Most function by 'peel apart' (Figure 9.10).

High-speed materials (ISO 3200/36°) are designed primarily to record through instruments such as microscopes or oscilloscope cameras. Others (ISO 400/27°) are for more general use, and some give a printable film negative as well as an instant print. Processing time is 15–30 seconds according to type. All these are useful to get immediate 'in progress' lighting, layout and colour-translation checks when shooting a black and white assignment using regular film. It is also reassuring to know that all the equipment works. You can buy instant material for high-contrast results, on paper or film.

Fig. 9.24 35 mm instant-slide film, with pack of processing fluid (A). Both are inserted in daylight processing unit B. See also Figure 11.28

Colour filters for black and white materials

Colour filters allow you to alter the tonal response to subject colours of a black and white film. A filter of any sort is a device for selecting and removing something from the general flow – impurities from water, dust from air, etc. A light filter is basically a transparent material which absorbs ('filters out') some wavelengths and transmits others. The rule is that a filter passes light matching its own colour, and absorbs other colours – particularly those farthest from it in the spectrum; see the colour wheel (Figure 9.25).

To see filter effects, first find yourself a bold, multi-coloured design – a book jacket or cornflake packet perhaps, or a motif like Figure 9.25. View it through a strong red filter (even a sweet wrapping will do). The whole subject appears red, but check how *light* or *dark* the original colours now appear. Strong blue and green subject areas are relatively

Fig. 9.25 Simplified colour wheel, based on the spectrum 'bent' into a circle. Oversize segments blue, green and red are the primary colours of light. Yellow, magenta and cyan are complementary colours, and (for filtering purposes) the most opposite to each primary

darker in tone, almost indistinguishable from black areas. This is because the light wavelengths they reflect cannot pass the filter.

Red parts of the subject, however, look much paler than before, practically the same as white areas since they reflect as much red light as the white areas do (the other colours that white reflects are absorbed by the red filter). The same tonal changes occur when the light source illuminating your subject is filtered instead of your eye or camera lens. Look at Figure 9.25 under a red ortho safelight in the darkroom.

Practical applications

Blue sky and white clouds normally record with the sky much paler than it seemed at the time, because film is more sensitive than the eye to blue (Figure 9.18). Clouds may therefore barely show up. But if you photograph on panchromatic film through an orange-red filter instead,

Uses	*Factors*	
	Daylight	*Tungsten*
Red	× 8	× 5
Darkens blue skies		
Turns red stains white		
Changes green against red into black against white		
Helps to reveal grain pattern in wooden furniture, etc.		
Orange	× 4	× 2
Like red but less extreme		
Yellow-green	× 5	× 4
Tones down blue skies		
Compensates for pan film oversensitivity to blues, deep reds, relative to eye		
Green	× 8	× 8
Darkens blue skies		
Turns green stains white		
Changes green against red into white against black		
Helps reveal detail in landscape foliage		
Blue	× 6	× 12
Lightens blue skies		
Turns red stains black		
Changes blue against deep yellow into white against dark		

Fig. 9.26 Filters in black and white photography. Colour chart (top) photographed on panchromatic film through deep red (centre) and deep green filter (bottom). The table summarises uses for a selection of filters

most of the blue is absorbed and white clouds stand out boldly against what is now dark sky. See Figure 9.28.

Using this filtration makes no change if the *whole sky* is white with clouds, and it has little effect if the sky is only weak blue (containing a high proportion of white light too). You must also consider any other colours present. If the sky is part of a landscape with green foliage, for example, the green darkens as well. A deep green filter darkens sky tone almost as much, but *lightens* the foliage instead.

A colour filter can be used to emphasise one coloured element in surroundings which, although a different colour, would normally merge with it in black and white. Filters strengthen or reduce coloured shapes, lettering etc., and even remove stains; see table in Figure 9.26. Any filter used to strongly increase or decrease tonal contrast is usually a deep colour, and is known as a 'contrast' filter.

One or two paler filters, normally yellow or pale yellow-green, are known as 'correction filters. They make colours record in grey tones closer to their *visual* brightness instead of that given by unfiltered panchromatic film. For most work this difference hardly shows. However, for landscape work with blue sky you could work with a yellow filter as standard. And a yellow-green filter will help give stronger caucasian skin tones and darker lips with portraits shot on fast pan (high red sensitivity) film in tungsten light.

Technical descriptions

The effect of a colour filter is often shown in technical literature as a graph (Figure 9.27). Since this graph has the same wavelength-calibrated base as emulsion colour sensitivity curves (Figure 9.18) you can relate the two. This proves, for example, how pointless it would be to use a red filter with ortho film – the filter only passes light to which the material is insensitive, so no image records. (Red provides a darkroom safelight colour for ortho materials.) Notice too how a pan film with a deep blue filter responds to colours in the same way as blue-sensitive emulsion unfiltered, while a deep blue-green (cyan) filter gives pan film the equivalent of ortho response.

Films and filters will not respond as expected when your *subject lighting* is not some form of white light source, i.e. containing the full

Fig. 9.27 Relative absorption/transmission curves for very deep blue, green and red filters – Kodak 47B, 99 and 25 – and pale blue filter CC10B

Fig. 9.28 Using filters. The top picture was shot on pan film without filter while the sun was diffused by a patch of thin cloud. A deep red filter was added for the bottom picture, shot a minute later when direct sun side-lit the building. Notice how filtering has darkened the mid-blue sky, the green grass and deep blue flag. Red tiles, however, appear lighter. Exposure was increased by two and a half stops

colour spectrum. Sodium street lighting, light from a red neon sign or red-dyed light bulbs, for example, contain little or no blue wavelengths. Using a deep blue filter (which only passes blue light) will be like leaving the lens cap on!

Filter forms

Colour filters are sold as thin square sheets of dyed gelatin or polyester which you either hold over the lens or cut down to fit a filter holder. These are relatively cheap but soon pick up finger marks and scratches if used often. Some filters are made in glass and sold

in circular mounts which screw into the front rim of your lens. The majority of dyed filters are now manufactured in optical (CR 39) resin, square in shape to slip into a holder. Remember that a glass or resin filter slightly alters the position of sharp focus, always focus with your filter in place, especially if shooting at wide aperture. Gelatins have no such effect.

Using a colour filter reduces the image light, but this is taken into account by a modern exposure meter located close to or behind the lens because it reads through the filter. When you are using a hand meter you will have to increase exposure by a 'filter factor', shown in the table in Figure 9.26. See also page 196. Other filters for general black and white photography include UV, neutral density, polarising and special-effects types which are discussed on page 178. Try to avoid using more than one filter at a time – their multiple surfaces progressively reduce image contrast and definition.

Colour films

Negative types

As shown on page 164, colour negative films carry in effect three types of black and white emulsion, recording blue, green and red respectively. They reproduce the image in *negative* tones and *complementary* colours. To understand complementary colours, look again at the colour spectrum of white light (Figure 9.29). If you remove all the red wavelengths from the spectrum, what remains appears not white but greeny-blue (called 'cyan'). Cyan is said to be complementary to red – opposite or negative to it in terms of coloured light. In the same way removing green produces a purply-red ('magenta'), and if you remove blue from white light you get a dominance of yellow. *Cyan, magenta* and *yellow* are therefore the complementaries of *red, green* and *blue* light. (Note: these differ from the complementary colours in paints and pigments.)

Each emulsion layer also contains a *colour coupler* chemical – a yellow dye former in the blue-sensitive layer, magenta in the green-sensitive layer, cyan in the red-sensitive layer. Couplers only turn into their designated colour dye when and where the silver halides to which they are attached are affected by light and developed in colour developer to black silver (Figure 9.30). So when towards the end of colour negative chromogenic processing (page 225) the silver is removed, what was originally the blue-sensitive layer contains an image in which all blue parts of the picture record as yellow. Similarly, in other layers, green parts record as magenta and red parts as cyan. Wherever the scene was some other colour the image is recorded in more than one layer, while white or grey records in all three. Viewed as one, the 'stack' of layers gives you the familiar colour negative image (plus a characteristic warm tint remaining in clear areas). During enlarging similar layers in colour paper give 'a colour negative of a colour negative', recreating subject colours and tones.

Most colour negative films are balanced for use with daylight or flash. If you use them in tungsten light instead, it is possible to make colour correction during printing, but this creates difficulties and restrictions owing to the amount of enlarger filtration required. It is far

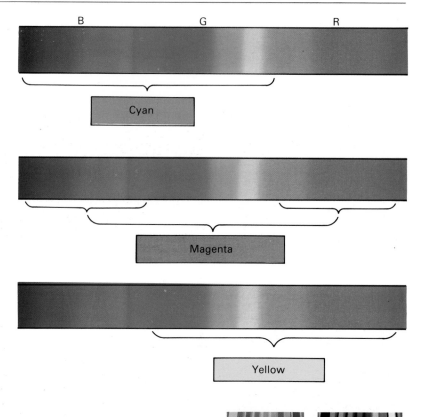

Fig. 9.29 When one-third of the spectrum (one of the primary colours red, green or blue) is removed from white light, the remaining mix of wavelengths appears cyan, magenta or yellow respectively. So each of these colours is a combination of two primaries and can be said to be 'complementary' to the missing third. See also Figure 9.25

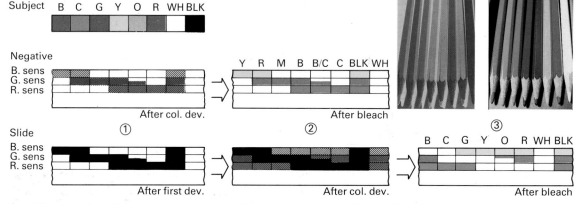

Fig. 9.30 How colour films reproduce colours. **Negative film**. 1: black silver develops and complementary dye forms where each layer responds to subject colour (compare this G and R response with Figure 9.26). 2: silver and remaining halides are removed, leaving negative image in dyes alone. **Slide-film**. 1: black silver develops only where layers respond. 2: remaining emulsion is turned into black silver plus dyes. 3: all silver is removed, leaving positive image in dyes alone

better to shoot on tungsten-balanced film instead, or use daylight type with a bluish conversion filter (Figure 9.31). Some colour-negative sheet films are tailored still more closely to their anticipated conditions of use, including reciprocity failure. Kodak Type L film, for example, is intended for tungsten lighting and 'longer' exposure times ($\frac{1}{50}$ to 60 seconds). Type S film is for daylight and 'shorter' exposures ($\frac{1}{10}$ second or less).

You have greatest choice of film speeds in 35 mm and rollfilm formats, from ISO 100/21° to ISO 1000/31°. Sheet films differ very little in speed, typically around ISO 100/21°. Like black and white material, fastest film shows more grain and gives poorer definition. Use 35 mm film of ISO 400/27° or above only if lighting and subject

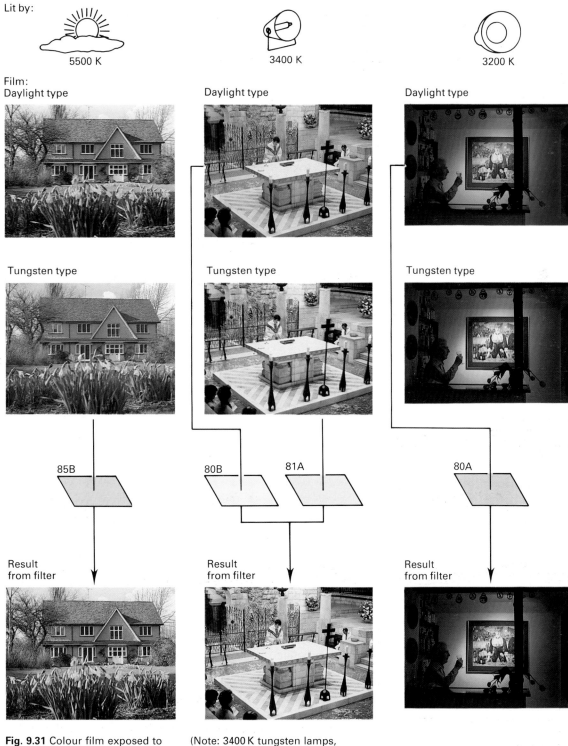

Lit by:

5500 K　　　　3400 K　　　　3200 K

Film:
Daylight type　　　　Daylight type　　　　Daylight type

Tungsten type　　　　Tungsten type　　　　Tungsten type

85B　　　　80B　　　81A　　　　80A

Result from filter　　　　Result from filter　　　　Result from filter

Fig. 9.31 Colour film exposed to subjects lit by a source of the wrong colour temperature shows a cast, unless you shoot using an appropriate conversion filter.

(Note: 3400 K tungsten lamps, regularly used for TV and movie lighting, require filtering on both daylight and tungsten stills-photography film)

conditions demand, or you want an image with a noticeable grain structure. Colour negative films offer less variety of emulsion contrast than black and white films. This and one kind of strictly standardised (C41 or equivalent) processing ensures the rigorous technical characteristics that images need to suit colour paper. (Special film such as Vericolor Internegative is made with adjustable contrast controllable by exposure level, and is designed for copying slides and colour photographs. It is used mostly by colour laboratories under carefully controlled conditions.)

Slide and transparency films

Colour films designed to give positive images direct include the suffix *chrome* in their brand name rather than *color*, which is used for negative types. For example, while Fujicolor is negative, Fujichrome is a slide film or (as formats larger than 6 × 6 cm are normally called) 'transparency' film. Chrome films are also collectively known as colour reversal films, because of the special reversal processing they must be given. These materials are especially important to the professional, as most colour pictures for reproduction on the printed page are preferred in this form.

All reversal films have a multi-layer structure, making use of blue-, green- and red-sensitive emulsions, and most have yellow, magenta and cyan dye forming couplers, similar to those in colour negative film. However, there are differences of contrast and a lack of 'masking' (see *Advanced Photography*), the result of which is that results have none of the overall pinkish tint characteristic of colour negatives.

During the first part of processing (page 228) only black and white developer is used, forming black silver negatives in the various layers. Dyes are then formed where the *unused halides* remain (Figure 9.30) so that when all silver is removed a positive, correct-colour image remains. For example, green foliage in a scene records on the green-sensitive layer and is developed as black silver there. The blue- and red-sensitive layers in this foliage area are not affected by the light and so form yellow and cyan, which together make the final image look green. A yellow flower records in the red and green layers (both sensitivities overlap into yellow wavelengths) but not in the blue. Black silver therefore forms in the red and green layers, yellow dye in the blue, resulting eventually in a yellow image.

The majority of reversal films are balanced for daylight or flash, but there are several tungsten-light films too. Daylight film needs a bluish filter if used with tungsten light; tungsten-balanced film needs an orange filter with daylight or flash (Figure 9.31). Image colour and density must be more accurately held than with negatives, as little correction is possible later, apart from some speed-rating compensation of complete films during processing.

Once again the widest range of films is available in 35 mm, from ISO 25/15° to ISO 1000/31°. Sheet films are generally around the middle of this range, each box containing a data sheet specifying the exact ISO speed and any fine-adjustment colour filtration needed for the particular batch. There are also subtle colour differences between reversal film brands, owing to the types of dye formed. Kodak Ektachrome, for example, has slightly 'colder' colours than Fujichrome or Agfachrome. Do not mix brands in covering any one assignment.

The vast majority of reversal films need what is called E-6 chromogenic processing and this, like C41, can be carried out by photographer or laboratory. Kodachrome, which is an older film type, needs a much more elaborate processing procedure (K-14) offered by various laboratories around the world, but these slow films offer exceptionally fine grain and sharpness and are much used by professionals when lighting conditions permit. E-6 films, on the other hand, can be much more readily adjusted during processing (page 229), either to correct overall exposure errors or to boost their speed. Some fast types can be uprated to 2–3 times their regular ISO figure this way, although the extra processing increases grain and contrast. They are a necessary choice for colour photojournalism under dim conditions.

Processed results from reversal film are brighter and richer in hue than colour negatives. They must have the brilliance of appearance expected in a final image, as opposed to an intermediate tailored to suit the characteristics of neg/pos colour printing paper later. Colour papers and other materials made for printing *direct* from slides therefore have to be very low in contrast in order to compensate, and they must also work by reversal to give a positive image from a positive image.

Special low-contrast transparency films are designed for copying slides, while others with boosted contrast are used for copying coloured line drawings, or low-contrast specimens photographed through the microscope, etc. You can also obtain false-colour infra-red Ektachrome for medical and aerial work, or special effects. Some of these materials use E-4 processing, offered by a few laboratories only.

Instant-picture 35 mm colour slide materials are made by Polaroid and known as Polachrome. These are processed in the same mechanical unit as black and white instant slides. They work on an 'additive screen' basis, internally quite unlike conventional multi-layer colour materials (see *Advanced Photography*). Others function in the same way as peel-apart colour print material but give their result on 10×8 in sheet film. Results are not yet up to the standard of regular colour transparency materials or instant black and white slides. Some 10×8 in sheet materials are designed to give high-contrast reproduction of drawings, computer displays, etc. Big instant picture transparencies are intended for use on an overhead projector for lectures and presentations.

Instant colour prints

The range of instant-print colour materials runs from $3\frac{1}{4} \times 3\frac{3}{8}$ in to 10×8 in. They are all balanced to suit daylight and flash. Of these the smaller sizes, up to 4×3 in, are in pack form and use integral chemistry – the image gradually forming automatically on the front of card ejected from an instant-picture camera.

Larger sizes work on the peel-apart principle, and come in packs or individual sheets in envelopes. Here the exposed sheet is sandwiched with a receiving material, jellied processing reagent spread between the two. The sandwich must remain for up to 60 seconds before it is peeled apart. Instant colour prints are used extensively for previewing lighting, checking against layouts, etc., before shooting regular colour pictures. However, remember that colours and colour balance may not exactly match your final results on other film.

Colour filters for colour materials

Colour filters are used with colour films either for correction or for special effects.

Correction filters

There are two kinds of colour correction filters. Firstly a small number of often quite strong 'colour conversion' filters (Figures 9.31 and 9.32) allow you to shoot film balanced for one colour

Fig. 9.32 Colour conversion filters

	When exposed under this light source				
	Daylight	*El. flash*	*Tungsten 3400 K*	*Tungsten 3200 K*	*Fluorescent (basis of test)*
Daylight film requires	no filter	CCl0Y*	80B	80A	CC40M
Tungsten film requires	85B	85B (+CC10Y)*	81A	no filter	CC50R

*A few small flash units

temperature in lighting of another. The second group consists of a wide range of mostly paler 'colour compensating' (CC) filters in six colours and various strengths (Figures 9.33 and 9.34). These allow you to 'fine-tune' adjustments towards warmer or colder results due to batch variations, working conditions, non-standard light sources, etc. They are especially important with colour transparency materials which, unlike colour negatives, cannot easily be adjusted at the printing stage. You can buy both forms of filter as gelatins, page 170. Some conversion types are also made in glass, and in acetate sheet for lamps.

Conversion filters with *odd* reference numbers are yellowish or orange, for lowering the colour temperature of the light. Filters with *even* numbers are bluish and raise the colour temperature. These set filters change a particular light source by the amount required for a particular film type. For example an 85B, which is orange, changes daylight to the colour equivalent of 3200 K tungsten lighting to suit tungsten-balanced film. An 81A, much paler pink, changes the slightly too-blue light of 3400 K photolamps to 3200 K to suit the same film.

Yellow	*Magenta*	*Cyan*	*Blue*	*Green*	*Red*
CC05Y	CC05M	CC05C	CC05B	CC05G	CC05R
10Y	10M	10C	10B	10G	10R
20Y	20M	20C	20B	20G	20R
30Y	30M	30C	30B	30G	30R
40Y	40M	40C	40B	40G	40R
50Y	50M	50C	50B	50G	50R

Fig. 9.33 Sets of colour compensating filters

Fig. 9.34 Some colour compensating filters. The numbers relate to their strength, the final letter to colour

An 80A and an 80B filter – both blue – change 3200 K and 3400 K tungsten lighting respectively to match daylight and so suit daylight-balanced film. These are particularly useful filters because manufacturers offer relatively few films balanced for tungsten light. (Many daylight 35 mm colour negative materials have no tungsten equivalent at all.)

You will probably need to carry 85B and 80A filters at least, especially for roll or 35 mm slide material where several situations may be recorded on one film. If subject lighting is mixed (a tungsten lamp used to 'fill in' and reduce contrast in a daylight-lit interior, for example) you can use the filter in sheet acetate form over one source to match it to the other. If this is impossible you may be able to split exposure into two halves – one with only the 'correct' colour light, the other with the wrong light only, but with a correction filter over the lens. (Never use a *lighting* acetate for the lens; its poor optical qualities will upset image definition.)

Be careful over your exposure adjustment with filters – sometimes the maker's leaflets quote a collective ISO rating for the film when used together with a filter. The arrangement is fine for a hand meter, but if you set this ISO figure on a camera meter and then read exposure through the lens with the filter on, the light loss caused by the filter will be taken into account *twice*; see Chapter 10.

Colour compensating filters, on the other hand, are best bought in sets of gelatins. The most useful ones are yellow, red and magenta, in CC10 and CC20 strength (used together these form a CC30). Filters are needed on the lens:

1. For making adjustments to a particular batch of sheet film as specified in the manufacturer's packing note or to compensate for reciprocity failure effects.
2. When using light sources for which no one conversion filter exists (see fluorescent tube sources, Figure 9.32).
3. To fine-tune your image colours, based on the result of tests. If, for example, a processed film test shows a slight bluish shift, view it through yellow CC filters of different strengths until neutral *midtone* subject areas look neutral again. The rule then is to use a CC filter *half* this value over the lens when you reshoot.
4. To help counter reflective coloured surroundings – vegetation, room decorations, etc. – which may otherwise tint your subject. They can also compensate for the effect of low-voltage supplies to lamps.
5. To give the scene an intentional slight all-over colour bias which strengthens mood, helps blend and coordinate a colour scheme.

In the case of 4, it is easiest to work with a colour temperature meter which gives you a precise K reading when pointed from the subject towards your light source; see *Advanced Photography*.

Special-effects filters

There are dozens of different colour filters for special effects. Some are so strong and assertive they destroy more pictures than they improve. Graduated filters have a tint which fades off into clear glass halfway across the disc. They allow you to tint just the sky (or ground) in landscapes – Figure 9.40 – or used vertically they can change the colour of one half of a street of buildings. Graduates that are almost colourless

or grey are very helpful for reducing light from the sky so that bright cloud detail records at the same exposure needed for darker land.

'Split' filters have strong contrasting colours in each half, with an abrupt join between the two. Both colours reduce light intensity by equal amounts so that image brightness remains even across the frame. So-called 'colour-spot' filters have a clear hole in the centre of an otherwise evenly coloured disc – typically red, green or yellow. They tint and darken all four corners of the picture, drawing attention to the correct-colour area at its centre.

It is helpful to buy all these filters a size larger than required for your lens. You can then shift the division (or spot) to affect different parts of the frame to suit your composition, rather than always having them dead centre. Check the effect through the lens at your chosen *f*-number, because the aperture setting affects whether the change of colour will be graduated or abrupt. (Such filters cannot be used precisely with direct viewfinder cameras.)

Use fast film with coloured effects filters. They cut down light considerably and you will want a choice of apertures for different results. Suitable subjects include relatively colourless scenes – clouded seascapes or open landscapes (particularly under snow), stone buildings, sand dunes, silhouettes and stark shapes against fairly plain backgrounds.

Colourless filters, for black and white and colour

Several important filters are equally useful whether you are shooting in black and white or colour.

Ultra-violet

UV-absorbing filters look like plain glass because they only absorb wavelengths our eyes cannot see. The sun's short-wavelength radiation is most readily scattered by particles in the atmosphere – a reason why sky looks blue and distant haze in landscapes has a bluish appearance. On films, however, this scattered UV records too, exaggerating the mistiness of haze and, on colour, exaggerating its blueness. The effect is especially notable with landscapes at high altitude and near the sea. A UV absorbing filter therefore helps to record the subject appearance you *see*. Modern camera lenses often incorporate a UV absorber within their optics.

For a stronger effect on colour film, use a 'skylight' or 'haze' filter (number 1A), which has a just perceptible shade of pink. Many photographers make this filter standard for Ektachrome outdoors, because of the film's slightly cold bias. All warm-coloured filters act as UV absorbers.

Neutral density

Grey, colourless filters affect all wavelengths equally and just cut down the image light by set amounts. See Figure 9.35. They are invaluable when you want to use a slow shutter speed (to create blur) or a wide aperture (for shallow depth of field) in intense lighting or with fast film, without overexposing.

Ref. (density)	Allows you to increase	
	aperture **or**	time
ND0.1	0.3stop	× 1.25
0.2	0.6	1.5
0.3	1	2
0.4	1.3	2.5
0.5	1.6	3
0.6	2	4
0.7	2.3	5
0.8	2.6	6
0.9	3	8
1.0	3.3	10
2.0	6.6	100

Fig. 9.35 Neutral density filters

Fig. 9.36 Polarised light. Top: unpolarised light, shown vibrating in two of many directions at right-angles to its path of travel, becomes restricted to one plane when passed through a polarising filter. (It would be polarised this same way if reflected off a shiny non-metallic vertical surface.) Bottom: polarised light stopped by a polarising filter turned 90° to the light's plane of polarisation

Polariser

A polarising filter also looks grey, and can be used as an ND filter, but has unusual extra properties which give it several applications. As Figure 9.36 shows, normal, unpolarised light waves vibrate in all planes at right-angles to their directions of travel. Polarised light is restricted to one plane. Unlike some creatures, our eyes cannot tell the difference between polarised and unpolarised light, but polarised light exists around us – in light from parts of blue sky at right-angles to sunlight, for example, or light reflected off any shiny non-metallic surface at a low angle (about 33° to the surface).

A polarising filter has a special molecular structure. Think of its effect on light waves as like an egg slicer or narrow parallel railings: when its 'lines' are parallel to the plane in which polarised light is vibrating, light is transmitted, but when they are at right-angles the polarised light cannot pass. In practice you look through the filter, rotating it until an unwanted reflection disappears, or the sky darkens, and so on.

Whole lake surfaces or every window of an office block can be cleared of reflected skylight if you have the right viewpoint. Blue sky can be darkened in colour as well as in black and white photography, making clouds prominent. The colour of glossy objects such as glazed ceramic or shiny plastic becomes more intense when the sheen reflected from surroundings is removed. If you are copying subjects like paintings behind glass, a polarising sheet over each light plus another on the lens allows specular reflections off any surface, and at any angle, to be suppressed. (*Note*: regular linear polarising filters, if used on some

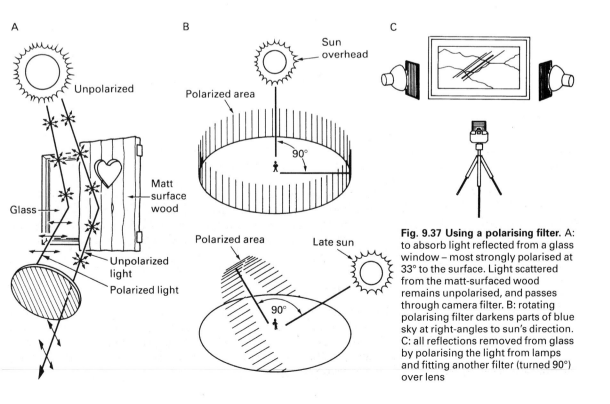

Fig. 9.37 Using a polarising filter. A: to absorb light reflected from a glass window – most strongly polarised at 33° to the surface. Light scattered from the matt-surfaced wood remains unpolarised, and passes through camera filter. B: rotating polarising filter darkens parts of blue sky at right-angles to sun's direction. C: all reflections removed from glass by polarising the light from lamps and fitting another filter (turned 90°) over lens

Fig. 9.38 Left: London's Albert Memorial photographed without polarising filter. Right: using polariser turned to give maximum absorption of the surface glare from one face of Memorial

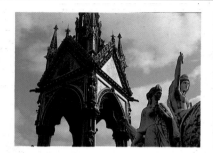

SLR cameras, will upset the exposure-reading or focus-sensing mechanisms. You must use only *circularly* polarised filters with such cameras. They have a similar image effect.)

Effects attachments

Multi-image refractors, diffusers and starbursts are all colourless special-effects attachments (they do not strictly *filter* anything out) suitable for both colour and black and white work. Multi-image units are simple faceted glass discs which form an overlapping repeat pattern of part of the normal image formed by your camera lens. The number of images depends on the number of facets – typically 3, 4 or 5. The longer your lens focal length the farther apart these images are spaced. Such attachments must be deeply hooded from stray light, or image contrast will suffer.

Diffusers spread light parts of the image into dark parts, diluting shadow tones and colours, lowering contrast and helping to give an atmospheric, often high-key effect, like faint mist. 'Starbursts' have a grid of finely etched lines which turn brilliant highlights into radiating spokes of light like a star. The number of 'rays' depends upon the number and angle of the lines. Diffraction sometimes adds a slight colour effect too.

There are several lens attachments designed to create 'rainbow' effects around brilliant highlights by diffraction of light (page 181).

Fig. 9.39 Using effects attachments on the camera lens. Left: multi-image faceted glass (lens used at wide aperture). Centre: diffuser spreads all highlight details. Right: starburst designed to add four 'spokes' to each intense highlight

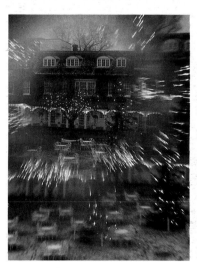

Fig. 9.40 Using a colour graduate filter. The empty-looking Welsh mountain landscape (above) is transformed into a dramatic atmospheric shot (right) by adding a tobacco graduate to tint only the sky, and underexposing by one and a half stops

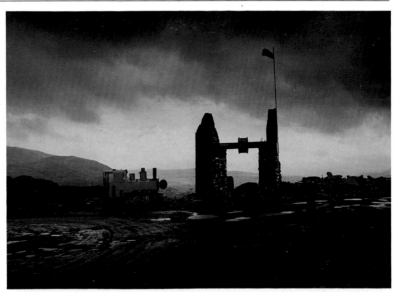

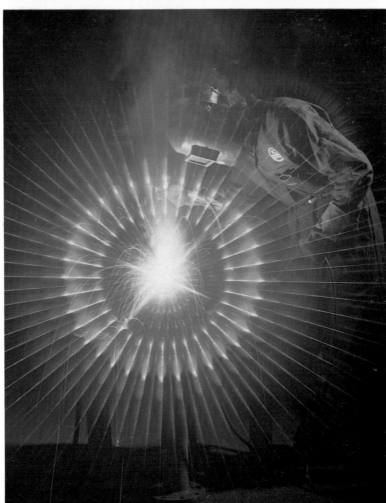

Fig. 9.41 A rainbow or 'colour-burst' diffraction attachment adds a graphic effect to this welder shot by Academy Studios. The intense highlight in dark surroundings is ideal for giving brilliant spectral patterns

Fig. 9.42 Effects attachments. Top: faceted multi-image unit. Bottom: half-lens (or 'split field') attachment – allows a close object filling half the picture to appear sharp when the camera lens is focused for distant objects in rest of frame.

They are plastic with finely etched lines, and have exotic names such as 'Nebula' or 'Color-burst'. It is vital to have intense point light sources in the picture – the sun, spotlights, or speckled reflections from water – otherwise diffraction attachments, like 'Starbursts', just give a slightly diffused low-contrast image. Beware of flare spots when including the light source.

All these effects attachments are helpful for 'jazzing up' product photography, enlivening city scenes at night, etc. But because results soon become recognisable and repetitive they are easily over-used. None of the attachments requires an increase in exposure.

Choosing film

With many emulsions to choose from it is best to narrow your field: use as small a range of films as your work allows, and get to know them thoroughly. Real familiarity with a film's characteristics is most likely to give technically consistent, reliable results. Just remember the existence of other materials for special tasks.

For most black and white work shoot on two or three emulsions, perhaps slow, medium and fast speeds, and processed in as few developers (Chapter 11) as possible. Understand the type of tone contrast, grain and tolerance to under- and overexposure that each film/developer combination offers, and know what print quality to expect from these negatives *on your enlarging equipment*.

When choosing colour film:

1. Decide whether the final end product should be a transparency or print, or both. If it is for reproduction on the printed page, a transparency or slide will probably be preferred, because it offers a higher-resolution image and suits the electronic scanners used in repro-processes. If the picture is, say, a wedding or family portrait the demand will be for prints, so shoot on colour negative stock. If your picture might be used in a whole variety of ways, shoot colour negative (from which even black and white prints can be made). Or if circumstances permit shoot on two kinds of film, using separate camera bodies, magazine backs or film holders.
2. Decide the best format. For example, is 35 mm acceptable for the size of the final print (or reproduction in print) and will you be shooting a lot of pictures fast, or just a few, which could be large format? Will you need extensive camera movements? Remember too that not all materials are made for every size of camera.
3. Think whether the film's colour balance and speed suit the type and intensity of your lighting, bearing in mind movement and depth of field requirements.
4. What processing will be required – can you or the laboratory produce results in time?
5. Do the contrast, general bias of colour, and grain suit the subject and mood of your picture?

Always test out a film you have never used before, prior to using it on an assignment. Furthermore try to buy your transparency film in batches all of the same coating number (printed on the box) and give

each batch a test to discover any CC filter needed to improve colour results with *your* lights and shooting conditions. If most of your photography is 'constructed' – using models in the studio or on location, working to layouts, etc. – use instant-picture material in a suitable camera back as well. Here it will help to pick material with an ISO speed matching your regular colour film, so that camera settings (which affect depth of field, etc.) remain the same for test and shot. Alternatively shoot on faster instant-picture material and use a suitable strength of neutral density filter to bridge the difference.

Storage

Keep your film – before and after exposure – away from warm, damp situations. Protect it from chemical fumes and X-ray radiation, for example airport baggage security systems. Even small radiation doses accumulate, so have films hand-checked instead.

The most common effect of overlong storage is loss of speed. Colour film is especially vulnerable to change because alterations to the finely adjusted relative speeds of its different emulsion layers upset colour balance. The best storage place is the general compartment of a domestic refrigerator. When kept here, sealed film will remain usable beyond its printed expiry date without changes. In any case expiry date is only a guide – so much depends on storage conditions.

Always allow time for film to warm up, unopened, between removing it from the refrigerator and shooting. Unsealing too soon may cause condensation to form on the emulsion. Recommended periods are 1 hour for cassettes and sheet film, or 3 hours for cans of bulk film. Remember too that instant-picture materials only function at their expected speeds when at 18°–30°C. Below about 10°C most will not work at all.

If you cannot process exposed film straight away store it in a cool, dry, dark place. If it goes back in the refrigerator keep it in a taped-up foil bag or airtight box, as without this your film is no longer protected from humidity. If possible include a packet of desiccating crystals such as silica gel within its container to absorb any moisture.

'Professional' and 'amateur' films

Some manufacturers designate certain films as *professional* and include this word on the pack. The main difference between professional and amateur film (apart from price) is that the former is designed to give optimum specified performance the moment it leaves the factory. So *provided you give it immediate refrigerated storage* at 13°C or less, as suggested for the product, it will record with great consistency. Professional film must be processed immediately after exposure too.

Amateur films are planned for a slightly different storage scenario – in which they remain at room (or shop) temperature for an average time after delivery, and there is a more variable time delay between exposure and processing. In practice, amateur films are in no way inferior for professional work, but it is more advisable to make checks for batch-to-batch variations. Having done this, colour consistency is better maintained if you use refrigerated storage as for professional films.

Filter kits

Exactly which filters you should carry in the camera case will depend on the range of subjects and lighting problems you meet, whether you shoot black and white as well as colour, and personal choice. The most worthwhile filters are also the most versatile – for example a polarising filter and a UV or haze type, both of which are best in glass form. For colour work you should carry appropriate colour balance conversion filters, plus perhaps a selection of CC types. These could be gelatin. Medium red (or orange), deep yellow, and green filters in either gelatin or glass are the most useful for black and white, although your warmer colour-conversion filters may do double service for some of these. The most versatile of the dozens of 'effects' filters might be a graduate in either pale grey or a brownish tint, to reduce overexposure of skies in landscape.

Summary: Camera films and filters

● Camera materials use light-sensitive silver halides plus gelatin, and other additives, to form an emulsion coated on a film base. During manufacture, grain size and resolution, speed and contrast (all interrelated) are brought to specification, and the material is sensitised to chosen bands of the spectrum.

● Light sensitivity is mostly quoted as an ISO rating – containing one figure which *doubles* with doubling of speed, and another (with degree sign) which *increases by three*. In practice effective speed figures vary with the processing you choose to give, also extremes of exposure time and colour of lighting.

● Most black and white films have full-spectrum panchromatic sensitivity. Ortho materials are insensitive to red wavelengths; blue-sensitive types do not respond to red or green.

● Slow films have finer grain, better resolution, slightly more contrast than fast types. Some monochrome films produce a final negative image in dye rather than black silver. Line and lith films give extreme contrast, when appropriately developed. You can also shoot 35 mm black and white slides – regular or instant-picture type – and larger-format instant prints and negatives.

● Colour filters (gelatin, glass or acetate) *lighten* the tone of subjects their own colour, and *darken* complementaries. The richer the colour of the filter and subject the stronger this effect. Filtered black and white results also depend on film colour sensitivity, and the colour of the lighting.

● Colour film emulsion layers are effectively sensitive to blue, green and red. Colour negative film contains couplers, forming negative images in complementary yellow, magenta and cyan dye during chromogenic development. Processing is standardised. Slide and transparency colour films first form black and white negatives, then the remaining emulsion is processed into Y, M, C dye images, finally creating a positive result.

● Colour film emulsions are balanced to suit set light sources. The two main types are for daylight/flash and 3200 K tungsten lamps. Use each type for other white-light sources with a colour conversion filter over the lens or light source. Negatives allow you further adjustment during printing.

- Some slide films can be adjusted for exposure during processing. Special low-contrast film is made for copying slides, high-contrast for line work.
- You can make instant-picture colour slides and OHP transparencies, and colour prints (integral or peel-apart).
- Colour compensating (CC) filter sets allow you fine adjustment of colour balance for correction or mood. Graduated, split, colour spot, diffraction and other lens attachments give special colour effects.
- UV, neutral density and polarising filters, and many colourless effects attachments such as multi-image, diffusers and starbursts, are usable for both black and white and colour work.
- Get really familiar with the practical performance of a selected range of films. Establish a technique which makes the most of your materials. Make batch tests of colour reversal film where practical. Remember you can check your equipment, technique and composition as you shoot, via instant prints.
- Protect stored film from humidity and heat. Refrigeration reduces the risk of emulsion changes – but allow film to warm up before use.

Projects

1. Make tests, under your own conditions, on black and white films of different speeds. Expose Pan X (ISO 50/18°), FP4 (ISO 125/22°), Tri X (ISO 400/27°) and Recording film (ISO 3200/36°) or equivalents on typical high, medium and low contrast subjects. Bracket your exposures (see page 191), and process in an appropriate choice of developer. Select the best negative from each subject/film combination and make equal-magnification enlargements. Compare tone quality, grain and sharpness in terms of their suitability for different kinds of image.
2. Check the visual effects of colour filters. Set up a slide projector in a darkened room and either use its light to illuminate a colourful poster, or simply project a slide containing many strong colours. Use a series of strong colour filters (see Project 3) in turn in front of the lens and notice which parts of the poster or slide image darken/lighten in tone.
3. Experiment with light mixing. With three projectors, form overlapping patches of light on a screen in a darkened room. Predict, and then visually check, the overlap colours formed when red (Kodak number 25), green (58) and blue (47) filters are used. Next try cyan (44), magenta (33) and yellow (15). Equivalent colour theatrical gels will do instead. Place objects to interrupt one or more light beams and cast shadows. Forecast, then observe, what shadow colours will be.
4. Check colour casts. Using a *daylight* slide film, shoot subjects (1) in daylight, (2) in tungsten light with and without an 80A filter, (3) in fluorescent light with and without a correction filter for the film, and (4) in daylight with an 85B filter. Using the same subjects, shoot the same sequence again on a *tungsten* light film. Compare processed results. Note the distorted colours given by mismatching, and try them for creative effects.

10
Exposure: equipment and methods

Strictly speaking, 'giving the right exposure' means making sure that your film receives the correct amount of image light (photons). In practice it is much more than this. Exposure can be used to give *emphasis*, by being correct for one chosen object in a scene, allowing other parts which are lighter or darker to be over- or underexposed. Exposure control is also the key to getting fine *tonal qualities* in your final pictures, whether prints or slides. And apart from its accuracy, the actual way you give exposure, via chosen permutations of lens aperture and shutter speed, strongly influences the appearance of things at different distances and the way that movement is recorded.

The exposure measuring and setting help provided by the camera itself varies considerably. At one extreme, most view cameras offer no light-measuring facilities, and leave you *all* the decisions on shutter and aperture settings – often a slow business with the aid of a hand meter. At the other extreme, a fully automatic compact will measure the light and instantly set controls according to an intelligent programme, without even telling you what is going on. Total automation ensures a high percentage of accurate exposures with average subjects, but takes many creative decisions out of your hands.

This chapter looks at what 'correct' exposure means and what we should aim for using different films. It discusses equipment for measuring and setting exposure, their different modes of use, features and disadvantages, and how to avoid mistakes with problem subjects. Shooting with flash brings in its own exposure features, and metering equipment and techniques are discussed towards the chapter end.

Factors that determine exposure

The main factors you take into account when measuring exposure are:

1. *Lighting*. The intensity and distance of the light source, including any light loss due to diffusers, acetates, etc., or atmospheric conditions between source and subject.

2. *Subject properties.* How much your subject reflects the light – its tone, colour, surface, from a black cat in a coalstore to a milk bottle in the snow.
3. *Unusual imaging conditions.* Light absorption due to lens filters and attachments, or an image made dimmer by extending the lens forward to focus close-ups.
4. *Film speed.* Its ISO speed rating, which will need adapting if you intend to alter processing. Speed may also be affected by film colour sensitivity relative to subject light source (page 163). The ISO rating becomes less if you work outside the range of exposure times considered 'normal', typically 1/1000 to 1 second. See reciprocity failure, page 161.
5. *Interpretative considerations.* Would it improve the picture to expose wholly for the brightest parts of the scene and make darker parts black; or expose for shadows and let light parts 'burn out'?

Factors 1 and 2 are taken into account by a separate, reflected-light exposure meter. Factors 1, 2 and 3 are covered if you use a through-the-lens camera meter. Factor 4 may be automatically sensed by the camera mechanism but then need modification by you, perhaps using the ± exposure-compensation dial. Factor 5 must be decided by you, and most likely carried out by the way you take the reading (pages 193 and 202).

The exposure you have read has to be given to the film by a combination of:

1. Intensity: the lens aperture. Bear in mind that this choice will affect depth of field, lens coverage and definition.
2. Time: the shutter speed. This influences the way any movement of subject or camera will reproduce, and the spontaneity of expression or action.

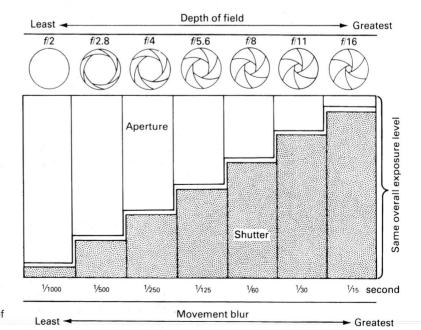

Fig. 10.1 Aperture/shutter-speed relationships. Identical exposure can be given through a range of intensity/time settings. For example, each combination here will give the same light effect to the film (an exposure value or EV of 12). You must choose between them, paying attention to depth of field and blur effects

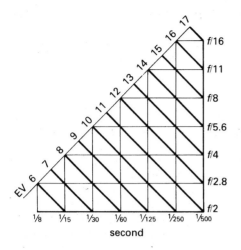

EV	Gives		
8	$\frac{1}{15}$ at $f/4$	$\frac{1}{8}$ at $f/5.6$	$\frac{1}{4}$ at $f/8$ etc.
9	$\frac{1}{30}$ at $f/4$	$\frac{1}{15}$ at $f/5.6$	$\frac{1}{8}$ at $f/8$ etc.
10	$\frac{1}{60}$ at $f/4$	$\frac{1}{30}$ at $f/5.6$	$\frac{1}{15}$ at $f/8$ etc.
11	$\frac{1}{125}$ at $f/4$	$\frac{1}{60}$ at $f/5.6$	$\frac{1}{30}$ at $f/8$ etc.
12	$\frac{1}{250}$ at $f/4$	$\frac{1}{125}$ at $f/5.6$	$\frac{1}{60}$ at $f/8$ etc.
13	$\frac{1}{500}$ at $f/4$	$\frac{1}{250}$ at $f/5.6$	$\frac{1}{125}$ at $f/8$ etc.
14	$\frac{1}{1000}$ at $f/4$	$\frac{1}{500}$ at $f/5.6$	$\frac{1}{250}$ at $f/8$ etc.
15	$\frac{1}{2000}$ at $f/4$	$\frac{1}{1000}$ at $f/5.6$	$\frac{1}{500}$ at $f/8$ etc.

Fig. 10.2 Exposure values. Each value expresses a series of shutter/ aperture combinations which all have the same exposure effect

As Figure 10.1 shows, intensity and time (aperture and shutter) have a reciprocal relationship. Within limits, halving the intensity and doubling the time maintains the same sum total of photons of light energy reaching the film.

Exposure values

Occasionally it's convenient to quote level of exposure *without* specifying *f*-numbers and shutter speeds. For this purpose an international series of 'exposure values' has been devised. Each EV number stands for a particular amount of exposure, which can be given by any of the paired aperture and shutter speeds shown against it in Figure 10.2. You will meet EV numbers as an additional read-out on hand meters. They are also used as figures to show the light sensitivity range of meters inside cameras (Figure 10.22 for example) and of passive autofocus devices.

Some cameras, such as Hasselblad, have EV numbers engraved as a scale where *f*-number and shutter-speed control rings intermesh. Turning the two rings together – maintaining the same EV – quickly changes settings from high-shutter-speed/wide-aperture to slow-shutter-speed/small-aperture. This can be useful for different situations under the same lighting conditions. Suddenly stopping down for extra depth of field, for example, you know the shutter is also adjusting in tandem to keep the same level of exposure.

Fig. 10.3 Each negative in this series received four times the exposure of the one to its left. (A) is grossly underexposed and (E) is grossly overexposed. The subject – a sunlit grey stone cross in a shadowy graveyard – is correctly exposed in (C). Notice how shadow details become indistinguishable from clear film ('off the toe of the curve') in A. In E highlight areas are choked, losing details of the stone

Requirements for different film types

The target results of 'correct' exposure, and the degree of measuring accuracy demanded of you, varies according to film type.

Black and white negatives

The less exposure a negative film is given, the paler the image tones in the processed result. Figure 10.3 shows how progressive underexposure makes subject shadows reproduce so 'thin' they lose their detail, becoming indistinguishable from the clear rebate. Then the same fate occurs to mid-tones, and finally to subject highlights too.

Going the other way, increasing overexposure makes all tones grow darker. Highlights become 'solid' with their details lost first, then this quickly spreads to mid-tones and finally to shadows. You often find too that, when enlarged, grain is more apparent in overexposed negatives and general light spread throughout the emulsion reduces sharpness.

Results like these can be shown on a graph called a 'characteristic curve' (see Figure 10.4 and Appendix D) with image intensity values along one axis ('log relative exposure') and final tonal density along the other. 'Correct' exposure should place all image tones as densities on the lower part of the curve, yet not below the point where it flattens out, meaning that densities are no longer separable and detail disappears.

The more contrasty your picture, the more accurate the given exposure must be – for it will take less overexposure error to bring highlights into the state of being unacceptably dense, and less underexposure to make shadows too thin; see Figure 10.5. These conditions are said to offer minimum exposure latitude.

Colour negatives

A correctly exposed colour negative should meet requirements broadly similar to those for a black and white negative. However, it is even more important to avoid underexposure – empty shadows often print with a different colour cast, and since there is little choice of contrast grade with colour paper (see *Advanced Photography*) you cannot prevent thin negatives printing grey and flat. Processed colour negatives are also deceptive in appearance. The presence of the yellowish mask makes you think the image is denser than it really is. (It may help if you assess negatives holding a filter matching the film rebate close to your eye.)

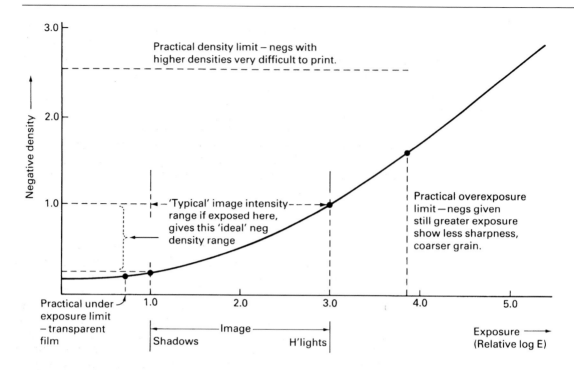

See page 294

Fig. 10.4 Characteristic curve of a black and white negative film (developed to a contrast index of 0.53). Every image is a *range* of light intensities, so highlights are shown farther right than shadows on the exposure scale here. When an image is overexposed, its intensity values all shift right and record denser, although shadows may still just fall in the ideal range. When it is underexposed, intensity values shift left and densities are too weak, although highlights may still be acceptable.

Published colour-negative characteristic curves show each emulsion separated vertically (Figure 10.6). If the film was exposed to light of the wrong colour balance without a correction filter curves will also be displaced left to right – one emulsion becomes effectively faster than another. Within reason this may be corrected by filters in colour printing. However, with a wide-tone-range (contrasty) scene, shot at incorrect colour temperature, it may even be possible for one of the emulsions to have underexposed low-contrast shadows while at the same time another has overexposed highlights. Printing will not correct the distortion this gives. (Unfortunately you cannot readily judge such a colour defect in a negative by eye alone.) In practice, therefore, colour negative films when shot in lighting of the wrong colour have less exposure latitude than black and white negative films.

Colour or black and white slides and transparencies

Positive images on film are much easier to judge because you can make direct comparison with what you remember of the original scene. As Figure 10.8 shows, the more exposure you give reversal-processed film, the *lighter* your result – with highlights especially becoming bleached of colour and tone. Underexposure has a darkening effect, particularly of subject shadows where colours eventually become engulfed in black. Of the two, overexposure is generally more objectionable than underexposure. This is partly because we tend to 'read' pictures by their light parts and accept dark shadows more readily than burnt-out highlights. Again, a slightly dense transparency is more acceptable for colour printing or printed reproduction than one where light parts of the image are literally missing.

Fig. 10.5 Exposure latitude. The more extreme the difference between image shadows (S) and highlights (H/L) the less latitude you have in exposing without exceeding ideal limits

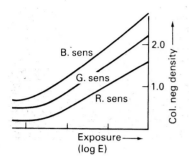

Fig. 10.6 Characteristic curves of a colour negative film, exposed to light for which it is colour-balanced. Emulsion response to R, G and B is plotted individually

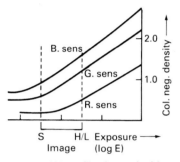

Fig. 10.7 When film is used with light of reduced red content (too high a colour temperature), the red-sensitive layer reacts as if relatively slow. Its curve shifts right. Red density and contrast now differ between image highlights and shadows, and may be impossible to correct in printing

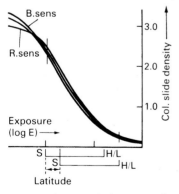

Fig. 10.8 Characteristic curves of a colour slide film, exposed to light for which it is colour-balanced. Compared with lower-contrast materials (Figure 10.5) the same shadow/highlight range image allows less exposure latitude

The published characteristic curves of reversal materials not only slope the opposite way, they have a steeper angle than negative films. This shows they are more contrasty, which is desirable in images that must look bright and rich in tone when projected. However this characteristic means you have less room for exposure mistakes. Figure 10.9 shows how quickly an exposure error in one direction brings highlights into the lower, detail-crushing over-exposed region, while the opposite error places shadows in the underexposed, dense zone. So slides and transparency materials have less exposure latitude than regular colour or black and white negative films, and this shrinks still further when your picture has a contrasty tone range.

'Bracketing' and clip tests

The simplest insurance against error, if circumstances permit, is to make several 'bracketed' exposures. With black and white film take one picture using the settings you *expect* to be correct, then shoot others giving half and twice this exposure. With colour negative film, bracket using closer increments: shoot one frame a half-stop underexposed, plus frames half a stop and one stop overexposed. For slides and transparencies, bracket at half stops too, but erring more towards underexposure than overexposure. If you use an exposure programmed camera (page 200), the quickest way to bracket is by turning its exposure-compensation dial by the required + or – settings.

Further modify your bracketing routine according to the exposure latitude. For example, a contrasty image (harsh lighting and/or a subject with strong inherent contrast), shot on a film which is contrasty or is to be uprated or is a reversal type (factors which increase contrast), and especially if it is in colour, will give absolutely minimal latitude. You should therefore try to take more bracketed exposures, with smaller differences between each. Reverse this approach if exposure latitude is exceptionally wide.

With most materials you can gain further protection by planning out all or part of one film as test exposures, to be processed and examined first. Use an extra magazine back, a separate 35 mm body or marked sheet-film holders to accumulate one extra 'correct' exposure of every subject you shoot during a day's location work, additional to your main run of exposures. Process this test set of shots normally and check them to decide which, if any, films will need adjusted processing (page 229). Alternatively, make sure you include three bracketed exposures at the *start* of a 35 mm film or *end* of a rollfilm. These are then easily clipped off and test processed to decide any changes required for the remainder of your film.

Measuring exposure (continuous light)

Apart from checking tables, the normal way of finding correct subject exposure is by measuring with a hand meter or some form of light meter inside the camera. Learning how a hand meter is used will help you understand the more common internal meter, which was born from it.

Fig. 10.9 Each colour slide in this series had four times the exposure of the one before. (A) is very underexposed, with shadows lacking detail and colour. (D) is grossly overexposed, with all lighter parts bleached

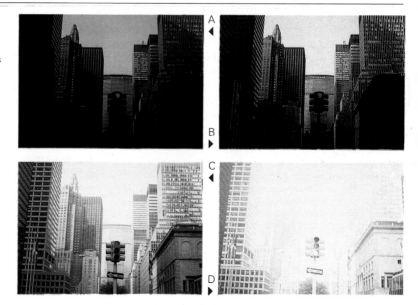

Tables and guides

Never despise that simple table of recommended exposure settings packed with your film – some day your meter or camera may not be working. Another emergency routine to remember is the following:

Use 1/ISO arithmetic speed as your shutter speed, then set $f/16$ for bright sun, or $f/8$ for cloudy-bright conditions or their equivalent.

The trouble with tables and guides is that they deal with subjects and situations only in the broadest terms. Tables that try to be more comprehensive often end up becoming incomprehensible.

Fig. 10.10 Exposure guide – ISO 100/21° film

Bright or hazy frontal sunlight, pale sand or snow surroundings	$\frac{1}{125}$	$f/16$
Outdoor open setting, cloudy bright (no shadows)	$\frac{1}{125}$	$f/8$
As above but heavily overcast	$\frac{1}{125}$	$f/5.6$
Outdoors, open shade	$\frac{1}{125}$	$f/5.6$
Indoors, domestic interior by existing (hazy) daylight	$\frac{1}{125}$	$f/4$
Shop interior, fluorescent tubes	$\frac{1}{30}$	$f/2.8$
Indoors, domestic incandescent lamps	$\frac{1}{15}$	$f/2$
Lights from traffic at night	10	$f/11$
Floodlit sports arena	$\frac{1}{60}$	$f/2$
Portraits by street lighting	$\frac{1}{30}$	$f/2$
Landscape lit by full moon	30	$f/2.8$

Hand meters

These are the oldest 'photoelectric' measuring aids, but in modern form still much used by professionals today. A typical meter (Figure 10.11) is a self-contained unit with a small light-responsive cell of cadmium sulphide (CdS) or a silicon photocell (SPC) behind a window. This

Fig. 10.11 Hand meter. Top: light-sensitive cell behind a small circular window in the front end gives general readings. Plastic dome slides over window for making incident-light readings: Bottom: large calculator dial must be programmed for film ISO speed. After setting needle light-reading against 'scale' pointer, you read off shutter settings against f-numbers at top of dial

sensor forms part of a circuit including a battery and current-measuring device. (Some older meters have selenium cells, which do not require battery power. These are much less responsive to low light levels, and the cell is more bulky.)

Basically you programme the meter with the ISO arithmetic speed of your film, point it towards the subject, and read off the exposure required. With some models you also feed in either the *f*-number or the shutter speed you want to use, then a liquid crystal display on the meter shows the appropriate shutter speed or *f*-number with which they should be paired. Others read out via a needle and a scale of figures. With these you transfer the figure shown to a large dial on the meter, and as you line it up against a pointer, a complete series of *f*-numbers is set against a series of shutter speeds. Each will give correct exposure – you are left to choose any pair according to depth of field and image movement conditions. An EV readout is often shown too.

There are several ways to use a hand meter, according to working conditions and personal preference. These are: (1) a general or 'integrated' reading of the subject, (2) two or more 'brightness-range' readings of the subject, (3) a grey-card reading, or (4) an incident-light reading of the light source.

1. *For a general reading*, you just point the meter from the camera towards your subject. The meter's angle of view usually approximates that of a standard lens, so it 'sees' a matching area of the scene. The meter averages out all the various light values this contains (naturally being more influenced by the values of large subject areas than small ones). Then it gives an exposure reading that would place this imaginary 'average brightness' about midway between under- and overexposure on the characteristic curve.

 Disadvantages. The most important element in your picture is not always the largest. With a portrait, for example, the face may only occupy 20 per cent of the picture area, the rest being background (Figure 10.13). In one version you might use a dark background and in another a white one, without any change to the face. Yet the meter, taking 80 per cent of its reading from the background in each case, will give low reading for the first shot and overexpose the face, and a high reading for the second version making the face underexposed.

 A general reading is therefore only satisfactory if the subject has a fairly equal distribution of light and dark areas in which you want detail. It often works with softly lit landscapes (tilt the meter down slightly to read less sky- and more land, if this is where details are more important). Another problem is that changing to a lens differing greatly from standard focal length makes camera and meter have very dissimilar angles of view. Used from the camera position the meter then reads a larger or smaller area than is included in the picture.

2. *For a brightness-range reading*, you first decide which is the lightest and which the darkest part of the scene where detail must still just record. Take separate readings of both, bringing the meter sufficiently close in each case to exclude everything else. (Don't cast a shadow on to what you are measuring, however.) You next split the difference between these light measurements and read off exposure for the resulting figure.

Fig. 10.12 Methods of using a hand meter: A: direct reading from camera (see Figure 10.11). B: separate readings of lightest and darkest important areas, then averaging. C: reading off a mid-grey card. D: incident-light reading through the meter's diffusing dome

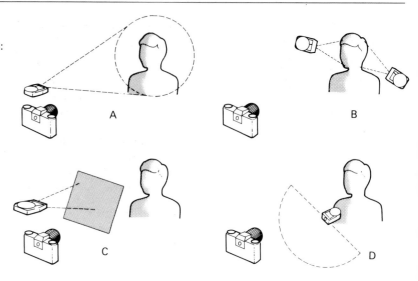

Brightness-range readings therefore make the best possible exposure compromise between subject extremes, and also remind you how much contrast is present. If highlights need 6 stops less exposure than shadows, for example, this means the range is 64:1, too great for colour negatives to record with correct values throughout. You could either soften lighting contrast by adding a reflector or flash, or wait for changing conditions, or alter your viewpoint. When contrast is high and you are shooting black and white or colour slide material you might uprate the film and shorten development – otherwise just accept too much or too little density at one end of the scale (dense highlights best with colour negative film).

Disadvantages. Two readings take longer than one. You may not be able to approach parts of the subject close enough (but see substitute readings, page 203). Unless you understand the technical limits of your film it is possible, with a contrasty subject, for the readout to produce overexposed highlights *plus* underexposed shadows.

3. *For a grey-card reading* you measure from a mid-grey card, held so that it receives the same light as your subject. (Kodak make a standard 18 per cent reflectance card for the purpose.) Exposure given according to this one reading should coincide with the average of darkest and lightest areas.

Disadvantages. You have to carry a card large enough to fill the meter's field of view, and avoid casting a shadow on it when reading. With contrasty scenes the extreme values, especially dark shadows, may exceed the range of your film – and this time you have no upper and lower readings to warn you.

Fig. 10.13 Conditions which fool a general or 'centre-weighted' meter reading. Although the figure in all these pictures received the same lighting, in A the large-area dark background causes the meter to give a reading which overexposes face. Bright background (B) makes it underexpose. Coming in close (C) and reading only off the face, without refocusing, ensures correct portrait exposure whatever the background tone (D)

A B C D

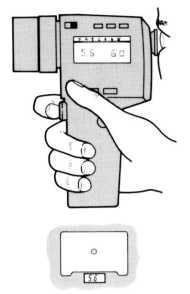

Fig. 10.14 Spot meter. The eyepiece shows you the subject magnified, a centre circle marking the light measuring zone. Having set ISO speed and shutter setting, the meter signals the required *f*-number

Fig. 10.15 Some hand meters accept accessories. A: fibre-optic pipe. B: narrow-angle adaptor. C: enlarging adaptor. See text

4. *For an incident-light reading*, you slip a white plastic diffusing dome over the meter's measuring window. Then the meter is held in the same lighting conditions as the subject, *pointing towards the camera*. It therefore takes into account all the (scrambled) light reaching the subject, rather than the subject's reflective properties. The plastic dome transmits 18 per cent of the light, so you end up with much the same situation as a grey-card reading, but in a more convenient form. Enthusiasts for incident-light metering claim it is simpler and less likely to give overexposed highlights than most other techniques, so it is especially suitable for reversal films. However, it shares the same disadvantages as grey card with exceptionally dark or light-toned subjects or close-up focusing – in which case be prepared to modify the reading by opening or closing the lens by one stop, or using the camera's exposure-compensation control.

Spot meters

A spot meter, Figure 10.14, is a special version of a reflected-light meter. It has an eyepiece for aiming the meter from the camera position. Inside you see a magnified view of part of the subject, with a small measuring area outlined. The meter's angle of view over this area is typically only 2–3°. Having set your film's ISO speed, you press a trigger-like button to get a reading, and the exposure settings are displayed inside and/or outside the meter. Spot meters are extremely convenient for taking brightness-range readings if you cannot easily approach your subject, and when shooting close-ups.

Its disadvantages are cost, bulk, and inability to take most other forms of reading. You can get totally inaccurate exposures if you don't carefully consider which subject parts to sample.

Meter accessories

Most reflected-light hand meters accept different accessories to increase their versatility (Figure 10.15). These include clip-on optional adaptors to allow spot reading (using an aiming sight), fibre optics to 'pipe' light from tiny or inaccessible parts of a still-life set, and convertors to turn the instrument into an enlarging meter. See also view camera TTL meters, page 201.

Conditions hand meters do not consider

All the above methods of reading exposure by meter should give you the same result, if used properly. Practise each of them and decide which is the most convenient and accurate for the majority of your work. Remember though that any meter used separately from the camera does not take into account:

1. *Close-up focusing conditions.* Increasing the lens-to-image distance to focus sharply a close subject makes the image dimmer. Inside the camera, this is like moving a projector farther away from a screen (the film). The projected image grows bigger but less bright, following the rule that twice the distance gives twice the image size and one-quarter the light over the film area. You must therefore

Magnification $= \dfrac{\text{image height}}{\text{subject height}}$	Increase exposure by:
0.1	× 1.2
0.3	× 1.7
0.5	× 2.3
0.7	× 2.9
0.8	× 3.2
0.9	× 3.6
1.0	**× 4**
1.3	× 5.3
1.5	× 6.3
1.7	× 7.3
2.0	× 9

Fig. 10.16 When using a separate hand meter, increase exposure for close-ups. See also Figures 5.22 and 2.10

Fig. 10.17 Built-in meters: light-measuring cell locations. A: viewing most of the image from above SLR eyepiece or pentaprism. B: spot reading through semi-silvered part of mirror. C: reading off the shutter blind or film once mirror has risen. Lower: compact camera with cell simply adjacent to fixed lens

increase the exposure the hand meter suggests, by a factor as shown in Figure 10.16. Increases here are based on magnification (subject height divided into the height of its image) using the formula: factor = $(M + 1)2$; see also Appendix A.

2. *Use of filters.* Most filters used over the lens cut down the light, so increase the exposure shown on the hand-meter by the factor printed on the filter rim or quoted by the manufacturer. Remember with colour filters that this factor may vary with the colour of your subject lighting together with the film's colour response. An unknown filter factor may be checked by comparing readings with and without the filter in front of the meter, but some measuring cells (particularly CdS) are oversensitive to red and can be misleading. Sometimes a film, intended for use with a filter, may have this taken into account in its quoted ISO speed and so does *not* need further exposure increase.

3. *The effects of exceptionally long or short exposure times.* Reciprocity failure is discussed on page 161.

Built-in meters

An exposure meter built into the camera is able to transfer its readout direct to aperture and shutter settings. If (as most do) it also measures light from behind the lens, it will take into account the image-dimming effects of close working, filters, etc., and of course adjusts its acceptance angle with any change of focal length.

Most internal meters use tiny silicon photocells. In most compact cameras the cell is behind a window right alongside the lens, where it can also read through filters. In SLR cameras one or more cells may view the image on the focusing screen (from above the pentaprism eyepiece, for example) while another below the mirror looks up towards the film. The 'off the film' (OTF) cell views the image as it appears on a reflective pattern on the front of the shutter blind, and on the emulsion itself both after the mirror has risen and during exposure. This allows it to measure and control the period of a time exposure as it actually takes place, as well as flash exposures (page 207). There may be a further cell, viewing through a semi-silvered part of the mirror centre, for 'spot' reading.

Usually you switch on the meter with a half pressure of the shutter release (it switches itself off later after a timed period). Modern compact cameras have a lens and viewfinder shield you slide open to switch on the meter and unlock the shutter release. With some older cameras you have a separate meter switch and it may then be possible to use the camera accidentally without the electronic circuit on, often resulting in one fixed shutter speed irrespective of lighting conditions.

Output from the light-sensing cells feeds to an internal microchip 'central processing unit'. This also receives various information from other parts of the camera, namely the ISO speed read off the cassette and conditioned by any setting you made on the exposure compensation dial, the *f*-number set on the aperture ring, and/or the shutter speed chosen. The CPU instantly computes and typically sends control signals to aperture and/or shutter, as well as displaying the required settings alongside the internal focusing screen and on top of the camera body. See Figure 10.18.

Fig. 10.18 Right: schematic layout of multi-mode built-in meter. Below left: set to 'aperture priority' mode: light reading, film speed and your chosen *f*-number are input, and the CPU translates this data into the correct shutter setting. Your aperture and the camera's chosen shutter speed are also displayed. Below right: set to 'program': the CPU inputs light and ISO data, outputs an EV figure to a program which then sets the most suitable shutter/aperture combination; see Figure 10.22

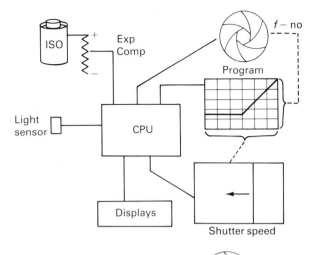

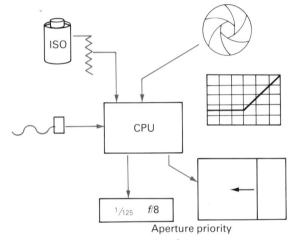

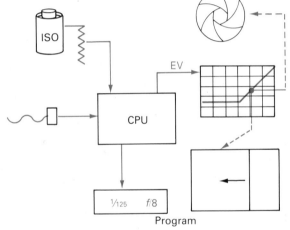

To make full use of built-in metering you need to understand (a) the area of your picture being measured, and (b) the effect of different 'modes' used to translate light readings into shutter and aperture settings.

Fig. 10.19 Meter measurement area. Left: relative distribution of sensitivity within frame of 'centre-weighted' system. Centre and right: with spot-reading system you must choose and align one or more subject areas you wish to read – in this case shadows and highlights

Measuring area

Most internal meters use *centre-weighted* measurement of the picture. This means that the reading is influenced more by central areas and least by the corners of the format (Figure 10.19). Precise layout of this 'sensitivity map' varies in different cameras – some pay more attention

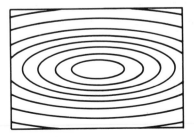

Fig. 10.20 Manual mode metering, as it might be signalled in SLR viewfinder (left), and on body panel (right). You alter either shutter speed (shown left of viewfinder) or aperture, until OK signal (e.g. green diode) shows

Fig. 10.21 Left: a viewfinder display with a camera in shutter-priority mode. You set shutter speed, and camera signals and sets required f-number. Right: same display in aperture-priority mode. You set f-number, and camera signals and sets shutter speed – warning you in this instance of camera-shake risk at 1/15 second

to the bottom of the (horizontal) frame to reduce sky influence in landscapes. Overdone, however, this creates problems in other, upright, pictures. Centre-weighted measurement is surprisingly successful, but you must still remember that large *areas* of tone have greater influence than smaller areas. Try to visualise your composition as tonal blocks and if necessary change their distribution by re-framing (Figure 10.13) while you take the reading.

Advanced TTL systems may measure by multipoint ('matrix') metering. The multi outputs are then compared against an in-built computer programme based on thousands of subject field trials. 'Fuzzy logic' fills in gaps in the sampling process.

Some cameras additionally offer you the option of spot metering, which measures the area enclosed by a circle or rectangle in the centre of the screen, giving the same advantages and disadvantages as a spot hand meter. And by aligning the spot with the brightest important part of your picture and pressing a 'hilight' memory-entry button, then aligning the darkest important area and pressing a 'shadow' button, the camera registers their *average*, in other words a brightness-range reading.

Setting modes

Fed by image light measurement and the other exposure information it needs, the CPU makes its choice of settings in various ways, according to 'mode'. Some cameras offer only one mode, others a choice of four or five that you select according to shooting needs. Each offers its own advantages.

So-called *manual mode* is the most basic and flexible arrangement. You turn the camera aperture and/or shutter speed controls, and the meter signals when a combination will give correct exposure. For instance, you can set the shutter to 1/125 second (for hand-holding) then change apertures until a signal – usually a green diode beside the focusing screen – lights up. Or you could set f/16 to suit depth of field and then change

shutter speeds until the same OK signal is given. Often manual mode also allows you to over- or underexpose by half or one stop simply by working to a different coloured signal; see Figure 10.20. However, this system requires longer to set correct exposure than any other mode.

Aperture priority (Av) goes a step farther – saving time if you must work at a particular aperture, perhaps having checked depth of field with the lens preview button depressed. In this mode you set the aperture and the camera automatically sets the shutter speed required for correct exposure. The arrangement can be very helpful for close-ups, where depth of field is critical; also for dim night shots (most cameras can set times up to 30 seconds or so). This mode will also handle a very wide range of light-intensity conditions, as there are far more potential shutter settings than *f*-numbers. However, you may sometimes find yourself hand-holding the camera at a slow speed, resulting in blur.

Shutter priority (Tv) mode works the other way around. You set shutter speed and the camera selects what *f*-number the lens aperture will close to when you take the picture. (As with most modes, a signal warns if the exposure required is over or under the setting range available to the

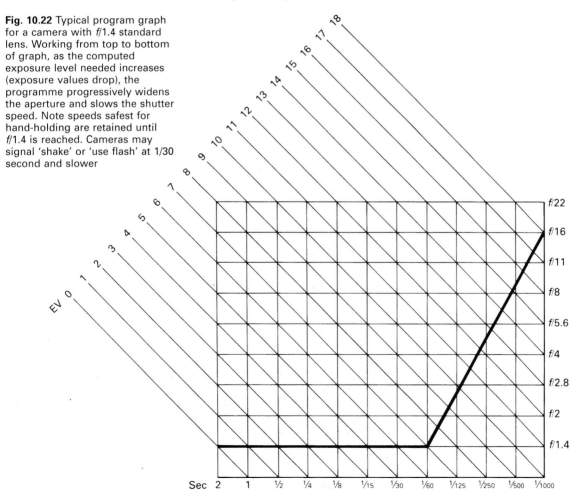

Fig. 10.22 Typical program graph for a camera with *f*/1.4 standard lens. Working from top to bottom of graph, as the computed exposure level needed increases (exposure values drop), the programme progressively widens the aperture and slows the shutter speed. Note speeds safest for hand-holding are retained until *f*/1.4 is reached. Cameras may signal 'shake' or 'use flash' at 1/30 second and slower

camera. In this instance, you should set a different shutter speed.) Shutter priority is useful for sports work and any action or interpretative photography where you must maintain control over the appearance of movement. Or it may be just that you prefer to shoot a hand-held series at a safe 1/125 second, or 1/250 second with a longer lens, and accept whatever depth of field the lighting conditions permit.

Programmed modes allow the camera to alter both shutter and aperture, running through an intelligent program of settings, from shortest time/smallest aperture, to longest time/widest aperture, according to inputs of light reading and film speed (shown in Figure 10.22 as exposure values). The chart illustrates a typical standard lens program in which there is a progression of both shutter and aperture changes until, with decreasing light, the lens's widest aperture is reached (in this instance *f*/1.4). From here onwards exposure time only increases, usually accompanied by a camera-shake warning light at speeds slower than 1/30 second.

Programs like this are often built into compact cameras as hidden systems which do not reveal to the user any technical information other than giving 'shake' and 'out of range' warnings. They have proved very successful for average amateur photography.

On SLR cameras, however, having one standard program may not be suitable when you use telephoto or wide-angle lenses. Some cameras therefore offer two additional programs – 'tele' and 'wide'. As Figure 10.23 shows, on *tele* the camera reacts to decreasing light by maintaining fast shutter speeds as long as possible, to counteract the ever-present risk of image blur with long-focal-length lenses. When *wide* is selected the camera makes equal alternating changes of aperture and shutter speed, bearing in mind that camera shake is less likely. This choice of program is either left to the user, or may be selected automatically when you fit a telephoto or wide-angle lens.

Several other programs are offered by individual manufacturers. Their names ('deep focus', 'flowing', 'stop-action', 'shallow focus')

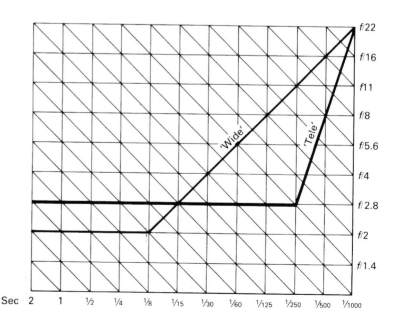

Fig. 10.23 'Tele' program (shown here for *f*/2.8 maximum aperture lens) retains shutter speeds of 1/250 second or faster as long as possible. 'Wide' program (*f*/2 lens) pays equal attention to aperture and shutter changes

are cosmetic but self-explanatory. Having many modes available is sometimes confusing and counter-productive. In practice, you will probably use only two or three at most. The most popular modes tend to be manual and aperture priority. The standard programs are handy for rush situations, while shutter priority is preferable if you do much action-freezing photography or use telephotos hand-held. In all modes the camera should show what settings are made, to allow you to pre-visualise and if necessary alter the effect of aperture and shutter on picture appearance.

Fig. 10.24 Add-on meters. Left: unit for 5 × 4 in view camera is carried on open frame the same size as film holder. The probe then allows selective 'spot' readings. Right: metering pentaprism for a rollfilm SLR gives overall reading

TTL meters that are either built-in or added-on as accessories to larger cameras are less comprehensive than 35 mm types. Most rollfilm SLRs, for example, offer a system providing centre-weighted measurement and a choice of either manual or aperture-priority setting modes. Add-on TTL meters for view cameras (Figure 10.24) use a probe you move around the image plane to make spot readings. Output is fed to a simple readout of settings, or wired to an electronic front shutter to allow aperture priority or manual modes. Meters and programming for *flash* are discussed on page 205.

Practical problems

Exposure metering equipment allows you choices and control at three main points: (1) the ISO speed set for the film, (2) the parts of the subject you actually measure, and (3) the alternative ways of dividing exposure between lens and shutter. Altering the film-speed figure upwards (or using a 'minus' setting on the exposure-compensation dial on auto-setting cameras) helps if you must get more sensitivity out of the film in dim light, or subject contrast is very flat. In both cases you must follow this up with extra development. You might also set a high figure just to get a meter response in dark conditions; see project on page 34.

Fig. 10.25 This sort of subject –
with more or less even
distribution of light, dark and
midtone areas – is ideal for
exposure reading by either
general or centre-weighted
measurement

Fig. 10.26 Here the most
important picture element is the
distorted reflection, which
occupies only about 25 per cent
of the frame. Measuring generally
would underexpose the reflection.
It is better to take a spot reading
off the reflected building, or
briefly recompose it to fill the
frame while taking a general or
centre-weighted reading. (If
necessary set Exposure Lock to
stop the camera reverting to a
faulty measurement when you
finally compose to shoot

Downrating or use of 'plus' compensation helps to reduce contrast
and grain when followed up by *reduced* development. (Remember
development changes are not advisable with colour negative films.)
Downrating alone is a way of compensating for subjects measured by
general reading against the light or with large bright backgrounds,
which you know will otherwise make them underexposed; or you might
use it to allow for a film's anticipated reciprocity failure (page 161).
Consider your plus or minus settings on the exposure-compensation
dial as a lighten/darken device for interpretative purposes too, just like
the controls on many instant-picture cameras.

Always think carefully about the area you measure. Decide the
priorities between various tones of your picture. If there is only one
really key tone, and you don't have spot reading, try to make it fill up
the whole frame. With a close-up you can do this by just moving

Fig. 10.27 Making a substitute reading off your hand, for a distant face. Both must be in the same lighting. By turning your hand you can match both lightest and darkest parts, and so make brightness-range readings

Fig. 10.28 Using a grey card to read exposure when copying drawings. If the original is larger than your card, move closer until it fills the frame. But don't refocus, or cast shadows

forward (don't refocus – extra extension may change the reading). If your key subject is inaccessible, take a substitute reading from something convenient that matches it in tone. The eye is good at judging comparisons. A grey card has already been suggested, but you can read off your hand, lining it up and turning it at angles in the light to match a far subject tone (Figure 10.27), or find some part of the ground or sky with the right-looking tone.

It helps to 'redistribute' your framing of the image so that the size of each tone area relates to its exposure importance. For example, twisting the camera may just include the lightest and the darkest important tone 50:50 in the frame, so your one reading averages the two. A zoom lens is helpful to enlarge or reduce the size of detail for this purpose (provided the lens maintains a constant aperture).

Copying line drawings, photographs, paintings, etc. often brings problems over how best to take a reading. Areas of dark and light are unlikely to be equal. Sometimes you can 'home in' on a midtone of sufficient size in a photograph or painting, but the best approach is to read off a grey card (or take an incident-light reading). Notice how important it is to have a TTL system that allows you to take a reading and then retain it after reframing the picture, removing the grey card, and so on. On some cameras you must activate an 'exposure lock' button, otherwise the meter goes on taking new measurements.

Another problem concerns exposure reading when using a *moving* light source to 'paint with light' an architectural interior or still-life – spreading the light and forming a softer, more even source, page 120. Provided the lamp is moved in an arc maintaining approximately the same subject distance, you can measure exposure accurately when it is still. With interiors partly lit by existing light, remember that results look more natural if you slightly underexpose any fill-in from the camera. See also flash fill-in, page 212.

Finally deciding the best way to divide the exposure your film needs between aperture and shutter is always something of a balancing act. Each shot has to be considered on its depth versus movement merits. Occasionally, requirements and conditions work together to give plenty of options, as with a scenic landscape with all its elements static and distant, in strong sunlight. At other times, they all conspire against you, as in a dimly lit shot of moving objects at different distances which must all record in detail. In this instance you must think how to improve conditions – perhaps by adding (flash?) lighting, altering viewpoint to reduce the range of distances, or uprating or changing to faster film still within grain and sharpness tolerances.

Measuring exposure (flash)

Control and exposure of electronic flash differs in several ways from continuous light source techniques. When a flash unit is switched on, a steady current is drawn into electrical storage tanks (usually capacitors) which cause a 'ready' signal to appear when fully charged. Firing the flash allows this stored power to discharge as a pulse through gas in the flash tube and so produce the light. Then the unit recycles (recharges) itself ready for the next shot.

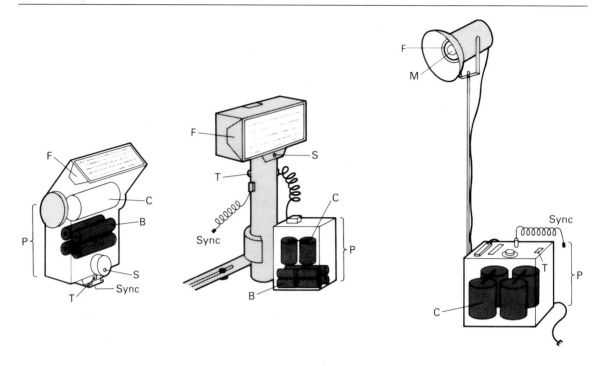

Fig. 10.29 Electronic flash units, showing key contents of powerpacks (P) greatly simplified. Power from batteries (B), or (studio unit) household supply, charges capacitors (C). These discharge through flash tube (F) when circuit is closed either by camera synchronising connections or test-button (T). S: sensor for measuring and self-regulating duration of flash. M: tungsten modelling lamp

Synchronous firing

A harmless, low-voltage circuit is used to actually fire the flash either (a) directly, through contacts that come together in the camera shutter or a test push-button on the flash unit, or (b) indirectly by means of a trigger that immediately responds to light from another flash, or even to sound or some other stimulus.

Electronic flash goes off instantly when fired, its light duration ranging from about 1/500 to 1/30,000 second according to type and conditions of use. So provided your shutter is synchronised to have the film fully uncovered at this moment, it is primarily the *flash* that determines exposure time, rather than the shutter itself. You can use electronic flash at any shutter speed with a between-lens shutter; similarly with a 35 mm focal-plane unit, provided your flash always delivers a 'long peak'. Most guns give shorter duration flash, and when they are used with an FP shutter at its fastest settings the blinds block out part of the picture like Figure 4.9. This is why the shutter's fastest 'safe' speed often has a different colour on the setting scale, or is marked ⚡ or X. On programmed cameras this speed (or slower) is automatically set when you switch on the dedicated flash unit.

Some shutters, such as between-lens types on view cameras, have an 'X/M' selector switch near the flash synchronisation lead connection. This must be set to X. With any camera you can always use an 'open flash' firing routine too, provided your subject and camera are static, and any ambient light is low. Open flash involves holding open the shutter on 'B' and firing the flash by its test button. Several repeated flashes can be given this way if your flash equipment is not powerful enough for the aperture you need to use.

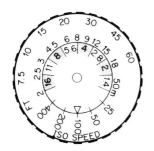

Fig. 10.30 Exposure calculator dial based on distance × *f*-number, for a flashgun with a guide number of 36 (metres)

Guide numbers

The most basic way to estimate flash exposure is to use the guide number (or 'flash factor') quoted for the unit. The GN is the distance between flash and subject, multiplied by the *f*-number required, when using film of a given ISO speed. Unless otherwise stated, figures are always quoted for ISO 100/21° film, and for distances in metres. So using a flash with a 36 guide number you set *f*/8 for a subject 4.5 m (15 ft) from the flash, or *f*/11 for 3.3 m (12 ft), using ISO 100/21° film. This might be built into a calculator dial like Figure 10.30, which can also include other film speeds and the use of the flash at fractions of full power, if this is possible. Self-regulating flashguns set to 'manual' work with a similar kind of calculator or table. Guide numbers are also quoted to compare the output of different flash units (Figure 10.31).

The much greater power output of studio flash units is more frequently quoted in 'watt-seconds' (= joules). The guide number of a typical 1500 Ws power pack unit is 200 (metres) using the head with a bare tube and reflector. This ratio varies with the head design, GN often being reduced to one-fifth when the same head is set behind the diffusing material of a window light, for example; see Figure 7.16. Studio power packs can also feed several heads, in which case output is divided by the number of equal power heads.

Disadvantages. In practice guide numbers do not take sufficient account of the reflective properties of a subject and its surroundings, and whether flash is direct or bounced, atmospheric conditions, etc., unless you keep making modifications. Also the basic manufacturer-quoted number tends to apply to favourable conditions, such as direct lighting of a pale-skinned person in a small room with pale-toned walls.

Flash meters

Fig. 10.31 Light output and performance of a cross-section of commercial flash units, from a miniature type built into a compact camera, to powerful studio equipment

A flash meter is similar in appearance and use to a hand-held incident-light exposure meter. You set it for film speed, hold it at the subject position facing the camera, and fire the flash, whereupon the meter shows the lens aperture required. Meters can be used 'cordless', meaning that you need an assistant to push the test firing button on the flash if it is beyond arm's length. Or a long cable links meter and flash unit so that you press a button on the meter to fire the flash.

Type	Guide no.		Duration		Recycle time (seconds)		Col. temp.
	m	*ft*	*Max. power*	*Min. power*	*Max. power*	*Min. power*	
	20	66	$\frac{1}{2000}$	$\frac{1}{40,000}$	10*	0.6*	5600 K
	36	119	$\frac{1}{3000}$	$\frac{1}{30,000}$	8*	0.4*	5600 K
	60	197	$\frac{1}{200}$	$\frac{1}{20,000}$	5*	0.3*	5600 K
1500 Ws	196	640	$\frac{1}{400}$	$\frac{1}{600}$ (quarter power)	3	0.8 (quarter power)	5500 K
6000 W s	390	1280	$\frac{1}{200}$	$\frac{1}{300}$	7	2	5500 K

*Relates to non-rechargeable batteries.

Flash meters are calibrated to within one-third or one-quarter of a stop, and give extremely accurate results when used carefully. Some types take measuring attachments such as fibre optics (Figure 10.15), and several do double duty, acting as continuous light meters too.

Disadvantages. A separate flash meter is really only practical where time and conditions permit you to take a flash reading before shooting – they are ideal in the studio, for example. Meters are also costly, do not automatically take into account camera filters or close-up focusing conditions, and like all incident-light meters their readings sometimes need interpretation (page 195).

Self-regulating units

Battery flash units – add-ons or built into the camera – mostly incorporate their own exposure reading system. In an add-on gun, this typically consists of a fast-acting sensor set behind a small window on the main body of the unit, facing your subject. The sensor has an angle of view of about 20°, and so reads the flash illumination reflected back from everything within the central area of your picture, assuming a normal-angle lens. The flash gun has to be set for the ISO film speed and the *f*-number you intend to use.

In the case of a compact with *built-in* flash the camera's own next-to-lens light sensor may act as the flash sensor, and is already fed with ISO speed and aperture information. (Alternatively most autofocus cameras set aperture based on subject distance measured by the AF system, simply working to a guide number.)

According to the light received, the unit instantly regulates flash duration to give correct exposure. For example, it might clip flash to 1/30,000 second if the subject is close or bright and therefore gives a strong light reading, or extend it to full (typically 1/500 second) duration with a distant or dark subject. Reciprocity failure further reduces exposure by half to one stop at the most extreme short speeds; see Figure 9.12.

The self-regulating range of such a flash unit in terms of subject distance is quite wide, but its limits change somewhat according to the lens aperture set. Figure 10.34 shows that the wider the aperture, the

Fig. 10.33 Exposure control systems. Left: compact camera's light sensor below lens measures and controls duration of built-in flash. Centre: similar sensor system within clip-on gun (must be programmed for ISO and aperture). Right: the same gun, if dedicated to the particular SLR, uses camera's 'off-the-film' exposure reading circuit instead

Fig. 10.34 Working range of a typical small self-regulating flashgun (set for ISO 100/21°) at various apertures. S: shortest flash duration. L: longest duration. See also Figure 10.31

farther the working range moves away from the camera, distances being doubled for every two stops change of aperture, as with guide numbers. Most of the time a setting about midway in the *f*-number scale gives a good working range unless you are working very close or far away. With the exception of smallest units, a 'thyristor' electrical circuit returns to the capacitors the energy saved when shorter flashes are used. You then find that the gun takes less time to recharge, just as it does if set manually to one half or one quarter of full power.

Most self-regulating add-on guns can also act as simple reflected-light flash meters. You make a preliminary flash, using the test button, and an 'OK' green signal will pulse if conditions suit film speed and aperture. On some models the best *f*-number to use is displayed.

Disadvantages. Although a self-regulating unit is a quick, more convenient way to control exposure than making a flash meter measurement, its subject viewing system is fairly crude. The constant angle of view measures a larger or smaller proportion of your picture area if you use tele or wide-angle camera lenses. It is also over-influenced by the relative areas of light and dark objects, like any other general reading meter. When shooting close-ups, there are severe parallax errors between sensor and lens, and no account is taken of light loss owing to close focusing conditions. With some clip-on units it is easy to change *f*-numbers on the lens but forget to change them on the flash. The light beam may not span the angle of view of your camera lens. See dedicated flash disadvantages, below.

Dedicated flash systems

A 'dedicated' flash takes self-regulation one important stage farther. Multi-circuits between a suitable add-on flashgun and camera allow

them to communicate with each other. As long as the camera has TTL exposure measurement 'off the film' this internal metering takes over the role of the flash unit's sensor, with the bonus of automatically taking into account f-number, ISO speed, close-up imaging, filters, etc. You also have use of the camera's exposure-compensation dial to cope with difficult subject conditions. If the camera is an SLR it accurately shows what subject area you are measuring, at any distance and with any lens. The flashgun, in return, communicates data such as 'charge ready' and exposure-check confirmation signals directly into the display alongside the focusing screen, so you need not remove your eye from the viewfinder.

Disadvantages. You cannot use any choice of add-on flashgun and camera – they must be matched to each other, the camera having OTF metering. Extra flash-heads must all be wired to the camera, as the system does not allow them to be set up independently and fired by a slave trigger (Figure 10.37). As with all add-on guns, it is still possible to mis-match light distribution from the flash reflector and the camera's angle of view, giving, for example, too narrow a beam so that only the centre of the wide-angle shot is illuminated. Wide-angle and telephoto 'beam shapers' are available to adapt the flash's angle of view, but only to match a limited range of lens focal lengths.

Practical flash techniques

Bounced flash

As discussed in Chapter 7, bouncing flash off a ceiling, wall or similar large surface area is a convenient way of softening lighting quality and improving evenness. However, you greatly reduce its intensity. When working by guide numbers the rule for a white bounce surface is: (1) halve the regular flash guide number, and (2) divide this new number by the *total* flash distance (i.e. flash to surface to subject) to discover your f-number.

Flash meters, and dedicated flash, will take bounce light conditions into account in measuring exposure. It's very important with a self-regulating flashgun that the sensor always *faces the subject*, even though the flash is directed upwards or sideways onto a bounce surface. This is usually taken care of in gun design, where the part containing the flash tube pivots and twists but the sensor remains fixed and forward-looking.

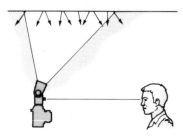

Fig. 10.35 When 'bouncing' flash, the light sensor must continue to face the subject direct

Using several heads at once

Like any other lighting, you often want to use two or more flash sources from different positions, especially in the studio. With studio flash units the best arrangement (Figure 10.36) is to have separate units each consisting of a single head and power pack independently plugged into the electricity supply. The power pack of one head is connected to the camera by synch lead, or has an infra-red trigger which reacts to a battery-powered IR pulse transmitter you mount in the camera's hot shoe. Each of the other packs may have a light-sensitive trigger (often built-in, just needing to be switched on) which fires the flash in immediate response to the one linked to your camera.

Fig. 10.36 Left: two independent studio flash units, the far one triggered when its plug-in slave sensor (S) reacts to light from nearer unit, sync wired to camera. Alternatively (right) using two heads from a single pack. Maximum power output is then split

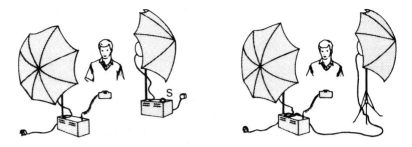

These 'slave units' can then be moved around in the studio with the freedom of tungsten lighting. Each pack can be turned down to half or quarter flash power: usually the modelling dims pro rata, to show you the effect of having sources at different intensities. Another, cheaper studio flash arrangement is to have just one power pack, plug several heads into it and place these in different positions. Only one link from the pack is needed to your camera. Remember, however, that power output from the pack is then *split* (for example, a 1500 watt-second unit gives 750 Ws each to two heads, 500 Ws to three, and so on).

The best way to measure exposure is by flash meter. If you use a guide number system instead, work with the GN and distance of your *main* light flash source only, ignoring the others. Another approach is to establish the intensity ratio between modelling lights and flash, then measure with any ordinary hand or built-in exposure meter (*Advanced Photography*).

With battery-operated 'hammerhead' flashguns, the power pack may have just sufficient power to split off usefully into several heads. With smaller guns this is impractical and you will need several complete flashguns on stands wired or 'slaved' to the camera (Figure 10.39). If guns are dedicated, you *must* have each one wired back to the camera to control their output. Then exposure measurement is simple – you just use the camera's TTL meter as normal.

Fig. 10.37 Instead of a direct sync lead, flash can be fired via a small battery-powered infra-red transmitter in the camera's hot shoe. A detector on the flash responds instantly the shutter fires

Fig. 10.38 Studio flash power-pack controls (simplified). Thickest lead connects capacitors to flash head and powers modelling lamp. Both flash and modelling can be set to four power levels. Test-firing button is next to fully charged 'ready' light. There is also an audio signal. Unit is fired by plug-in sync lead to camera, slave light sensor (bottom right) or IR receiver (Figure 10.37)

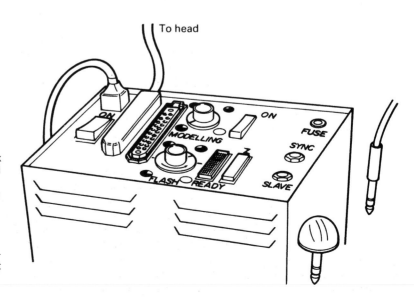

To head

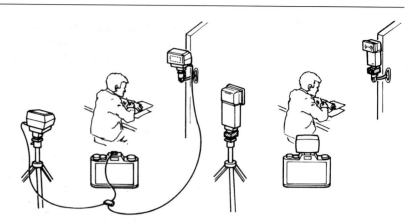

Fig. 10.39 Left: two dedicated flashes controlled from their 'off the film' metering camera by direct wiring. Right: set-up using self-regulating guns set to manual, the two off-camera being triggered by light slaves fitted below; these respond to a small flash on camera. (If frontal lighting is objectionable, IR triggering can be used instead.)

If your flashguns are self-regulating but not dedicated types (or a mixture), it is least confusing to set them all to manual, wire them to the camera or a trigger for firing purposes, and then measure exposure by meter or just work from the guide number for your key source. Lack of modelling lamps is a big disadvantage with all battery flash when using several heads – you need experience and skill to predict where to place each one; see Chapter 7.

Rapid-repetition flashes

The faster your flash power unit will recycle, the more rapidly you will be able to take pictures. This is important in most action and press photography, where any delay waiting for the flash to come up to power could lose you an unrepeatable image. And it is vital if you are shooting a sequence by motor drive.

One way of working is to use a battery flash unit with a powerful power pack turned down to a fraction of its full output. For example, one such unit allows you to select 1/100th of full power, and then recycles in 0.25 second. The flash is also extremely brief, in this instance 1/50,000 second. You get a similar performance when taking close-ups of light-toned subjects with a self-regulating or dedicated flash. Duration may then be clipped to about 1/30,000 second and recycling to 0.2 or 0.3 second, given fully charged batteries. Colour slide films in particular need some compensation for reciprocity failure at these speeds; see page 161.

Most studio units have a high-output flash and then take several seconds to recycle on full power. They easily overheat too, if made to fire and cycle in continuous sequence. Special models are therefore made with rapid-firing facility, but give a fraction of normal output.

If you shoot a different frame with each flash pulse, the exposure must of course be based on one flash. But if you run a fast series of flashes during one shot – to give a stroboscopic effect to a moving figure like Figure 10.40, for example – you may additionally have to stop down. Much depends on how much each 'frozen' image overlaps the next and so adds to the exposure it has received.

Fill-in flash

Flash on the camera is a good way to lower subject contrast in side, top or back-lit ambient lighting situations. Obviously you cannot expect to

fill-in landscapes and general views this way, but it is useful for portraits and average size room interiors. (Make sure, when shooting in colour, that flash and ambient lighting are the same colour temperature – in tungsten light conditions fit an orange 85B filter over the flash tube window and shoot on tungsten film.) You must have the flash close to the lens to avoid casting additional shadows, and arrange to underexpose the flash aiming for a flash/existing-light ratio of 1:4 (colour negatives).

For example: (1) set your flashgun to manual, and if your camera offers various exposure modes set this to manual too; (2) use the camera or a hand meter to take a normal reading of parts of the subject strongly lit by the ambient illumination; (3) set the shutter to the flash speed or slower (choose any speed on a bladed shutter) and set the aperture shown necessary by (2) for this shutter speed; (4) shoot from the subject distance shown on the flashgun's manual calculator dial against the f-number you have set; (5) before exposing, turn the flash down to quarter power, or cover the flash with either a $\times 4$ neutral density filter or a diffuser absorbing 75 per cent of the light. See Figures 10.41 and 7.22.

Summary: Exposure – equipment and methods

● Exposure level controls image tonal and colour qualities, allows emphasis and helps interpretation.
● The exposure needed depends on lighting, subject, imaging conditions and effective film speed. It is given to the film through the combined effects of the *intensity* of the image light, and the *time* it acts on the emulsion. Exposure can be quoted in f-numbers and shutter speeds, or exposure values.
● With negative films avoid underexposure, which produces empty flat shadows. Severe overexposure gives grainier, less sharp results. Overexposure is worse than underexposure shooting slides and transparencies. Contrasty scenes allow you least exposure latitude. Where possible, intelligently bracket your exposures as insurance.
● Integrated or general readings are quick and convenient, but inaccurate when important areas are relatively small. Averaged brightness-range readings (ideally taken by spot metering) take longer but reveal scene contrast, too. Grey-card or incident-light readings pinpoint tones independently of the subject, but need interpreting with contrasty scenes.
● TTL meters match lens angle of view, take into account close-up focusing and filters, and can make exposure settings direct. Readings are typically centre-weighted or spot.
● TTL setting modes offer choices such as manual, aperture priority, shutter priority; also standard, wide or tele programs.
● There are three main exposure decisions – the ISO rating you set for your film (to allow for lighting conditions), the subject parts you measure (emphasis), and how exposure is distributed between shutter and aperture (movement and depth of field effects).
● Substitute readings, and recomposing different areas of subject within the frame, will often help to give you more accurate measurements.

Fig. 10.40 Series of six flashes fired from a hand flashgun in a darkened room, from one side of the model. The camera shutter was locked open on B throughout. Flashgun was totally separate from the camera, and fired manually using the test button. Notice how the almost stationary trunk and legs build up exposure, while hands and fingers receive only one flash each. Set an *f*-number half-way between these extremes

Fig. 10.41 Fill-in flash. Near right: existing light only, no flash, 1/60 second at *f*/11. Far right: same exposure with addition of flash from the camera set to one-quarter correct power for this subject distance

● Flash exposure can be based on *guide numbers* (*f*-number × distance), or measured by *flash meter* (most practical with studio units), a *sensor* on a self-regulating built-in or clip-on flashgun, or the camera's *TTL system* in circuit with a dedicated gun.
● Electronic flash synchronisation (X sync) is offered by focal-plane shutters at a nominated flash shutter speed or slower, and by between-lens shutters at all speeds.
● Self-regulating flash units, independent or dedicated, give shortened flash (and faster recycle) when there is a strong reflected-light measurement from the subject.
● Flash factor is halved at least with bounced flash; remember to measure the *total* light-path distance. Avoid coloured ceilings/walls.
● With multi-unit set-ups, synchronise one studio flash to the camera and 'slave' the rest. Set self-regulating units to manual, have them wired or slaved to the camera. Check exposure by flash meter, or work with the factor for the key light only. If you have dedicated flash units, wire them all to the camera, then use the TTL camera meter.
● Fast-recycling flash is essential for rapid sequence work. Use a powerful gun at fractional setting, or a specially designed flash unit.
● To fill in and reduce the contrast of ambient lighting, use underexposed on-camera flash. Have the camera settings correct for existing light. (Shutter speed must be suitable for flash.)

Projects

1. Practise substitute readings. Judge by eye a nearby tonal substitute (perhaps your hand?) for a more distant part of a scene. Read the substitute, then approach and read the part of the scene to see if they agree.
2. Compare reading methods. Using the same subject set-up, measure exposure by general, brightness-range, grey-card, and (if a hand meter) incident-light attachment readings. They should all generally agree. If not, discover why.
3. Check the measuring area of your TTL meter. Set up a subject containing a spot of light (a small hole in card with light behind) and image this as tiny as possible on the focusing screen. Set the camera for correct exposure with the spot dead centre. Then turn and slightly angle the camera so that the spot gradually moves outwards, in a spiral track (without changing its size). Note at what positions underexposure is signalled, and so build up a sensitivity 'map' like Figure 10.19.
4. Practise fill-in flash. Work out settings which give you 1:1, 1:2, 1:4 and 1:8 flash/ambient ratios. Compare their visual results. Establish the best simple routine with your equipment for fill-in portraits.

11
Film processing

Having taken so much care to light and compose your image, and accurately expose it on film, don't risk ruined results at the processing stage. Processing is a responsible job, essentially a consistent, controlled routine. It is done by using processing *solutions*; from these the gelatin of the emulsion absorbs chemicals which then react with silver halides, in the case of developers differentiating between exposed and unexposed crystals. Using liquid you can also wash out by-products and chemicals from the emulsion without disturbing the actual image.

Processing is ideally suited to automatic machinery, which gives very consistent results but is expensive and really only justified for photographic departments and laboratories which have a high through-put. This chapter therefore concentrates on the processing of different kinds of camera films in small quantities, by hand. You may well decide, like most professionals, to have colour films processed by a local laboratory, but to do your own black and white work. After all, colour chemical costs are quite high, and the capacity and keeping qualities of most solutions are limited. Black and white processing lends itself to much greater choice and manipulation of developer and development, and is generally less rigorous in terms of temperature control.

For all forms of film processing you can use light-tight tanks. Provided these are loaded with film in darkness, permanent darkroom facilities are not essential (unlike printing, Chapter 12). Consistency is maintained through *timing*, and careful control of *temperature* and solution *agitation*. You can also give additional or less development – usually by adjusting timing – to alter the characteristics of the final image. These changes mostly affect density, contrast and grain.

Processing is often mundane, but it requires concentration and care over detail. You must avoid contaminating one chemical with another, and be sure to wash by-products out of the emulsion. Times and temperatures have to be closely monitored. Wet film is very vulnerable to physical damage too, including scratches and dust which, when enlarged, ruin final results, or call for hours of retouching. In short,

Fig. 11.1 35 mm and rollfilm hand processing tanks. A: stainless steel 120 film reel tank and lid. B: steel reel loader for 35 mm; cassette fits in cradle, guide bows film across width to load from reel centre. C: tank bodies for processing two and three reels at a time. D: plastic rim-loading reel and tank for 35 mm; see also Figures 11.7 (b) and 11.8

although processing is not difficult, the fact remains that a few moments' carelessness can ruin dozens of unrepeatable pictures.

This chapter begins by discussing the equipment and general preparations needed before processing any kind of film. It then looks at the routines, choices and controls over results when processing black and white negatives, colour negatives, and slides.

Equipment and general preparations

Before you start you will need some essential items of hardware, chemicals which may require mixing or diluting for use, and a suitable place to work. Your chief item of equipment is a processing tank. This must hold sheet films suitably separated, or roll and 35 mm films in open coils, so that chemicals or wash water can circulate over the

Fig. 11.2 Film processing accessories. G: graduate and mixing rod for mixing and diluting. S: solution storage containers and funnel. T: thermometer – electronic digital, or traditional alcohol type. M: minutes timer. F: clips for hanging up film. W: wash hose to push down into hand tank, and protective gloves

Fig. 11.3 Half-full concertina storage container can be compressed (left) to minimise air left in contact with solution. This extends life of developers by reducing oxidation

unobstructed emulsion surfaces to affect them evenly. You also need a photographic thermometer, preferably a digital type, and various graduated measures ('graduates') for measuring and mixing solutions, as well as a plastic mixing rod.

For small tanks in particular you require chemical storage bottles, a funnel (to return solutions to containers), a hose for washing, and photographic clips for hanging up films to dry. You can time processing from any watch or clock, but it is easier to use an electronic timer or a reliable cassette recorder you programme for the complete sequence of stages, including agitation periods. Also have some means of maintaining solution temperatures during processing, and a drying cabinet.

Solution preparation

The main considerations for care when preparing chemical solutions are health and safety, and accidental contamination. It is always advisable to wear rubber or plastic gloves to protect your hands from direct contact with liquid or powder chemicals. When dissolving dry chemicals or diluting concentrated solutions do this near a ventilator or open window, and avoid inhaling vapour. Figure 11.4 lists some common photographic solutions you are likely to meet and which require care in this respect. Don't add water to powdered or liquid concentrated chemicals, always the reverse. Read the warnings on labels, and keep all solutions away from your eyes and mouth as well as from cuts or grazes. *Never* have food or drink near chemical preparation areas. And make sure all your storage bottles are correctly labelled and cannot be mistaken for something else.

Contamination of chemicals will often make expensive solutions useless and, worse still, ruin films – especially colour films. To begin with, make sure all items that come into direct contact with photochemical solutions are made from appropriate inert materials such as PVC plastic, stainless steel or glass. Copper, bronze, galvanised iron, chrome or silver plated materials, zinc, tin or aluminium are all unsuitable, because they react with chemicals and fog film. Absorbent materials such as wood or polyurethane soak up solutions and then contaminate the next thing they touch. Only a drop or so of some chemicals can totally neutralise others. Be careful not to contaminate accidentally through poorly rinsed graduates or storage containers, by solution carried over on a glove, thermometer or mixing rod, or by mixed-up bottle caps.

Processing chemicals are bought either as complete kits containing all stages (as for colour film processing) or as individual items (such as black and white chemicals). In both instances, they may be concentrated liquids or premixed powders which need dissolving. Sometimes, with unusual solutions, you might have to weigh out and mix chemicals according to a published formula, see Appendix B. Instructions are always included with prepacked chemicals; follow them meticulously with regard to the *order* in which the contents of any sub-packets are to be dissolved, and the *temperature* of the water. Failure to do so may either oxidise your solution or make powder impossible to dissolve.

Often concentrated liquid chemicals must be diluted *by part*. For example 'one part stock solution to eight parts water' or 1 + 8. Parts may mean any unit of volume, as long as you use the same unit for

⚠️

AVOID skin contact or inhaling fumes from:
Chromium intensifier
Selenium toner/powder
Formalin/formaldehyde
Dish cleaner
Iodine bleacher
Lith developer
Hydroquinone
Sepia (sulphide) toner
Blue toner
Stabiliser
Acids of all kinds

Do NOT store chemicals or solutions in a refrigerator.

Fig. 11.4 Safety precautions with processing chemicals. See also Appendix E, page 296

concentrate and water. 1 fl oz with 8 fl oz water (total 9 fl oz) or 1 US pint with 8 US pints (total 9 US pints) are both 1 + 8 solutions. It is also useful to know how much concentrate you need for a set volume of working solution. The formula is:

$$\text{Parts concentrated solution} = \frac{\text{final working volume}}{\text{parts water} + 1}$$

In other words, the amount of concentrated developer to prepare a 12 litre tankful of one part stock to five parts water is $12 \div 6 = 2$ litres.

Occasionally you have to use a *percentage* solution (handy when a chemical is used in different amounts in various solutions). The 'percentage' of a solution means the ratio of chemical to the final quantity of its solution in water. For example, a '5 per cent solution' is five parts of chemical made up to a total 100 parts with water. In the case of solid chemicals, this is worked as weight per volume. So both 5 grams of solid chemical made up to 100 ml with water (total 100 ml), and 5 ml of liquid chemical made up to 100 ml (total 100 ml) are 5 per cent solutions.

Processing tanks (sheet film)

The most common way of hand-processing sheet film is in a series of 15 litre PVC 'deep tanks' (Figure 11.5), one for each stage of processing. A floating lid rests on the surface of solutions, such as developer, prone to oxidation with the air; it is removed completely during processing. Each tank has a main lid which is loose-fitting but light-tight, so that you can switch on white light to check time, etc. once films are in the solution.

You remove each sheet film from its holder in darkness or correct safelighting (page 249) and clip it into a stainless steel hanger. You can lower hangers individually into the first tank of solution, where they are supported by a ledge near the top. For batch processing, hangers can first be slotted into a rack which makes them much easier to agitate. Similarly several standard reels containing roll or 35 mm film can be

Fig. 11.5 Deep tanks. Sheet films are clipped in individual hangers, which hang in solution within tanks. For processing larger quantities racks hold many hangers, or films in reels. Films must be moved (in darkness) between separate tanks of developer, stop bath and fixer. Tanks are housed in flat-bottomed PVC sink

Fig. 11.6 Small-volume sheet film processing in (left) stainless steel daylight tank, or (centre) rotary drum. The latter maintains both film drum and chemical containers in a temperature-controlled water bath; see side view (right)

fitted within a cage-like stainless steel rack for batch handling in the same way. You must switch off the white light and open the tank lid each time you agitate films or transfer them to the next tank.

Alternatively you can process up to six or so sheets of film in one of two ways. Firstly, they may be curved and fitted within a horizontal PVC drum, which fits on a motorised cradle like a colour print drum processor, Figure 11.6. This is economical, as the rotating tank needs only a small volume of each solution to be inserted and drained in turn through a light-trapped entry funnel. Agitation is continuous. Secondly, the films may be slotted without hangers into a small rectangular

Fig. 11.7a Loading reels. Top: cut off 35 mm film leader in light (if film has wound in completely use a film retriever to pull out end). Next remove film from cassette in the dark. Top right: rollfilm backing paper is unwound in dark until you reach end of film. Centre: plastic 35 mm reel is loaded from rim inwards. Rocking both flanges in opposite directions draws the film in fully. Cut off and tuck in end. Bottom: with a stainless steel 35 mm reel, clip film to the centre core, then turn reel to wind in, bowing film gently between fingers. Again cut and push end into groove

Fig. 11.7b 35 mm tools. Left: retriever, inserted into a 35 mm cassette in daylight, pulls out the tip of the exposed film which has been wound in. Right: opener to remove the end of the cassette, in darkness

'daylight' developing tank. This has a lid with a light-trapped inlet and outlet, so you can pour processing solutions, wash water, etc. in and out of the closed tank in normal lighting.

Processing tanks (roll and 35 mm)

Hand processing tanks and reels are made of either plastic or stainless steel. Reels have open ends with a spiral channel for the film (Figure 11.1). The stainless steel types are more expensive, but quicker to dry between processing runs, and easier to keep clean. They are quicker to load once you are practised, but unlike some plastic types are not adjustable to accept film of different widths.

Having cut off the shaped leading end of the film cleanly, you open the 35 mm cassette in darkness (using an opening tool or a bottle opener) to remove your spool of film. With rollfilm, unroll backing paper until you reach the film itself. Plastic reels are mostly loaded from the outer rim; steel reels always from the centre outwards, keeping the film slightly bowed across its width. You must not kink the film and form dark crescent-shaped marks, nor buckle it so one part of the coil touches another, leaving unprocessed patches. A loading aid (Figure 11.1) makes it easier to fill centre-loading reels in the dark.

Tank bodies hold single reels, or you can buy various taller versions taking multiple reels. Once each film is on a reel, placed inside a body and sealed from light by the lid, you can work entirely in normal lighting, pouring solutions in and out in turn through a light-trapped opening in the lid.

Agitation

Giving correct agitation is of great importance. Too little, and by-products from the emulsion gradually diffuse down the film towards the tank bottom leaving the image with pale-toned streamers. Excessive, over-energetic agitation creates currents from hanger clips or film

Fig. 11.8 Light-trapped lid allows solutions to be poured into and out of a hand tank in normal lighting (stainless steel type shown here)

Figure 11.9 Agitation. Top: tap hand tank gently on bench to dislodge air bells, at start of development. Then use inversion technique at regular, specified intervals throughout processing. Bottom: basic routine for agitating rack of sheet films, in darkness. Alternatively, gas distributor (right) fits under rack and gives bursts of nitrogen to agitate deep tank solution

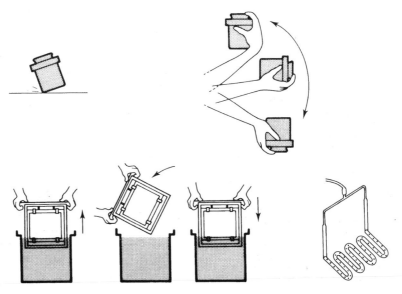

perforations which give uneven flow marks. Most small tank development times are based on 'intermittent' agitation – typically a period of 5 seconds every $1\frac{1}{2}$ minutes. This is given by inverting the film tank or rotating the reel, or lifting and tilting sheet films (Figure 11.9).

It is vital that you be *consistent* in your routine, or the processing will vary. For sheet film in deep tanks the most convenient way of agitating is through timed bursts of inert nitrogen gas, piped to a distributor under the rack inside the tank. In motorised processing the action of continuous drum rotation, or passage of the film through solutions between moving rollers, provides the agitation; see page 231.

Fig. 11.10 Temperature control. A: simple water jacket. B: commercial tempering unit using warmed air (hand tank fits in centre). C: stainless steel tempering coil. D: immersion heater. C and D are for deep tanks

Temperature control

Have developers, in particular, ready at just the right temperature, and maintain this within tolerances for the solution while they act on the film. (Temperature latitude is as little as $\pm 0.2°C$ with some colour developers, but much wider for fixers, etc.) The best way to hold

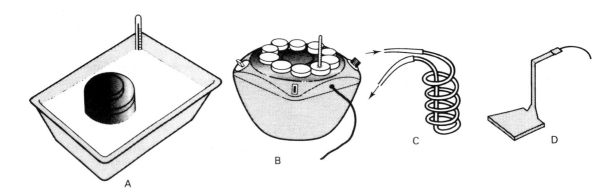

temperature with a small tank is to have a 'tempering unit' (Figure 11.10). This is an enclosed jacket containing electrically heated air or water, thermostatically controlled within narrow limits. Alternatively stand your tank, and graduates of chemicals, in a bowl or deep tray filled with water of the required temperature.

Larger volumes of chemical in deep tanks hold their temperature more readily. To alter temperature use a thermostatic immersion heater, or a tempering coil (through which you pass and discharge warm or cold water), or just stand tanks in a large flat-bottomed sink filled with water.

Working layout

Fig. 11.11 Changing bag made of light-proof material, with elasticated armbands. Tank, scissors, etc. are placed inside through zip opening before starting to load film. Can also be used for loading sheet film holders

Keep your 'dry' working area – rollfilm tank or hanger loading – away from the 'wet' chemical preparation and processing areas. If necessary, small tanks can be loaded in any (clean) light-tight cupboard or even a changing bag, then moved somewhere else for processing itself. Deep tanks, however, need to be in a blacked-out room (page 237). Both large and small tanks will have to stand in an empty sink for washing stages. Have a hose from the water supply pushed down into the open

Fig. 11.12 Film washing. Simple use of hose pushed fully into opened reel tank (left), and wash tank for sheet films (right)

Fig. 11.13 Glass-fronted film drying cabinet accepts roll or sheet film in mixed sizes

rollfilm tank. For sheet film use a purpose-made wash tank (Figure 11.12) with water inlet jets. Both arrangements are designed to allow water to overflow and go to waste.

The quickest and safest way to dry film is in a drying cabinet. Unwind roll and 35 mm film, attach clips at each end and hang them vertically. Sheet film can remain in hangers. See also wetting agent, page 225. The built-in air heater will dry them in 10 minutes or so, or you can just leave them several hours at room temperature. (Never change from one rate to the other part way through drying, or you create drying marks.) You must of course dry films somewhere well away from dust, fluff, grit or chemicals, which could settle on the delicate emulsion surface. If you intend to reuse reels or hangers immediately for further processing, first make sure they are *absolutely* dry.

Processing black and white (silver image) negatives

What happens

Your first processing solution is a developer, containing developing agents (such as metol, Phenidone, hydroquinone) and supportive ingredients including an alkali, preservative and restrainer chemicals; see page 290. During development, electrons are donated to the film's light-struck silver halide grains already carrying silver atoms. This leads to the formation of vastly more silver atoms until the film's latent image grows visible as an image in black metallic silver. In return the developer receives bromine, in the form of potassium bromide discharged from the emulsion in proportion to the silver formed, plus exhausted developing chemicals devoid of their electrons. (As these by-products accumulate they gradually weaken and slow the developer.)

During development, the image of subject highlights appears first, then midtones and shadows. The density of highlights builds up faster than shadows so that *contrast* steadily increases with development. However, development also has some effect on unexposed grains, eventually giving a grey veil of 'fog' to shadows and clear rebate areas of the film if you overdevelop excessively. Development is halted by rinsing the film, or better still treating it briefly with an acidic 'stop-bath' which neutralises any carried-over developer.

The next processing solution contains acidified ammonium or sodium thiosulphate ('hypo') to fix the emulsion. Fixing means converting all remaining silver halides – undeveloped, still creamy looking and light-sensitive – into invisible soluble by-products, which you wash from the emulsion in the final stage of processing prior to

Kodak D76 Ilford ID11 Kodak HC110 (1 + 7 or 1 + 15)	Normal contrast fine grain; good compromise between fine grain and full emulsion speed
Acuspeed	Speed enhancing (up to 3 × ISO)
Microdol X Perceptol	Finer grain at the expense of speed
Rodinal Emofin Neofin Blue	High acutance, low max. density
Kodak D23 Neofin Doku Technidol	Low contrast
Kodak D8 Dokulith	High contrast (regular and line films) High contrast (lith films)

Fig. 11.14 Some black and white film developers

drying. Usually fixer contains a gelatin hardening agent to strengthen the processed emulsion and hasten drying. From the latter half of fixing onwards you can work with the lid off your tank if you wish, as results are no longer affected by light.

Degree of development

With any one type of film, and assuming it is correctly exposed, the amount of development it receives depends on:

1. *Type of developer*, its dilution, and general condition (e.g. how many films it has processed, and how much contact it has had with the air). You have dozens of negative developers to choose from. Some are general-purpose fine-grain types like D76/ID11, others are speed-enhancing (primarily for fast emulsions), or high-acutance (for medium or slow materials), or high-contrast (for line films); see page 166. Their keeping properties vary according to type of formula. Diluting a developer reduces the contrast it gives (even though you extend time). Dilution is also necessary if processing time must be increased to avoid unevenness. However, this adding of water further shortens solution-keeping properties because more oxygen reaches its chemical contents.
2. *Solution temperature.* The higher the temperature the faster the development (Figure 11.15). But if you work a solution much above or below its recommended temperature (typically 20°C/ 68°F) each component of a developer may react differently. At low temperatures some of the developing agents become inert. At high temperatures you risk over-softening the emulsion gelatin, and development times become too short for even action. In general, temperatures within 18–24°C can be fully compensated for by change of time.
3. *Timing.* Within limits imposed by the type of developer and film, the longer your development time the greater the image contrast, density (highlights more than shadows), grain and fog level. Change of timing is the most practical way of altering the amount of development you give, see 'pushing' (facing page). But avoid times less than about 5 minutes when tank processing, as it is difficult to get an even effect. Timing must also be increased each time a solution is re-used.
4. *Agitation.* This needs to be rigorously standardised, as discussed on page 219.

Fig. 11.15 Left: development time factor curve, for use when the correct time is known for 20°C. As simple rule-of-thumb, halve the time for an increase of 5.5°C (10°F). Right: time/temperature graph. Temperatures below 18°C cannot be fully compensated by increased time, and much above 22°C here times become too short for tank processing to be even. (Both graphs apply to a typical normal-contrast developer, dilution and agitation given)

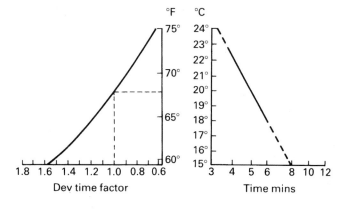

Processings	Timing
1–2	Normal
3–4	Normal + 6%
5–6	Normal + 12%
. . . then discard	

Fig. 11.16 Development time increase with successive uses (D76, single reel tank)

Choosing developer

You need to find the developer(s) which best suit the film, the shooting conditions, and the type of negative you prefer. Another factor is whether to use 'one-shot' (dilute from stock, use once, and throw away) or a long-life reusable solution (increasing your times gradually with each film batch and replenishing when necessary with some fresh chemicals). The latter type is essential for deep tank use; the former is ideal for small tank processing because it is less fuss and ensures consistency, although it may cost more. Extremely energetic developers (lith developer for example) have such a short life at working strength they are best used 'one-shot', so you will probably have to tray-process line sheet films.

Start by using the developer recommended on the film's packing slip. A reusable developer like D76 (1 + 1) or HC110 (1 + 15) is remarkably versatile, suitable for most continuous-tone films and subjects, given appropriate timing. Alternatively, an acutance developer such as Rodinal or Emofin gives high edge-sharpness with slow films and has some 'compensating' effect, restricting maximum density yet giving a good range of other tones.

'Pushing' and 'holding back'

Fast films are most suited to extra development (push processing) to enhance speed, because they are less likely than slow films to become excessively contrasty. ISO 400/27° film can easily be rated at ISO 1250/32°, for example, if processed in speed-enhancing developer, or shot at ISO 800/30° and given × 1.6 normal time in regular D76. Such a routine may be necessary for dim-light documentary photography, or simply when you know you have accidentally underexposed. Don't overdo this if the subject is contrasty, and remember that the extra grain will reduce detail. Slightly extended development helps to improve negatives of very low-contrast images, preferably shot on slow film to avoid excessive grain.

Reduced development (holding back) is less common, but will help when you have accidentally overexposed or want to record a contrasty

Fig. 11.17 Suggested 35 mm film development times (20°C)

Developer	D76 (1+1)	Perceptol	HC110 (1 + 15)	Rodinal (1 + 25)	Neofin Blue	Microphen (1 + 1)	Acuspeed	Neofin Doku	Dokulith
Film									
Agfa 25	13	10*		5	10	10[†]			
FP4	9	8*		8		8[†]	7[‡]		
Plus X	8	8*	8.5	11.5	20	8.5[†]	7.5[‡]		
HP5	14	14*	4.5	7		13[†]	9[‡]		
Tri X	12	14*	7	5		11[†]	9[‡]		
2475 Recording									
Lith								15	
Kodak Tech Pan 25								6.5	2.5

*ISO down, typically –50%
†ISO up, typically +50%
‡ISO up +200%.

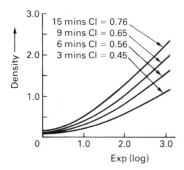

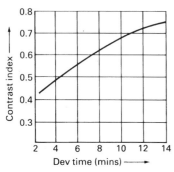

Fig. 11.18 The effect of development on a normal-contrast black and white film. As development time increases, contrast index rises. The steeper the curve, the denser and more contrasty the negative. The lower graph plots CI against time. Film used was 35 mm Plus X processed in HC110 (1 + 7) at 20°C, to specified agitation

image. The best approach is to use a superfine-grain, speed-losing developer such as Perceptol, or D76 diluted 1 + 3. This holds back most films to half their normal ISO rating. (Limits are reached when your negative holds detail throughout an extreme-contrast subject but is too flat and grey to give a satisfactory print.)

Reading technical data

Developer effect can be shown by changes in the film's characteristic curve. Figure 11.18 shows the same film as Figure 10.4, given four different development times. You can see how the curve steepens, giving increasing negative contrast. There is an old adage in photography to 'expose for the shadows and develop for the highlights'. In other words, make sure you give enough exposure to put shadows on the rising toe of the curve, then control development to get sufficient (but not too much) density in highlights.

Degree of development is given a 'contrast index' figure. A CI of 0.45 produces a negative of an 'average' subject (say 100:1 tone range) which prints on normal-contrast paper using a condenser enlarger. Work to 0.56 for a diffuser enlarger (page 240). Manufacturers therefore publish CI/time curves as guidance for various film/developer combinations.

For example, if a CI 0.56 negative suits your enlarger, Figure 11.20 shows that with one popular ISO 400/27° film you could achieve this by giving 8 minutes in HC110 used at dilution B, or $11\frac{1}{2}$ minutes in D76 (1 + 1) at 20°C. The latter would be better for tank development as the longer time lessens the risk of uneven action. In practice, curves cannot provide *all* the information; final negative contrast is also dependent on subject and lighting contrast, atmospheric conditions, the camera lens, colour filters and reciprocity failure (page 161), as well as film development.

Post-development stages

As soon as the development time is up, you pour out developer and refill with stop-bath or water, or (deep tanks) transfer hangers in

Fig. 11.19 Two of the characteristic curves shown in Figure 11.18, related to a subject in which highlights (H) are 100 times brighter than shadows (S). When this is correctly exposed on the film (see exp. axis) and developed to a CI of 0.45 the resulting negative has a density range of 0.8. Developed farther, to CI 0.56, the negative is more contrasty and has a 1.1 density range. Relate these ranges to printing papers, Figure 12.16

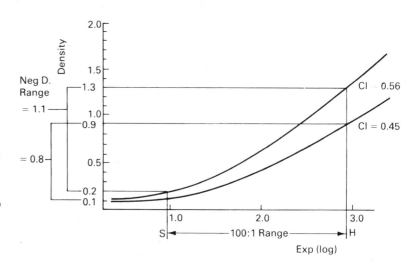

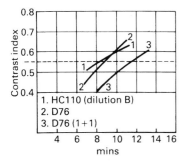

Fig. 11.20 CI versus time curves for an ISO 400/27° film processed in three different developers; figures relate to 20°C, and specified agitation

Fig. 11.21 Working life of typical black and white film processing solutions. Figures for processing capacity assume times are increased with re-use

darkness into the stop or wash tank. After agitating throughout the 15 seconds or so required here, you next treat the film with acid fixer solution, preferably one containing hardener. After about 1 minute it is safe to look at the film in normal light. It may take a little longer for the fixer to make all creaminess disappear from the emulsion and twice this period for film to be fully fixed. Agitate at the beginning of fixing and then about once every minute. Both stop-bath and fixer are long-lasting and can be used many times, see Figure 11.21.

Washing in running water takes about 15–20 minutes, less if the emulsion was unhardened (see page 291 for permanence test). Finally add a few drops of wetting agent to the last of the wash water, to reduce surface tension and so encourage even drying. Then hang up the films to dry in a dust-free atmosphere.

Solution	Processing capacity (35 mm films per litre)	Keeping properties without use	
		Stock in full container	Working sol. in deep tank
Developer			
D76	5 × 36 exp.	6 months	1 month
Lith	use once only	6 months*	–
Stop-bath (typical)	12 × 36 exp.	indefinitely	1 month
Fixer			
Regular and rapid	30 × 36 exp.	2 months	1 month

*Separate A and B solutions

Assessing results

As a general guide, a correctly exposed and developed continuous-tone negative should represent the darkest wanted shadow detail as just perceptibly heavier than the clear, unexposed film rebate. Tones representing the subject's brightest important details must not be so dark you cannot still read these words through the film when laid emulsion down on the page and viewed in sunlight.

Figures 11.22 and 11.23 show some common negative faults. It is important to distinguish *exposure* errors from *development* errors, and faults originating in the camera from those caused while processing. Unsharp images are not caused by processing, whereas uneven patches of density usually are. Dark, light-fog marks limited to picture areas alone often mean a camera fault; fog across the rebates as well may be either a camera or a processing mishap.

Processing chromogenic (colour and black and white) negatives

Colour negative films and monochrome dye-image films can both be processed in the same C-41 process chemical kit. (There is also one kit specially modified for the monochrome film only.) C-41 stages are shown in Figure 11.24.

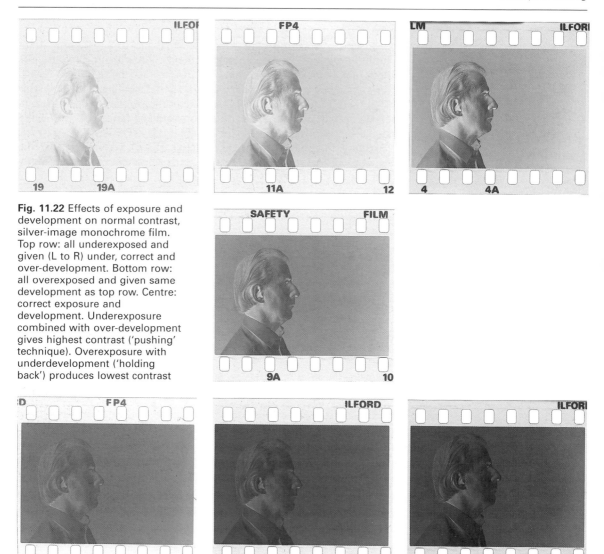

Fig. 11.22 Effects of exposure and development on normal contrast, silver-image monochrome film. Top row: all underexposed and given (L to R) under, correct and over-development. Bottom row: all overexposed and given same development as top row. Centre: correct exposure and development. Underexposure combined with over-development gives highest contrast ('pushing' technique). Overexposure with underdevelopment ('holding back') produces lowest contrast

What happens

In the first solution (colour developer) the developing agents form a black silver image, but this time exhausted agents react with dye couplers to simultaneously form a different coloured dye image in each emulsion layer. The reaction is known as chromogenic development. In the next solution (a bleach), development is stopped and the black silver is turned into silver halide so that it can be fixed out together with all the remaining unprocessed halides. The fixer may be incorporated in the same solution (then called 'bleach/fix'), or be a separate stage following a brief wash. You are now left with dye images only; see page 172. Finally, the film is washed to remove fixer and all soluble by-products, and rinsed in stabiliser (to improve dye stability and harden the emulsion) before hanging up to dry.

Fig. 11.23 Some monochrome silver image processing faults. A: slight fogging to light before processing – typically reel loading in an unsafe darkroom. B: partly fogged towards the end of development. C: extremely uneven development because tank contained insufficient solution. D: rollfilm showing black crescent-shaped kink marks, and clear patches where coils have touched during development. E: general abrasion and crease marks due to rough handling in reel loading. F: circular uneven drying marks, due to splashes or droplets clinging to the emulsion when drying after processing

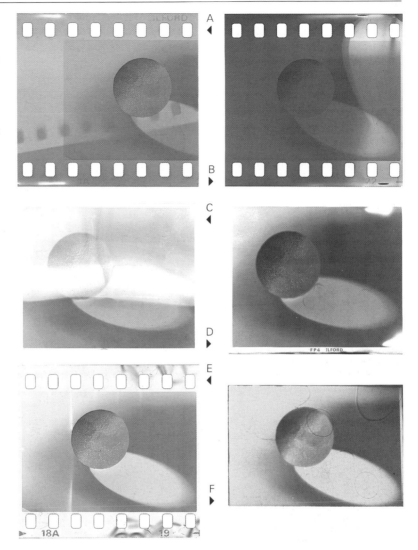

Processing tolerances

All this takes place at a higher temperature than silver negative processing. The higher the temperature, the more accurately it must be held, so it is essential that you use an efficient tempering unit (Figure 11.10).

Development is the really critical stage. Most colour negative films will not tolerate development changes because *colour* is affected along with *density* and *contrast*. All chromogenic black and white and some colour-negative films designed for the purpose do allow adjustment of developing times – so you can 'push' or 'hold back' to compensate for shooting at a lower or higher ISO rating. Overdone, colour negative results often show colour casts that are different in shadows and highlights. Pushed film has a high fog level and grain, while held-back

Fig. 11.24 Colour processing
stages (these are updated from
time to time, and so should be
taken only as a guide)

C-41. For colour and chromogenic black and white negatives

Stages	Kodak 37.8°C (100°F)	Paterson 38°C	Temp (°C) tolerance
Colour developer	$3\frac{1}{4}$ min	3 min	±0.25
Bleach	$6\frac{1}{2}$	–	24–41
Wash	$3\frac{1}{4}$	–	24–41
Fix	$6\frac{1}{2}$	–	24–41
Bleach/fix	–	3	24–41
Wash	$3\frac{1}{4}$	5	24–41
Stabilise	$1\frac{1}{2}$	$1\frac{1}{2}$	24–41

E-6. For colour slides

Stages	Kodak 38°C (100.4°F)	Hobby-pac 38°C	Temp (°C) tolerance
1st developer	7 min	$6\frac{1}{2}$ min	±0.3
Wash	2	1–3	±1
Reversal bath	2	–	±1
Colour developer	4	6*	±1
Wash	–	1–3	20–40
Pre-bleach	2	–	20–40
Bleach	6	–	33–40
Fix	4	–	33–40
Bleach/fix	–	10	33–40
Wash	3	4	33–40

*Includes fogging agent

film gives negatives too flat to suit any colour paper. Never try these techniques purely to compensate for image contrast, as in black and white work.

As a rough guide, increase development time for colour negative film by 30 per cent for one stop underexposure, or reduce normal time 30 per cent for one stop overexposure. All other steps remain the same. Whenever you judge processed dye-image films, both colour and monochrome, remember that results appear partly opalescent and 'unfixed' until completely dry.

Processing colour slides and transparencies

Virtually all general-purpose colour slide and transparency films which can be user-processed require the use of an E-6 process chemical kit. Like colour negatives there is no choice of developer – only complete kits, which barely differ in sequence (Figure 11.24) or effect.

What happens

The first solution, a slightly contrasty black and white developer, forms black silver negatives in each of the emulsion layers. Next, film is washed to halt the action and remove developer, and typically treated in a reversal bath containing chemical which fogs remaining halides to

Fig. 11.25 Modified E-6 slide
processing

For camera exposure:	Or meter setting:	Alter 1st developer time by:
2 stops under	× 4	+ 90%
1 stop under	× 2	+ 30%
Correct	Normal	
1 stop over	× 0.5	− 30%

give an effect similar to fogging by light. From this point onwards you
can work with the lid off the tank if you wish.

The next solution, colour developer, has a similar (chromogenic)
function to developer used for colour negatives. The silver halides
fogged by the previous solution are developed to metallic silver in each
layer. At the same time the special exhausted developing agents formed
react with dye couplers attached to these halides undergoing change.
The result is yellow, magenta and cyan positive dye images, which at
this point are masked by the presence of both negative and positive
silver images. The last stages are typically pre-bleach solution, to stop
chemical carry-over, and bleaching, fixing and washing to remove all
the silver. You are then left with the positive dye images alone.

As Figure 11.24 shows, some kits cut down on time and the number
of stages by combining solutions. Times differ slightly according to
whether you are using deep tanks, a hand tank or a drum processor.

Processing tolerances

Once again, solution temperatures are higher than in black and white
processing. The critical solutions are first developer (± 0.3°C) and
colour developer (± 1.0°C), with the others 20–40°C or 33–40°C, in
kits for processing at 38°C. Most brands of reversal colour material can
be successfully 'pushed' or 'held back', which you do by altering the
first development time (Figure 11.25). All other times remain constant.
Regard one stop either way (i.e. doubling or halving ISO speed) as the

Fig. 11.26 Results of adjusting the
first developed stage of E-6 slide
film processing (Ektachrome).

Top left: Overexposing 2 stops
and holding back.
Top right: Correct exposure and
processing.
Bottom left: Underexposing 1 stop
and push processing.
Bottom right: Underexposing 2
stops and push processing further

normal limits, with pushing up to two stops as more of an emergency treatment or for special grain effects.

In general, pushed processing increases graininess and contrast, and leads to shadows empty of detail. But in moderation it can improve shots of low-contrast subjects and help when you must have maximum emulsion speed. Held-back processing reduces contrast, which is useful with contrasty subjects, such as when copying slides. The precise effect of altered processing on final image colours varies with different brands and types of film. Fast films survive push processing far better than slow ones. Usually pushing gives coarser hues, and holding back produces less brilliant colours and warmer highlights. Any slight colour cast (due to lighting conditions or subject surroundings, for example) seems to become exaggerated.

Most custom laboratories offer a compensation processing service, at extra cost. Some of the most common reversal processing faults are shown in Figure 11.31. Remember not to judge results until the film is fully dry and has lost its milky appearance.

Processing other film materials

Black and white slides from conventional film

You can reversal-process black and white negative films to produce direct black and white slides using the procedure shown in Figure 11.27. Choose slow film such as Pan-F, rating it at $\times 2.5$ its regular ISO

Fig. 11.27 Reversal processing of black and white negative film at 20°C

1.	D19 developer (+ 2 g per litre potassium thiocyanate)	6 min
2.	Wash	5 min
3.	Bleach in R21 solution A	4 min
4.	Wash	5 min
5.	Clear in R21 solution B	2 min
6.	Rinse	$\frac{1}{2}$ min
7.	Expose to 150W lamp at 1 ft (film reel under water in white bowl)	$2\frac{1}{2}$ min
8.	Blacken in D19 developer	4 min
9.	Rinse	$\frac{1}{2}$ min
10.	Fix in regular film fixer	5 min
11.	Wash	20 min

For formulae of D19 and R21 see Appendix B.

speed. (Unsuitable films give flat slides, often with a greenish tinge to blacks.) See Appendix B for the chemicals required. Notice that, unlike E-6, you bleach the developed black silver without affecting *unexposed* halides. These remaining halides are then fogged by light instead of by chemicals.

Instant-picture slides

Processing Polaroid instant-picture slides (colour and black and white) is a mostly mechanical task. You insert the film and its appropriate 'processing pack' into a special processing tank unit. Following the instructions, the pack's container of thick processing fluid is punctured and feeds by gravity onto a 35 mm wide plastic band. The fluid-coated band is clipped to the end of the exposed film, and wound up in face contact with the exposed emulsion through rollers and on to an internal core. Here the processing agents develop exposed halides in the top

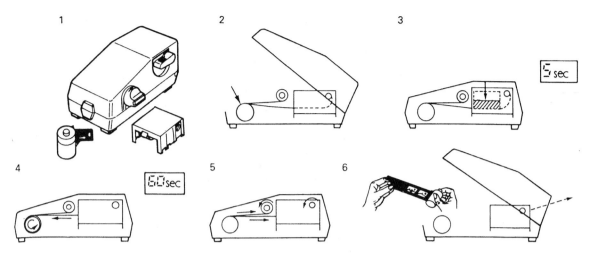

Fig. 11.28 Instant-picture slide processing. 1: processing unit, exposed 35 mm film and appropriate processing pack (film is wound emulsion outwards, exposed with base towards camera lens). 2: end of film and applicator band are attached over stud on drum. 3: cover closed, lever ruptures pod of processing fluid; allow 5 seconds for fluid to drain on to applicator band. 4: winder draws film and fluid-soaked band into tight contact around drum; allow 60 seconds for processing to take place. 5: reversed gearing returns film to cassette, and band (plus stripped-off top emulsion layer) to pack. 6: removal of cassette of processed slides: used pack is discarded

emulsion layer to a silver negative, and cause *unexposed* halides to migrate to a lower gelatin layer. They become anchored here and convert to black silver (by a controlled form of dichroic fog).

You wait a short period for processing to complete, then turn a handle which winds the film back into its cassette, and the band back into its pack. As the latter does so it splits off the damp top layer of the film containing the negative image, and carries this away with it. Opening the unit you discard the pack and contents, and pull the barely damp strip of processed slides from its cassette. Temperature latitude for the whole process is 17–30°C (60–85°F).

Processing machines

Automatic machines for processing conventional films range from small drum units to dip-and-dunk and roller-transport machines. Given sufficient tanks and appropriate temperature/time programming they can all tackle C-41, E-6 or black and white processing.

Drum units (Figure 11.6) are the least expensive machines and simply mechanise what you would otherwise do by hand. In automatic versions the film drum is filled from chemical reservoirs, rotary agitated, emptied, washed through, etc. Chemicals are usually 'one-shot' and so discarded, but some (bleach/fix for instance) are stored for further use. After the final stage you remove your film or batch of films for drying.

Dip-and-dunk machines work by physically tracking and lifting batches of sheet film in hangers and roll or 35 mm films suspended on clips, from one tank to another, in a large darkroom-size unit. Transport is at a steady speed, but by having tanks longer or shorter, different periods in each solution are made possible. Finally films are lifted and passed through a drying compartment.

Roller-transport machines also use a sequence of tanks but these are filled with many motor-drive roller units (Figure 11.29) which pass sheets and lengths of film *individually* up and down through the tanks and finally through an air-jet drying unit. An emulsion area monitoring system replenishes tanks with fresh processing chemistry pro-rata to the amount of film put through. Since both dip-and-dunk and roller machines need large tankfuls of expensive chemical solutions, they are

Fig. 11.29 Large-volume film processing machines. Roller-transport type (centre) contains racks of rollers (detail left). Rollers turn continuously; you insert individual films in the darkroom end, and they appear from the drier into a normally lit room. 'Dip-and-dunk' machine (right) processes film in batches. Tanks are open, so developing stages must take place in darkroom

Fig. 11.30 Below: A minilab printing unit for APS films. Below right: the leading end of a processed APS film showing in addition to recorded picture areas. A: data magnetically logged by camera. B: manufacturer's optically shown film type date. C: magnetic data recorded by lab (number of prints off, etc.)

only viable for regular, high-volume film processing; see also *Advanced Photography*.

Mini-lab roller transport machines provide film processing, printing and paper processing all linked up as either one or two stand-alone units. As mini-labs are designed for full operation in daylight, they are ideal for installations in retail shops. APS films in particular are designed for this form of photofinishing. The equipment pulls out and detaches the film from its cartridge before processing. It also reads digital information recorded by the camera along the film edge, which automatically adjusts image format ratios (see Figure 4.13b) and degree of enlargement at the printing stage, as well as helping to set accurate filtration and exposure. Finally the processed APS film is reattached into its original cartridge and output together with the trimmed and sorted print order.

Permanence of results

Correctly processed film images should remain stable for many years. Anticipated life without any perceptible change for dye images, unprojected and stored at 21–24°C and 40 per cent relative humidity, is 10–20 years (fast films) and 40–100 years (slow films; also black and white silver images). Two ways to ensure maximum permanence with black and white films are: (a) use two fixing baths, giving 50 per cent

Fig. 11.31 Some E-6 colour slide processing faults (A is correctly processed). B: fogged to low level light before processing. C and D: fogged during processing. E: contamination of first developer with fixer (including fix spots). F: colour developer contaminated with bleach

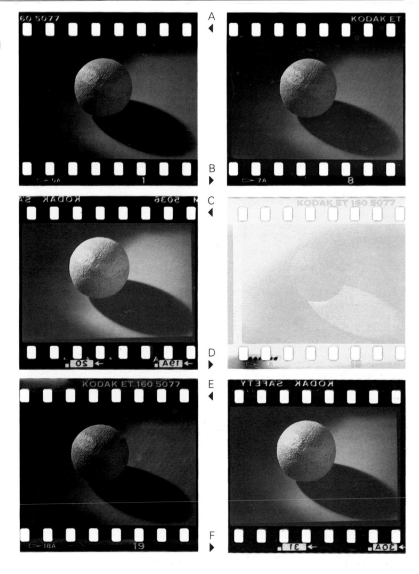

Fig. 11.32 Working life of colour reversal and colour negative processing solutions. This is updated from time to time, as chemical compositions change

Solution	Processing capacity (35 mm films per litre)	Keeping properties without use	
		Working sol. in full container	Working sol. in tank with floating lid
E-6 slides			
First developer	*9 × 36 exp	2 months	
Reversal bath/pre-bleach	20 × 36 exp	2 months	
Colour developer	20 × 36 exp	3 months	
Bleach and fix	20 × 36 exp	6 months	
C-41 negatives			
Colour developer	†8 × 36 exp	6 weeks	1 month
Bleach	16 × 36 exp	indefinitely	indefinitely
Fix and stabiliser	16 × 36 exp	2 months	2 months

*Extend time after 6 films by 8%
†Extend time after 4 films by 8%

of the fixing time in each, when the first is exhausted (Figures 11.21 and 11.32) replace it with the second and make up a new second bath from fresh solution; (b) rinse films after fixing and treat in hypo clearing agent prior to washing. This also allows washing time to be reduced by 75 per cent.

Store negatives in sleeved ring-file sheets, made for the purpose from inert material. Slides can be mounted in card or glass mounts, 'spotted' to show correct image orientation for projection (Figure 11.33) and stored in pocketed sheets which hang in a filing cabinet. Give each image a reference number. (Use the frame number near the edge of roll and 35 mm negatives as part of this reference when film is stored in strips.)

The best way to maintain a film-image file is on computer disk, where it is easily cross-indexed for date, subject, client, invoice number, etc. The computer can then print out a selective listing for any permutation of headings you choose, to locate particular pictures.

Fig. 11.33 Storing results. Left: slides are mounted and 'spotted' top right when image is inverted but right way round. Placed in the projector this way, picture appears correct on screen. Diagonal line drawn across top edge of set of slides shows up any missing or disordered. Centre: negative file for rollfilm negatives. Right: suspension file system. Slides are stored in plastic sheets with pockets, 20–24 at a time

Summary: Film processing

● Key skills in film processing are (1) loading the hardware with film, in darkness, (2) preparing solutions, (3) ensuring correct temperature, timing and agitation, and (4) drying the wet film without damage.

● Protect yourself from breathing-in or touching chemicals. Always add chemicals *to* water. Avoid solution contamination through contact with unsuitable materials or other solutions.

● Concentrated chemical may need dilution by *part* (e.g. 1 + 8) or be used as a *percentage solution* (e.g. percentage of chemical to final solution volume).

● Deep tanks are used in sets, films being transferred between each solution in the dark. Smaller tanks are used singly, having a light-trapped inlet/waste for solutions to act on the film in sequence. Drum processors work similarly but are motor-driven and use small volumes of mostly one-shot chemicals.

● Agitation must be consistent, not under- or overdone. Nitrogen-burst gear aids solution flow in deep tanks, where chemicals permit.

● Use a tempering unit, tempering coil or thermostatic immersion heater to maintain the temperature of solutions and tank.

- Black and white negatives should be exposed for shadows, developed for highlights. Development increases contrast, density, graininess and fog level. The degree of development a film receives depends on solution type, condition and dilution; temperature; agitation; and timing.
- Black and white developers are general-purpose or specialised (high-acutance, contrast, speed-enhancing, etc.); 'one-shot' or reusable (regularly extending times, or replenishing). Normal processing temperature 20°C (68°F).
- 'Push' black and white film by extending time or using high-energy developer. 'Hold back' by diluting developer, reducing time, or using speed-reducing superfine-grain formula.
- Black and white negative contrast indices of 0.45 and 0.56 suit condenser and diffuser enlargers respectively. CI/time curves show film performance in different developers.
- Featureless *shadows* are a sign of negative underexposure; low contrast and grey *highlights* a sign of underdevelopment.
- Most so-called user-processed colour films need C-41 chemistry (negatives) and E-6 chemistry (reversal slides and transparencies). Temperatures are higher than black and white, latitude much less. Main chemical stages for negatives: colour developer, bleach/fix, stabilise. For slides: first-developer, reversal, colour developer, bleach/fix.
- Suitable films can be 'pushed' or 'held back' one stop or more. In general avoid any change of colour negative processing, unless the film is designed for ISO speed adjustments.
- Processing machines – drum discard, dip-and-dunk, roller transport – offer complete automation. Their cost in hardware and chemicals is unjustified for small-volume workloads.
- For maximum black and white image permanence use two-bath fixing, treat film with hypo clearing agent at wash stage, and store carefully.
- Remember health and safety when using chemicals, Appendix E.

Projects

1. Establish film/developer combinations. By practical experiment discover developers and times giving negatives which best suit your enlarger. Try pairing up slow films with Rodinal or Perceptol, and fast films with Microphen or Acuspeed. Compare with the more all-purpose D76/ID11 or HC110.
2. Assess colour film development variations. Using sheet transparency film, shoot and process (a) normal, (b) pushed one stop, and (c) held back one stop, versions of the same subject. Try daylight and tungsten balanced film, using the correct lighting for each. Compare contrast and colour.
3. Test the effects of pushing. Shoot both contrasty and low-contrast subjects on ISO 400/27° black and white film with correct exposure and development. Then repeat, pushing film speed to 800/30°, 1600/33° and 3200/36°. Make the best possible enlargements from each before comparing image qualities. Try the same with colour slide film. This time, use two projectors to compare pairs of results.

12

Black and white printing: facilities and processes

Vital though the negative may be, it is the final print which people see. Your ability to produce first-class print quality is therefore of utmost importance: good prints cannot be made from poor negatives, but sub-standard prints are all too easily made from good negatives if you lack the essential skills.

This chapter is concerned with darkroom organisation, enlargers and other equipment. It looks at the choice of printing materials, then discusses basic print-processing chemicals and methods.

Darkroom organisation

Film processing in small tanks can take place almost anywhere (provided you can initially load the tank in darkness). But, like deep tank processing, printing on a professional basis really calls for a permanent darkroom set-up.

There are four basic requirements for a darkroom: (1) it must be light-tight, (2) it needs electricity and water supplies, and waste outlet, (3) the room must have adequate ventilation, and a controllable air temperature, and (4) layout should be planned to allow safe working in a logical sequence, including easy access in and out. Requirements (3) and (4) are just as important as the other, more obvious, facilities. After all, you should be able to work comfortably for long periods, so shutting out light must not also mean shutting out air. If others are using the darkroom too, it is helpful if people can come and go without disrupting production.

General layout

Size naturally depends upon how many people use the room at one time, how long they need to be there, and the work being done. An 'all day' printing room for one person might be 20 cubic metres (70 cubic feet) e.g. 2.5 m × 3.2 m × 2.5 m high, plus 4 square metres of floor space per additional user.

Fig. 12.1 A one-person general black and white darkroom, for small-format developing and printing. Note clear separation of 'wet' and 'dry' areas. Film and print drying takes place elsewhere

Fig. 12.2 Light-trap entrances (plan view). A is often the easiest way to adapt an existing doorway. C takes up less space, but will disorient occasional users. D is a commercially made revolving shell you step into, then turn; unlike the others, it does not promote ventilation. All labyrinths must have internal matt black finish

The best entrance arrangement is a light-trap or labyrinth (Figure 12.2). This will prevent entry of light, provided it is properly designed and finished in matt black paint. It allows you free passage without having to open doors or pull aside curtains (both can become contaminated and sources of chemical dust and fluff). It is especially useful if you are carrying trays, etc. Equally important, the light trap will freely pass air for ventilation. Elsewhere in the room you should have a light-proof air extractor fan, or better still an air conditioner. Ideally aim for a steady inside air temperature of 20°C (68°F). If you *have* to use a door instead, make sure there is a light-trapped air grill within it or somewhere in the wall nearby.

Inside, rigorously divide your space into 'wet' and 'dry' areas. The wet area should contain a PVC flat-bottomed photographic sink about 6 inches deep with integral splashback, and large enough to hold at least three of your largest print trays. Have one water outlet fed through a hot and cold mixer unit, and positioned sufficiently high for you to fill a bucket or tall container. This, and one or more cold-water outlets, can be threaded to firmly accept a hose coupling to a wash tank or tray (see above). As Figure 12.1 shows, the sink might have dish racks underneath, a shelf above for storage of small items, and a bench on one side with PVC draining top for larger containers of concentrated developer, fixer, etc.

Have your 'dry' bench on the opposite side of the room, far enough away to avoid splashes. Here it can accommodate enlarger, printing

papers, negative file, etc., as well as allowing space for loading film hangers and rollfilm tanks. Fit closed storage cupboards below the bench. Have ample power points at bench height along this side for your equipment, plus a sealed outlet higher on the wall near the wet bench for an immersion heater or tempering unit (Figure 11.10). The latter should be controlled by ceiling-mounted pull switches – you must not be able to operate switches with wet hands.

For your working illumination, have one safelight no closer than its recommended distance (page 249) directly above the processing sink. Unless your room is quite small, have another safelight suspended centrally near the ceiling for general illumination (not too near the enlarger, or it becomes difficult to see projected images). If necessary install another small safelight illuminating a wall clock or process timer. Have all safelights controlled by one pull-switch near the door.

For white light, use a ceiling light bulb (not a fluorescent tube, which may glow faintly in the dark). Operate this from a wall-mounted pull-switch, its cord run *horizontally* along the length of the darkroom at above head height. Then you can reach and switch it on to check results wherever you may be standing in the room.

Choose a wall and ceiling finish inside the darkroom which is as pale as possible, preferably matt white. Provided your room is properly blacked out, generally reflective surroundings are helpful. Your safelight illumination will be more even, and working conditions less oppressive. But keep the wall around your enlarger matt black – like the room entrance, white light will be present here.

Dry benches can be topped with pale-toned laminate and the floor sealed with a seamless, chemical-resistant plastic material. Discourage dust and dirt from accumulating by having a flat surface to walls, with no unnecessary ledges or conduits. Bare cold-water pipes near the ceiling are often a menace, gathering a film of condensation which then drips on to work. Do your drying of pictures (film drying cabinet, print dryer), the dissolving of any dry chemicals, and all image-toning processes out of the darkroom, in some separate, well-ventilated area.

Equipment: the enlarger

The enlarger is your most important piece of printing equipment. It is designed like a vertically mounted, low-power slide projector. A lamphouse at the top evenly rear-illuminates your negative, held flat in a slide-in carrier. An enlarging lens at an adjustable distance below the negative focuses an enlarged image on to the baseboard of the enlarger, where the printing paper is held flat in an easel or masking frame. Sliding the whole enlarger head (Figure 12.3) up or down the supporting column alters the *size* of the image on the baseboard. Adjusting the distance between lens and negative alters *focus* (needed for every change of size). And changing lens aperture by *f*-stop intervals alters *image brightness*, just as it does in the camera.

When choosing an enlarger the issues you must decide are (1) the range of negative sizes it should accept, (2) the most appropriate lens, (3) the type of negative illumination, (4) the largest print size you will want to make, and (5) any necessary extra facilities required such as enlarger movements, etc.

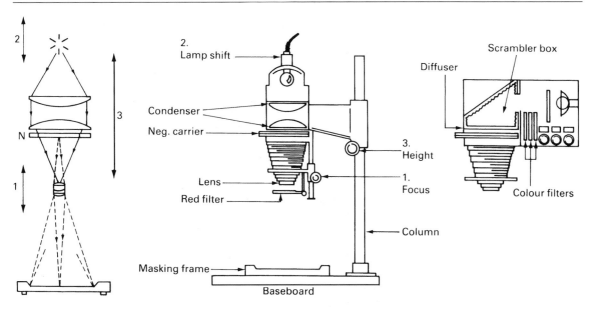

Fig. 12.3 Enlargers. Left and centre: basic condenser type. Arrowed lines show path of illuminating light through condensers and negative (N), directed into lens. Broken lines denote light refracted by lens. Adjustment I shifts lens, to focus image. 2 raises/lowers lamp relative to lens position, adjusts for evenness. 3, movement of whole unit, alters image size. Right: diffuser type, also suitable for colour printing. Dials raise filters into light beam. Light scrambler box scatters and diffuses light to give even light and colour. Reflex layout makes it easier to cool high-intensity lamp, reduces headroom

Negative size

A 35 mm-only enlarger is small and cheaper than one of similar quality accommodating several negative sizes. If you use rollfilm cameras too, get an enlarger for the biggest format and adapt it downwards for the others (you cannot adapt *upwards*). As well as interchangeable negative carriers you will need lenses of different focal lengths to get a useful range of print sizes off each format, and if the enlarger has condenser lighting (see below) this requires adjusting too.

Enlargers for 4 × 5 in or 9 × 12 cm negatives are much more substantial. It is helpful to keep a separate enlarger for these large formats: many do adapt down for smaller films, but you will find it awkward to keep changing fitments when a mixture of negative sizes is being printed. Very few enlargers are made for up to 10 × 8 in negatives, and they are extremely expensive and bulky. Most of them adapt down to 4 × 5 in.

Lens

An enlarger lens is designed to give its maximum resolution when the 'subject' (in this case the negative) is closer than the image. It can therefore do a better job than your camera lens under enlarging conditions, although if necessary a camera lens (preferably a macro type) could be used instead. Typical focal lengths for each negative size are shown in Figure 12.4. In effect, focal length is a compromise. If it is too long you will not start to get sufficient-size enlargements until the enlarger head is near the top of the column. Too short, and the lens may not have sufficient covering power (page 38) so that image corners appear unsharp or fade to white on the print, especially at large magnifications. You will also find it is difficult to position the lens close enough to the negative; and when making small prints there is insufficient space below the lens to shade or print in; see page 262.

Format	Normal focal length
35 mm	50 mm
6 × 6cm	80 mm
6 × 7cm	100 mm
5 × 4 in	150 mm

Fig 12.4 Enlarger lenses

The wider the maximum aperture the easier it will be to see and focus the image. (However, prints will very rarely be *exposed* at this setting; see page 260.) Always buy the best lens you can afford. False economy here can effectively reduce the fine image qualities given by all your camera lenses.

Illumination

Your negative must be illuminated evenly, but more than this, the quality of the light – soft or hard – influences printing results. A *diffuser* head passes scattered light through the film and the negative appears as though lit by a lightbox or viewed against overcast sky. Most enlarger heads for colour printing give diffuse illumination (Figure 12.5). A colour head with all filters set to zero makes a good diffuser enlarger for black and white printing, plus the bonus that some filters can be used for controlling variable-contrast paper (page 247). Diffusion absorbs a lot of illumination, and to counteract this many enlargers use a bright, quartz-iodide light source. A heat filter and a lamphouse designed with 90° turn of light path prevent negative overheating.

Another diffuse source of illumination is a 'cold-light' or 'cold cathode' head – a grid-shaped fluorescent tube producing heatless, bluish light. It works through a small high-voltage transformer and comes in a range of sizes to suit formats from 35 mm to 10 × 8 in. Cold light is unsuitable for variable-contrast papers and for colour work.

A *condenser* head gives hard illumination. The lamphouse contains one or more simple but large condenser lenses (diameter exceeding negative diagonal) to gather diverging light from a tungsten lamp and direct it through the negative to focus into the enlarging lens itself. The negative appears to the lens as it would look to the eye if rear-illuminated by a spotlight.

This harsh direct light has the important effect of making projected images slightly more contrasty than with diffuse illumination. This is the Callier effect (Figure 12.5). Condenser illumination also tends to show up any negative surface blemishes, such as scratches or debris. Its contrast enhancement strengthens the appearance of fine detail, and also picks out grain more clearly.

The most extreme condenser effect comes from a 'point source', meaning the use of a small, clear projection-type lamp. This is effective for big enlargements where you want every speck of grain to appear sharp and crisp. However, a point source is awkward to use – to get even light you must reposition the lamp or condensers for *every* change of print size. Unless you use the lens at wide aperture, vignetting occurs, so you control intensity through a variable transformer to the lamp.

Regular condenser lamphouse enlargers are therefore a compromise. They use an opal tungsten lamp which the condensers focus as a *patch* of light over the lens (Figure 12.6). This allows you to make a range of enlargement sizes, without adjusting the lamp for every setting. You can also stop down. However, unlike diffuser lamphead enlargers, a condenser system *will* need lamp repositioning or changes to the condensers to get even negative illumination (a) when you make an extreme change of print size, and (b) whenever you change enlarger lens focal length. (In each instance the negative-to-lens distance changes considerably.)

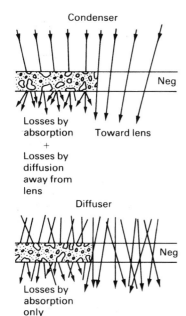

Fig. 12.5 Why a condenser gives more contrast than diffuser illumination – the Callier effect. Top: right-hand clear area of negative passes almost all light directed at lens. Image areas absorb and scatter light away from lens. Density range is therefore exaggerated. Bottom: diffused light source gives density range determined by absorption alone. Callier effect is much less marked with a dye image than a silver image – dye molecules give less scattering of light

Fig. 12.6 Enlarger head systems.
A: point-source condenser head, needs lamp refocusing for even light with every lens position change. B: opalised lamp gives broader beam, allows lens focusing latitude. C: extra condenser alternative to lamp shift when using shorter focal length lens, for smaller format. D: diffuser head (equipped with printing filters). E: cold cathode head. F: enlarger with pivoting movements, allows correction of converging lines etc. on negative. Relate these movements to Figure 6.14

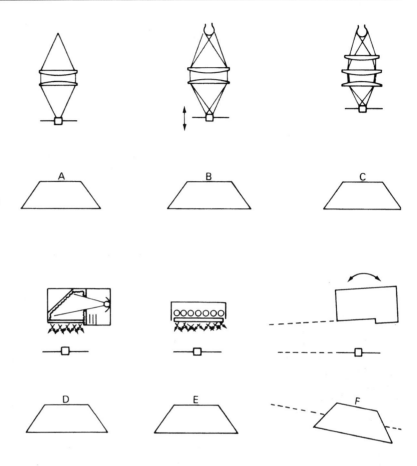

Both types of enlarger illumination have their virtues, and on many models you can change one lamphouse system for another. As discussed on page 224, it is important to process negatives to a contrast index which suits your particular enlarger. Then you can make fullest use of the range of printing paper (page 247) to adjust contrast up or down for individual pictures.

Print size

The size of image the enlarger will give from your negative depends on the lens focal length, and the lens-to-paper distance:

$$\text{Magnification} = \frac{\text{lens to paper distance}}{\text{focal length}} \text{ minus one}$$

For example, if your enlarger column can raise the lens 60 cm above the baseboard, you can make a 30 × 45 cm enlargement from a 6 × 9 cm negative (magnification of × 5) using a 100 mm lens. The taller the column the bigger the enlargement possible, within the limits of your darkroom ceiling height. For still bigger enlargements the enlarger head may be designed to rotate so that it projects the image horizontally on to a distant wall. Some bench models turn to work vertically downwards onto the floor. See Figure 12.7.

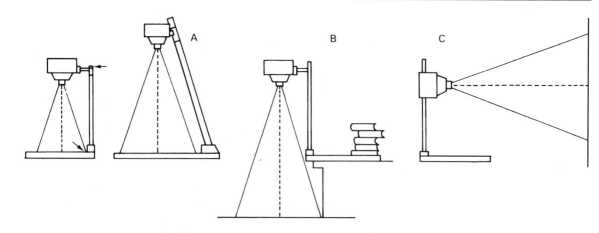

Fig. 12.7 Making big enlargements: limiting factors are the height of column, and column base fouling the image area (left). Solutions include (A) angled, extended column and larger baseboard; (B) turning head to project from bench to floor; or (C) rotating head to project on to distant wall

At the other extreme your enlarger (paradoxically) will allow prints *smaller* than the negative dimensions, provided you lower the head and can position the lens sufficiently far away from the negative; see Figure 12.9. If the bellows will not stretch this far, try fitting camera-type lens extension rings (Figure 12.10).

Fig. 12.8 'Throws' necessary for 35 mm enlarger (50 mm lens); and 5 × 4 in enlarger (150 mm). Most 35 mm standard column enlargers allow lens to be raised at least 60–70 cm above baseboard

Focal length	Distance negative to lens	Magnification	Distance lens to paper
50 mm	7.5 cm	× 2.0	15 cm
	6.6 cm	× 3.0	20 cm
	5.5 cm	× 10	55 cm
	5.25 cm	× 20	105 cm
150 mm	25 cm	× 1.5	37.5 cm
	23 cm	× 2.0	45 cm
	20 cm	× 3.0	60 cm
	16.5 cm	× 10	165 cm

Fig . 12.9 Ratios necessary when making prints smaller than negative

Focal length	Distance negative to lens	Magnification	Distance lens to paper
50 mm	10 cm	× 1.0	10 cm
	11.5 cm	× 0.75	8.6 cm
	15 cm	× 0.5	7.5 cm
150 mm	30 cm	× 1.0	30 cm
	34.5 cm	× 0.75	26 cm
	45 cm	× 0.5	22.5 cm
	75 cm	× 0.25	18.8 cm

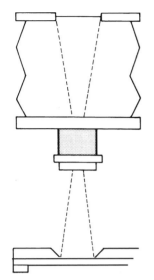

Fig. 12.10 An extension ring spaces this 50 mm lens farther from the negative when enlarger bellows reach their extreme limits. Ratios here allow a print 0.75 the size of the negative

Fig. 12.11 Some enlargers have their controls for focusing and raising/ lowering located under the baseboard. This is especially useful with column extension units, which allow the baseboard down to floor level. Enlarger column is bolted to wall

Other features

Most negative carriers are 'glassless' – holding the film flat between metal frames. You may occasionally need a glass carrier when enlarging a sandwich of two films, or using large-format thin-base negatives, which can sag in the middle. However, sandwiching between glass creates problems because (a) you have four more surfaces to keep clean, and (b) when glass and film are not in perfectly even contact light-interference causes a faint pattern of concentric lines, called Newton's rings, to appear over the image.

It is very useful to have a swing-across red filter below the lens or somewhere in the light beam. This will allow you to see the image projected on to the paper without actually exposing it – helpful when preparing to shade, print in, or make a black edge line (page 264). The filter is also an alternative means of starting and stopping exposure, provided you are careful not to jolt the image.

Other optional features include metal sliding masks within the negative carrier to block light from any rebate or part of the image you are cropping off (reduces potential flare). Remote controls for head shift and focusing positioned at baseboard level are a convenience; and an angled column (Figure 12.7) will avoid the column base fouling images when you make big prints. Enlarger movements (a pivoting head and lens panel) are helpful when you must alter image shape without losing all-over sharp focus. This will allow you to give some compensation for unwanted converging verticals, etc. due to shooting with a camera lacking movements.

Autofocus enlargers have mechanically linked controls for head-raising and lens focus, so that your projected image remains sharp as you alter its size. This feature means the equipment is more bulky, and change of lens focal length becomes less simple, but it is a great time-saver if you frequently make sets of prints in various sizes off the same negative.

Enlarger condition

Make sure that your enlarger does not shift its focus or head position, once set. The head must not wobble when at the top of its column, nor the lamphouse and negative overheat because of poor ventilation or use of the wrong voltage lamp. Regularly check that no debris has accumulated on top surfaces of condenser lenses or diffusing panel. (Both add shadowy patches to negative illumination, only seen in the projected image when you stop down the enlarging lens.) Dust, grease or scratches on enlarging lens surfaces, however slight, scatter light and degrade the tonal range of your prints.

Equipment: accessories

Dry items

The enlarger is easiest to use with a timer, wired between the lamp and supply. This will also have a switch to keep the enlarger on for focusing. You must have a masking frame (or 'easel') for the enlarger baseboard, with metal masks adjustable to the print size you need. The frame provides a white surface on which to focus the image, and a

Fig. 12.12a Enlarger accessories.
1: focusing magnifier. 2:
compressed air for cleaning. 3:
adjustable masking frame. 4:
timer/exposure meter. 5: 'dodgers'
for shading. 6: card with choice of
various shaped apertures for
'printing-in'

means of positioning and holding the paper flat during exposure, with
edges protected from the light to form white borders. You may also
need a focusing magnifier (or 'grain magnifier'). This allows a small
part of the projected image to be reflected on to an internal focusing
screen which you check through a magnifier (Figure 12.12a). Some
photographers consider an enlarging exposure meter (either an adapted
hand meter or an 'on-easel' colour analyser in exposure reading mode)
an essential aid; see page 260. Other accessories include tools for
shading (page 262), a glass-top contact printing frame (page 258), and
a can of compressed air or blower brush for removing any dust or hairs
from film and glass surfaces.

Wet items

Have sufficient trays for developer, stop bath, and preferably two fixing
baths. You will also want a wash tray or tank suitable for the papers you
are using (resin-coated or fibre base). If it is difficult to maintain
developer at working temperature, use a larger tray to enclose your tray
of developer and act as a water jacket. Have a large mixing graduate and
containers of concentrated print developer, stop bath, acid fixer and
hardener.

A dish thermometer is essential, as well as a wall-mounted clock
with clear minute and second hands. Two pairs of plastic print tongs –
each distinctly different for developer and fixer trays – will help keep
your hands out of chemical solutions. Finally, don't forget a roller
towel, and a waste bin you empty daily to avoid darkroom
contamination from chemicals drying out of discarded prints.

Printing papers

Black and white printing papers differ in their type of base, surface
finish, size, image 'colour', emulsion contrast, and colour sensitivity
(important relative to safelighting).

Fig. 12.12b Plastic print tongs
allow you to gently grip a corner
of your print at times during
processing – either to agitate it or
transfer it to the next solution

Base type

There are two main kinds of paper base – resin-coated and fibre. This
difference is more than cosmetic, because their processing and washing

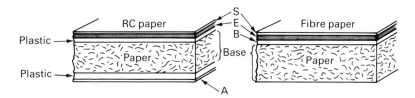

Fig. 12.13 Cross-sections of RC and (single weight) fibre bromide papers. S: supercoat. E: emulsion. B: baryta coating. A: anti-static layer

times, drying and mounting procedures are different. Resin-coated materials (also known as 'RC', 'plastic' or 'PE') consist of paper, sealed front and back with waterproof polyethylene, then face-coated with emulsion and protective supercoat; see Figure 12.13. Because the base cannot absorb solution except along its edges, RC prints wash and dry quickly. When dry, prints do not curl, and have good dimensional stability. Like colour papers (which are all RC based) they are also well suited to machine processing (page 255).

The more traditional type of paper is fibre-based. It is first surface coated with a foundation of baryta (barium sulphate) as a whitening agent, followed by an emulsion layer and gelatin supercoat. The total processing cycle for fibre papers is about four times as long as for RC papers, and a glazer is necessary if you want to give glossy paper a highly glazed finish (Figure 12.29). However, final prints are less likely to crack and otherwise deteriorate, especially when displayed over long periods. Fibre prints are also easier to retouch.

In practice, the vast majority of amateur enlargements and commercial prints, especially long runs, are made on RC papers. RC is also convenient for contact prints. But for archival prints and exhibition quality images, fibre paper is still difficult to beat. A further influence is the silver-enriched thick emulsion papers, made only with fibre base, capable of outstanding tone range and aimed at the quality-at-all-cost market.

Thickness and tint

Regular fibre-base papers are made in single weight (about the thickness of this page) and double weight. Single weight is cheaper, but easily creases during processing if used for prints larger than about 12 × 10 in. A few special-purpose papers are made on lightweight base. RC paper is only made in so-called medium weight, just slightly thinner than double weight. Some silver-enriched papers have 'premium weight' base – more a card than a paper.

At one time, most papers could be bought with a cream or an ivory tint instead of white, but these have tended to go out of favour because they limit the tone range of image highlights. In fact, white bases often incorporate 'optical brighteners' which glow slightly under fluorescent or daylight illumination and so further extend image tone range. See also tinted special-effects papers (page 270).

Surface finish, size

You have a choice of surface finishes ranging from dead matt, through what are variously called semi-matt, lustre or high lustre, to glossy. RC glossy dries with a shiny finish naturally, but *fibre-base* glossy dries semi-matt unless it is put through a glazer after washing.

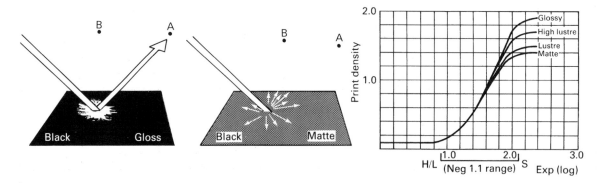

Fig. 12.14 Paper surface and maximum blacks. Left: seen from position A, gloss paper has specular reflection glare spot, but from B and other positions black appears intense. Centre: matt paper scatters a little light in all directions. and black looks less rich from every viewpoint. Right: paper characteristic curves show surface affects maximum possible black (highest reflection density). A typical negative will print with its subject shadow detail more compressed on matt than glossy. See also Figures 2.6 and 11.19

5 × 7 in	12.7 × 17.8 cm
7 × 9.5 in	17.8 × 24 cm
8 × 10 in	20.3 × 25.4 cm
9.5 × 12 in	24 × 30.5 cm
11 × 14 in*	27.9 × 35.6 cm
12 × 16 in	30.5 × 40.6 cm
16 × 20 in†	40.6 × 50.8 cm
20 × 24 in‡	50.8 × 61 cm

*Gives four 5 × 7 in
†Gives four 8 × 10 in
‡Gives six 8 × 10 in

Fig. 12.15 Main black and white printing paper sizes

The combination of base brilliance and surface texture has great influence on the maximum white and black the paper offers you. As Figure 12.14 shows, glossy finish produces richest blacks, when lit correctly. Matt cannot give much beyond a dark grey – which may suit moody, atmospheric pictures. Both papers, however, appear with similarly deep blacks when compared wet, so be prepared for changes when matt prints are dried. Photographs for reproduction should be made on white glossy paper (glazed or unglazed), *never* on paper with an assertive surface pattern which interferes with the mechanical screen used in ink printing processes; see *Advanced Photography*.

Figure 12.15 shows the most common printing paper cut sizes. Some papers are also sold in rolls, with widths ranging from 8.9 to 127 cm. As you can see, some larger sheets can be cut in half or quartered to give smaller standard sizes – one reason for keeping a trimmer in your darkroom.

Image 'colour'

Most printing papers have an emulsion containing silver-bromide halides, which give a neutral black image in the recommended developer. Chlorobromide papers additionally contain silver chloride which results in a 'warmer', slightly browner, black. The warm tone can be exaggerated by your choice of print developer, see below. Silver chloride is slower than bromide, and also develops slightly faster – so the degree of development makes a big difference to chlorobromide 'colour' too (page 250).

Choosing between bromide or chlorobromide paper depends mostly on subject and personal preference. The slight extra tonal richness of chlorobromide helps improve shadow detail and is popular for exhibition work. But it is unsuitable in pictures for regular mono-chrome reproduction, because printer's standard black ink will lose the subtleties of warm tone.

Contrast

All but the most specialised papers are sold with a choice of emulsion contrasts. You control contrast by purchasing different boxes of *graded* papers – grade 1 (soft), grade 2 (normal), grade 3 (hard), etc. Or use just one box of *variable-contrast* paper and achieve similar changes by filtering the enlarger light. The softer the grade, the more greys it can form in the print between maximum black and white. As Figures 12.16

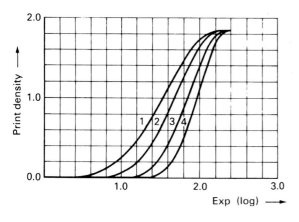

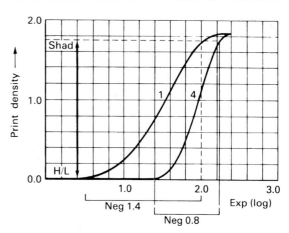

Fig. 12.16 Left: characteristic curves for four grades of one manufacturer's bromide paper. Right: a relatively contrasty negative (1.4 density range) printed by diffuser enlarger on grade 1 paper gives a similar result to a flatter 0.8 negative on grade 4. Note grade 4 is slower speed and requires more exposure. Darkest (subject highlight) parts of negative correspond to a *low* figure on the exposure log axis of printing papers. Similarly palest (subject shadow) parts are represented by a higher figure because here the negative allows more light to reach the paper

Fig. 12.17 Curves for four grades of a printing paper, all designed to match in speed

and 12.18 show, soft grades form a relatively gentle 'staircase' of tones between these extremes, whereas hard grades rise more steeply and give a harsher and more abrupt range of greys.

Basically, choice of contrast allows you to compensate for contrasty or flat negatives; for example, a fairly harsh continuous-tone negative gives similar results printed on grade 1 to a softer negative printed on grade 4. In practice, choice of grade depends on many factors – type of subject, enlarger illumination, the visual effect you want to achieve, how the picture will be used, and so on. Often by exaggerating contrast beyond how your subject actually *looked*, you can strengthen a bold design.

Bear in mind that one manufacturer's grades 1, 2, 3, etc., may not match those of another. Some papers are made in one or two grades only; others (white smooth glossy, for example) come in six grades.

Variable-contrast (also known as 'selective contrast' or 'multigrade') papers work by having a mixture of *two* emulsions. For example, one is contrasty and sensitive only to blue light. The other is low-contrast and sensitised towards the green region of the spectrum. So you can use one of a range of gelatin filters from deep yellow (gives grade 0) to deep purple (gives grade 5) over the enlarger lens to achieve the contrast you want. Or, if the enlarger has a colour printing head, you can dial in appropriate filters here. See settings, Figure 12.21. Some enlargers have special heads for variable-contrast paper – you select grade numbers on a remote keyboard to adjust filtered light beams automatically.

Variable-contrast paper reduces the range of paper stock you have to keep. Most importantly it also allows you to *vary* contrast across a print, by exposing one area of the image at one grade setting and the rest at a different setting. See shading, page 262.

Speed figures for printing papers, originally devised by the American Standards Association, are known as ASAP speeds. The main practical value of published speeds is to show whether you should alter exposure when changing from one paper type to another; see Figure 12.20. Do this by multiplying the previous exposure time by the speed number of the paper you used; then divide the result by the speed number of the paper you are changing to. (Note: paper speed numbers bear no direct relationship to film speed ratings.)

Fig. 12.18 The same negative printed on four different grades of the same paper. Clockwise from top left: Grade 1 (soft), grade 2 (normal), grade 3 (hard) and grade 4 (extra hard). The harder the paper the fewer the grey tones. Variable-contrast paper gives similar results by change of colour filters

Negative density range		Paper grade likely
On diffuser enlarger	*On condenser enlarger*	
1.15–1.40	0.87–1.10	1
0.95–1.15	0.72–0.87	2
0.80–0.95	0.60–0.72	3
0.65–0.80	0.50–0.60	4
0.50–0.65	0.38–0.50	5

Fig. 12.19 Negative density ranges for various paper grades. These figures are only approximate, because so much depends on subjective judgements. See also Figure 11.19

Graded paper	*G1*	*G2*	*G3*	*G4*
General-purpose bromide (fibre)	500	320	200	160
General-purpose bromide (RC)	400	400	400	200
Chlorobromide	160	125	160	200
Variable contrast	*1*	*2*	*3*	*4*
Bromide	250	250	160	64
Chlorobromide	32		30	

Fig. 12.20 Sample paper (ASAP) speeds

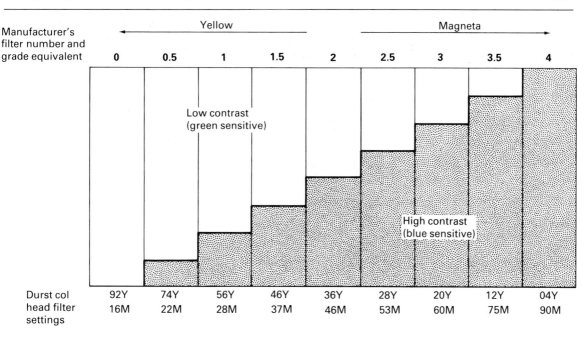

Fig. 12.21 Filtering contrast. Chart shows how different proportions of the high- and low-contrast emulsions present in one variable-contrast paper are used according to your chosen colour filtration. Increasingly deep magenta filters absorb green content of the light (see Figure 9.29) and make paper more contrasty. Increasing yellow suppresses blue and gives opposite effect. Durst numbers suggest settings when using a colour head enlarger – combining two filters here keeps the light output the same so that the exposure time remains constant

Safelighting and colour sensitivity

Darkroom safelighting should be as bright and easy to work under as possible, without of course fogging your paper. The colour filter screening the light bulb or fluorescent tube must pass only wavelengths to which the material is insensitive (Figure 12.22). However, no filter dyes are perfect, and if the safelight is *too close*, or contains a light source *too bright*, or is allowed to shine on the emulsion *too long*, fogging will still occur. See testing project, page 257. Follow the distance, wattage, and maximum safe duration recommendations for your particular safelight unit.

Regular bromide, chlorobromide and multigrade papers are safe under a 'light amber' safelight, such as Kodak 0C. Some materials such as lith paper have orthochromatic sensitivity to improve otherwise

Fig. 12.22 Safelight filters. Combining emulsion colour sensitivity and filter transmission curves shows that regular (blue-sensitive) and variable-contrast printing papers are safely handled under 'light amber' safelighting. Notice from curve overlap that ortho printing materials, such as lith, would fog to amber, so they require deep red safelighting instead. Red is also safe for the other two materials, but unnecessarily dark

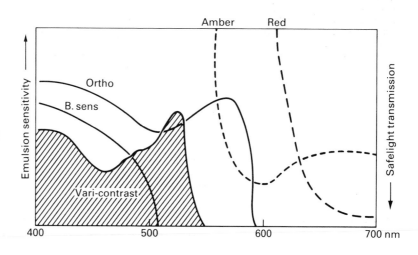

Fig. 12.23 Panchromatic paper. Prints from the colour negative shown in Figure 9.30: (left) on regular black and white bromide paper, (right) on pan bromide paper, and (centre) on pan paper through a greenish filter. Filtering here gives the same tonal effect as filtering when shooting on pan black and white film. Compare these results too with Figure 9.17

extremely slow speed. They therefore need the same deep red safelighting as for ortho films.

There are also a few *panchromatic* printing papers, designed to give correct tonal response to subject colours when you make black and white prints from colour negatives. (Such negatives printed on to regular blue-only sensitive bromide paper make subject reds and yellows too dark, blues too light. In other words, results are like a black and white photograph taken through a blue filter.)

One feature of pan paper is that, when enlarging colour negatives, you can filter to alter the tonal values of subject colours. Follow the same logic as when camera filtering (page 168). To lighten tonal reproduction, colour print through a filter matching the subject's colour; a complementary coloured filter has the opposite effect. You can use a colour head to do this – for example, dial in 50Y to darken blue sky and so emphasise clouds.

Panchromatic paper can be handled under a deep green pan film safelight, or is safe under dark amber Kodak 13 safelighting because of its slow speed. Safest of all, work in total darkness (remembering to have an audio timer for processing). Always check the label on any unfamiliar paper for the safelight colour you must use.

Print processing

Chemical stages

In the main, print developers are similar to MQ or PQ type black and white silver negative developers, although in more concentrated form. (Some 'universal' developers serve both functions, given different dilutions.) Unlike the development of negatives, however, it is important to produce an acceptable image *colour*, along with good tone values, rich black and clean white. Graininess is not a consideration – paper is so slow and fine-grained that any graininess seen in prints is the enlarged structure of the negative, although often emphasised if printed on contrasty glossy paper.

Developers formulated for use with bromide papers tend to be energetic, and give a good neutral black provided you fully develop.

Fig. 12.24 Left: print on bromide paper. Right: the same negative printed on chlorobromide paper and processed in warm-tone print developer. (Both pictures are reproduced on this page by full-colour printing methods)

(Some black and white panchromatic papers are designed for processing in RA-4 colour paper chemicals.) A range of 'restrained' developers are made for chlorobromide papers, giving different degrees of warm tone according to formula. See Figure 12.25.

It is important that you fully develop prints, at correct temperature. Aim to standardise this aspect of printing – having chosen the paper and developer, do all your controls through exposure manipulation under the enlarger. Dilute an ample amount of developer from stock solution for your printing session and discard it at the end. Take care not to exceed the maximum print quantities your volume of developer or fixer can handle, Figure 12.26.

Work with a tray of developer slightly larger than your paper size, and first slide the exposed print under the solution emulsion up, or place it face down in solution and immediately turn it over. Commence rocking the tray gently – for example, by raising each side in turn about 1 cm and lowering it smoothly. Continue this throughout the development period, then lift the sheet, drain for 2–3 seconds and transfer it to the next solution.

Fig. 12.25 Paper developers and image colour

Image colour	On chlorobromide	On bromide	
			Warm
			↑
Brown-black	Neutol WA		
Neutral brown	Neutraltyp, Neutol NE		
Neutral black	Dektol, Neutol BL	Dektol, PQ Universal	
Blue-black		Neutol BL, Ilfospeed	↓
			Cold

Fig. 12.26 Working life of black
and white print processing
solutions

Solution	Processing capacity (10 × 8 in sheets per litre)	Keeping properties without use	
		Stock in full container	Working sol. in dish
Developer			
Dektol (1 + 2)	30	10 months	24 hours
Stop bath with indicator	Until colour change	indefinitely	3 days
Fixer			
Regular and rapid (1 + 7)	26	2 months	7 days

If you want to develop several sheets at once, immerse them at regular intervals, then draw out the sheet at the bottom of the stack and place it on top. Continue this, leafing through the pile continuously (this substitutes for rocking) until development time is up. Then transfer them in the same order to the next bath. To avoid contamination, pick them from the developer with one hand and immerse them in the next tray with the other.

The solution filling the second tray should be stop bath. It has the same function as with films. If possible use a stop bath containing indicator dye – this changes the solution colour to warn you when it is nearing exhaustion. Next, the paper must be fixed to make remaining halides soluble and so form a permanent image. Unlike film fixing you cannot easily see the creamy halides disappearing, so it is important to adopt an efficient routine. Use an acid hardening fixer, either normal (containing sodium thiosulphate) or rapid (ammonium thiosulphate), diluted to print strength. This can be a single bath which you monitor and discard after, say, 25 prints, 10 × 8 in, per litre. Better still, have *two-bath fixing*, giving half the recommended fixing time in each. The second bath, which should be fresh solution, is used successively to replace the first bath each time this becomes exhausted and is discarded.

Acceptable limits for accumulation of silver salts in the fixer are much lower for papers than for films. So avoid solution that has been used for film fixing – it may still work on films and seem to fix prints too, but has such a concentration of silver complexes that insoluble compounds are formed in the paper emulsion that cannot be removed during washing. Don't overfix, either. Rapid fixer, in particular, can begin to bleach image highlight detail, and with fibre papers sulphur by-products of fixing can bond themselves into the base. From here they will not wash out, and start to attack the silver image perhaps months or years later.

Time and temperature

Typical times and temperature tolerances for dish processing are shown in Figure 12.27. Notice the timing difference between RC and fibre papers. Most RC papers incorporate developing agent in the emulsion – inert, but activated when placed in the regular developer solution. Here it is immediately able to start acting on exposed halides, so this arrangement shortens the period needed for development to about 45–60 seconds, making such papers suitable for machine processing (page 255). The rapid response can sometimes be inconvenient in a

	Developer (20°C)	Stop bath (18–21°C)	Fix (1) (18–24°C)	Fix (2) (18–24°C)	Optional holding bath	Hypo-clear (18–24°C)	Wash (1) (Not below 10°C)	Wash (2) (Not below 10°C)	Total
RC	1 min	5 seconds	1 min	1 min	As needed		2 min	2 min	7–8 min
Fibre	1 1/2 min	5 seconds	4 min	4 min	As needed		15 min (40 min D/W)	15 min	40–50 min
					or	2 min	5 min (12 min D/W)	5 min	22–24 min

Fig. 12.27 Tray processing of prints. The times given are typical, but you should refer to detailed instructions for each processing solution. The 'holding bath' is a rinse tray, used to accumulate prints during a printing session into batches for washing. Times for fibre papers assume single weight unless shown D/W

dish, especially if you are batch processing, because there is greater risk of either uneven development or over-development. With all RC papers, the stages following development are shorter too. The emulsion absorbs new solutions quickly as there is so little carry-over of the previous chemical.

When you have sufficient experience in judging the image under safelighting you can begin to develop 'by inspection', making *slight* corrections for exposure by adjusting the development time within acceptable limits (typically ± 30 per cent). This is really practical only with those fibre and RC papers offering longer developing times. Insufficient development gives you grey, degraded blacks; over-development also begins to lower contrast with papers incorporating developing agent. So it is in your best interests to try to work strictly to the recommended time and temperature.

Fig. 12 28 Print washing equipment. A: tray washer for small volume RC prints. B: plastic rack and wash tank for RC. C: syphonic tank, which empties completely each time it is full. D: cascade system. Newly processed prints go into lower sink, are later transferred to upper sink for second half of wash period. Tube in each waste outlet maintains solution level. C and D suit both types of paper

Washing

RC paper needs a relatively short period of efficient washing. Remember that sheets are plastic, so you simply need to keep a flow of water over the emulsion surface. A shallow flow tray, or a film wash tank fitted with a print rack (Figure 12.28), will complete washing in about 3 minutes. If prints are just left in running water in an ordinary tray or sink for 3–4 minutes, make sure they are agitated, not allowed to clump together.

When washing fibre paper you must allow time to let by-products soak out of the porous base as well. It will help greatly if you first

place prints in hypo clearing agent (typically 2 minutes treatment) prior to washing. This agent causes an 'ion exchange', helping to displace the fixer more readily from all layers of the material. The best wash arrangements are either soak-and-dump, using a siphon to completely empty a dish or sink at regular intervals, or some form of cascade system. Typical wash time is 30 minutes for single weight, 40 minutes for double weight. This can be reduced to one-third or less if hypo clearing has been used. See also archival print processing, page 268.

Wash water temperature is not critical, preferably 10–30°C for RC paper, 18–24°C for fibre type. Excessive soaking – say several hours at 24°C, or overnight at any temperature – may cause emulsion to start parting company with the base. It may even begin gelatin disintegration, especially if you used a non-hardening fixer.

Drying

Your print drying method is important because it affects the final *surface*. The simplest but slowest technique is air-drying. You must first remove surplus water from back and front print surfaces with a rubber squeegee. Then leave prints on absorbent material such as cheesecloth or photographic blotting paper, face up for RC paper, face down (to reduce curl) for hardener-treated fibre prints. Or you can peg them on a line with plastic clothes pegs at top and bottom – fibre prints in pairs back-to-back, RC prints singly. Drying may take several hours at room temperature.

To speed up the drying of RC prints, hang them in a heated film drying cabinet, or blow them over with a hair dryer (temperature not exceeding 85°C). Better still, pass the *thoroughly wetted* prints through an RC dryer, designed to deliver dry prints in about 10 seconds.

For fast drying of fibre prints, have a flat-bed or rotary glazer, which uses canvas to press the paper against a heated (usually polished

Fig. 12.29 Print drying. Rotary (A) and flat bed (B) glazers, suitable for fibre prints. Air drying using muslin racks (C) or line pegging (D). Hot-air dryer (E) for RC paper only; print must be inserted covered by film of water, direct from tray

chrome) metal surface. Placing the back of the print towards the heat gives a final picture surface similar to air drying. However, to get a glazed finish with glossy fibre paper, you squeegee it face down on to the chrome sheet, so the gelatin supercoat sets with a matching mirror-like finish when dry. Unless this is done, glossy fibre papers will dry semi-matt. You can at any time remove the glaze by thoroughly resoaking the fibre print and then drying it faced the other way. (Avoid hot-glazing other fibre paper surfaces, and RC prints of any kind. The former take on ugly patches of semi-gloss, the latter will melt at 90°C or over and adhere firmly to the metal and canvas.)

Manufacturers of premium fine-art fibre papers recommend air drying unless you are glazing glossy. The fact is, anything touching the emulsion during drying is a potential source of damage. There is always a risk, when using a glazer for other fibre paper surfaces, that the canvas will either mark the final emulsion finish, or chemicals previously absorbed from drying insufficiently washed prints will transfer into your print. However, this is still the best drying method for thin-base prints, which tend to curl badly if air-dried instead.

Machine processing

There are two quite different kinds of automatic processing machine. Both are suitable for RC papers (including variable-contrast types) that incorporate developing agents within the emulsion and so fully develop in about 1 minute. Machine processing of prints is valid where there is a consistently high volume of work, or where urgent deadlines have to be met.

One type of machine is the roller-transport tank system that accepts mixed size sheets (or rolls) of exposed paper, feeds them through tanks of regular developer, rinse, fixer, and wash; then passes them directly through an RC paper dryer (Figure 12.30). These machines are expensive but produce a fully processed dry print in about 2 minutes – or 450 prints, 10 × 8 in, per hour.

The other type of machine is called a rapid-access stabilisation processor. This is a simpler, bench-top unit with rollers which apply a powerful alkali 'activator' solution to the emulsion, causing its internal developing agents to develop the image in 2–4 seconds. Then the paper passes quickly through a trough of 'stabiliser' (such as 36 per cent

Fig. 12.30 Black and white print processing machines. Far right: roller-transport unit that delivers washed, dried RC prints. It may stand wholly in darkroom, or be built through wall and issue prints into normally lit area. Near right: rapid access darkroom processor, producing unwashed, stabilised prints in seconds. It requires no plumbing – two bottle reservoirs supply activator and stabiliser solutions

ammonium thiocyanate). This neutralises developer, but instead of fixing, the solution converts undeveloped halides into whitish compounds which are reasonably stable in white light. Your print emerges through rollers damp-dry, about 12–15 seconds after entering the machine.

Stabilised prints are impermanent, lasting at most just a few months. But they are acceptable for rush proofs or newspaper work. You must not glaze or tone (page 277) such prints because they are still saturated with chemical, but if conventionally fixed and washed they become as permanent as regular RC prints. A rapid-access processing machine is easily portable and requires no plumbing, so it can be used in various temporary, makeshift printing locations.

Summary: Black and white printing: facilities and processes

● Have a darkroom of adequate size, light-tight but ventilated, stable in temperature, away from dust and pollution, allowing easy access, and serviced by electricity and hot and cold water.
● Divide darkroom layout into wet and dry areas to suit your work pattern. Consider both chemical and electrical safety carefully, see Appendix E. Have the room well illuminated by safelighting, with light-toned walls except at light trap and enlarger. Avoid ledges, pipes, etc., which encourage dust and condensation.
● Enlarger choice factors: range of negative sizes, type of illumination, lens, and maximum print size. Condenser illumination enhances image contrast, grain and detail, but picks out any negative blemishes. Be prepared to adjust condensers for a lens change, and extreme changes of image size. Process negatives to suit your enlarger's illumination system.
● To calculate the image magnification an enlarger will give, divide the lens-to-paper distance by focal length, then subtract one.
● RC and fibre papers differ in the times required for processing, washing, drying; also in drying treatment, dimensional stability and archival permanence. Fibre papers include silver-enriched emulsions and premium weight base; RC papers may have emulsions incorporating developing agents.
● Other printing paper variables: tint, surface, size, neutral or warm-tone emulsion, contrast (graded or variable), speed and colour sensitivity. Safelights must be appropriate colour, wattage, distance. Even then, don't exceed maximum safe exposure time.
● Choose a developer remembering image colour – particularly with chlorobromide papers. Aim to standardise your development time and temperature. Use a stop bath, then acid hardener fixer. Don't use exhausted fix or fixer used for negatives. Avoid overfixing too.
● Have a wash system that efficiently removes soluble salts. Fibre papers are helped by a hypo clearing stage. Dry RC prints by heated air dryer, or natural air. For fibre prints either heat-dry (essential if glazing), or hang up thicker papers to air dry.
● RC paper incorporating developing agents can be machine-processed using either a roller-transport multitank system (for volume throughput), or an activate/stabilisation machine (for fast access but impermanent results).

Projects

1. Find out the range of print sizes you can make. Physically check the upper and lower limits of image magnification your lens(es) and enlarger design allow, while still maintaining an evenly illuminated negative. Remember the use of extension tubes.

2. Test your darkroom safelight. Set up a typical negative in the enlarger (preferably including some pale tones, such as cloudy sky). With safelights on, make a correctly exposed print, including masked white borders, and tray-process it normally. Call this print A. Next expose and process another print using exactly the same technique but with the safelight *off*. Call this B.

 Now expose a further print, without the safelight on. Before processing it, position it emulsion-up on a large card placed on top of the developer tray. Cover 25 per cent of the print with opaque card and switch on the safelight. After 1 minute cover 50 per cent, after 2 minutes 75 per cent, then leave the final 25 per cent a further 4 minutes before switching the safelight off again. (This gives you tests of 0, 1, 3 and 7 minutes respectively). Call this print C and process it in darkness, the same way as print B.

 Wash and dry your prints and analyse results. If all three prints are identical your safelight conditions are safe. If A shows lower contrast, or greying highlights or borders relative to B, you have serious fogging. Confirm safelight colour, check for bleaching or light leaks, and reduce intensity or increase distance. If C shows highlight degradation in any of the fogging test strips, remember to avoid exposing paper for this long. If such a period is too short to be acceptable, take corrective measures. Finally test again.

13

Black and white printing techniques

Well-organised darkroom facilities and equipment are important, but still only a means to an end. You can now get down to printing itself. The most important aspects of learning to print are (a) being able to distinguish really first-class print quality from the merely adequate, and (b) mastering the skills to control your results fully. Other requirements, such as speed and economy, will come with experience – but unless you have standards to strive for and the knowledge of how to achieve them, you will too easily accept second best. This chapter concentrates on the basic controls possible in making prints. It also looks at the archival permanence of results, and some out-of-the-way printing materials and methods.

Making contact prints

Try to produce contact prints – negative size prints made with the film in direct contact with the paper – from all your new negatives as soon as they are processed. Then you can safely file away the films, and just handle the sheets to pick and choose which shots to enlarge, mark up possible cropping, etc. To make contact prints, use the enlarging equipment described in Chapter 12, plus a contact-printing frame (Figure 13.1) or at least a 10 × 8 in sheet of clear plate glass. Set up the empty enlarger so it projects an even patch of light on the baseboard slightly larger than your paper. Reduce the lens aperture about two stops and (assuming you are not using panchromatic paper) set the red swing-over filter in the light beam.

Switch off white room lights. Place a sheet of grade 1 or 2 paper, or variable-contrast equivalent, emulsion upwards within the projected patch of red light. Lay out the negatives emulsion downwards, on top, pressed down by the glass. If you use a contact frame, you can first slip negatives into thin transparent guides on the underside of the glass. This is especially helpful when printing more than one contact sheet off a film, or working in the dark using pan paper.

Exposure varies according to the intensity of your light patch, and negative densities. As a guide, having switched off the enlarger and

Fig. 13.1 Contact-printing equipment. Top and centre: units for 35 mm and 120 rollfilm strips of negatives, which are slipped into thin transparent guides on underside of glass. Bottom: basic arrangement using plate glass

Fig. 13.2 Test-exposing a contact sheet. Use red filter to position glass and paper in light patch (A). By covering one-third of the paper after 5 seconds (C), two-thirds after a further 5 seconds (D), and then giving a final 10 seconds, bands receive 5, 10 and 20 seconds exposure

Fig. 13.3 Sheets of contact prints. Top: a test sheet exposed for 5 seconds (left), 10 seconds (middle), and 20 seconds (right). Bottom: the final sheet, given 10 seconds overall

swung back the filter, use your timer to bracket trial exposures around 10 seconds. (Give different parts of the sheet 5, 10 and 20 seconds as shown in Figure 13.2.) Remove and process the paper, waiting until it has reached and remained in the fixer for at least 1 minute before you view results in white light.

Rinse the contact sheet and hold it out of the solution; prints look deceptively pale underwater. They also darken slightly when dried. The darkest band of density on your print received the longest exposure time. If results prove you were wildly out in guessing exposure, a further bracketed test may be required. But the chances are that you can now decide from the most promising band of density what exposure will be correct for your next and final contact sheet.

Of course, if the set of negatives you are printing vary greatly in density, the correct contact-sheet exposure will have to be a compromise between darkest and lightest frames. Variations will be less if you use soft rather than hard contrast paper – it is important that contacts show the detailed picture content of every frame, even if print quality has to look rather flat at this stage. You can also help matters by 'shading' or 'printing-in' individual frames which otherwise print much darker or lighter than the majority (page 262). Make sure the finished contact sheet carries your film's reference number, perhaps written on the back of the paper.

'Straight' enlarging

Decide the shot you want to enlarge, based on composition, sharpness, expression, action, etc., selected from the contact sheet. If there are several near-identical frames which differ mostly in density, pick out all these negatives. Then decide from the technical quality of each one which negative will print best. Check sharpness, and look especially to see that there is sufficient detail present in important highlight and shadow areas. Ensure that both surfaces of the film are free of marks or debris before inserting it into the negative carrier, emulsion downwards.

Adjust the masking frame to your paper size, allowing for any white borders. Then switch off white room lighting, switch the enlarger on and open the lens to full aperture. Raise or lower the enlarger head until the wanted part of the projected image fills the masked area, focusing the image and if necessary readjusting height until composition is correct. (Never focus with a thick red filter over the lens – it will alter the focus setting, and when removed the image may be unsharp.) At this point, if you have a condenser enlarger, you could remove the carrier and check the projected light patch for evenness. Adjust lamp or condensers as necessary.

Next, stop down the lens two or three *f*-settings – more if the negative is rather thin. The reasons for stopping down are (1) to give a conveniently long exposure time (10 seconds or so, for example, gives you more time to locally shade exposure – see below – than something as short as perhaps 1 or 2 seconds), (2) to get peak image performance from the lens, and (3) to compensate for any slight focusing error, by extending depth of field.

Look at the image on the easel, and decide the most likely paper grade. If you have an enlarging exposure meter calibrated for your enlarger and developer, set this with the paper's speed. Take a spot reading from part of the image you expect to print mid-grey, and read off the time needed. But even if you use a meter, print results are so subject to final visual judgement that it is still helpful to make a bracketed series of test strips. This is why many black and white

Fig. 13.4 Spot measurement of exposure from an area chosen to print mid-grey, using enlarging meter probe. Meter will have been calibrated from previous tests using your equipment and materials

Fig. 13.5 Test-exposing an enlargement. By holding an opaque card stationary in the light beam, different areas of a half sheet of printing paper can be given a range of exposure times

Fig. 13.6 Always position exposure test bands across an enlargement so that each one includes both light and dark parts of the image, as here. If these three bands had been run vertically instead, two would have shown information about sky and foreground only

printers consider that metering is just time-consuming. With experience, it is possible to look and guess test exposures closely enough.

Use the metered or guessed time as the centre point of a geometric range of exposures on a half sheet of paper (Figure 13.5). Think carefully how to position these strips – for greatest information, each one should include both darkest and lightest parts of the image. After exposure and processing, judge the best strip, looking especially at key areas such as flesh tone in a portrait, and checking how much detail (present in the negative) has printed in shadows and highlights. If the best strip looks too harsh or too flat, change to a different paper grade – or with variable-contrast paper alter the filtration. Adjust exposure for this change if necessary (page 247) and test again. Should exposure

time now become awkwardly short or long, alter the lens aperture: opening it one stop allows time to be halved, closing it one stop allows it to be doubled. (Aperture has no effect on contrast.) Finally take a full sheet of paper, position it under the enlarging easel masks and give the exposure time you consider correct.

Controls during enlarging

Local control of exposure

A single 'straight' printing exposure as described above often fails to suit every part of the picture. The reason may be that the negative density range, while well matched to the paper for most subject tones, exceeds it at one extreme or the other. Perhaps a patch of shadow becomes solid black or highlight detail looks 'burnt out', when midtones are correct for density and contrast. Perhaps subject

A

B

C

D

Fig. 13.7 Shading and printing-in. Large areas at one side of the picture are conveniently shaded with the edge of your hand (A). To make isolated 'island' areas lighter, shade with a 'dodger' (B) made from card and thin flower wire. To darken isolated areas, print-in through a hole in opaque card (C) or form a shape between cupped hands (D)

lighting was uneven, or you simply want to darken and merge some parts of a composition in order to emphasise others. In fact there is hardly a picture that cannot be improved in some way during printing by locally reducing exposure (known as 'shading', 'holding back' or 'dodging') or extending it ('printing-in' or 'burning-in').

To *lighten* part of the picture insert your hand, or red acetate or opaque card, into the light beam during part of the exposure. Have your shading device about halfway between lens and paper, and unless you are shading up to a hard edge, such as a horizon or the side of a building, soften the shadow by keeping it slightly on the move. To *darken* a chosen area, follow up the main exposure with an additional period when you print-in using a hole in a card, or the gap between your cupped hands; see Figure 13.7. Merge the edge of your exposure-controlled area in the same way as for shading.

To decide how long to shade or print-in, make the best possible straight print first. Then, with the aid of the red filter, place pieces of printing paper in excessively dark or light image areas and make test-strip exposures at shorter and longer exposure times respectively. If necessary sketch out a shading 'map' (Figure 13.8). This will remind you where and by how much you must shade during your main exposure, and the same for extra exposure afterwards. The harder the contrast of your paper, the greater these exposure differences will have to be. If burning-in will take an unacceptably long time, you can halve it by carefully opening the lens one stop after the main exposure, provided you do not shift lens or paper. Remember to stop down again before exposing the next print.

Sometimes an area being heavily printed-in to black contains some small highlights which still appear as grey shapes, no matter how much additional exposure you seem to give. The best solution then may be to fog over these parts. Either print-in with the enlarger turned out of focus, or fog using a small battery torch fitted with a narrow cowl of black paper (Figure 13.10). Keep the enlarger on, red-filtered, to show you the exact image areas you are treating with white torch light.

Overall = 22

+14 −4 and −5

Fig. 13.8 Reminder sketch, to record different exposures needed for various areas of the picture (refer to Figure 13.9)

Local control of contrast

Shading and printing-in are like retouching: if done well, no one should know they have taken place. But when they are overdone you will find that shadows look unnaturally flat or grey, and burnt-in highlights veil over, again with lost contrast. This will happen most readily when parts of the subject were exposed on the tone-merging 'toe' of the film's performance curve (Figure 10.4), or near the top end where irradiation again destroys tone separation. Perhaps the cause is general under-

Fig. 13.9 Print shading. Top: a 'straight' print given 22 seconds shows pale sky, and dark detail at top and right side of memorial. Middle: test pieces for sky (given 35 seconds) and memorial (10 seconds). Bottom: working from the test information this print was exposed for 22 seconds, during which memorial areas were shaded for 4 and 5 seconds – see the shading plan (Figure 13.8) Then the sky was printed-in for an extra 14 seconds

Fig. 13.10 Local fogging-in with a battery torch darkens small unwanted light parts, which then blend with dark areas. Alternatively print-in normally, but defocus the lens

exposure or overexposure respectively, or just subject range beyond the capabilities of your film.

Either way, these tone-flattened areas need extra contrast, which you can achieve with variable-contrast paper by using selective filtration. Imagine, for example, that you need to shade and contrast-boost a simple patch of shadow in a picture which otherwise prints with grade 2 filtration. You (a) shade this shadow throughout the *entire* period while the rest of the picture is being printed, then (b) change to grade 4 or 5 filtration, and (c) print the shadow area back in, to the level of exposure it would have received if shaded normally.

Overall reduction of contrast

Sometimes, perhaps due to an emergency situation, you have to print a negative so contrasty that it is beyond your softest paper grades. Three techniques are then worth trying, either singly or all together:

1. Make the enlarger illumination less hard. If you have a condenser enlarger, place a piece of tracing paper on top of the condenser or in the lamphouse filter drawer. Light output will probably be quartered, so widen the lens aperture and increase exposure. Negative contrast will be reduced by about one grade.
2. Reduce paper contrast by 'flashing'. This is a tiny amount of controlled fogging to light – not enough to make the paper look grey, but sufficient to overcome 'inertia' and raise the image exposure received in highlight areas to a developable state, with very little change to darker tones. To do this, first expose the paper normally. Then, while it is still in the masking frame, hold tracing paper just below the lens and give a second or so 'flash' of (totally diffused) light. You must discover the best amount of flash exposure by trial and error.
3. Change to a low-contrast print developer, which still gives a good black but a more graduated range of greys. Perhaps the best paper developer to do this is Beers (Appendix B) using 'A' solution only. See also contrast masking in *Advanced Photography*.

Overall increase of contrast

An excessively flat negative, provided it still contains sufficient shadow and highlight detail, will usually print on a grade 5 paper. However, other worthwhile techniques to boost contrast include:

1. Chromium-intensifying the negative, page 291 (only suitable for silver-image film).
2. Developing your printing paper in a line developer, such as D8.
3. Printing on lith paper using lith developer, page 268.
4. Changing from a diffuser enlarger to a condenser enlarger, or from a condenser to a point-source enlarger.

Edge lines

Fig 13.11 Arrangement for fogging in a black edge line to the picture area (see Figure 13.12). The narrow gap must be even all round

You sometimes have a dark subject against a light background, which is cropped first by framing in the camera and then by white print borders into a truncated shape. Figure 13.12 is one example. To help pull these isolated pieces of the image together it helps to add a thin black line between picture edge and border. You can do this by felt pen

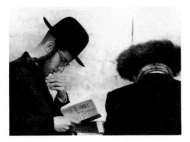

Fig. 13.12 The picture above has strong 'cut out' shapes awkwardly truncated by edges of the frame. Printing-in a black edge line (right) helps to hold the main elements of the image together

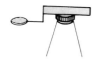

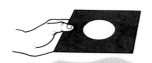

Fig. 13.13 Vignetting. Hold the cut-out shape almost stationary throughout exposure

Fig. 13.14 Typical vignetted print result. Use a large shading card fairly close to the paper, otherwise the vignette may print dark and 'dirty' near the centre

as an after-treatment, but for single or short print runs photographic fogging gives best results. Use thin black card cleanly cut to a size a few millimetres smaller than the picture area set on your masking frame, Figure 13.11. Expose a print in the usual way, but without removing it from the easel cover the emulsion with the card, weighted down with a few coins. Use red-filtered enlarger light to check that a small gap is left *evenly* all round the edge. Then remove the negative carrier and fog the paper to unfiltered enlarger light, giving the same exposure time used before when the negative was in place.

Vignetting

To avoid clear-cut borders completely, you can turn to the old Victorian-style vignettes. which have the picture fading out to white paper like Figure 13.14. Cut a large hole – typically oval – in a sheet of opaque card. Have this held ready the correct distance between lens and paper before starting exposure, checked with the red filter over the lens. Then swing back the filter and expose, keeping your vignetting card in position (moving slightly) to shade all four sides of the paper for the entire exposure.

Common print faults

Always check any unexpected faults on the print first of all with the corresponding image on the negative. Assuming that the negative itself is free of blemishes, the most common faults in printing and their causes are:

● White specks and hair shapes, due to debris temporarily lying on the paper surface, the negative or any carrier glass. If marks are very unsharp the dirt may be on a condenser surface.
● Uneven patches of density, which may be quite large, caused by not submerging the print's emulsion surface quickly and evenly in the developer. Perhaps development time was impractically short.

● Small whitish patches with distinct edges, caused by water or wet fingers reaching the emulsion before processing.

● A purple patch, or purple all over. Insufficiently fixed print emulsion, reacting to white light.

● Fine black lines, often short and in parallel groups, caused by abrasions of the (dry) emulsion, perhaps from dropping paper on the floor or slipping it roughly under the masking frame masks.

● One or two short, thick black marks fairly close to a print edge. Caused by over-energetic gripping by print tongs in the developer.

● Only part of the image is sharp (e.g. centre but not edges; one side but not the other). The negative is bowed, or at an angle to the paper.

Fig. 13.15 A normal contrast negative printed four ways onto a lith type bromide paper, processed in a lith developer. This page, top: 10 seconds exposure and full development. Bottom: 8 seconds exposure and full development. Both prints have a rich black, contrasty image-enhanced look – each reproducing only a small part of the negative's range of tones (compare water surface and background woods). Opposite page, top: exposed 20 seconds with enlarger lens opened one stop. Processed by inspection in diluted developer. Bottom: exposed 30 seconds with lens open an additional stop. Processing as above. The greater the overexposure and underdevelopment the 'warmer' the midtones and the lower the contrast

● Part of the picture shows an offset, double image. The masking frame, lens or negative has been knocked between your main and printing-in exposures.

● Grey, muddy image, with smudged shadow detail and sometimes veiled highlights, caused by grease, dust, or temporary condensation (from moist hands during shading?) on the lens.

● A slight fog-like dark band close to the white border, due to light spread from the rebate of the negative included in the carrier, and perhaps reflected from side rails on the masking easel.

● Contact prints unsharp. Insufficient pressure between cover glass and paper.

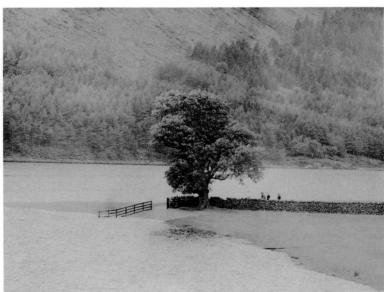

● RC papers only: collapsed blisters in the emulsion surface, where it has parted company with the base. The print was not fully covered by a film of water when passed through a roller RC heat dryer.
● White areas, including borders, veiled with grey. Extreme over-development, or fogged by your darkroom safelight (see safelight testing, page 257).

Archival permanence

You can process to get prints of average stability for normal commercial use and storage conditions, or you can work to the highest possible archival permanence. The latter should certainly be the aim when selling a print as an expensive piece of fine art, or producing records which will be filed away in archives and so must survive the longest possible period. But with most jobs – where prints are intermediates for reproduction on the printed page, for example – the additional work would not be worth the time and trouble.

An archival print is one that is as free as possible of residual thiosulphate (fixer) and silver by-products, and has extra protection from chemical reactions with air pollutants. One form of protecting the silver image is to coat it or convert it to a more stable material by a process called toning.

Present thinking suggests the following as the best archival printing routine. Choose a fibre-based printing paper, preferably a silver-enriched premium weight type. Make sure you develop fully. Follow this by effective stop-bath treatment but don't use the solution at greater than the recommended concentration. Fix in rapid fixer with hardener, using a two-bath system and remembering to agitate regularly. Then there are two choices. Either rinse and treat in hypo clearing agent, or tone the image using selenium toner made up in working-strength hypo clearing agent. See toning, Chapter 14. In both cases agitate continuously. Finally wash prints for 60 minutes in an effective print-wash system, then squeegee and air dry them. (At one time, hypo eliminator solution, containing hydrogen peroxide, was recommended as part of archival processing, but this is now considered harmful. Don't confuse hypo eliminator with hypo cleaning agent.)

Just how long your finished print will last also depends on factors outside your control – adverse temperature or humidity, display under excessive UV radiation, effects of atmospheric pollution, or contact with non-archival packing, mounting or framing materials. But at least it will start out with the best possible chance in life.

Unusual printing materials and techniques

Using lith paper

A few manufacturers, such as Sterling, include among their products extreme-contrast lith-type paper. Processed in a lith developer – such as Tetanal Dokulith or AN-79b, page 291 – this paper gives stark black and white prints off continuous-tone negatives, also exaggerat-

ing their grain and sharpness. However, its main interest lies in the range of tones – from brown-black to yellow – you can achieve by gross overexposure and underdevelopment. See Figure 13.15.

Some lith papers are orthochromatic, and so will need deep red safelighting. Choose a negative that is rich in pattern or texture, and pin-sharp. First make test strips based on the exposure you would give with normal bromide paper but bracketed with only about 20 per cent differences of time. Process fully in lith developer (typically 2 minutes) followed by regular stop bath and fixer. Decide what you consider correct exposure, ignoring the extreme contrast.

Now make a full print giving *four times* this exposure time, or opening up the lens two stops. Dilute some of your previous working-strength developer, 1 part developer 5 parts water, and develop this print purely by inspection, removing it quickly from the developer at whatever stage the image looks best. When you view your fixed print in white light it will show a mixture of black shadows and tinted midtones, with generally normal contrast. Increasing exposure by large amounts and reducing development still further produces more colour and lower contrast. Do any shading or printing-in as normal.

Tinted-base papers

Various brightly tinted bromide papers are made by some of the smaller manufacturers. You need quite contrasty negatives because the coloured base has a contrast-reducing effect. Print processing is the same as for regular papers, and gives a neutral black image. Similar results are possible by soaking any fibre-based print in a cold water fabric dye. However, with some coloured paper products you can treat your processed print in a special bleach (see Appendix B) which removes the black silver and also the dye in this image area. Results therefore turn from a black image on coloured base to a white image on coloured base. If you then treat this print in suitable dye you get a two-coloured result; see Figure 13.17.

Monochrome prints from slides

The quickest way to make black and white prints off a (small) number of slides is through the enlarger. Prepare a double-sided 4 × 5 in film holder, with white paper loaded into one side and a sheet of ISO 125/22° normal-contrast panchromatic film in the other. Open the paper-loaded side and set the holder into one corner of the masking frame, Figure 13.16.

De-mount your slide, place it in the enlarger negative carrier and focus up the image on the white paper. Either have the picture almost filling 4 × 5 in or make it the same size as the slide, using extension tubes if necessary. Stop down fully. Then switch out all lights, turn over the film holder and open the other (film-loaded) side. Give about 1 second exposure to the image, close the holder and switch on the lights again.

Now process your film using a tank, dish or machine, and giving only two-thirds normal development to reduce contrast. When the film is dry, either enlarge it direct if you have a 4 × 5 in enlarger, or (if same-size) cut out the negative and fit this in your smaller-format

Fig. 13.16 Use of 5 × 4 in film holder on enlarging easel, for exposing a colour slide on to black and white film. This produces a negative image for printing

Fig. 13.17 Prints on tinted-base paper. Top left: enlarged direct from a black and white negative, and normally exposed and processed. Top right: the same print after treatment in silver/dye bleacher. Bottom: for this version an enlargement on regular RC bromide paper was contact-printed onto tinted base paper. This negative print was silver/dye bleached, then lightly coloured with yellow (skin) and maroon (masks) dyes. Use dyes or oil colour suitable for resin coated paper

Fig. 13.18 Double printing. Top left: test print from Manhattan skyline negative, shading bottom half throughout. Top right: test print from converging building negative, shading top half throughout. Bottom: the two exposures made in sequence onto one sheet of paper

Fig. 13.19 A few multi-image attachments for camera work will function on the enlarger, if spaced away from the lens and used faceted side up. However, they tend to greatly reduce image contrast

enlarger for printing. You can, of course, colour-filter at the negative-making stage to control tone values, in the same way as when shooting (page 168) or printing colour negatives on pan paper.

Optical distortions

Most special-effects attachments for camera lenses (page 180) fail to work effectively on the enlarger lens. Others reverse their normal role; for example, a diffuser which spreads subject *highlights* in the camera spreads *shadows* during enlarging. Results look smudged and sombre instead of brilliant and exuberant, but work well with an appropriate moody picture.

Interesting scrambled-image effects are possible by standing one or more metal mirrors on end on the paper surface. Or you can distort shapes by tilting or corrugating the paper instead of laying it flat. Be sure to focus the image for a position halfway between nearest and farthest parts of the paper, and stop down to the smallest aperture. You also have to shade parts nearest the lens because they receive more light (inverse square law). Tape down the paper firmly in its chosen configuration, to prevent any shifting during exposure.

Double printing

Having exposed a sheet of paper to the image from one negative, you can then expose it to another. This of course gives superimposition – the shadows and darker tones of one image showing up mostly in highlights and paler tones of the other. But by shading part of the first image, and then printing this area of the paper back with the second image, one scene can be made to *merge* into the other – often with interesting surreal effect. See Figure 13.18.

Selective-contrast paper is ideal for this work because you can adjust filters to compensate for any contrast differences between negatives. It also helps to have two enlargers, each set up with a negative so that you

Fig. 13.20 Negative print, made by face-to-face contact printing the enlargement shown in Figure 10.26 (resin coated paper) onto another piece of grade 2 paper. The sandwich was pressed down hard under glass and given 25 seconds exposure under the empty enlarger, at wide aperture

only shift the paper from one baseboard to the other. You can use carefully cut card shapes tape-hinged to the easel as flaps, to help mask out unwanted parts of one or other image along a sharp-edged boundary.

Summary: Black and white printing techniques

● Contact prints are an important means of proofing/filing images. Aim for maximum information of picture content in every frame.
● Select and clean negatives for enlarging; remember to stop down, and give a geometric series of test exposures, each spanning shadows and highlights.
● Make local density changes by shading and burning-in; make local contrast changes by altered filtration (variable-contrast paper).
● To reduce printing contrast, use softer grade paper, diffuse the enlarger illumination, 'flash' expose the paper or change to softer-working developer.
● To increase contrast, use harder grade paper, consider negative intensification, line developer, lith materials, or change to condenser or point-source enlarger.
● Check print faults against your negative. Most white marks are caused by light obstruction, black marks by fog or rough handling, patchiness by careless processing.
● For highest standards of permanence, work with fibre paper. Fully develop, then use stop bath and a two-bath acid hardening fix. Rinse and use hypo-clearing, or selenium-tone the image. Wash fully and air dry.
● Materials and methods worth exploring: lith paper, tinted bromide papers (with bleach stage), monochrome prints off slides, optical distortions and double printing.

Projects

1. Make a 'ring-around'. Pick an interesting negative and make a wide-ranging set of prints
 (a) on various types, contrasts and surfaces of paper, and
 (b) using different developers. Mount these on a card for reference.
2. Make strong linear and tonal designs by means of photograms – laying objects in direct contact with the printing paper or within the enlarger light beam. First form an even patch of light with the empty enlarger, stop down, and test for exposures (normal-grade paper) which give pale grey, mid grey and (just) full black. Try:
 (a) Numerous opaque objects – paper clips, beans, etc. – which you shift around the paper or partly remove after one-quarter, half and three-quarters the full black exposure.
 (b) Some objects on a glass sheet a few inches above the paper, others in surface contact. Hold tracing paper just below the enlarging lens to make the raised objects form soft-edged shadow shapes. The others remain sharp and are therefore emphasised.

 (c) A few larger objects on the paper, exposing these with a moving torch (Figure 13.10) following each circumference – like a paint spray around a stencil.

3. Try printing images from paper. Enlarge from a negative or slide (emulsion upwards in the carrier) on to 10×8 in RC soft-grade glossy paper. Process and dry. Now contact-print this result, face down, on to another sheet of paper, pressed together under glass. Expect to expose for about 20 seconds at widest aperture. Handled in this way, film negatives produce negative prints, and slides positives.

14
Afterwork and presentation

Once the darkroom side of black and white printing is over, you can still make radical changes to a picture by various processes workable in normal light. These include bleaching, toning and colour tinting. Most pictures do not need such manipulation, but they still require routine spotting and mounting. Finally, for work which is to be displayed, you must decide the best form of presentation – whether this be on the page of a folio, or in a suitably lit frame on the wall.

Image reduction, bleach-out

The two most useful forms of print reducer are Farmer's, which you use to *lighten* the image, and iodine bleach, which removes part of the image *completely*. Formulae for each appear in Appendix B. Remember health and safety in handling these chemicals, page 296.

Farmer's reducer

This is also known as ferricyanide reducer or 'ferri'. Basically it is a combination of potassium ferricyanide, which changes the print's black silver image back to silver halide, and hypo (sodium thiosulphate, fixer) which makes the halides soluble so that they can be washed from the paper. Farmer's reducer can be used as a sequence of two separate solutions, but it is much easier to see the reduction effect with both chemicals present, even though the mixture does not then keep and must be used 'one-shot'.

Use Farmer's reducer to lighten just those areas of the picture you have been unable to shade sufficiently. Alternatively, applied to the whole print, it will 'clear' veiled highlights and give extra sparkle to light tones – which it reduces more quickly than darker tones.

The print you want to work on should be fully fixed, rinsed and squeegeed on to a clean flat surface. Dilute the Farmer's reducer with water until tests on a scrap print show that its image-lightening action is fairly slow, and therefore controllable. Then apply it to your main print by cottonwool swab. Keep stopping the action by hosing over the print surface with water (remembering that if you go too far, reduction

Fig. 14.1 Changing local tone values with reducer. Left: straight print from negative. Right: this print had nearly twice as much exposure. Then after processing, the fallen branch was lightened back by repeatedly applying dilute Farmer's reducer on a large watercolour brush

cannot be reversed). When the image has altered to the visual result you require, give the print normal fixing, washing and drying.

Iodine bleach

This is the best bleacher for giving a 'clean' complete erasure of the image. It is a dark brown solution containing iodine and potassium iodide, which combine with the silver to form a silver halide. This in turn is fixed and washed out. Use the bleacher to convert small black spots into white spots, for subsequent spotting-in with dye or water colour; see later. It is also excellent for 'shaping-out' subjects from their backgrounds.

Thoroughly blot off the fixed, rinsed print you want to bleach, and apply the undiluted solution with a brush or (for large areas) a swab. A deep brown stain immediately appears, but you can see the black image fading away beneath it. When this bleaching is complete, soak the print in a tray containing some fresh fixer for 5–10 minutes until the treated areas are completely stain-free and white. Then wash and dry the print normally. Discard the fixer because of the iodide by-products it now contains.

When 'shaping out' a very complex subject you can first dry your print, paint over or cover parts you do *not* want to bleach with a waterproof resist, and then place the whole sheet in a tray of the bleacher. Afterwards peel off the resist at the refixing stage.

Fig. 14.2 Bleaching out background. Above: straight print shows moss-covered tree stump with confusing background. Right: by carefully applying iodine bleacher with a swab and brush, and finally refixing, unwanted parts of the image are reduced to white paper

Toning

Toning changes the black image into a colour, by either coating the silver or converting it into another, coloured, chemical or dye. The paper base remains unchanged. Some toned images (sepia, red) are at least as permanent as the original silver. Others (blue, green) are not.

You may want to tone your print to subtly improve tonal richness and increase its permanence, using selenium or perhaps gold. Or you might sepia-tone, either to create an antique-looking image, or as a preliminary to tinting (see below). Stronger colours should be used with restraint, unless you need a gaudy effect.

Image colours given by typical toners are shown in Figure 14.4. Some are sold as prepared chemicals, others must be made up (see Appendix B). In addition you can buy ready-to-use kits such as 'Colorvir' offering a whole range of colours.

Some toners require *two stages*. First, you bleach the area you want to tone in a ferricyanide solution (without fixer), then you redevelop this bleached image as a coloured chemical image in the toner. Redevelopment can take place in normal room lighting because only halides representing the image are present, so fogging is impossible.

Fig. 14.3 Toners. Take care: some are hazardous to use (see Figure 11.4, also Appendices B and E)

For this final image colour	Use this toner
Blue	Iron
Bluish-white	Gold
Green	Iron tone, then vanadium
Yellow	Vanadium
Red, red-brown, magenta	Nickel
Warm black to metallic red	Copper
Red	Sepia tone, then gold
Chocolate brown	Hypo alum
Warm brown to sepia	Sulphide
Purple brown to warm brown	Selenium
Purple black to sepia	Tin

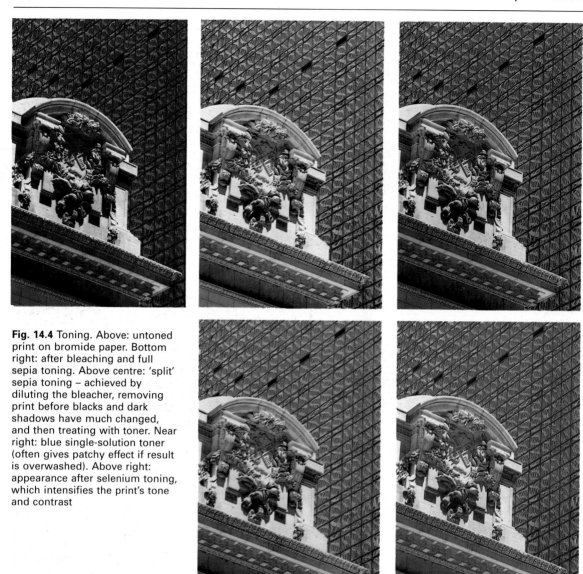

Fig. 14.4 Toning. Above: untoned print on bromide paper. Bottom right: after bleaching and full sepia toning. Above centre: 'split' sepia toning – achieved by diluting the bleacher, removing print before blacks and dark shadows have much changed, and then treating with toner. Near right: blue single-solution toner (often gives patchy effect if result is overwashed). Above right: appearance after selenium toning, which intensifies the print's tone and contrast

Fig. 14.5 Opposite: given a subject like this, which is mostly one colour, toning the print can add great strength and richness. 'Theo's grandmother's walnuts' by Jean Dieuzaide, is a sepia-toned fibre-based print

Others are *single-solution* toners, and gradually displace or form an amalgam with the black silver, starting with palest tones first. Yet others (mostly in kits) use *dye-coupled development*, in which the existing image is first bleached, then redeveloped in a developer plus a chosen colour coupler, and finally bleached again to remove the black silver simultaneously reformed during the redeveloping stage. This leaves an image in dye alone. Notice the similarity with colour film processing.

Whichever toning formula or kit you use, you can choose to change the whole image to a coloured form or, perhaps by means of a paint-on resist (see above), tone selected areas only. Unaffected parts which remain as black silver can next be toned a further colour. Yet another, often very rewarding, way of working is to 'split-tone' – meaning that

shadows and dark tone values in your picture remain black while paler parts take on colour, or the reverse. See Figure 14.4.

The way you achieve this two-tone effect will depend on the formula and colour. With sepia toner, for example, you dilute the bleach bath, allowing time to remove your print before silver from the darkest parts has been much affected. Then in the toner, only paler, bleached tones become fully sepia. In single-bath toner (e.g. blue), you treat the print just long enough to start affecting the lighter tones.

Prints for toning should be fully developed in the first instance. Toners such as sepia slightly *lighten* the image, and others such as blue slightly *intensify* it, so anticipate this when making the original print. You will also find that final colours differ somewhat according to whether the print is on bromide, chlorobromide or lith emulsion paper.

Tinting

Tinting means hand-colouring your print with water-based colours or oil paints. Oils are applied by brush; other paints by brush or airbrush. The main advantage of tinting over, say, colour photography is that you can choose the colour of every single element in your picture – or restrict colour to something you want to emphasise or show in an interpretative way. There is little point in aiming for an accurate, objective record. See Figure 1.10.

If you colour over a normal black and white image, its black silver will mute most of your hues. Instead, work with a print which is warm in image tone and slightly pale. You might sepia-tone the print, for example, or make it in the first instance on chlorobromide paper processed in warm-tone developer. Remember that tinting, unlike toning, colours both the image and clear parts of the paper. In fact colours show as stronger and more pure in highlight areas.

Water-based colours

These are applied to the print while it is still damp. Blot off the print surface and add a wash of colour to largest areas first. Build up sufficient density of colour gradually. Work down to the smaller areas, always blotting off the print after each colour application. When only tiny coloured details remain to be done, dry the print and mount it (see below), then add these final tints using a small brush.

Oil-based colours

Here you must work on a dry, mounted print. Squeeze artist's oil colour on to a palette and pick up and apply small amounts at a time, using a fine brush moistened in turpentine. Again work from the largest to smallest areas. Progress is slow because a coloured surface must dry for about 24 hours before you can add other coloured details on top. However, colours can be erased or changed more readily than with water-based tints, by means of a cotton bud dipped in turpentine.

Fig. 14.6 Airbrushing. Left: equipment connected to can of compressed air. Centre: loading reservoir with watercolour from brush. Right: pressing down lever increases air flow, pulling back allows spray to commence

Airbrushing

Much commercial colouring and retouching of prints is still handled with a miniature paint spray known as an airbrush (Figure 14.6). This is powered by compressed air from a can or an electric pump and compressor unit, and projects a fine spread of spirit- or water-based dye or pigment. Control is by a single button – pressing it down controls air flow, and pushing it forward or back allows paint to flow in a narrow or broad spray from a small internal reservoir. Airbrushing is a skilled job demanding practice, but short of working digitally is the best way to create smooth, graduated areas of colour or tone. To work up to a hard edge you must first protect this part of the print with self-adhesive masking film.

Fig. 14.7 Dry mounting. A: attach centre of mounting tissue to back of print, using heated tacking iron. B: trim off borders plus excess tissue. C: tack corners to mount. D: cover print with silicon release paper and place in hot press

A B C D

Mounting methods

Mounting is an important stage in presenting work. In addition it can help to protect the photographic image from chemical deterioration and handling damage.

Dry mounting

Provided you have access to a heated, thermostatically controlled press, *dry mounting* is the best means of attaching a print to a board with a professional looking finish. As Figure 14.7 shows, you first attach a thin sheet of heat-sensitive material to the back of your (untrimmed) print. Then you trim the print plus heat-sensitive material together, and position them accurately on a suitable acid-free board (preferably museum board).

You next protect the print surface with a sheet of silicon non-stick release paper. Board, print and silicon cover sheet must all be absolutely dry. The whole sandwich then goes face-up into the top-heated press, which melts the adhesive layer into both print and mount

Fig. 14.8 Window mat mount construction, using thin linen tape to tack untrimmed print in place and hinge the top board over it. Cut-out area has bevelled edge

Fig. 14.9 'Girl On The Tube' by Tansy Spinks. A print on lith paper was given blue split-toning to enhance its dreamlike image. This, plus the unsharpness and de-personalised male figures, contribute to a sense of isolation

within a few seconds. Press temperature is especially critical with RC prints, and above 99°C (210°F) blisters may occur. Stabilisation papers also stain at this temperature. Most dry-mounting materials are designed for temperatures between 66° and 95°C, according to type.

The most common dry-mounting faults are (1) tiny pits or protrusions in the print surface due to grit caught between print and press, or print and mount, respectively; (2) unmounted patches due to uneven heat or pressure; (3) adhesive firmly mounted to the print but not to the mount, owing to insufficient heat; (4) adhesive stuck to the mount but the print detached (and blistered if RC) because of excessive heat.

Adhesive tape

Fig. 14.10 Opposite: 'David Graves Looking at Bayswater London November 1982', a paste-up of instant picture prints. David Hockney's 'joiners' are not meant to be accurate mosaics but a selective build-up of a scene from its detailed elements

Double-sided adhesive tape (or sheet) is a quick way of mounting small prints, especially RC materials, but it is less permanent than dry mounting. Single-sided linen tape can be used to tack one side of a double-weight untrimmed print to mounting board. (One-sided attachment allows for differences in expansion.) Then the print is held down flat with a window mat cut from similar or thicker high-quality board; see Figure 14.8. The mat also protects the print surface from sticking against glass if the work is framed, and allows air circulation.

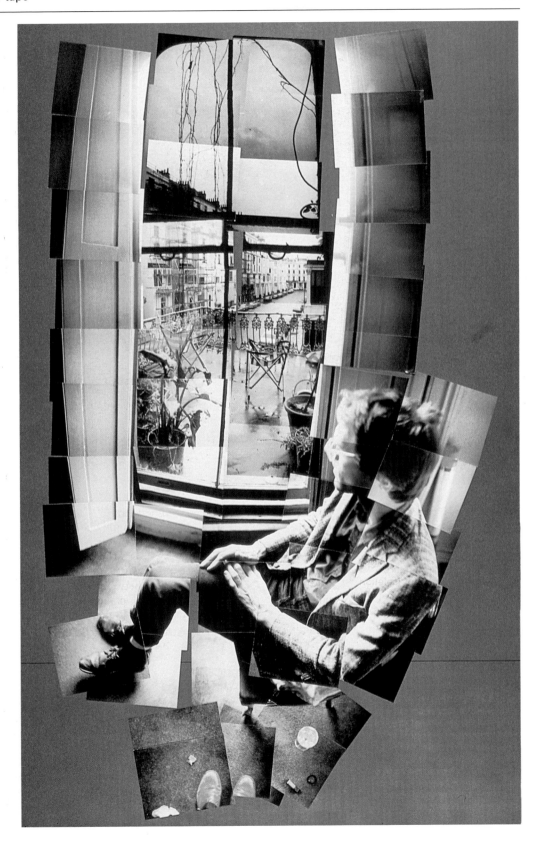

Liquid adhesives

Most general-purpose household adhesives are unsuitable for photo-graphic mounting, as chemicals eventually attack the emulsion. Heavy-duty wallpaper adhesive is the most practical way to mount very large prints. Handle them the same way as wallpaper, and if you are mounting on to flexible board, remember to paste several strips of paper across the *back* of the board too, to avoid curl as your print dries and contracts. Wipe the print surface over with a damp squeegee or sponge.

Resin-coated prints can only be mounted this way if your board is porous enough to allow solvent from the adhesive to evaporate.

Impact adhesive is another way of mounting oversize prints: coat both the print back and mount, allow them to dry, then bring them firmly into contact with a roller squeegee. Aerosol spray-on adhesive is recommended only for temporary 'paste-ups' such as montages or panoramas which will eventually be rephotographed. Dry-mount your base print. Then cut out and chamfer the edges of the print you want to mount on top, by sandpapering the back until wafer thin. Spraying then allows you to apply a very thin layer of adhesive to this surface before pressing the cut-out print into place. (Note: often impact adhesives are highly flammable – use them only in a well-ventilated place.)

Spotting

Most prints have occasional white spots which you must 'spot in'. Use diluted dye or water colour – either black or the appropriate tint – and apply it with an almost dry, fine-tipped brush. By patiently adding tiny specks (not a *wash*) of matching tone, pale defects can be merged with adjacent image grain; see Figure 14.11.

Spotting is easiest with a grainy image on matt or semi-matt paper. Glazed glossy prints are almost impossible to spot without leaving some evidence of retouching on their mirror-like surface. However, gum arabic (e.g. from the flap of an envelope) mixed in with the water-colour helps it to dry with some form of matching glaze.

Fig. 14.11 Spotting-in white specks and a hair mark on a print surface. Use an almost dry 0 size watercolour brush (right) with a good point. Far right: patient stippling-in of tone is half completed. A hair line like this is best broken in two or more parts first, then each section matched into surrounding tone

Dark spots are best tackled earlier – turned into white by spotting the negative, or by touching the print with a brush tip loaded with iodine bleach (page 276). Then they are spotted like any other white defects. However, on matt prints you can try direct print spotting with white pigment.

Style of presentation

Your choice of presentation depends largely on the picture's function and content, and where it is to be shown. When putting together a set of work to take around to potential clients, for example, you can just have prints on thin board filling a ring-binder type portfolio or box (Figure 14.12). This makes it easy to change your selection and order

Fig. 14.12 Forms of presentation. Left: prints in acetate sleeves, in zip-up portfolio. Centre framed behind glass. Right: fold-open box for loose mounted prints – pictures are transferred to other half of box as viewed

of pictures to suit the occasion. Portfolios which have acetate leaves for slip-in prints give them good protection, but remember that if people view your work through the acetate, image tone qualities appear degraded. Darkest tones especially become weak and lost.

Much the same degradation problem applies to photographs framed behind glass. In an exhibition you may be able to control this by careful positioning of spotlighting, Figure 14.13. In locations with many surrounding reflective surfaces, or flat frontal light, it may even be best to remove glass from the frames.

The form of presentation which least influences picture content is flush mounting – attachment to a board or block, trimmed to the picture edge. This is often a good, direct way to show journalistic and social documentary photography. Flush mounted prints, displayed proud from a wall and spotlit, also suit commercial and industrial exhibitions, etc.

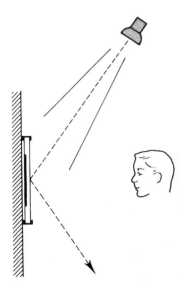

Fig. 14.13 For prints exhibited behind glass, position lighting from a high, oblique angle. Flare reflection will then be directed downwards on to the floor, not towards the viewer However, have the light source as distant as possible, to minimise unevenness between top and bottom

At the other end of the scale, framed portraits, decorative landscapes, etc. for hanging in a domestic or office location are effectively picked out if space is left between picture edge and frame. This might be a wide border left on the print or mounting board, or a window mat (Figure 14.8). (Bear in mind that a mat gives you a final opportunity to adjust composition.) Make sure that the *tone* and *width* of any surrounding material suit the picture content. For example, an elaborate coloured window mat runs the risk of dominating your black and white picture. Unless you aim for a special effect, use only a mount or mat which has a very muted hue, and harmonises with either the print's emulsion colour or tinted base.

Fig. 14.14 Exhibition display.
When hanging pictures of mixed
proportions work to a common
top line using tensioned
horizontal cord set by spirit level
as a hanging guide. For variety,
use end facing walls for large
bold 'points of emphasis', and
enclosed areas to show smaller
prints in a contrasting
environment

A dark-toned surround tends to emphasise your print's lighter contents,
and any shapes formed where pale objects are cut by picture edges
stand out. A white surround has the opposite effect. As a general guide,
have slightly more space below the picture than you leave surrounding
it on the other three sides. And remember that wide areas surrounding
a relatively small print tend to make it look smaller (and more intimate)
still.

With any exhibition or display area, the size and tone density of your
pictures, and the form of presentation, should ideally be related to the
physical conditions in which they will be seen. The intensity and
evenness of the lighting is one factor. The height and layout of display
walls is another: corners offer natural breaks in a sequence and alcoves
intimate enclaves, whereas a long unbroken surface and tall ceiling suit
a run of large prints. Think too of likely spectator viewing distance
relative to the perspective of your major pictures (page 80).

An exhibition should contain variety – carefully considered 'high-
points' created through juxtaposition of picture content, size and
proportions. You need a thread of continuity, too, without lapsing into
dull uniformity. Much can be done here by maintaining consistent
image colour, mat tint and style of frame, and ensuring that they also
relate well to the tone and texture of the exhibition display surfaces.

Summary: Afterwork and presentation

● Use dilute Farmer's reducer to lighten print density and brighten
highlights. Halt its effect at any point with water. Stronger-acting iodine
bleach will remove chosen image parts altogether. Follow both by re-
fixing and washing.
● For limited-area chemical treatment, first paint a resist over the
image parts you want to protect. Or work up to subject shapes, applying
solution by brush on the blotted, barely damp print.
● Toning chemically changes the image colour. Use it for colourful
effects; to enrich print tone values; increase permanence (selenium or
gold toning); or (sepia) as a preliminary to hand tinting. Some toners
reduce image permanence.

● Toners may work as single solutions. Others require the print to be bleached, then toned during a redevelopment stage. Yet others use bleaching and dye-coupled development (wide choice of couplers), followed by optional silver bleach.

● Prints can be toned (a) overall, (b) selected area, or (c) according to image density values ('split' toning).

● Tinting, by applying water or oil colours, allows total control of colouring and is often best used subjectively. Work from largest to smallest areas. Graduated tone or colour is effectively applied by airbrushing, provided you have mastered the necessary skill.

● Mount your prints by dry-mounting; sandwiching behind a window mat; use of self-adhesive sheet or tape; or (giant prints) a wallpaper liquid adhesive.

● Mounted prints can be trimmed flush without borders, left with white print or mount borders, or window-matted.

● Retouch white spots using dye or water colour on a fine brush, gradually blending in with surrounding tone.

● Choose a style of presentation appropriate to subject and viewing conditions. Avoid reflections, and any transparent print-covering which dilutes richness of tones. Underplay coloured mounts or mats. Display prints with due regard to variety and continuity. Fully exploit the physical layout of an exhibition to create natural breaks, give points of emphasis.

Projects

1. Make two suitable prints of a landscape or cityscape, identical in size. Use a dye-coupled toner kit to multi-colour tone one of these prints. Tone different areas – sky, vegetation, buildings, etc. – separately, and allow some parts to remain black and white. For each colour, work either by applying bleacher carefully only to the part being toned, or by coating all the rest of the print with resist. The other print should be selectively sepia-toned and hand-tinted with water colours, working to a similar colour scheme. Compare.

2. Make a 'model' of a scene, using cut-out images like scenery in a 3D theatrical stage set. If possible, work from a subject such as a room interior, still-life or group of people, where the camera can remain set up in a fixed position and a series of pictures taken – first with all elements shown; next after foreground items are removed; then with middle distance items removed so only background is shown. Keep the enlarger at one setting and print appropriate negatives so you have unobstructed, self-scaled images of near, mid and distant detail. Mount all these prints, and cut around the shapes of mid-distance and close elements so they can stand up in front of the background print.

3. Shoot a panorama, or a 'joiner'. For the panorama shoot from one position with a normal or long focal length lens, panning the camera between shots. The subject content of each frame should overlap that of the next by at least 30 per cent. A joiner (Figure 14.10) can be more loosely structured, varying viewpoint slightly to give more an impression than a record. Make a series of prints matched in tone and size, and mount to give one composite picture.

4. Photograph a full-length figure against a plain white background. Make a series of at least six enlargements from the negative on single-weight paper, each one 10 per cent smaller than the next. Make your larger prints progressively darker than smaller ones. Cut out and mount the figures on a suitable background print, so they appear as a line of people tapering into the distance. Retouch any obvious edges. Copy the result to give a black and white slide or a (reduced size) print.

Appendices

A: Optical calculations

Pinholes. The best size pinhole for forming images has to be a compromise. It must be small enough to form quite tiny circles of confusion, so that as much subject detail as possible can be resolved. But the smaller the hole the more diffraction (page 29) increases, so that eventually detail no longer improves and rapidly becomes worse.

$$\text{Optimum pinhole diameter} = \frac{\sqrt{\text{distance from film}}}{25}$$

Thus for a pinhole placed 50 mm from the film, best diameter is $\sqrt{50} \div 25 = 0.3$ mm. To make the pinhole, flatten a piece of thin metallic kitchen foil on a pad of paper. Pierce the foil gently with *the tip* of a dress-maker's pin. Check with a magnifying glass that the hole is a true circle and free of ragged edges. By placing the millimetre scale of a ruler next to the hole and examining both through the magnifier it is easy to measure diameters down to about 0.2 mm.

In the example above the relative aperture is $f/150$. However, a modern SLR camera set to aperture priority (Av) mode should be sufficiently sensitive to measure exposure from the image itself. You may need to adjust your film's ISO setting to compensate for long exposure reciprocity failure. see page 161.

Image size, object and image distances from lens
Codings:

F = focal length
M = magnification
I = image height
O = object height (neg height when enlarging)
V = lens to image distance*
U = lens to object distance* (to neg or slide when enlarging or projecting)

*See warning note, right.

Magnification formulae:

M = I divided by O
M = V divided by U
M = V divided by F, minus one
I = O multiplied by M
O = I divided by M

Object/image distance formulae:

V = M plus one, multiplied by F
U = one divided by M, plus one, multiplied by F
V = F multiplied by U, divided by U minus F

Close-up exposure increase when not using TTL metering:

Actual exposure required = exposure read by meter multiplied by E

where E = M plus one, squared
or E = V squared, divided by F squared

***Warning note on telephoto and inverted-telephoto lens designs**. The above formulae are sufficiently accurate for most large-format camera lenses, enlarging lenses, and normal focal length lenses for rollfilm and 35 mm cameras. However, expect some discrepancy if using any formula containing V or U for lenses of either telephoto or inverted-telephoto construction. As Figure 5.12 shows, the principal planes of such lenses – strictly the measurement points for object and image distances – are often some distance from the front or rear lens elements. It is therefore difficult to know from where to make simple measurements with a ruler alongside the lens. In these circumstances you can still calculate close-up exposure increase accurately provided a formula is used based on M rather than V or U. Measure M by comparing object and image sizes; often in the studio this can be done by laying a ruler across the object and checking its size on the camera focusing screen.

B: Chemical formulae

Most proprietary forms of developer (Acuspeed, Rodinal, etc.) do not have published formulae. They are only sold as ready-mixed concentrated solutions or occasionally as powders. However, the table at the foot of this page gives some well-established developers you can prepare yourself at relatively low cost, from bulk chemicals.

Many of the other formulae in this appendix have a long history but are still listed because they remain of practical value, although not available in a ready-prepared form. The component chemicals you need are stocked by a few suppliers in major cities (in London for example by Silverprint and by Champion Photochemicals). Chemicals marked * should be handled with special care. Be sure to read over the appropriate advice in Appendix E before you begin.

Preparing solutions from bulk chemicals. First weigh out all the dry chemicals listed in your formula, using clean paper on the scales for each one. The quantities shown in formulae below are in metric units (for conversion see Appendix C), and relate to dry chemical in anhydrous or crystalline form.

Start with about three-quarters of the final volume of water, and fairly hot (typically 50°C). Tap water is satisfactory unless distilled water is specified. Always dissolve chemicals one at a time, in the order given. Tip powder gradually into the water, stirring continuously. Wait until as much as possible has been dissolved into solution before starting to add the next chemical. Measure and pour in liquid chemicals in the same way, taking special care over strong acids; see notes on safety. Finally add cold water to make up the full amount and if possible leave the solution some hours to further dissolve and cool to room temperature. If your formula contains metol and sodium sulphite it is best to dissolve a pinch of weighed-out sulphite first – to help prevent the metol oxidising (turning yellowish brown) during mixing. Then dissolve the remaining sodium sulphite after the metol, as listed in the formula.

Alternative forms of chemical. Many photographic chemicals come in anhydrous form (also known as 'desiccated'). Weight for weight this is much more concentrated than the same chemical in crystalline form. A few chemicals are marketed in 'monohydrate' (H_2O) form, which in terms of concentration falls between the other two. When a formula quotes the weight for one form of the chemical and you can only obtain it in another, make adjustments by the amounts shown in the table below.

Substitutions

Chemical:	When formula quotes weight for:	And the only available form is:	Multiply weight by:
Sodium carbonate	Anhydrous or desiccated	Monohydrate or H_2O	1.2
Sodium carbonate	Anhydrous or desiccated	Crystalline or decahydrate	2.7
Sodium sulphite	Anhydrous or desiccated	Crystalline/heptahydrate($7H_2O$)	2
Sodium thiosulphate	Crystalline/pentahydrate	Anhydrous/desiccated	0.6
Sodium thiosulphate	Anhydrous/desiccated	Crystalline/pentahydrate	1.7
Borax	Crystalline/decahydrate	$5H_2O$	0.8

Developers (all weights of solids in grams)

Chemical	Gen-purpose fine-grain		Soft-working D23	Contrasty D19	Line D11	Prints D72	Vari-contrast (Beers)		Function*
	D76/ID 11	DK50					A	B	
Metol ('Elon') cryst	2	2.5	7.5	2	1	3	8		Dev agent, soft-working
Sod sulphite anhyd	100	30	100	90	75	45	23	23	Preservative
Hydroquinone cryst	5	2.5		8	9	12		8	Dev agent, contrasty
★Pot/sod hydroxide		1.5							Extreme alkali
Sod carbonate anhyd				45	25.5	67.5			Alkali or accelerator
Pot carbonate anhyd							20	27	Alkali or accelerator
Borax cryst	2	7							Alkali or accelerator
Pot bromide cryst		0.5		5	5	2	1.1	2.2	Restrainer
Make up to	1 litre	1 litre	1 litre	1 litre	1 litre	1 litre	1 litre	1 litre	
Working sol, if different from above (stock + water)	1 + 1	1 + 1				1 +2	See chart, facing page		
†Typical dev time (min) at 20°C(68oF)	7–12	4–7	5–9	5–14	4	$\frac{3}{4}$-2	2-2$\frac{1}{2}$		

*For terms see Glossary †Times apply to formulae here but may differ from pre-packed versions.

Lith developer AN-79b

	Sol A	Sol B
Sod sulphite anhyd	1	120
Paraformaldehyde	30	
Pot metabisulphite	10.5	
Boric acid cryst		30
Hydroquinone cryst		90
Pot bromide cryst		6
Make up to	1 litre	3 litre
Working solution		1 part A + 3 parts B
Typical dev time (20°C)		2 mins

Beers print developer: proportions and contrast

	Lowest						Highest
Sol A	8	7	6	5	4	3	2
Sol B	0	1	2	3	4	5	14
+ Water	8	8	8	8	8	8	0

Hypo eliminator HE-I (not recommended for film)

Water	500 ml
★ Hydrogen peroxide (3%)	125 ml
★ Ammonia (3% solution*)	100 ml
Water up to	1 litre
Treatment time about 6 minutes	

* for 3% solution add 2 parts ammonia 28% solution to 9 parts of water.

Stop baths

	SB-5 (for films)	SB-1 a (for lith)	SB-1 (for paper)
Water	500 ml	500 ml	750 ml
★ Acetic acid (80%)	11 ml	44 ml	17 ml
★ or Acetic acid (glacial)	9 ml	35 ml	13.5 ml
Sod sulphite anhyd	45 g		
Water up to	1 litre	1 litre	1 litre
Treat for	30 seconds	10 seconds	5–10 seconds

Some bromocresol purple can be added to SB-1 to form an indicator stop bath The solution then appears yellow when fresh, turns orange in use, and becomes purple when the stop bath is exhausted and must be replaced.

Fixers

	F-24 Non-hardening*	F-5 Hardening acid fix	F-7 Rapid hardening acid fix[†]	Function
Water (at about 50°C)	600 ml	600 ml	600 ml	
Sod thiosulphate (hypo) cryst	240 g	240 g	360 g	Fixing agent
Ammonium chloride			50 g	
Sod sulphite anhyd	10 g	15 g	15 g	Acidifying components
Sod metabisulphite	25 g			
★ Acetic acid (80% sol)		17 ml	17 ml	
Boric acid cryst		7.5 g	7.5 g	pH buffer
Pot alum			15 g	Hardener
Water up to	1 litre	1 litre	1 litre	

*As required when selenium toning etc.
†Prolonged fixing time may bleach image

Residual fixer test HT-2

Water	350 ml
★ Acetic acid (80% sol)	22 ml
★ Silver nitrate cryst	3.75 g
Water to	500 ml

Store solution away from light, in a labelled brown screw-top bottle. To test a washed print or film, cut off a small strip of rebate and wipe off surface water. Place a drop of HT-2 on the emulsion surface and allow it to stand for 2–3 minutes. Rinse off. There should be little or no staining. Prints can be compared with a Kodak hypo estimator colour chart.

Negative intensifier: chromium IN-4

Bleacher stock solution:

Water	500 ml
★ Potassium dichromate	90 g
★ Hydrochloric acid (conc)	64 ml
Water to	1 litre
Use 1 + 10 parts water	

Film, which should be hardened, is bleached until yellow-buff right through, washed 5 minutes, then darkened in a regular print developer. Rinse, fix and finally wash 5 minutes. Can be repeated for greater effect.

Sulphide toner T-7a (sepia)

Bleacher working solution (reusable):

Water	700 ml
Potassium ferricyanide	50 g
Potassium bromide	50 g
Water to	1 litre

Toner stock solution:

Water	300 ml
Sodium sulphide anhyd	50 g
Water to	500 ml
Dilute stock 1 + 9 parts water for use	

Fully bleach the black image to pale straw colour (about 5 minutes). Then rinse 1 minute, and tone for 4–5 minutes. Finally wash thoroughly, separately from other prints.

Hypo alum toner IT-2 (purplish-sepia)

Hot water	750 ml
Sodium thiosulphate cryst	150 g
When dissolved add (a little at a time):	
Potassium alum cryst	25 g
Water up to	1 litre
Then add this solution:	
Water	20 ml
★ Silver nitrate cryst	0.14 g
★ Just sufficient drops of strong ammonia to dissolve the milky precipitate.	

Prints tone in about 10 minutes at 50°C. Finally wash well, and swab. Instead of the silver nitrate solution you can 'ripen' the toner (minimise its reducing effect) by immersing several waste prints first .

Blue toner IT-6

Sol A	Water	700 ml
	★ Sulphuric acid (conc)	4 ml
	Potassium ferricyanide cryst	2 g
	Water up to	1 litre
Sol B	Water	700 ml
	★ Sulphuric acid (conc)	4 ml
	Ferric ammonium citrate	2 g
	Water up to	1 litre

Use one part A plus one part B. This toner has an intensifying action, so start with a *pale* black and white print. Immerse prints until the required tone is reached, then wash gently until the whites no longer have a yellow stain. Over-washing begins to bleach the blue – this is reduced by adding salt to the wash water

Copper toner (red)

Sol A	Water	700 ml
	Copper sulphate cyst	25 g
	Potassium citrate	110g
	Water up to	1 litre
Sol B	Water	700 ml
	Potassium ferricyanide	20 g
	Potassium citrate	110 g
	Water up to	1 litre

Use one part A plus one part B. Results range from warm black to purplish-red, depending on length of immersion

Gold toner GP-I (blue-black or red) For red tones, sepia tone the print first.

Water	700 ml
Gold chloride, 1% stock solution*	10 ml
Sodium thiocyanate	10 g
Water up to	1 litre

Make up just before use. Treat for 10 minutes, then wash 10 minutes. *1 g of sodium chloro-aurate in 100 ml water.

Bleachers
Farmer's reducer R-4a

Sol A	Water	250 ml
	Potassium ferricyanide	37.5 g
	Water up to	500 ml
Sol B	Warm water	1 litre
	Sodium thiosulphate cryst	480 g
	Water up to	2 litres

Mix one part A, plus 8 parts B, and 50 parts water, just before use. For faster reduction of density, double the quantity of solution A.

Iodine IR-4
Recommended for locally bleaching out the print image completely, leaving white paper.

Warm water	750 ml
Potassium iodide	16 g
★ Iodine	4g
Water up to	1 litre

Keeps well. For bleach-out, apply neat with brush or cottonwool to the damp (blotted) print. Finally rinse and treat in a small quantity of regular print fixing bath (5–10 minutes) to completely remove deep brown stain. Discard this fixer. Wash fully.

Dichromate bleacher R-21A (updated R-21)
As required for black and white reversal processing (page 230).

Sol I	Water	500 ml
	★ Potassium dichromate	50 g
	Cold water up to	1 litre
	★ Sulphuric acid (conc)	50 ml
	Time 3–5 minutes	

To clear resulting stains, wash 2–5 minutes, then place film in:

Sol 11	Water	500 ml
	Sodium sulphite, anhyd	50 g
	★ Sodium hydroxide	1 g
	Water up to	1 litre
	Time 2 minutes	

Bleacher for coloured-base bromide papers (page 270)

Sol A	Water	600 ml
	Cupric chloride	48 g
	★ Acetic acid (glacial)	220 ml
	Water to	1 litre
Sol B	★ Hydrogen peroxide in '20 volumes' form	

Use equal parts of A + B. Immerse prints for 2–3 minutes, then (wearing rubber gloves) rub the emulsion surface to remove the black silver and coloured dye from image areas. Works with fluorescent but not metallic coloured papers.

C: Conversions: metric, UK and US units

Use the information below in conjunction with a pocket calculator.

To convert length and area

Millimetres to inches	Multiply mm by 0.039
Metres to feet	Multiply metres by 3.28
Inches to millimetres	Multiply inches by 25.4
Feet to metres	Multiply feet by 0.305
Sq centimetres to sq inches	Multiply by 0.155
Sq inches to sq centimetres	Multiply by 6.45
Sq metres to sq feet	Multiply by 10.76
Sq feet to sq metres	Multiply by 0.093

To convert volume and weight

Millilitres to UK fl oz	Multiply by 0.035
Millilitres to US fl oz	Multiply by 0.034
UK fl oz to millilitres	Multiply by 28.4
US fl oz to millilitres	Multiply by 29.6
US fl oz to UK fl oz	Multiply by 1.04
Litres to UK fl oz	Multiply by 35
Litres to UK gallons	Multiply by 0.22
Litres to US gallons	Multiply by 0.264
UK gallons to litres	Multiply by 4.55
US gallons to litres	Multiply by 3.79
US gallons to UK gallons	Multiply by 0.833
Grams to ounces	Multiply by 0.035
Ounces to grams	Multiply by 28.35
Kilograms to pounds	Multiply by 2.20
Pounds to kilograms	Multiply by 0.454

To convert temperature:

°Celsius into °Fahrenheit:	Multiply by 1.8 then add 32
°Fahrenheit into °Celsius:	Subtract 32 then multiply by 0.56

D: Basic sensitometry

Sensitometry is concerned with finding out how photographic materials respond to exposure and to processing. Response is normally plotted on a performance graph which produces a curved line called a 'characteristic curve' for the material. Characteristic curves are often published by manufacturers as part of the technical data for each product, especially films.

Understanding what different curve shapes mean allows you to quickly compare one material with another, in terms, of contrast, speed, tolerance of over- and underexposure, and so on.

Producing the graph

Typically, to produce the characteristic curve of a black and white film (Figure D.1) the material is first given a series of tightly controlled 'light dosages'. This is done in an instrument called a sensitometer, which exposes the emulsion to a series of light intensities a small patch at a time, giving the same short exposure for each. This is rather like exposing an image in the camera, except that (a) it gives a much wider range of intensities (over 100 000:1) than you are likely to find in any one actual scene. Also (b) the amount each separate patch or step differs in exposure from the preceding one is an exact regular factor, normally 2.

The exposed sample film is next developed under strictly controlled conditions. The processed result is a series of tone patches, from clear film to something quite dark. The exact darkness of these results is measured with a densitometer instrument, which reads out the values as *density* figures. (Density is the \log_{10} of *opacity*, which is incident light divided by light transmitted by the film. When half the incident light passes through the sample opacity is 2.0 and the density reading is 0.3).

'Input' (exposure to light) can now be plotted against 'output' (the resulting series of density readings). To prepare a characteristic curve graph, the vertical axis is scaled in density values. See Figure D.1. The horizontal axis is scaled in log exposure (or relative log exposure) values. The use of a \log_{10} scale here is to avoid an otherwise unmanageably long range of figures; the axis also becomes compatible with the \log_{10} sequence for density. An increase of 0.3 on the log E axis means doubling of exposure.

A densitometer linked to a computer plots density figures against each exposure given to the test film. It reads out a graph which is not a straight line, but escalator-shaped.

Significance of curve shape

Most characteristic curves can be divided into three distinct regions: the toe; the straight-line portion; and the shoulder. Remember that both density and exposure axes cover a very wide range of conditions for maximum information. In practice most actual *images* you expose on film are unlikely to have a brightness range much beyond 100:1, which spans just 2.0 on the log E axis. See Figure 10.4. This means that, like selecting a group of notes from a long piano keyboard, you have *options*. You might underexpose your image so that it wholly falls on the lowest part of the curve, where there are least resulting densities. Or by giving it greater exposure, the image can correspond to values wholly within the straight-line portion. Again, by overexposing, you might make use of the curve shoulder, which produces the heavier densities.

So the characteristic curve of a material is its total performance graph under given processing. And the part that relates to a particular shot depends on your image

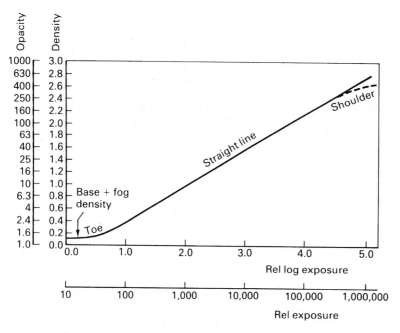

Figure D.1

brightness range (a low-contrast scene spans a much shorter length of the log E axis than one that is very contrasty), and whether you under-, over- or correctly expose it.

The toe. The very bottom of the characteristic curve becomes a horizontal straight line. Here the film has received too little light to respond at all. The very slight density value present is due to the film base itself, plus normal fog density. As log E values increase the graph begins to rise gently, meaning that density values are increasing too. However, the image tones are very compressed – shadow parts of the subject are still difficult to pick out (any density less than about 0.1 above fog usually prints indistinguishably from black).

Gradually, with more exposure, the upper region of the toe merges into the straight line. The actual length of the toe varies with different films – for example it is longer with Tri-X than Plus-X.

The straight line. In the straight-line part of the graph image tones are still compressed as the material translates them into negative densities, but now the log exposure/density relationship is more constant: *tones are compressed evenly.* You might assume from this that getting your image to fall entirely on the straight-line portion would be the most 'correct' exposure. However, to maximise film speed, and to avoid image highlights becoming so dense that sharpness suffers and graininess is increased, 'correct exposure' is regarded as using the *upper* part of the toe plus only as much as is necessary of the *lower* part of the straight line. See Figure 10.4.

Figure D.2

Printing paper characteristics are designed to suit negatives exposed in this way, and reproduce mid-tones to shadows with contrast slightly greater than mid-tones to highlights. Curves: Figure 12.16.

The steepness of the film's straight-line portion also shows you what contrast to expect. A steep line as in Figure D.3 indicates that the particular combination of emulsion and development gives a much more contrasty negative (for the same brightness-range image) than material with a lower pitched slope, Figure D.2.

The shoulder. At the top of the characteristic curve the graph begins to flatten out again. Increasing exposure now gives less and less increase in density. The material is approaching its maximum black under these development conditions. Finally it becomes a horizontal line again.

With most films the shoulder is never reached in practical picture making because of the poor image quality produced, as mentioned above. In fact the shoulder of the curve is often not included in data published for general-purpose films because of its unimportance.

Theory into practice

Exposure meters are so calibrated that a single overall (or centre-weighted) reading, which is assumed equivalent to a mid-grey in the scene, is 'placed' on the average film's characteristic curve at about the lowest part of the straight-line portion. Given an 'average' 100:1 range camera image this means that shadows will fall on the toe, but not beyond the lowest useful part. Highlights fall further up the straight-line portion, but nowhere near the definition-destroying upper part or shoulder. You can see from this that a lot of assumptions have to be made.

For tighter control it is better to use a spot or local reading, provided you know what you are doing. This way you can choose your own mid-tone in the scene to place on the curve. Or by using a camera with a 'shadow' spot-reading mode you can read your scene's darkest *important* shadow and the meter will ensure this is pinned at a final negative density of about 0.2.

On the other hand, highlight quality in a scene may be of critical importance. By using spot reading in 'hi-light' mode the camera pins your chosen highlight at a point on the straight line which ensures that unacceptable heavy density is avoided.

By taking two spot readings – darkest important shadow, brightest important highlight – you measure your image contrast range. If this greatly exceeds the 'average' it will also remind you that for better results you might well slightly overexpose and underdevelop. The development change will reduce the slope of the whole characteristic curve and so avoid an excessively contrasty negative. The reverse is true if your two camera readings show the image is much flatter than average. See Figure 11.19. Of course, this kind of adjustment is more difficult if you have a whole mixture of subjects exposed on one film. A magazine-type camera back is then especially useful: you can expose all your most contrasty subjects on the same film, earmarking this for reduced development.

Figure D.3

E: Health and safety concerns

Preparation and use of chemicals. Most common chemicals used in photography are no more dangerous to handle than chemicals – cleaners, insect repellents, adhesives – used every day around the home. However, several of the more special-purpose photographic solutions such as bleachers, toners and intensifiers do contain acids or irritant chemicals which must be handled with care. (These are listed in Figure 11.4 and also picked out in the formulae given in Appendix B).

Your response to direct contact with chemicals may vary from finger staining to direct irritation such as inflammation and itching of hand or eyes, or a skin burning or general allergic reaction which may not appear until several days later. A small minority of photographers are particularly sensitive to chemicals present in developers. Metol, also known as Rhodol or Elon, can be troublesome to such people. Changing to a developer of different make-up such as those containing Phenidone instead of Metol (i.e. PQ developers) may solve the problem.

The following guidelines apply to all photographic chemical processes:

● *Avoid direct skin contact with all chemicals*, especially liquid concentrates or dry powders. Do this by wearing thin plastic (disposable) gloves, and using print tongs when lifting or manipulating prints during processes in trays, page 244.
● *Avoid breathing-in chemical dust or fumes.* When weighing or dissolving dry powders work in a well-ventilated (but not draughty) area. Don't lean over what you are doing, and if possible wear a respiratory mask (the fabric type is used by bikers are inexpensive).
● *Be careful about your eyes.* When mixing up chemicals wear eyeshields, preferably the kind you can wear over existing spectacles. (Remember not to rub an eye with a chemically contaminated gloved hand during processing.) If you do splash or rub an irritant into your eye wash it with plenty of warm water immediately – it is always advisable to have a bottle of eye-wash somewhere close to where you are working.
● *Keep things clean.* Liquid chemical splashes left to dry out turn into powder which you can breathe in or get on your hands or clothes, as well as damaging films and equipment. Similarly don't leave rejected test prints, saturated in chemical, to dry out in an open waste bin close to where you are working. To prevent chemicals getting onto your clothes – wear a PVC or disposable polythene-type apron.
● *Labels are important.* Carefully read the warnings and procedure the chemical manufacturer has printed on the label or packaging, especially if you have not previously used this product. Clearly label the storage containers for chemicals and stock solutions you have made up yourself. Never, ever, leave photographic chemicals in a bottle or container still carrying a food or drink label. Conversely don't put food in empty chemical containers.
● *Keep chemicals and food and drink well separated.* Even when properly labelled keep all your chemicals well out of the reach of children – and never store them in or near the larder. Avoid eating in the darkroom or processing in the kitchen where food is prepared.
● *Chemical procedure.* Where a formula contains an acid which you must dilute from a concentrated stock solution, always slowly add the acid to the water (adding water to acid may cause splattering). Don't tip one tray of chemical solution into another of a different kind, as when clearing up – cross-reaction can produce toxic fumes.
● *Spray adhesives.* Take special care to ensure ample ventilation when working with aerosol sprays of this kind. Their contents could cause nerve damage if you subject yourself to prolonged exposure in a confined space when mounting or montaging prints this way.

Electrical hazards
Many of the safety precautions you need to take are also common to domestic and simple workshop situations. For example:
● *Circuit protection.* Make sure that all your equipment – enlarger, lamps, heaters – are effectively earthed ('grounded') via three-core cable. Plugs should contain fuses which are appropriate to the equipment they serve. This is more than a question of not drawing more power than the fuse will handle, page 123. A 13 amp fuse for instance is quite suitable for equipment drawing 10 amps, but used with something taking 4 amps only you are under-protected – before this fuse burns out the cabling could heat up considerably. A circuit-breaker at the mains fuse box in a good protective measure for the whole system. When lighting subjects at locations you have not used before check that the circuit is sufficiently powerful and in good condition to supply your gear. (To light a large area it may be best to hire a generator).
● *Cables.* Check all your equipment cables regularly for signs of cracked or worn installation, or loose connections. Don't roll lighting stands over cables on the floor. Never pull out a plug by means of tugging on its cable. Don't power a lighting unit through a long cable still coiled on a drum – electricity can heat the coiled-up cable until it starts smouldering. Make sure your main cable is of a suitable gauge to carry all the power you need – will not heat up due to overloading, especially when it feeds several pieces of equipment through adaptors or splitter boxes. Avoid cable runs which come into contact with moisture (condensation as well as water) unless fully protected in a waterproof sheath. Damp grass, wet bench areas of darkrooms, bathrooms and saunas are all hazardous.
● *Electronic flash.* Studio equipment and even small, handflash units should not be opened to make your own repairs – residual charge held in internal power-storage components may give you an electric shock.

Glossary

accelerator Chemical ingredient of developer to speed up the otherwise slow activity of developing agents. Normally an alkali such as sodium carbonate. borax, or (high:contrast developers) sodium hydroxide. Also known as 'activator' or alkali component'.

acid Chemical substances with pH below 7. Because acid neutralises an alkali, acidic solutions are often used to halt development – as in stop bath or fixer.

adaptor ring Narrow threaded ring which fits the front rim of a lens to allow use of accessories of a different ('step-up' or 'step-down') diameter.

AE Automatic exposure metering.

aerial perspective Sense of depth conveyed by changes of tone with distance. Typically seen in a rolling landscape when atmospheric haze present.

AF Autofocus.

alkali Chemical substances with pH above 7. Solution feels slippery to the touch, can neutralise acid. *See also* accelerator.

ambient light General term covering existing subject lighting, i.e. not specially provided by the photographer.

angle of view Angle, formed at the lens, between lines from the extreme limits of a (distant) scene just imaged within the diagonal of the picture format. Varies with focal length and format size.

anhydrous (anhyd) Dehydrated form of a chemical. More concentrated than same substance in crystalline form.

ANSI American National Standards Institute. Present title of organisation once called American Standards Association. *See ASA.*

anti-halation Light-absorbing dye present in film to prevent reflection or spread of light giving 'halos' around bright highlights. Disappears during processing.

aperture Circular opening within the lens. Usually variable in diameter. and controlled by a diaphragm calibrated in *f*-numbers.

aperture preview SLR camera control to close lens diaphragm to the actual setting used when exposing. For previewing depth of field.

APS Advanced Photographic System. System of easy-load cameras and film cartridges about 30% smaller than 35 mm, planned and introduced (1996) by a consortium of manufacturers – Canon, Fuji, Kodak, Minolta and Nikon.

archival processing Procedures during processing aiming for the most stable image possible.

artificial light General term for any man-made light source. Artificial-light film, however, normally refers to tungsten illumination of 3200 K.

ASA American Standards Association, responsible for ASA system of speed rating. Doubling the ASA number denotes twice the light sensitivity. Now replaced by *ISO*.

autofocus System by which lens automatically focuses the image (for a chosen area of subject).

Av Aperture value. Auto-exposure camera metering mode. You choose the aperture, the meter sets the shutter speed. (Also known as aperture priority system.)

B setting *See bulb.*

bag bellows Short, baggy form of bellows used on view cameras for wide-angle lens. Allows camera movements otherwise restricted by standard lens bellows.

ball and socket Swivelling ball joint between camera and tripod, monopod, etc. Camera may be angled and clamped.

barndoors Set of folding metal flaps fitted around front of spotlight. Controls light spill or limits beam.

baryta papers *See fibre-based paper.*

baseboard camera Camera with fold-open baseboard, which supports lens and bellows.

bellows Concertina light-tight sleeve used on some cameras and enlargers between lens and film to allow extensive focus adjustment.

between-lens shutter Bladed (or 'leaf') shutter positioned between elements of a lens, close to aperture.

bleacher Chemical able to erase or reduce image density.

blue-sensitive Emulsion sensitive to the blue region only of the visible spectrum. Also known as 'ordinary'.

bounce General term for lighting reflected off a surface (normally diffuse) before reaching the subject.

bracket In exposure, to take several versions of a shot giving different exposure levels.

brightness range *See subject brightness range.*

bromide paper Printing paper with predominantly silver-bromide emulsion.

buffer Chemical substance(s) used to maintain the pH (acidity or alkalinity), and therefore the activity, of a solution such as developer or fixer. Helps counteract restraining effect of bromine acquired from emulsions during processing, or the 'stopping' action of an acid stop in fixing solution.

bulb Also 'brief'. The B setting on a shutter – keeps the shutter open for as long as the release remains pressed.

bulk film Film sold in long lengths, usually in cans.

burning-in *See printing-in.*

C-41 process Processing procedure used for the vast majority of colour (and monochrome chromogenic) negative films.

cable release Flexible cable which screws into camera shutter release. Allows shutter to be fired (or held open on 'B') with minimal shake.

capacitor Unit for storing and subsequently releasing a pulse of electricity.

cassette Light-proof metal or plastic film container with light-tight entry slot. Permits camera loading in normal lighting.

cast Overall bias towards one colour.

CCD Charge-coupled device. Electronic light-sensitive surface, e.g. used in AF systems to detect image sharpness. Probable future substitute for film.

CdS Cadmium disulphide. Battery-powered light sensor cell, widely used in exposure hand meters.

characteristic curve Graph relating exposure to resulting image density, under given development conditions. See page 294. Also known as H and D curve.

chlorobromide paper Warm-tone printing paper. Uses emulsion containing silver chloride and silver bromide.

chromogenic film Films which form a final *dye* image rather than one of *silver*, when given appropriate dye-coupled processing (C-41 or E-6 for example). Also applies to monochrome film designed to be processed with standard colour film chemistry.

CI *See contrast index.*

CIE Commission Internationale de l'Eclairage. Originator of a standard system for precise description of colours.

circles of confusion Discs of light making up the image formed by a lens, from each point of light in the subject. The smaller these discs the sharper the image.

clearing time The time taken in a fixing bath for a film emulsion to lose its milky appearance.

click stops Aperture settings which you can set by physical 'feel' as well as by following a printed scale.

close-up lens Additional element added to the main lens, to focus close objects.

coating Transparent material deposited on lens glass to suppress surface reflections, improve image contrast.

cold-light enlarger Enlarger using a fluorescent tube grid. Gives extremely diffused illumination.

colour balance (of film) The type and colour temperature of subject lighting under which a colour film is designed to record colours accurately. Typically expressed as daylight balance (5,500°K) or tungsten light balance (3,200°K).

colour head An enlarger lamp head with a colour printing filter system built-in.

colour temperature Way of defining the colour of a (continuous spectrum) light source, in kelvins. Equals the temperature, Absolute scale, at which a metal black body radiator would match the source in colour.

complementary colours Resulting colour (cyan, magenta or yellow) when one of the three primary colours (red green or blue) is subtracted from white light. Also called 'subtractive primaries', 'secondary colours'.

condenser Simple lens system to concentrate and direct light from a source, e.g. in a spotlight or enlarger.

contact print Print exposed in direct contact with negative therefore matching it in size.

contrast The difference between extremes – of lighting, of negative or print tone values, of subject reflectance range, etc. The greater the difference between extremes present together the higher the contrast.

contrast index A numerical index relating image brightness range to resulting processed density range when 'correctly exposed' on the film's characteristic curve. Therefore relates to development, and contrast. (Most general-purpose negatives to be printed on diffuser enlargers are developed to a CI of 0.56.)

conversion filter Colour filter used to compensate for differences between the colour temperature of the light source and the colour balance of the film, where the two differ.

convertor lens Multi-element lens unit specially designed to (typically) double the focal length of each of a given range of long focal length camera lenses. Fits between prime lens and camera body.

covering power The area of image of useful quality that a lens will produce. Must exceed camera picture format, generously so if movements are to be used.

CPU Central processing unit. Solid-state electronic chip housed within camera. Used to compute exposure, focusing, etc., from data input by other electronic components.

cropping To trim one or more edges of an image, usually to improve composition.

cross front Camera movement. Sideways shift of lens, parallel to film plane.

cut-off Term describing the blocking-off of image light ('vignetting') usually at one or more corners of the picture format.

D log E curve *See characteristic curve.*

D max Maximum density.

D min Minimum density.

darkslide Removable plastic or metal sheet fronting a sheet-film holder or film magazine.

daylight film Colour film balanced for subject lighting of 5500 K.

dedicated flash Flash unit which fully integrates with camera electronics. Sets shutter speed; detects film speed, aperture, light reading, subject distance, etc.

dense Dark or 'thick', e.g. a negative or slide which transmits little light. Opposite to 'thin'.

densitometer Electro-optical instrument for reading the densities of a film or paper image.

density Numerical value for the darkness of a tone. The log (base 10) of *opacity.*

depth of field Distance between nearest and furthest parts of a subject which can be imaged in acceptably sharp focus at one setting of the lens.

depth of focus Distance the film (or printing paper) can be positioned either side of true focus whilst maintaining an acceptably sharp image, without refocusing the lens.

developing agent Chemical ingredient(s) of a developer with the primary function of reducing light-struck silver halides to black metallic silver.

diaphragm Aperture formed by an overlapping series of blades. Allows continuous adjustment of diameter.

diffraction Change in the path of light rays when they pass close to an opaque edge. The cause of poorer image quality if a lens is used with an extremely small size aperture.

digital image An image defined by a stream of digitalised electronic data, typically made visible by display on a computer monitor screen.

DIN Deutsche Industrie Normen. German-based system of film speed rating, much used in Europe. An increase of 3 DIN denotes twice the light sensitivity. Now replaced by *ISO.*

dodging *See shading.*

dry mounting Bonding a photograph to a mount by placing dry, heat-sensitive tissue between the two and applying pressure and heat.

drying mark Uneven patch(es) of density on film emulsion, due to uneven drying. Cannot be rubbed off.

DX coding Direct electronic detection of film characteristics (speed, number of exposures etc.) via sensors in camera's film-loading compartment.

dye-image film *See chromogenic film.*

E-6 process Colour reversal processing procedure in widespread international use for most forms of colour slide/transparency film.

easel *See masking frame.*

edge numbers Frame number, film type information, etc., printed by light along film edges.

effective diameter (of lens aperture) Diameter of light beam entering lens which fills the diaphragm opening.

electronic flash General term for common flash units which create light by electronic discharge through gas-filled tube.

emulsion Mix of light-sensitive silver halides, plus additives, and gelatin.

EV Exposure value. See page 188.

expiration date The 'use by' date found stamped on the packaging of most light-sensitive materials.

exposure-compensation dial Camera control effectively overriding film-speed setting (by + or – exposure units). Used when reading difficult subjects, or if film is to be 'pushed' or 'held back' to modify contrast.

exposure latitude Variation in exposure level (over or under) which still produces acceptable results.

extension tube Tube, fitted between lens and camera body, to extend lens-to-film distance and allow focusing on very close subjects.

f-numbers International sequence of numbers, expressing relative aperture, i.e. lens focal length divided by effective aperture diameter. Each change of *f*-setting halves or doubles image brightness.

fast Relative term – comparatively very light sensitive.

ferrotype sheet Polished metal plate used for glazing glossy fibre-based prints.

fibre-based paper Printing paper with an all-paper base.

field camera Traditional-type view camera, often made of wood. Folds for carrying on location.

fill-in Illumination that lightens shadows, so reducing contrast.

film holder Double-sided holder for two sheet films, used with view cameras.

film pack Stack of sheet films in a special holder. A tab or lever moves each in turn into the focal plane.

film plane The plane, in the back of the camera, in which the film lies during exposure.

film speed Figure expressing relative light sensitivity. *See ISO.*

filter Optical device to remove (absorb) selected wavelengths or a proportion of all wavelengths.

filter factor Factor by which exposure should be increased when a filter is used. (Does not apply if exposure was read through lens plus filter.)

fisheye Extreme wide-angle lens, uncorrected for curvilinear distortion.

fixed focus camera Camera (typically very simple type) with a non focus-adjustable lens. Usually set for its hyperfocal distance.

fixer Chemical solution which converts silver halides into soluble salts. Used after development and before washing, it removes remaining light-sensitive halides, so 'fixing' the developed black silver image.

flare Unwanted light, scattered or reflected within lens or camera/enlarger body. Causes flare patches, degrades shadow detail.

flashing Giving a small extra exposure (to an even source of illumination) before or after image exposure. Lowers the contrast of the photographic material.

flat A subject or image lacking contrast, having minimal tonal range.

floodlight Artificial light source giving broad, generally diffused illumination.

focal length Distance between sharp image and lens, when lens is focused for an infinity subject. More precisely, between this image and the lens's rear nodal point.

focal plane Plane on which a sharp-focus image is formed. Usually at right-angles to lens axis.

fog Unwanted veil of density (or bleached appearance, in reversal materials). Caused by accidental exposure to light or chemical reaction.

format or 'frame' General term for the picture area given by a camera. See page 60.

FP Focal-plane flashbulb. Sometimes found on sync socket of older cameras. Do not use for electronic flash.

gamma Tangent of the angle made between the base and straight-line portion of a film's characteristic curve. Once used as a measure of contrast.

gelatin Natural protein used to suspend silver halides evenly in an emulsion form. Permits entry and removal of chemical solutions.

glossy Smooth, shiny print-surface finish.

gradation Variation in tone. Tonal range or scale.

graded papers Printing papers of fixed contrast. You purchase the grade you need as indicated by a number on the packaging. The lower the number the lower the contrast.

graduate Calibrated container for measuring liquids.

grain Clumps of processed silver halides forming the image. Coarse grain destroys detail, gives a mealy appearance to even areas of tone.

guide number Number for simple flash exposure calculations, being flashgun distance from subject times *f*-number required (ISO 100/21° film). Normally relates to distances in metres.

halftone Full-tone-range photograph broken down into tiny dots of differing sizes, for ink reproduction on the printed page.

halides Alkali salts such as potassium iodide or potassium bromide, which when combined with silver nitrate form light-sensitive *silver* halides.

hard Contrasty – harsh tone values.

hardener Chemical which toughens the emulsion gelatin.

high key Scene or picture consisting predominantly of pale, delicate tones and colours.

highlights The brightest, lightest parts of the subject.

holding back Reducing development (often to lower contrast). Usually preceded by increased exposure. Also called 'pulling'. Term is sometimes used to mean *shading* when printing.

hot shoe Flashgun accessory shoe on camera; it incorporates electrical contacts.

hyperfocal distance The subject distance focusing setting for a lens which gives depth of field extending from half this distance to infinity.

hypo Abbreviation for sodium hyposulphite, the fixing agent since renamed sodium thiosulphate. Also common term for all fixing baths.

incandescent light Illumination produced from electrically heated source, e.g. the tungsten-wire filament of a lamp.

incident light Light reaching a subject, surface, etc.

incident-light reading Using an exposure meter at the subject position, pointed towards the camera, with a diffuser over the light sensor.

infinity A subject so distant that light from it effectively reaches the lens as parallel rays. (In practical terms the horizon.)

instant-picture material Photographic material with integral processing, e.g. Polaroid.

inverse square law With a point source of light, intensity at a surface is inversely proportional to the square of its distance from the source; e.g. half the distance, four times the intensity.

inverted telephoto lens A lens with rear nodal point well behind its rear element. It therefore has a short focal length but relatively long lens-to-image distance, allowing space for an SLR mirror system.

IR Infra-red. Wavelengths longer than about 720 nm.

IR focus setting Red line to one side of the lens focus-setting mark, used when taking pictures on IR film.

ISO International Standards Organisation. Responsible for ISO film speed system. Combines previous ASA and DIN figures, e.g. ISO 400/27°.

joule Watt-second. Light output given by one watt burning for one second. Used to quantify and compare the power output of electronic flash (but ignores influence of flash-head reflector or diffuser on exposure).

kelvin (K) Measurement unit of *colour temperature*. After scientist Lord Kelvin.

keylight Main light source, usually casting the predominant shadows.

kilowatt One thousand watts.

large format General term for cameras taking pictures larger than about 6 × 9 cm.

latent image Exposed but still invisible image.

latitude Permissible variation. Can apply to focusing, exposure, development, temperature, etc.

LCD Liquid crystal display. Electronically energised black lettering, symbols, etc., used in camera's viewfinder or top-plate readout.

leaf shutter *See between-lens shutter.*

LED Light-emitting diode. Used for light signalling – camera viewfinder information, battery check, etc.

lens hood, or shade Shield surrounding lens (just outside image field of view) to intercept side-light, prevent flare.

light meter Device for measuring light and converting this into exposure settings.

light trap Usually some form of baffle to stop entry of light yet allow passage of air, solution, objects, according to application.

lighting contrast ratio The ratio between deepest shadow and brightest lit areas of a scene. Assumes that in both instances the tone of the actual subject remains the same (grey card in each area for example).

line image High-contrast image, as needed for copies of line diagrams or drawings.

linear perspective Impression of depth given by apparent convergence of parallel lines, and changes of scale between foreground and background elements.

lith film Highest-contrast film. Similar to line but able to yield negatives with far more intense blacks.

location photography Photography away from the studio.

log Logarithm. In photography common logarithms, to the base 10; e.g. \log_{10} of $10 = 1$ and \log_{10} of $100 = 2$.

long focus lens A lens of longer focal length than normal for the format.

long-peaking flash Electronic flash utilising a fast stroboscopic principle to give an effectively long and *even* peak of light. This 'long burn' allows an FP shutter slit to cross and evenly expose the full picture format, at fastest speeds.

low key Scene or picture consisting predominantly of dark tones, sombre colours.

M Medium-delay flashbulb. Flash sync connections marked M close circuit before the shutter is fully open. Do not use for electronic flash.

macro lens Lens specially corrected to give optimum definition at close subject distances.

macrophotography *See photomacrography.*

macro zoom Zoom lens which offers a close focusing setting, usually accessed by a 'macro' position on the distance scale.

magnification In photography, means linear magnification (height of object divided into height of its image).

manual mode Selectable option on a multi-mode camera whereby you choose and make the settings (e.g. for exposure).

masking frame Adjustable frame which holds printing paper during exposure under enlarger. Also covers edges to form white borders.

mat, or overmat Cardboard rectangle with cut-out opening, placed over print to isolate finished picture.

matt Non-shiny, untextured surface finish.

maximum aperture The widest opening (lowest *f*-number) a lens offers.

medium format camera Camera taking pictures larger than 35 mm but smaller than sheet film sizes. A rollfilm camera, for example.

microphotography Production of extremely small photographic images, e.g. in microfilming of documents.

midtone A tone mid-way between highlight and shadow values in a scene.

mirror lens Also 'Catadioptric' lens. Lens using mirrors as well as glass elements. The design makes long focal length lenses more compact, less weighty, but more squat.

mode The way in which a procedure (such as measuring or setting exposure) is to be carried out.

modelling light Continuous light source, positioned close to electronic flash tube, used to preview lighting effect before shooting with the flash itself.

monochrome Single colour. Also general term for all forms of black and white photography.

monorail camera Metal-framed camera, built on rail.

motor drive Motor which winds on film after each exposure.

ND Neutral density. Colourless, grey tone.

negative Image in which tones are reversed relative to original subject.

neutral density filter Colourless grey filter which dims the image by a known amount.

normal (or 'standard') lens Lens most regularly supplied for camera, typically has a focal length equal to the diagonal of the picture format.

notching code Notches in sheet film, shape-coded to show film type. See page 160.

object The thing photographed. Often used interchangeably with *subject*.

one-shot processing Processing in fresh solution, which is then discarded rather than used again.

opacity Incident light divided by light transmitted (or reflected, if tone is on a non-transparent base).

opaque Impervious to light.

open flash Firing flash manually while the camera shutter is open.

'opening up' Changing to a wider lens aperture.

ortho Orthochromatic sensitivity to colours. Monochrome response to blue and green, insensitive to red.

OTF Off the film. Light measurement of the image whilst on the film surface during exposure – essential for through-the-lens reading of flash exposures.

pan and tilt head Tripod head allowing smooth horizontal and vertical pivoting of the camera.

pan film Panchromatic sensitivity. Monochrome response to all colours of the visual spectrum.

panning Pivoting the camera about a vertical axis. Following horizontal movement.

panorama camera Camera giving long-narrow format proportions by using the centre strip of the image given by the (wide-angle) lens.

panoramic camera Camera in which the film moves behind a slit whilst the lens pivots about a vertical axis during exposure. Gives a long-narrow picture with curved horizontal perspective.

parallax Difference in viewpoint which occurs when a camera's viewfinding system is separate from the taking lens, as in compact and TLR cameras.

PC lens Perspective control lens. A lens of wide covering power on a shift (and sometimes also pivoting) mount. *See shift lens.*

PE Continental code for resin-coated paper. *See RC paper.*

PEC Photo-electric cell. Responds to light by generating minute current flow. Used in older, non-battery hand meters.

pentaprism Multi-sided silvered prism. Converts laterally reversed image on the focusing screen of SLR camera to right-reading.

perspective Device to give impression of three-dimensional depth and distance in an image.

pH Acid/alkalinity scale 0–14, based on hydrogen ion concentration in a solution. 7 is neutral, e.g. distilled water. Chemical solutions with higher pH ratings are increasingly alkaline, lower ones acid.

photoflood Bright tungsten studio-lamp bulb. Often 3400 K.

photogram Image recorded by placing an object directly between sensitive film (or paper) and a light source.

photomacrography Preferred term for extreme close-up photography giving magnification of × 1 or larger, without use of a microscope.

photomicrography Photography carried out using a microscope.

polarised light Light waves restricted to vibrate in one plane at right-angles to their path of direction.

polarising filter Grey-looking filter, able to block polarised light when rotated to cross the plane of polarisation.

Polaroid back Camera magazine or film holder accepting instant-picture material.

positive Image with tone values similar to those of the original subject.

PQ Developer using Phenidone and hydroquinone as developing agents.

preservative Chemical ingredient of processing solution. Preserves its activity by reducing oxidation effects.

press focus Lever on most large-format camera shutters. Locks open the shutter blades (to allow image focusing) irrespective of any speed set.

primary colours Of light: red, green and blue.

printing-in Giving additional exposure time to some chosen area, during printing.

program, programme, or P Setting mode for fully automatic exposure control. The camera's choice of aperture and shutter settings under any one set of conditions will depend on its built-in program(s).

pulling *See holding back.*

push-processing Increasing development, usually to improve speed or increase contrast.

quartz iodine Compact tungsten filament lamp. Maintains colour temperature and intensity throughout its life.

rangefinder Optical device for assessing subject distance, by comparison from two separate viewpoints.

rapid fixer Fast-acting fixing bath using ammonium thiosulphate or thiocyanate as fixing agent.

RC paper Resin (plastic) coated base printing paper.

rebate Unexposed parts outside a film's picture areas.

reciprocity law Exposure = intensity × time. Relationship breaks down at extremely long (and short) exposure times.

reducer Chemical able to reduce the density of a processed image. (Paradoxically the term 'reducing agent' is also applied to developing agents.)

reflected-light reading Measuring exposure (usually from the camera position) with the light sensor pointing towards the subject.

reflector Surface used to reflect light.

reflex camera Camera using one or more mirrors in its viewfinder system.

refraction Change in the direction of light as it passes obliquely from one transparent medium into another of different refractive index.

relative aperture. *See f-numbers.*

replenisher Solution of chemicals (mostly developing agents) designed to be added in controlled amounts to a particular developer, to maintain its activity and compensate for repeated use.

restrainer Chemical component of developer which restrains it from acting on unexposed halides.

reticulation A now rare 'wrinkly' overall pattern created in an emulsion during processing, due to extreme changes of temperature or pH.

reversal system Combination of emulsion and processing which produces a direct image of similar tonal values to the picture exposed on to the material.

ring flash Circular electronic flash tube, fitted around the camera lens.

rising front Camera front which allows the lens to be raised, parallel to the film plane.

rollfilm back Adaptor back for rollfilm.

safelight Working light of the correct colour and intensity not to affect the light-sensitive material in use.

saturated colour A strong, pure hue – undiluted by white, grey or other colours.

scrim Metal mesh attachment to lighting unit. Reduces intensity without altering lighting quality or colour.

secondary colours *See complementary colours.*

selective focusing Precise focus setting and shallow depth of field, used to isolate a chosen part of a scene.

self-timer Delayed-action shutter release.

sepia A colour ranging from reddish brown to chocolate, as formed in sepia toning by different combinations of toner and silver halide emulsion.

shading Blocking off light from part of the picture during some or all of the exposure.

shadows In exposure or sensitometric terms, the darkest important tone in the subject.

sharp In-focus and unblurred.

sheet film Light-sensitive film in the form of single sheets.

shift camera General term for a bellowless, wide-angle lens architectural camera with movements limited to up/down/sideways shift of the lens panel. No pivots or swings.

shift lens Wide-covering-power lens in a mount permitting it to be shifted off-centre relative to film format. Useful in cameras lacking movements.

shutter-priority mode *See Tv.*

silhouette An image showing the subject as a solid black shape against white background.

silver halides Light-sensitive compounds of silver and alkali salts of halogen chemicals, such as bromine, chlorine and iodine.

single-use camera Simple, ready-loaded camera, broken open and disposed of by the lab when processing your exposed film.

slave unit Flash unit which reacts to light from another flash and fires simultaneously.

SLR Single-lens reflex.

snoot Conical black tube fitted over spotlight or small flood. Restricts lighting to a small circular patch.

soft (1) Low contrast. (2) Slightly unsharp or blurred.

spectrum Radiant energy arranged by wavelength. The visible spectrum, experienced as light, spans 400–700 nm.

speed (of emulsion) A material's relative sensitivity to light.

spot meter Hand meter, with aiming viewfinder, to make spot exposure readings.

spot mode Narrow-angle exposure reading of the subject with a TTL meter. The small area measured is outlined on camera's focusing screen.

spotting Retouching-in small white specks or hairs – generally on prints – using water colour, dye or pencil.

still-life General term for an inanimate object, set up and arranged in or out of the studio.

stock solution Chemical stored in concentrated liquid form, diluted for use.

stop Historical term still used in connection with lens aperture settings, and changes in exposure. See page 40.

stop bath Acidic solution which halts development, reduces fixer contamination by alkaline developer.

stopping down *See stop.*

strobe Inaccurate general term for electronic flash. Strictly means fast-repeating stroboscopic lamp or flash.

subject The thing being photographed. Term used interchangeably with object, although more relevant to a person, scene or situation.

subject brightness range The ratio between the most brightly lit reflective part, and the most dimly lit dark toned part of the subject appearing in your picture.

supplementary lens. *See close-up lens.*

sync lead Cable connecting flashgun to shutter, for synchronised flash firing.

synchro-sun Flash from the camera used to 'fill-in' shadows cast by sunlight.

T setting 'Time' setting available on some large-format camera shutters. Release is pressed once to lock shutter open, then pressed again to close it.

tele-convertor *See convertor lens.*

telephoto Long focal length lens with shorter back focus, allowing it to be relatively compact.

tempering bath Large tank or deep tray, containing temperature-controlled air or water. Accepts drums, tanks, bottles or trays to maintain their solution temperature during processing.

'thick' image Dense, dark result on film.

'thin' image Pale, ghost-like film, lacking density.

tinting Applying colour (oils, dye, water colours) to print by hand.

TLR Twin-lens reflex.

toning Converting a black silver image into a coloured compound or dye. The base remains unaffected.

transparency Positive image on film. Includes both slides and larger formats.

TTL Through-the-lens camera reading, e.g. of exposure.

tungsten-light film Colour film balanced to suit tungsten light sources of 3200 K.

Tv Time value. Auto-exposure camera metering mode. You choose the shutter speed, the meter sets the aperture. (Also known as shutter priority system.)

'universal' developer A developer designed for both films and prints (at different dilutions).

uprating Increasing your film's speed setting (or selecting a minus setting on the exposure-compensation dial) to suit difficult shooting conditions. Usually followed up with extended development.

UV Ultra-violet. Wide band of wavelengths less than about 390 nm.

UV filter Filter absorbing UV only. Appears colourless.

variable-contrast paper Monochrome printing paper which changes its contrast characteristics with the colour of the exposing light. Controlled by filters.

view camera Camera (usually large-format) in which the image is viewed and focused on a screen in the film plane, later replaced by a film holder. View cameras are primarily used on a stand. *See also field camera.*

viewpoint The position from which camera views subject.

vignetting Fading off the sides of a picture into plain black or white, instead of having abrupt edges.

warm tone A brownish black and white silver image. Often adds to tonal richness.

watt-second. *See Joule.*

wetting agent Detergent-type additive, used in minute quantity to lower the surface tension of water. Assists even action of most non-acid solutions, and of drying.

white light Illumination containing a mixture of all wavelengths of the visible spectrum.

wide-angle lens Short focal length lens of extreme covering power, used on relatively large format to give a wide angle of view.

working solution Solution at the strength actually needed for use.

X Electronic flash. Any flash sync socket and/or shutter setting marked X is for electronic flash.

zone system Method of controlling final print tone range, starting with your light readings of the original subject. Pictures are previsualised as having up to nine tone zones, adjusted by exposure and development. Propounded by photographers Ansel Adams and Minor White.

zoom lens Lens continuously variable between two given focal lengths, whilst maintaining the same focus setting.

zooming Altering the focal length of a zoom lens.

Picture credits

Fig. 1.1 Harold Egerton. MIT. 1.3 Henri Cartier-Bresson/Magnum. 1.4 Lee Friedlander, New York. 1.5 Dorothea Lange, Library of Congress. 1.6 Edward Adams, Associated Press. 1.8 Jerry Uelsmann, Florida. 1.9 Robert Demachy, RPS Collection. 1.10 Sue Wilks, London. 1.11 Stephen Dalton/Natural History Photo Agency. 1.12 The Estate of Bill Brandt, permission Noya Brandt. 1.13 John Batho, Paris. 2.1 Alexander Keighley, RPS Collection. 5.5 Walker Evans, Library of Congress. 6.5 John Bethell, for National Trust. 7.3 Russell Lee, Library of Congress. 7.19 Andreas Vogt, A1 Studios. 8.1 Don Fraser, Academy Studios Ltd. 8.2 Russell Lee, Library of Congress. 8.4 Jack Delano,

Library of Congress. 8.5 Edward Weston, Arizona Board of Regents, Center for Creative Photography. 8.6 The Estate of Bill Brandt, permission Noya Brandt. 8.7 Nick Rogers Photographic Ltd. 8.8 Pradeep Luther. 8.9 Elliott Erwitt/Magnum. 8.12 and 8.14 Fay Godwin/Barbara Heller Photo Library. 8.15 Franco Fontana, Modena. 8.16 Jack Delano, Library of Congress. 8.17 Arthur Rothstein, Library of Congress. 8.18 Fay Godwin/Barbara Heller Photo Library. 8.22 John Batho, Paris. 8.26 Jean Dieuzaide, Toulouse. 9.2 Courtesy Kodak Research Division. 9.40 Tim Stephens, London. 14.5 Jean Dieuzaide, Toulouse. 14.9 Tansy Spinks, London. 14.10 David Hockney/Tradhart Ltd.

(All other pictures by the author.)

Index